Video Mind, Earth Mind

Semiotics and the Human Sciences

Roberta Kevelson
General Editor

Vol. 5

PETER LANG
New York • San Francisco • Bern • Baltimore
Frankfurt am Main • Berlin • Wien • Paris

Paul Ryan

Video Mind, Earth Mind

Art, Communications and Ecology

PETER LANG
New York • San Francisco • Bern • Baltimore
Frankfurt am Main • Berlin • Wien • Paris

Library of Congress Cataloging-in-Publication Data

Ryan, Paul.
 Video mind, earth mind : art, communications, and ecology /
Paul Ryan.
 p. cm. — (Semiotics and the human sciences ; v. 5)
 Includes bibliographical references and index.
 1. Video recordings, 2. Ecology. 3. Semiotics. 4. Semiotics
and the arts. I. Title. II. Series.
PN1992.945.R9 1992 304.2—dc20 92-4840
ISBN 0-8204-1871-4 CIP
ISSN 1054-8386

Die Deutsche Bibliothek-CIP-Einheitsaufnahme

Ryan, Paul:
Video mind, earth mind : art, communications, and ecology /
Paul Ryan.—New York; Berlin; Bern; Frankfurt/M.; Paris; Wien:
Lang, 1992
 (Semiotics and the human sciences ; Vol. 5)
 ISBN 0-8204-1871-4
NE: GT

The paper in this book meets the guidelines for permanence and
durability of the Committee on Production Guidelines for
Book Longevity of the Council on Library Resources.

Printed in the United States of America.

Peter Lang AG

INTERNATIONALER VERLAG DER WISSENSCHAFTEN

Moosstrasse 1 · Postfach 350 · CH-2542 Pieterlen · Switzerland

please forward payment to:
PETER LANG PUBLISHING, INC.
Gen.Post Office,POBox 30019
New York, NY 10087-0019

Telephone	212-647-7700
Fax	212-647-7707
Customer Service	212-647-7706
Internet	www.peterlang.com

10747169

Delivery address
450964
Connie Chen
350 W. 42nd Street
US - New York, NY 10036
USA

450964
Connie Chen
350 W. 42nd Street
US - New York, NY 10036
USA

JAN 1 2011

INVOICE 1 3 1 6 0 1 3

Date	Your order: 29.12.2010	Page	1
3.1.2011			

Article number	Author Title	Series Volume	Quantity	Price/Copy*)	Discount %	Value US$
69871	RYAN PAUL VIDEO MIND, EARTH MIND (PB) ISBN: 978-0-8204-1871-1 USISBN: 978-0-8204-1871-1	SEMHUM 5	1	38.95		38.95

Paid by AMERICAN EXPRESS

Lieferbedingungen

Unsere Bücher werden ausschliesslich von der Schweiz ausgeliefert.

Unsere Preise sind unverbindliche Preisempfehlungen. Preisänderungen behalten wir uns vor. Unterschiedliche Relationen zwischen den einzelnen Währungen bei verschiedenen Titeln sind auf Wechselkursschwankungen während der Produktionszeit zurückzuführen.

Dem Buchhandel gewähren wir in der Regel 10% Rabatt auf den empfohlenen Richtpreis. Spezialvereinbarungen ausgenommen.

Bei Bestellungen von 10 oder mehr Exemplaren des gleichen Titels gewähren wir Mengenrabatt.

Universitätsbibliotheken und -institute erhalten 5% Rabatt.

Porto und Verpackungskosten gehen zu Lasten des Bestellers. Auf Grund der niedrigen Auflagen können wir keine Ansichtsexemplare versenden. Unsere Rechnungen sind zahlbar innert 30 Tagen ab Rechnungsdatum und verstehen sich rein netto. Wir akzeptieren auch Kreditkarten (VISA und Eurocard/Mastercard).

Mit Ihrer Bestellung erklären Sie sich mit den genannten Lieferbedingungen einverstanden. Gerichtsstand und Erfüllungsort ist

Conditions de livraison

La distribution de nos livres se fait uniquement depuis la Suisse.

Nos prix sont indicatifs et susceptibles de modifications. Des éventuelles différences entre certaines monnaies sont tributaires des fluctuations du taux de change en période de production.

Notre remise habituelle aux libraires s'élève à 10% sur le prix de vente indicatif. Dans certains cas particuliers, un rabais plus important est accordé.

Des rabais plus élevés sont accordés en cas de commande de 10 exemplaires ou plus d'un même ouvrage.

Les bibliothèques d'universités et les instituts universitaires bénéficient d'une remise de 5%.

Les frais de port et d'emballage sont à charge du commanditaire. Le faible tirage de nos ouvrages ne nous permet pas de livrer d'exemplaires à l'examen. Nos factures sont payables dans les trente jours, la date d'émission faisant foi, et sans escompte. Nous acceptons les règlements par cartes de crédit (VISA et Eurocard/MasterCard).

En nous passant commande, vous vous engagez à respecter nos conditions de livraison. En cas de litige, le lieu de juridiction est

Conditions of Sale

All our books are distributed from Switzerland.

Our prices are recommended sales prices and are subject to change without notice. Differences between currencies are due to variations in the exchange rate during production of the books.

Our standard bookseller discount is 10% due to the limited print runs we publish. Higher discounts may be granted under special circumstances.

Higher discounts apply if you order 10 copies or more of a single title.

University libraries and departments receive a 5% discount.

Postage and handling charges are to be paid by the receiver. Due to our limited print runs we cannot send out books on approval. Our bills are payable within 30 days net. We accept credit cards (VISA and Eurocard/Mastercard).

By placing an order with our publishing house the customer accepts these terms and conditions. Legal domicile in case of litigation is the seat of the company in Bern, Switzerland.

Peter Lang AG

INTERNATIONALER VERLAG DER WISSENSCHAFTEN

Moosstrasse 1 · Postfach 350 · CH-2542 Pieterlen · Switzerland

please forward payment to:
PETER LANG PUBLISHING, INC.
Gen.Post Office,POBox 30019
New York, NY 10087-0019
Telephone 212-647-7700
Fax 212-647-7707
Customer Service 212-647-7706
Internet www.peterlang.com

Delivery address
450964
Connie Chen
350 W. 42nd Street
US - New York, NY 10036
USA

450964
Connie Chen
350 W. 42nd Street
US - New York, NY 10036
USA

10747169

Copy

INVOICE 1 3 1 6 0 1 3

Date	Your order: 29.12.2010	Page	1
3.1.2011			

Article number	Author Title	Series Volume	Quantity	Price/Copy*)	Discount %	Value US$
69871	RYAN PAUL VIDEO MIND, EARTH MIND (PB) ISBN: 978-0-8204-1871-1 USISBN: 978-0-8204-1871-1	SEMHUM 5	1	38.95		38.95

Paid by AMERICAN EXPRESS

Lieferbedingungen

Unsere Bücher werden ausschliesslich von der Schweiz ausgeliefert.

Unsere Preise sind unverbindliche Preisempfehlungen. Preisänderungen behalten wir uns vor. Unterschiedliche Relationen zwischen den einzelnen Währungen bei verschiedenen Titeln sind auf Wechselkursschwankungen während der Produktionszeit zurückzuführen.

Dem Buchhandel gewähren wir in der Regel 10% Rabatt auf den empfohlenen Richtpreis. Spezialvereinbarungen ausgenommen.

Bei Bestellungen von 10 oder mehr Exemplaren des gleichen Titels gewähren wir Mengenrabatt.

Universitätsbibliotheken und -institute erhalten 5% Rabatt.

Porto und Verpackungskosten gehen zu Lasten des Bestellers. Auf Grund der niedrigen Auflagen können wir keine Ansichtsexemplare versenden. Unsere Rechnungen sind zahlbar innert 30 Tagen ab Rechnungsdatum und verstehen sich rein netto. Wir akzeptieren auch Kreditkarten (VISA und Eurocard/Mastercard).

Mit Ihrer Bestellung erklären Sie sich mit den genannten Lieferbedingungen einverstanden. Gerichtsstand und Erfüllungsort ist

Conditions de livraison

La distribution de nos livres se fait uniquement depuis la Suisse.

Nos prix sont indicatifs et susceptibles de modifications. Des éventuelles différences entre certaines monnaies sont tributaires des fluctuations du taux de change en période de production.

Notre remise habituelle aux libraires s'élève à 10% sur le prix de vente indicatif. Dans certains cas particuliers, un rabais plus important est accordé.

Des rabais plus élèves sont accordés en cas de commande de 10 exemplaires ou plus d'un même ouvrage.

Les bibliothèques d'universites et les instituts universitaires bénéficient d'une remise de 5%.

Les frais de port et d'emballage sont à charge du commanditaire. Le faible tirage de nos ouvrages ne nous permet pas de livrer d'exemplaires à l'examen. Nos factures sont payables dans les trente jours, la date d'émission faisant foi, et sans escompte. Nous acceptons les règlements par cartes de crédit (VISA et Eurocard/MasterCard).

En nous passant commande, vous vous engagez à respecter nos conditions de livraison. En cas de litige, le lieu de juridiction est

Conditions of Sale

All our books are distributed from Switzerland.

Our prices are recommended sales prices and are subject to change without notice. Differences between currencies are due to variations in the exchange rate during production of the books.

Our standard bookseller discount is 10% due to the limited print runs we publish. Higher discounts may be granted under special circumstances.

Higher discounts apply if you order 10 copies or more of a single title.

University libraries and departments receive a 5% discount.

Postage and handling charges are to be paid by the receiver. Due to our limited print runs we cannot send out books on approval. Our bills are payable within 30 days net. We accept credit cards (VISA and Eurocard/Mastercard).

By placing an order with our publishing house the customer accepts these terms and conditions. Legal domicile in case of litigation is the seat of the company in Bern, Switzerland.

| | | 0.640 kg | 1 | Postage and packing | | 5.00 |

						Total
Value for goods	Postage and packing	Net value	VAT %	Value VAT	US$	43.95
38.95	5.00	43.95	0.00	0.00	0.00	43.95

*) Recommended price
Payable net within 30 days

АПЕХ

Pre-billed but
Paid will
Payée avec

All sales are final
When paying please quote invoice-number and client-number. Th

Bezahlt mit
Paid with
Payée avec
VISA/MASTERCARD

AMEX

		0.640 kg	1	Postage and packing		5.00
Value for goods	Postage and packing	Net value	VAT %	Value VAT	US$	Total
38.95	5.00	43.95	0.00	0.00		43.95

*) Recommended price
Payable net within 30 days

All sales are final
When paying please quote invoice-number and client-number. Th

. . .dedicated to the waters of planet earth. . .

Note on the Book Cover

In keeping with the wishes of Series Editor, Roberta Kevelson, I selected a Daumier lithograph for the cover of *Video Mind, Earth Mind*. Daumier's lithograph is titled "NADAR elevant la Photographie a la hauteur de l'Art" and appeared in May of 1862. NADAR was the pseudonym adopted by Felix Tournachon when he began to write for Paris journals as a young man. Later he opened a photographic gallery under the name of Pantheon-Nadar and became famous. As Daumier's image indicates, Tournachon built a huge balloon he called "The Giant" to photograph from the air.

The lithograph reproduction is from the collection of The Metropolitan Museum of Art, Harris Brisbane Dick Fund, 1926. (26.52.4).

Contents

Acknowledgments

A book like this is not produced without a network of support. That support of course, begins with my father and mother who gave of themselves in ways that cannot be measured. At the risk of forgetting some of the others who have helped me, I want to acknowledge and thank by name the people who have supported me in various ways over the years. First, I want to thank my teachers including my older brother, Jim, Reverend John McHugh, Sister Charles Eileen, Sister Thomas, Christopher Collins, C.P., Augustine Paul Hennessey, C.P., Thomas Berry, C.P., Claude Ponsot, Robert Pollack, Conor Cruise O'Brien, George Steiner, David Caute, Walter Ong, Marshall McLuhan, Edmund Carpenter, Horst Janson, Al Scheflen, and Gregory Bateson. Also, I wish to thank and acknowledge the friends, colleagues, and associates who assisted me in my explorations: Denis Walsh, Joe Drexel, Ed Morris, John Culkin, Nancy Rambush, Frank Gillette, Ira Schneider, Michael Shamberg, Howard Wise, Charlotte Moorman, Nam June Paik, Jud Yalkut, Beryl Korot, Peter Bradley, Russell Connors, Vic Gioscia, Barbara Haspiel, Dean and Dudley Evanson, Jodie Sibert, Megan Williams, Louis Jaffe, Andy Mann, Phyllis Segura, Jack Golden, Gerald O'Grady, Charlotta Schoolman, Avery Johnson, Warren Brodey, Billy Carrigan, Craig Cassarino, Janet Fehring, Bob Lenox, Linda Zerella, Lucas Corrubia, Steven Kolpan, Robert Schuler, Robert Woodriff, Michael Horowitz, Brenda Bufalino, Laura Rowley, Steve Katz, Dorothy Anderson, Tom Ehrlich, Ann Marie Miller, Lonnie Deland, Peter Berg, Judy Goldhaft, Freeman House, David Simpson, Jane Lapier, Chip Lord, Ken Ryan, Roy Skodnick, Nancy Zimmerman, Francesca Lyman, George Tukel, Cynthia Lightbody, Trent Schoyer, Joanna Hefferen, Willoughby Sharp, Suellen Newman, Marita Sturken, Red Burns, Anne McKay, Mark Siegeltuch, Tom Ryan,

Barbara London, Lynn Hoffman, Myrdene Anderson, John Giancola, Arthur Tsuchiya, Morris Berman, Gerd and Sally Stern, John Brockman, Katinka Mateson, George Gorman, Linda Crane, Peter Reynolds, Very Reverend James Parks Morton, Pamela Morton, Paul Gorman, Amy Fox, Paul and Julie Mankiewicz, Stuart Leigh, Gary Hill, Al Robbins, Michael Kalil, Rolf Kloepfer, Frank Moretti, Tom de Zengotita, Jeanne Heyman, Stacy Lorenz, Richie Corozine, Serge Grovansky, George Stoney, Trisha Dair, Caroline Angiolilo, Steve Jambeck, Charles Potter, and David Levine.

Regarding the production of this book, I want to thank Lawrence and Dulcie Kugelman. Without their generous support, there would have been no book. Jean Gardner's steadfast support was likewise essential. I also want to thank the series editor, Roberta Kevelson, for inviting me to contribute to this series on Semiotics and the Humanities and writing a foreword for Peirce scholars. Also, special thanks to Frank Gillette, John Giancola, Peter Berg and Tom de Zengotita for contributing their forewords for this book and the many fruitful conversations over the years. Michael Flamini, Christine Marra, and Kathy Iwasaki of Peter Lang Publishing, Inc. were all gracious and helpful in the production process. Thanks also to Gary Allen for providing the graphics, to Jim Ryan and Jean Gardner for close reading of the introductory texts, to Janet Marks for copyediting and to my daughter, Kyra, who worked as the principal editor of this book. Kyra helped make the selections, order the sequence, edit the previously unpublished material, and edited the introductory remarks to each section. Much of whatever clarity there is in this book is due to her fearless questioning of her father's sometimes enigmatic style.

I also want to thank the following for permission to reprint articles included in this book—*Media and Methods* for "Videotape: Infolding Information" and "Cable TV: The Raw and the OverCooked"; *Radical Software* for "Self Processing" and "Guerrilla Warfare and Cybernetic Theory"; *Talking Wood* for permission to reprint editorial statements, "Relationships," and the material from "Watershed Watch"; *All Area* for "Metalogue: Gregory Bateson: Paul Ryan"; Willoughby Sharp

for "From Teenage Monk to Video Bareback Rider"; *IS Journal* for "Ecochannel Design"; *Leonardo* for "A Genealogy of Video" and "The Earthscore Notational System for Orchestrating Perceptual Consensus about the Natural World"; The Reality Club for "Video, Computers, and Memory"; and Mouton de Gruyter for "'A Sign of itself.'"

Foreword Regarding the Ecological Crisis

The reality of the planetary biosphere lies just below the plastic-wrapped surface of our Industrial Era consumer world of perceptions. We only see it from the inside, in incomplete glimpses: grass growing in a sidewalk crack, a line of ants suddenly assembled on a kitchen countertop, a frantic bird flying though a window into the room. We know that in some way this uncontrolled natural realm is the ultimate basis for our highly ordered and smooth-surfaced lives. But we don't know the actual relationships. We are of nature but have put a wall between it and ourselves. This may be the most critical failing in the current ecological crisis.

Paul Ryan is trying to see through this wall. He comes out of a rigorous intellectual tradition that built cathedrals to exhibit ideas, so it is not strange that he erects formidable mental constructs to achieve the direct visual perception he seeks. They are necessary components of his project. Just as we erect planetariums to support telescopes that gain sightings of stars, so Ryan's mental constructs provide the plans with which we can erect terrestrial observatories housing video.

I did not understand the unique qualities of video until Paul showed me tapes he had made of water descending at Great Falls, New Jersey. The usual sight of foam and torrents appeared but there was something more. There were oddly similar patterns and an interplay between them that I had never noticed before. In fact, the whole experience of watching video of a relatively common event was extremely different from being present to see it in person. Video made it specimen material for later study. One could actually see more information of various kinds within the waterfall action than otherwise, and the tape was a record that could be

replayed, held for comparison with future conditions and used in many other ways.

After I introduced Paul to the bioregional concept of considering geographical places as living entities of which human life is a part, he began developing techniques to employ the observational qualities of video to record bioregionally related phenomena such as watersheds, land forms, native plants and animals, weather, and other local natural characteristics. Although they were always there in some form, he has since elaborated technical, social and cultural aspects of this process. Altogether these aspects hold rich promise for identifying and interacting with non-human features of bioregions so that their inhabitants can restore and maintain them while discovering sustainable ways to fill basic requirements of life.

Paul Ryan has taken the challenge of reconnecting people in a harmonious way with the rest of nature seriously. He is helping us to literally see the state of interdependence we exist in, and that is an important first and lasting goal.

Peter Berg
Director
Planet Drum Foundation
San Francisco

Foreword for Educators

Paul Ryan's collection of essays and proposals is a product of twenty five years of research and field work. *Video Mind, Earth Mind: Art, Communications, and Ecology* is a feast. These social models derived from art, semiotics, and the structure of cybernetic theory advance the conversation about educational, relational, and environmental problems in our times.

Ryan challenges us to restructure our learning environments, and reinvent our relationship to one another, and the natural environment. He offers a language of unities, and where language cannot adequately represent unities, other sensory expressions are engaged. Reading through the manuscript, I was reminded of Lewis Mumford's warning that we have placed too great an emphasis on the technological-rational and too little emphasis on the artistic. Ryan's perspective, on the other hand, is a fresh synthesis of the artistic and the technological.

Empiricists, traditionally concerned with predictability and control, may be interested in the innovative data-collection strategies put forth in Ryan's notational system for comprehending the natural world. Interactionists committed to the hermeneutic goal of interpretation will find Ryan's idea of "video as infolding information" consistent with the movement toward self-reflexivity in research. Scholars committed to the activist goal of critical inquiry will be seriously engaged with questions implied by the social models presented. Thus, these essays are relevant to educators in the broadest sense of that term — those who seek curriculum renewal, whether for preschool, K through 12, or graduate studies.

There are five essays in this collection that hold special import for educators, in *Video: Infolding Information* the author discusses the early pedagogical mistakes made with video — how educators copied the broadcast model, thereby reinforc-

ing the concept of passive learning—the received view of information. How can video be used to turn students into a dynamic force for inquiry? This essay is a primer for those who are looking for ways to create partnerships in learning.

Cable TV: The Raw and the Overcooked distinguishes between the reflexive nature of recorded video and television as a distribution system for information. It outlines an approach for educators interested in working with their local cable TV company.

The Circuit analyzes the book-orientation of the classroom and presents a model by which the classroom may also be oriented toward the computer. In this essay Ryan demonstrates how three students, given three separate tasks by the computer, worked together without resorting to hierarchical structure within their group.

In *The Earthscore Method and Education*, Ryan re-constructs a teaching experiment he carried out at The Dalton School. He took a dozen teenagers into the field to study the state of the environment by creating four teams, a Video Team, a Word Team, an Image Team, and a Number Team. In the engaging essay the reader is introduced to a later essay which outlines one of Ryan's most significant concepts, *The Earthscore Notational System for Orchestrating Perceptual Consensus about the Natural World*.

The Earthscore Notational System enables artists equipped with video cameras to operate out of a pre-conceived design by which they continually present information to the community at large about the state of the natural world. In this essay, the reader can discern the confluence of McLuhan's larger cultural agenda for media, Bateson's cybernetic theory, Peirce's semiotics, and Ryan's artistic vision, which is informed by a monastic epistemology of relating the whole of nature to its parts. While reading it, I was reminded of Susanne Langer's description of the artistic process as a way of knowing. Langer believes that artists express, not from feelings, but from their insights into the *structure* of feelings. Just as there exists language symbols for rational thought, there exists also symbol systems for the expression of feeling. Because Peirce's semiotic system embodies both perceptual and linguistic signs,

Ryan was able to extrapolate from Peirce to a notational system that goes well beyond the confines and misrepresentations of language in "monitoring" our natural environment. There is no refutation of science and technology here; rather, a system is defined that embraces the multiple ways that humans "know," in order to address the environmental crisis of our times before it proves to be our undoing.

Ryan has forged a blueprint for the beginning of our new millennium, strategies by which humans can engage their senses and formidable communication technologies in problem-solving, without sacrificing the democratic values associated with consensus-making. It is food for thought and food for action.

John Giancola
Associate Professor
Communications
University of Tampa

Foreword for Peirce Scholars

In all speculative and prudential thinking, the doubt or irritation of the
brain comes from the imagination.
— Charles Sanders Peirce, MS 350

Paul Ryan reminds us at the outset of his remarkable book,
Video Mind, Earth Mind, that his purpose is not so much to
explicate Peirce's writings on the creative relationship which,
ideally, may obtain between the earth's evolution and our own
human role which is to observe and interpret this process.
Rather, the author's purpose, as I see it and try to compress it
into a few words, is to suggest a parallel process between the
structure and dynamic semiosis of Peirce's logic of relations
and an ecovaluation of the earth. In this valuation cultivation
and creation of the earth as observed, and the human viewer
as observer, enter into a dialogic relationship such that each
contributes to the ongoing creation of the other. It is this
reciprocity and intersubjective process which informs Peirce's
theory of signs and acts as a referent for his special under-
standing of the pragmatic method.

Paul Ryan sees this interplay, or dialogic and relational
process as an interpretive sign, or "sign of itself." The video
"I/Eye" and the evidence everywhere and in all recesses of the
observable natural world conjoin into an evolutionary
Becoming. What Peirce sees as the Play of Musement, or
interlude during which the new images or iconic qualities of
the world observed, emerges as the rudiments of new
commitments involving viewer and viewed.

It is literally a kind of magic-making that Paul Ryan
discusses in his use of a Peircean semiotics with a proposed
way of cultivating the earth. From ancient times to present,
across the boundaries of cultures and states, various peoples
have expressed the marriage of mankind and the earth in
terms of a sacred game — a *Hieros Gamos*. But in the sophisti-
cated and industrialized societies this sense of wonder has

become attenuated and the I-Thou relation is reduced to an I-It expediency. Peirce first grasped the importance of the I-Thou interaction when he was an undergraduate, studying Schiller's notions of the Aesthetic; Peirce carries the value of a dialogic and reciprocal I-Thou process of realizing a meaningful sense of the world throughout his long, difficult and prolific life. In Peirce's semiotics this Play of Musement leads to his emphasis on the continuing Becoming of a holistic viewer and viewed world-frame; it leads to the development of a multilevel concept of Possibility and to the affirmation of genuine novelty entering the world through Pure Chance.

In this sense Paul Ryan's astute and important insights into a Peircean semiotics can be said to make a linkage between video art and the natural world, in which this connection is a kind of *poeisis*, or value-creating experiment.

Toward this project Gregory Bateson and Marshall McLuhan are brought into a kind of triadic partnership with Peirce, one might say, and thus into a multidisciplinary perspective on ecological issues confronting us.

I have called attention also to Peirce's notion of observation as a catalyst which acts relationally to further the interdependence between viewing and thinking, i.e., between sense perception and the complex development of complex concepts, of Significance and the Real (Kevelson: 1990).

In Paul Ryan's "video mind" and "earth mind" there is an analogous parallel with a Peircean Observer and Observed: the provocation of wonder begins with the world as imaged, with the new dimensions of the Real as focused upon, as viewed. Just as David Brewster regarded the kaleidoscope which he invented as a new instrument for creating new forms of beauty, Paul Ryan regards video "minding" in such a worldmaking way.

My first meeting with Paul Ryan was at one of the Round Tables on law and semiotics, where he presented a video show and commentary, and clarified, for all of us privileged to be there, some of the most difficult concepts of Peirce's theory of signs, showing how this conceptual frame of reference itself

illuminated aspects of the viewer/viewed relationship in the ecological world.

It is with such pleasure and sense of privilege that, with these few words, I preface Paul's book.

Roberta Kevelson
Distinguished Professor
Penn State

Foreword for Anthropologists

A collaborative and activist anthropology has been on the academic agenda for decades. But the "observer" in "participant-observer" remains predominant. That emphasis in even the most daring of postmodern programs within the academy becomes strikingly apparent by comparison with Paul Ryan's life work— which is nothing less than an attempt, not only to conceive but, actually, to realize a new socio-cultural form, a form adapted to ecological crisis on a planetary scale.

Prepared by years in a monastery to think transcendentally and reverently, Ryan learned from mentors Gregory Bateson and Marshall McLuhan a way to think about ecology and mind which brought his meditations to practical focus in the late sixties and early seventies. Anthropologists will profit most from Ryan's work if they remember that he is, first and foremost, a political artist working in a medium ("video as evolutionary tool") through which he hopes to transform a world on the brink of disaster and a style of mind which propelled us to that brink. Concepts and topics associated with many disciplines, including anthropology, are brought to the service of such a project, but as colors on the palette, ingredients in a *practical art*, in the full sense of both words. Ryan has exercised the license his art confers without the elaborate justifications of deconstructivist philosophies, not to make objects to hang on a wall, but to make a "relational practice" capable of generating environment-conscious human communities. Like a postmodern *bricoleur*/shaman, he makes cultural things from the cultural things he has encountered over the course of twenty-five years of study and action—in anthropology, but also in philosophy, logic, biology, psychology, and in the flow of culture itself, whether tribal, ancient, modern, high or popular, religious or secular. Ryan respects no boundaries but those he has found to be immanent

to his project. He is not merely interdisciplinary, but inter-cultural. He can therefore offer anthropologists, postmodern and otherwise, a genuinely fresh encounter with notions grown all too familiar in an academic discourse. It is like catching an unexpected glimpse of yourself from an unusual angle in a mirror. To see what Ryan does with anthropology is to realize what anthropology has become and what it failed to be.

For me, the most interesting particular instances all flow from Ryan's persistent and developing critique of duality — of dyads of all kinds — in favor of an assortment of triadic structures which he devised in an attempt to bring a self-regulating openness to human consciousness and community. He summons Peirce's tripartite logic to the service of Waddington's chreods, not in theory but in actual ritual processes, proposed and performed, processes designed to replace the static (or schizmogenetic) dyad with the cybernetic triad. In the process, he keeps reminding us how profoundly anthropological inter-pretation has depended on dyadic contrasts, on dichotomies like nature/culture, right/left, sacred/profane, male/female. Levi-Strauss and the structuralists spring to mind as the most obvious referent, but as soon as we invoke them, we are reminded of structuralism's dependence on the binary in the phonological stuff of language. So when Ryan summons neurophysiologist McCulloch to complain that, given dyadic relations, all he can make are "strings and circles," the exchange systems of *The Elementary Structures of Kinship* are specifically recalled. In Ryan's consideration of incest from the triadic point of view, the taboo as it depended on the dynamics of exchange in Levi-Strauss opens out to Mary Douglas's account of taboo as boundary marker. The search for a bridge between an essentially functionalist cybernetics and an essentially interpretive structuralism dominated anthropological thought in the sixties and seventies. The call to *praxis*, in the style of the Frankfurt school, was sounding most clearly during that same period. Could it be that what was missing was a *praxis* which really applied the lessons of *Naven* and Bororo moieties rather than repeating outworn forms of political action adapted to the modern system?

Ryan's triadic practices, in all their variety, suggest an affirmative answer to that question.

But the real object of Ryan's critique of dualism goes beyond disciplinary foundations. It is not dualism in anthropology or even western thought which ultimately concerns Ryan. Oppositions between moieties were sustained by people who never heard of dualism *per se*, people who found "triadic" resolutions to problems generated by their binary structures — as in the Naven ceremony, or in the three castes hidden by the two Bororo clans — but who did so without making explicit the structural and adaptive principles and needs involved. In the context of world ecological crisis, we cannot afford to wait upon natural processes we have ourselves overridden or undermined. We must consciously recover and consciously apply them. This is a tall order. Ryan emphasizes again and again that we are inclined by in-built aspects of our nature to privilege duality. We are physically bilateral: two arms, front and back; we cannot look into more than one pair of eyes at a time; above all there are only two sexes. And on the plane of communication, in language, in metaphor, we constantly divide the sign from the object. In answering Peirce's call for something that could be "a sign of itself" — a call which anthropologists will find echoed in, for example, the work of Sperber or Wagner on symbolism — Ryan registers yet again the pull of dualism rooted deeply in our nature, and the complementary need to overcome it. The upshot is this: when Ryan takes on duality, he takes on human community and consciousness itself, not an academic commentary. Anthropologists accustomed to grappling with these issues on the level of commentary, while acting in conventional institutional modalities, will find themselves challenged at both levels by exposure to Ryan's radical attempt to bring theory and practice together in his political art.

Thomas de Zengotita
Anthropologist
New York University
The Dalton School

On Ryan's Sign(s):
Foreword for the Art World

With the commercial introduction in the mid-sixties of decentralized portable television recording/instant-playback technologies, a veritable melange of attitudes and subsequent practices ensued—all embedded in the novel properties intrinsic to this unique hybrid medium. Several camps—conflicting, contentious, and occasionally aligned—immediately emerged. Springing up like mushrooms out of their respective mycelium, divergent views as to the proper application of this revolutionary technology were rife. The crush and grind that followed pivoted around three essential positions, to wit: a) The new technology should be, must be, employed to invade, or at least infiltrate existing broadcast TV, offering alternative programming to a bemused though reluctant establishment, b) To set up alternate "networks" for the dissemination of counter-cultural information by way of tape distribution, and c) By forgoing a & b and concentrating on the equally revolutionary *aesthetic* attributes that could be leached from the new technology by various ways and means; e.g., idiosyncratic compositions on tape harboring no interest or intent whatever in being broadcast, and/or by utilizing the multi-channel capacity inherent in the decentralized medium towards site-specific installation formats, complete with time-delay systems, live (real-time) and recorded feedback, as well as magnetic-induced distortions, analog and digital overlays, and vitrines of biological specimens under electronic observation.

Into this rather dicey mix, enter Paul Ryan. Present at the creation, so to speak. Ryan's seminal contribution tends to span, in varying degrees, a, b, & c. Nevertheless, it is with his contribution to the medium within its aesthetic dimension that brands his work with a significance beyond and above this

synthesis. Beginning with his installation *Everyman's Möbius Strip* in the Howard Wise Gallery's pioneering show "TV as a Creative Medium" in May of 1969, Ryan has consistently, if not relentlessly, forged an *ouvre* that integrates explicitly social and ecological partisan concerns with participatory formal innovations. Therefore, situating Ryan's perch in the art world is not a simple matter of merely determining and locating the importance of his inclusion of the social-ecological sphere as it intersects with formalist discipline. Instead, in balance, it provides us with a conundrum as to *how* this wobbly combination could possibly work — satisfying aesthetic and didactic responsibilities simultaneously. No small task.

Thus the singular relevance of Ryan's ongoing project resides in *bridging* the trenches dividing social-ecological activism from the aloof preoccupations of art for its own sake. The undulating flux of formalist propositions holds down and maintains an utterly different ontic status than the advocacy and constancy of urgent issues swirling around social-ecological imperatives. Once successfully intertwined, however, they represent a peculiar fusion between the techniques of aesthetic conjury with methods alerting us to the undeniable bald-faced facts of a rapid and exponential dismemberment of the natural world.

Impudent, strident, blithe Philistines seem to possess the firmest of grips on the policy-making mechanisms that effect all of us-from whales to bats to snails. What can art's agencies possibly do to counter-state, resist and deflate this perverse, toxic hegemony? This is *the gravitational* question, the crux, the *heart* of the matter Ryan's work addresses.

His proposals run the gamut from real-time monitoring of relatively pristine natural sites situated in the very midst of urban settings (a contemporary version of the traditional land-scape genre; to utilizing portable video technology as a *perceptual tool* to inculcate respect, even reverence, for the natural world; to the *relational practice*, essentially an extended performance piece, in which participants interact in triads, generating inter-relations that are perforce simultaneously volitional *and* mutually dependent for a successful outcome.

In a curious sense, the *relational practice* is the inverse of the *Prisoner's Dilemma*.

From biosphere to semiosphere, from Rene Thom's *catastrophe's* to Klein's bottle, from cybernetics to C.S. Peirce's logic — Ryan's array of interests and experimental research tends to focus upon the daunting task of radically altering perceptual behavior and, as a consequence, instituting a distinct *kunstler's* epistemology. Such an epistemology proceeds at full bore to establish an *interactive* knowledge of the world inaccessible by other means. Though vastly different in other respects, Ryan's attitude of mind in this regard is comparable to Joseph Bueys's concept of sculpture as social action. With Bueys, an animist, neo-shamanist stance was bred in the bone; offering himself, his body as both catalyst and lightening rod for absorbing, thus naturalizing, the lingering menace of social/ethnic intolerance of every stripe, as well as counteracting accelerating ecological dissolution. With Ryan, the function of the artist, at this historical juncture, is grounded in creating operational contexts in which *awareness* of the environment's precarious state is clarified, expanded, and complemented with social action.

The successful entrenchment of the post-modern ethos, pervading virtually all domains of cultural activity, has opened wide sluice gates to every feasible sensibility — intermixing all possible stylistic combinations of cross-reference, mixed codes and contextual overlays. Palimpsests of meaning now peel away revealing themselves within ahistorical terms and parameters never anticipated by their initial intent. Hither and yon *value itself* is now exposed, deconstructed and subject to random (if not nihilistic) interpretation, to incidental and capricious connections, to the whims of political and/or arbitrary association. This is the current milieu within which serious art is now made, whether the artist is in sympathy with the post-modernist position or not.

For Ryan, this condition cuts to several quicks at once. Firstly — with the modernist's boundaries either dissolving in swift retreat, or holding down the rear-garde — it permits the widest latitudes for incorporating diverse ideational elements

and performance maneuvers. Next, the trans/multi-cultural impetus promulgated by post-modernist theorists plays into Ryan's long-held view that artistic production must encompass a global dimension. And finally, functioning within an omnibus of strategies and flexible tactics, it embraces aesthetic practices, procedures and materials that are an anathema to whatever remains of the strictly "formalist" canon.

This is emphatically *not* to maintain that Ryan is a typical post-modernist. On the contrary, his polymath position began evolving at least a decade prior to the term's critical application to the plastic arts. Instead the defining moment, the etiology of his mature development stems from Peirce's doctrine of signs, where semiosis involves an irreducibly triadic relation among a sign, its object, and its interpretant. It was this confluence of Peircean logic and the urge to make art with an unmistakable *social-ecological* context that set Ryan off on his course.

The *Eco-Channel* project is the most cardinal, generic and ambitious of Ryan's work to date. If fully implemented, it may very well make a difference which makes a profound difference. For, contrary to pedestrian assumptions that art is a cavalier luxury (a sort of fluffy dessert after one's fill of meat and potatoes), art is a necessity — one upon which the survival of this species probably depends. Hence, the principle of the *Eco-Channel* is, in medieval terms, *aliquid stat pro aliquo*, that is it represents or refers to something, some capacity, to which we (excluding sociopaths and their ilk) can all relate. Cable or "dish" television channel(s) would permit anyone, anywhere, anytime, to monitor a multitude of natural sites in real-time. Uroburous-like, it would link our most sophisticated communications technologies with unfolding views of primeval nature.

Given the intricate spectrum of Ryan's discourse, it is doubtless that certain swaths of the wheezing art world gerontocracy will cluck with snide disapproval at his proposals. "What does it have to do with art?" they will ask. Without palpable objects, why not approach anthropologists, communication specialists, naturalists and environmentalists with your

ideas—why us, they will intone. The appropriate response to such queries is from none other that Giordano Bruno: "Rules are not the source of poetry, but poetry is the source of rules, and there are as many rules as there are real poets."

Frank Gillette
Artist
New York City

Video Mind, Earth Mind

General Introduction

No one can say for sure how long we humans can go on abusing the ecosystems that support our life. Some think the time is short. In 1990, the respected Worldwatch Institute predicted the earth could only endure another forty years of overpopulation, ozone depletion, rain forest destruction and global warming. And then? Then we pass a threshold of irreversible environmental destruction. The door to a healthy life on earth deadbolts behind us. We watch our grandchildren garbage-pick their way through life in ecosystems that are terminally ill.

Whatever the time frame for earth's tolerance, it is clear we must change our ways. *Video Mind, Earth Mind* is a collection of texts offering ideas about how video and television can be used to facilitate the needed change. For example, these writings present the development of a teachable method for producing video interpretions of the natural world. Based on this method, I am able to articulate a systemic way of using television to ground human communication in ecological systems. Grounding our television communications in ecological systems will help control our runaway destruction of this planet and shape ways of living on earth that are sustainable.

I authored the texts gathered here over a twenty-four year period (1968 – 1992) while working as an artist using video. The title *Video Mind, Earth Mind* plays on the title of Suzuki Roshi's classic text *Zen Mind, Beginner's Mind*. Zen invites a fresh way of paying attention to the world. Similarly, to see through a video camera is to begin again. Fresh. I remember once carrying my fretful, six-month-old daughter from a dark house out into the birdsong of sunrise. Her cries stopped. Her eyes and ears opened to the morning. So did mine. Carrying a video camera on your shoulder is like carrying an infant into the dawn.

Portable video is a technology of perception that has been with us for almost a generation. I was fortunate to be among those who shared, in the words of Wallace Stevens, "the original earliness" of the video movement in New York City during 1968. We saw fresh. We were watchful. Together. Spontaneously, we initiated an open process of creating meaning based on the video perceptions we shared.

Spontaneities run their course. By definition they are far from equilibrium, lack formal structure and cannot stabilize. The early video movement dissolved into an eclectic mix of individuals pursuing individual visions. Our culture has yet to develop a mature use of video that stabilizes an open and watchful way of seeing among many people and creates meaning based on what is seen. In this book, I present a formal approach to such maturity. Using this approach, we can cultivate a beginner's mind, a video mind that would help reconnect our human minds with the "mind" of the earth. Of course, formalities alone do not ensure success. A host of other factors must come into play including cooperation, money, luck, cunning, and the sheer desire to live.

For me, the effort to develop a video mind resonant with the mind of the earth began in 1970 at a small conference on social change in Princeton. During that conference, Gregory Bateson, the author of *Steps to an Ecology of Mind*, laid out in clear and unambiguous terms how our species was at risk because of environmental destruction. Shortly after the conference, my father died suddenly of cancer at age fifty-seven. The shock of recognizing my own mortality in my father's death became one with the shock of recognizing the mortality of our entire endangered human species. After this shock, I began reinterpreting the meaning of my own life in terms of this death threat to our species. This reinterpretation was facilitated by the fact that Bateson, or Gregory, as he is known, became a friend and a mentor. Much of what you will read in this book is influenced by his thinking.

Another major influence on my thinking is the work of the American philosopher, Charles Peirce (1839–1914). Lest my reference to this relatively unknown philosopher scare off the general reader, let me say that I have relegated the technical

discussion of his work to a few essays. The rest of the book can be understood without prior knowledge of Peirce. For the reader unfamiliar with Peirce or Bateson, this collection offers an opportunity to learn about their work by examining various projects that make use of their thinking. The cybernetics I learned from Bateson involves thinking in circuits. The philosophy I learned from Peirce involves thinking in signs. Over the years I have combined thinking in circuits with thinking in signs to conceptualize a range of projects. The projects include a plan for an intentional community, an art of triadic behavior, the organization of a bioregional magazine, a design for a television channel dedicated to the environment, a computer program for generating consensus, and a notation for interpreting ecological systems.

Charles Peirce likened thought to a moving image. The fecundity of Peirce's thinking for understanding how to create meaning with the moving image is evident in a two volume study of cinema written by Gilles Deleuze. Deleuze combined Peirce's philosophic categories with Henri Bergson's understanding of movement to produce a compelling interpretation of filmmakers as philosophers. The filmmakers whom Deleuze examined did not consciously use Peirce's philosophy in their filmmaking. In my philosophic videomaking I have consciously used Peirce.

Peirce is the founder of modern American semiotics, or the study of signs. Semiosis is the process of making meaning with signs. In Peirce's terms, this book is about making meaning with video signs, or, if you will, about video semiosis. These writings take place on a cusp between print signs and video signs. I estimate that for every page of print I have authored in this book, I have recorded at least three hours of moving video images. Peirce's understanding of signs provides a framework in which to appreciate and interpret the discontinuity between video and print. Unlike the language based semiotics generated by Swiss author, Ferdinand de Saussure, Peirce's semiotics encompass both image and word. The words gathered here are signals from the video world to the print world about how video imaging can be used to reckon with the dangers of our present ecological situation.

Peirce is important to me for another reason. He wanted to develop a logic of relationships to organize his philosophic system. In my essay 'A Sign of itself,' I claim to have created the logic of relationships Peirce tried to develop but failed to produce. I would like my claim to be scrutinized by Peirce scholars so that the general reader interested in video and the ecology might eventually get a professional opinion about the logic I am using. I may not understand the engineering specifications for the bridge that I wish to cross, but I do want to know that others who can read the engineering specifications trust the design.

Finally, the general reader should understand that I am extending a friendly hand to Peirce scholars because of the practical implications of this book. I hope to see the Earthscore Notational System, the core of what I propose in this book, taken seriously and used to help reconnect our species with the ecologies of the earth. This would be a major undertaking. The Earthscore Notation uses the entire sixty-six-fold sign classification schema developed by Peirce to accomplish this task. However, it is not surprising that Peirce's semiotics can be used to interpret ecological systems. Peirce spent most of his professional life working for the United States Coast and Geodetic Survey, an agency that was the forerunner of the National Oceanic and Atmospheric Administration. This agency now plays a key role in interpreting the global environment.

While based primarily on my own synthesis of the cybernetics of Bateson and the semiotics of Peirce, the texts in this book also draw on a range of ideas assimilated from other thinkers: an understanding of media learned from McLuhan, an analysis of the structure of the classroom derived from Walter Ong, an appreciation of art history based on Horst Janson, a comprehension of notational systems based on Nelson Goodman, an appreciation of catastrophe theory based on Rene Thom, an understanding of bioregions learned from Peter Berg, a sense of cultural history learned from Thomas Berry, and an understanding of the interplay of art and politics learned from Conor Cruise O'Brien, George Steiner, and Michel Foucault.

The texts collected here are organized chronologically in five periods: Early Video, Earthscore, Bioregions, Ecochannel and NEST. **Part One: Early Video** covers the period from 1968 to 1971 in New York City when the video movement began. For me, this period included working with Marshall McLuhan, participating in the Howard Wise art show, "TV as a Creative Medium" and working with the countercultural video group, Raindance. **Part Two: Earthscore** indicates the period from May of 1972 to 1976 when I worked in the Hudson River Valley trying to start an intentional community whose *raison d'etre* was to use video to interpret ecological systems. **Part Three: Bioregions** covers the period from 1977 to 1980, when I worked in the bioregional movement. My participation included fighting with the Frisco Bay Mussel Group in San Francisco against the development of a huge water canal, starting an ecological magazine in the Passaic River Watershed of North Jersey, and doing a video score for the Coast of Cape Ann above Boston. **Part Four: Ecochannel** covers the period from 1981 to 1985 when I lived in Hoboken, New Jersey, learning about computers and developing a design for a television channel which would monitor the ecology of the Hudson Valley and facilitate building consensus about sound environmental policies and practices. **Part Five: NEST** includes pieces written between 1986 and 1991, when I had returned to Manhattan, the place where I was born, and articulated my work in the religious, civic, educational, intellectual, and artistic worlds of New York City. NEST is an acronym for a proposal I developed during this period called New Eco System Television.

It may be useful to note that originally I attempted to order this collection thematically. Yet every thematic organization with which I experimented distorted the way the work itself has developed. Organizing the texts in five periods, and taking some liberty with the strict chronology of each period to cluster the work according to themes, offers the reader the clearest understanding of my work for a number of reasons.

1. The chronology of the texts can be easily correlated with the chronology of the videotapes I've made. In each

introduction to the different periods of my work, I provide a discussion of the interrelationship between the tapes I was making at the time and the texts presented. An appendix provides a composite chronology of texts and tape.

2. Video is a temporal medium. In video production there is an editing technique called time-based correction. The electronics in video equipment are all synchronized to work in phase with a recurring electronic pulse generated precisely for this purpose. This sync pulse, as it's called, is like the beat in music or the cadence of a football quarterback calling plays. When you want to copy a tape for broadcast to a larger audience, you put that tape through a time-based corrector that stabilizes the sync pulse. Without sync pulse stability, the electronic image will break apart. Placing these texts in chronological order uses the cadence of our yearly revolution around the sun as the sync pulse for broadcasting this collection.

3. My thinking is best understood when it is unfolded over time. I tend to circle around themes, to keep coming back to them from different angles and in different contexts. I learned this recursive pattern in the oral tradition of the monastic preaching order I was a member of for four and a half years as a young man. A chronological presentation allows the reader to see more clearly how my ideas develop and grow using this circling procedure. What you have in your hands is a series of pieces which once stood alone and which now grow into each other through internal redundancies. Where the redundancy was mere repetition, I have edited it out. Where the redundancy was critical to the internal coherence of the piece or seemed useful for following my pattern of circling back to recurring themes, I have chosen to leave it. By respecting the internal coherence of each piece, I have allowed the reader the option of moving in and out of the book without following a strict beginning to end sequence. When the copy editor, Janet

Marks, read through this collection, she said that the redundancies bothered her until she started to think of them as recurring themes in a musical composition. Other readers may find that analogy helpful.

4. Lastly, the progression of our ecological crisis does have a terrifying temporal dimension. In this context, marking time by the passage of years reminds us how quickly we must act to correct environmental devastation. Television could be used to help. Interestingly enough, in their 1992 State of the World Report, Worldwatch calls for systematically reassessing the role of the media in addressing our environmental situation.

It may seem strange that so many texts in this collection take the form of proposals. Much of my work involves imagining new perceptions and social behaviors made possible by the video medium. In this way I am not unlike an architect who imagines how behaviors and perceptions can be shaped by a building he or she is designing. Like many current architects who generate a considerable number of unrealized buildings on paper, so I have generated a number of projects articulated on paper, but as yet unrealized in video. While the general reader may find that he or she only needs to sample some of these proposals to comprehend the themes in this book, I believe the reader who is also a fellow videomaker will appreciate the level of specification available in these proposal texts.

Though ample, this is not a complete collection of my writings between 1968 and 1991. The selection process has been simple. For a text to be included it had to provide resonance for the final essay of this collection, "The Earthscore Notational System for Orchestrating Perceptual Consensus about the Natural World." This essay codifies my approach to cultivating an ecology of mind with video into a notational system that others can use. This final piece is not a conclusion but a compacting of the themes I sustained over the years of work represented by this collection of texts. Because it is a compact articulation of my work, some readers may choose to read this last essay first.

The poet Charles Olson advises that when presenting something you let the roots show, even show the dirt on the roots, because nowadays people need to know where you are coming from. In presenting this collection of texts, written in different voices, at different times, for different audiences, I have taken Olson's advice. Frankly, letting the dirt on the roots show in print does not seem that risky to me. This is because my experience recording and presenting many of my activities on video has habituated me to a level of self-exposure much greater than I have experienced with the written word.

Unconcealing oneself in print and unconcealing oneself in video entail differences that are not well understood. If I were to generalize from my experience using semiotic terms, I would say that video recording deals directly with iconic images and indexical evidence of actual realities much more than it does with conventional symbols like words. For example, sending someone a videotape of oneself talking about a topic can be immensely more revealing than sending a letter about the same topic. In the videotape, the iconic image might be one's tired face talking, the indexical evidence the uncleared kitchen table at which one is talking. By contrast, the word spelled t-i-r-e-d does not expose nearly as much as the image of an actual face at an uncleared kitchen table. Of course, the writer can respond, "Give me a paragraph to talk about t-i-r-e-d and I'll match the level of self revelation in your videotape." I will not pursue this argument here. All I want to do is alert the reader to the fact that my tolerance for self-exposure, developed while working with video, spills over into my writing. Based on my video experience, I consider this exposure minimal. For me to write a book about video that covered up this aspect of video semiosis would be dishonest.

Besides noting the dirt on the roots, I should also mention that there are some essays missing from this collection, not because these essays have been left out, but because they are unwritten. I want to acknowledge these absent texts to explain any sense of incompleteness the reader might experience in reading. The texts are absent for two reasons. One is because serious video production required time that I could not give to writing. I am seldom able to work simultaneously on a writing

project and a video project. Work in either mode requires both the totality of my energies and significantly different ways of using my mind.

The other reason is what the novelist, Tillie Olson, (no relation to Charles), calls the "unnatural silences" that many writers and artists without stable funding must endure in America. I have held no academic position apart from occasional adjunct teaching of undergraduates at SUNY, New Paltz and Ramapo College, and of graduate students at New York University and The New School for Social Research. Support has come through a combination of irregular grants and jobs that have ranged from teaching science to gifted middle school children through driving a cab in New York City to doing construction in California. My opportunities to write have come in patches of time in between such jobs and the video work. I have developed an elliptic, condensed style. Hopefully, this style will stimulate the reader's own process of semiosis. Yet, in an ideal world some of the ideas packed into these writings should have been given a more complete treatment. For example, the essay "Video, Computers, and Memory" was once an outline for a full-length book. Also, the discussion of triadic relationships and gender in the essay on "Relationships" merits considerable expansion. At one time I had hoped to use the triadic thinking that emerged from my video work as a basis for an extended commentary on Dorothy Dinnerstein's provocative book, *The Mermaid and the Minotaur*, subtitled "Sexual Arrangements and Human Malaise." Another unfinished project is an analysis of Shakespeare's plays from the perspective of triadic relationships. Perhaps I will still get the chance to do some of this writing. Perhaps I must see these unwritten texts as water under the bridge. As Wallace Stevens said, "The actual is a deft beneficence." May these actual texts be a beneficence for you.

PART ONE: EARLY VIDEO, 1968-1971

Even from the vantage of twenty-four years later, it is difficult to make clear what was going on in the video movement during its initial period. Later in this book I include an essay entitled "The Genealogy of Video," which examines the video movement of the late sixties in the critical categories of Michel Foucault. An ethnography of early video is now being prepared by John Giancola, the Director of the University of Tampa Telecommunications Program and a former Director of the Media Program at the New York State Council on the Arts, which funded early video. Other efforts are being made to unravel what happened and what it meant. In this account, I offer only brief remarks about my own participation that provide a context for the texts presented.

In 1965, the Selective Service of the United States tried to draft me for the war in Vietnam. I applied for conscientious objector status using as the foundation of my position John Dewey's understanding of God. This North American philosopher presented God as the tension between the ideal and the actual. I argued that there were better ways for me to work for an ideal world than fighting in the Vietnam War. Based on this argument, the Selective Service granted me conscientious objector draft status.

In the spring of 1966, I took part in protest marches against the war. The experience was frustrating. Marches seemed to have so little effect. Vietnamese children were being killed. American soldiers were dying. Vietnamese monks and young men in the United States were burning themselves to death to protest the war. I locked myself up in a garret on the Lower East Side of New York City and pounded a typewriter. I thought that by writing fiction I could somehow make a difference. The war went on.

Midway through the summer of 1966, I tuned in to WBAI's radio coverage of the International Writers' Conference. The speaker was saying, "Of course, in this electronic age of computers, satellites, radio, and television, the writer can no longer be someone who sits in his garret pounding a typewriter." It was Marshall McLuhan. What he said upset my nascent identity as a writer. I read his books and all I could find of his source material. If what this author of books said about books was true, then I could not make a difference isolated in a garret with a typewriter. I decided to learn how to work hands on with the new electronic media.

By the following spring, I was studying at Michigan's graduate school of computer sciences. However, after I had started my graduate program, the draft board refused to give me a student deferment on my alternate service as a conscientious objector. They insisted my service be done right away and offered me work as an orderly in a New Jersey Hospital. I contacted John Culkin at Fordham's Communications Center and inquired about the possibility of working there because I knew McLuhan was to be a visiting professor. Culkin hired me. Now all I had to do was convince the draft board that working at Fordham with McLuhan would be more beneficial for society than working in a hospital. The protest movement had been focusing on misuse of manpower in conscientious objector work programs. In that context I went to the draft board with a copy of *Understanding Media* in my pocket and convinced the board it would be good for the country if I did my alternate service working with McLuhan.

Although there are rumblings of a McLuhan revival in the 1990's, generally he seems as forgotten now as he was famous when I worked with him at Fordham in 1968. Yet, despite the ebb in his popularity, many of his ideas have filtered into the mainstream. McLuhan honed his message into a gestalt that was picked up by the popular media. In a sense, he beat the media folks at their own game by becoming a media star himself. He managed to convey very sophisticated ideas about communications to a whole generation of people not able to study these ideas in graduate schools.

McLuhan explicated the history of education itself based on the work of his colleague and a former teacher of mine, Walter Ong. Ong's book, *Ramus, Method and the Decay of Dialogue*, is an exhaustive study of the way in which the Renaissance educator, Peter Ramus, shaped the modern classroom based on the then new technology of print. The first two essays in this section, "Videotape: Infolding Information" and "Cable Television: The Raw and the Overcooked," explore how video and cable television could be used for education. They were originally published in the journal, *Media and Methods*, and are indebted to both Ong and McLuhan. The writing style in these essays also reflects McLuhan's influence. Like a McLuhan text, my prose displays a willful disregard for linear sequence and a willingness to appropriate any reference from Eskimos to Snow White in order to make a point.

At the time I worked with McLuhan, I was not reading the philosophic writings of Charles Peirce. Later on I would be delighted to learn that Peirce knew of Ramus and, like McLuhan, was very critical of him. In a Harvard lecture Peirce gave at age twenty-six, he scorns the linear, dyadic view of logic espoused by Ramus as "at once the narrowest and lowest" (Peirce [1870] 1982: 163). Indeed, once I tasted the learning possibilities inherent in making video, print-based education did seem like a very narrow and outdated approach.

McLuhan detailed how the print medium habituated our minds to think in linear sequences. About halfway through my year with McLuhan, I started experimenting with portable video equipment, trying to use this new medium to fashion a non-linear way of thinking. My experimentation included weekly sessions at a Montessori school recording the learning processes of the children for the children and playing with anyone I could find in New York City who also wanted to play with video. Insights and anecdotes from this experimentation are related throughout the texts in this part.

In the beginning of my experimentation with video, I did not keep the tapes. I regarded as true the saying that when you take somebody's image you take their soul. When I took images of people, I would either erase the images immediately in front of the people I recorded or give them the tape. I also

did extensive experiments recording and playing back my own video image for myself.

I distilled this experience with video playback into an art piece for a show at the Howard Wise Gallery presented in the spring of 1969 and entitled "TV as a Creative Medium." I called my piece *Everyman's Möbius Strip*. Essentially, it provided a booth in which people could experience their video image in private, knowing that the tape would be erased. The implications of the power videotape gives you to see yourself as others see you are discussed in "Self Processing," the third text in this section.

"TV as a Creative Medium" was a successful, exciting show. Out of it emerged an alternate video group called Raindance, of which I was a member. Artist Frank Gillette founded Raindance as a countercultural think tank. We made tapes as a collective and showed them at a loft on East Twenty-Second Street in Manhattan. Some of these black-and-white, "raw" tapes are still extant in the Raindance archives. The ones I remember most vividly include documentation of the first Earth Day in New York City, various "street tapes" made in New York City, documentation of an alternate Media Conference at Goddard College in Vermont, *Rays*, a spontaneous tape we made while playing on a California Beach, and *Supermarket*, a tape about surveillance in a Los Angeles chain store.

The intensity that characterized the experience with Raindance is evident in the fourth essay in this section entitled "Guerrilla Strategy and Cybernetic Theory." It is an angry text from the counterculture of the late sixties and early seventies in which I present portable video as a weapon for cultural transformation. This text uses a combination of hip street talk and cybernetic terms to create a manifesto for alternate video. I use a range of references from rock star Elvis Presley to one of the originators of cybernetics, Norbert Wiener. The rhetoric is biting and the stance is uncompromising. The Nixon White House, then in control of the military industrial complex, was not to be trusted. The terrorism espoused by some radicals was an abhorrent alternative. For me and for others, my manifesto of cybernetic guerrilla warfare, published in the

Raindance magazine *Radical Software*, was a feat of imagination that achieved a militant middle way. Michael Shamberg picked up the ideas I expressed in this manifesto and used them in his well-distributed book, *Guerrilla Television*. The ideas became seminal for the guerrilla television movement.

My anger over the Vietnam War, shared by many of my generation, determines the tone for much of the writing in this section. I've never liked the phrase "angry young man" because of its dismissive connotations. However, to prepare the reader for the tone of these texts, especially the essay on cybernetic guerrilla warfare, I can only describe them as the writings of an angry young man in an angry time. As I collected the texts for this book at age forty-eight, I found I could not dismiss that anger by deleting these texts. Rather, I find myself practicing patience toward this young man, honoring his anger as just, experiencing sadness at the blind spots rage caused, and hoping for sympathetic readers.

In the final essay in this section "Attempting a Calculus of Intention," I articulate for the first time the formal breakthroughs in triadic thinking that appear in incremental levels of comprehensibility throughout this book. In his lectures on the foundations of mathematics, Ludwig Wittgenstein says, "All the calculi in mathematics have been invented to suit experience and then made independent of experience" (Wittgenstein [1939] 1975: 43). In this early essay, I invent a calculus to suit my experience of doing repeated videotapes of myself. The calculus uses a tube that repeatedly passes through itself. Later on in this book, the calculus becomes independent of my experience. However, in this essay, the calculus and the experience are mixed together in a rather amusing way. Groping for some way to explain my experience with video, I rattle on in that style of speech peculiar to the sixties, talking about John Lilly's report on his experience with LSD and about designing inflatable couches. At the time, both LSD and inflatables were staple references for the counterculture. Now both appear as anachronistic curiosities, although during the late sixties and early seventies they were part of a nutritive context for exploring alternatives.

Shortly after my conceptual breakthrough in triadic thinking, I produced a videotape, using two portable production systems (entitled *Tender is the Tape*). The viewers of the tape see and hear me talking to them on a TV screen contained within another TV screen on which I was commenting on what I was saying and doing on the first screen. This commentary is, in turn, contained within another commentary. The process of commenting on the previous commentary is repeated six times. While technically very crude, this tape sparked considerable interest. Filmmaker Shirley Clarke said it was the first video she saw which was not an attempt to copy film.

In the four years covered in this part of the book, I moved from being a writer protesting the war through involvement with McLuhan and education, to using video as a countercultural tool. I began to work as an artist. I began to understand cybernetic theory. I initiated my work on triadic logic. I was lucky to find a way of shaping my rage over the war in Vietnam into a passion for the new possibilities opened up by video. This selection of early texts is presented to suggest to the reader how these new possibilities looked to me as a young man, twenty odd years ago.

Videotape: Infolding Information

Replay time. Six neighborhood Youth Corps kids from Brooklyn and I are watching videotapes we took at a state park in Jersey. Don Herd is smiling and threading his tape: "Wait'll you guys see this. Wait'll you see it." He had fought with the group and had gone off alone into the woods with one of the two half-inch battery portables we were using. The tube shows trees, shaky trees. Fifteen minutes into the twenty-minute tape and we're bored.
"You haven't seen it yet!"
"Seen what, seen what?"
"The best part. Wait, just wait . . . here it comes now, here it comes." He's squeaking with delight and he's serious.
The camera pans shakily around an open field. Suddenly out of focus and grinning, Don Herd himself. A shy laugh from the tube. The camera slides off the face, hesitates, and comes home to rest on the happy face of Don Herd.

This experience of Don Herd had a kind of coherence and completeness hardly possible for him and his classmates in the present school system. Classroom space and clock time condemn them to a three-dimensional game of tick-tack-toe in which experience is blocked out by time schedules and movement from classroom to classroom, a game in which there is very little coherence.

Into the grid of this game ETV (Educational Television replete with the playback capacity of videotape recorders) entered, enthusiastic. This system could do the old job better. One ad for the video tape recorder, VTR, calls it the "incredible copying machine;" it lets you make "carbon copies of a single gifted teacher for the entire school system." X-space could be conquered by videotaping the lesson to be pigeonholed into the classroom at a convenient hour. X-Space. O-Time. And the game goes on.

Manufacturers entered into the game, enthusiastic. They encouraged the stenciling of the commercial television system, with its complex and costly traditions, onto the school system. The only difference was that now "educational" materials were being transmitted and you were working with a captured audience of kids rather than consumers to be captured — who

at least had the indirect option of forcing a show off the air by not watching it.

Shoot first, ask questions later. So the new medium, video-tape, masquerading as the incredible copying machine, has wedded itself to the physical fact of school buildings and their classrooms. The automatic bells ring out anniversary celebrations every forty-one and a half minutes. But the Don Herds are not happy.

ETV Audience as Researchers

Ten months of experimenting with videotape has convinced me that the bias of this medium is not to play three-dimensional tick-tack-toe. But before getting into the grammar of videotape itself and what it suggests for schools, I'd like to pass on an insight of McLuhan's applicable to ETV in general.

> . . .The classroom, as much as any other place, can become a scene in which the audience can perform an enormous amount of work. The audience as work force has unlimited possibilities. Suppose we were to brief fifty million people on some extremely difficult problems facing top-level scientists. Inevitably, some dozens, hundreds of the fifty million audience would see instantly through any type of opaque problem, even on the highest scientific levels. Robert Oppenheimer is fond of saying that "there are children playing in the street who could solve some of my top problems in physics because they have modes of sensory perception that I lost long ago." There are enormous possibilities for using an audience as work force in scientific research, or any other type of research. It is simply that we insist on beaming instruction at them instead of allowing them to participate in the action of discovery (McLuhan 1966: 204).

ETV has taken from commercial television the metaphor of the audience as consumers of information. Programs are produced, packages are made, often of the classroom lecture. The students consume.

With next to no adaptation, present ETV facilities could change the role of the student from consumer to problems researchers. The X-ray capacity of the TV tube could be utilized to present the anatomy of real problems. This does not mean a journalistic report on a problem. Nor does it mean pseudo-problem-solving: urban air pollution is not

solved by inhaling the country's atmosphere through a Salem cigarette. Presentation of real problems, like cancer research, could begin to take the place of prepackaged information.

TV facilities can transfer information over distance at high speeds to many people. With problem presentation, the more people reached quickly, the better the chances of solution. ETV could be a mass brainstorming media.

Sculpting Time and Space

VT is not TV. If anything, it's TV flipped into itself. Television, as the root of the word implies, has to do with transmitting information over distance. Videotape has to do with infolding information. Instant replay offers a living feedback that creates a topology of awareness other than the tick-tack-toe grid. Anthropologist Edmund Carpenter tells a story about two Eskimos who went on solo trips around an island. They were asked independently to draw maps of the island. Their maps were good replicas of the island, yet they both differed in one significant aspect. Each had camped and hunted near a certain cove, and that area on their maps was larger according to the length of time each had stayed there. Videotape creates a kind of Eskimo awareness of time-space. Especially with the half-inch battery-operated portables, one can sculpt time-space in accord with the contours of experience. Information can be infolded to enrich experience.

Participating in Your Own Audience Participation

With videotape, the performer and the audience can be one and the same, either simultaneously or sequentially. In an actor's class a student did a piece from *Spoon River Anthology* first without the monitor, with me shooting her face from a distance with a 1-10 zoom. Then she did the same piece facing into the monitor so she could see herself while performing. Delighted with both experiences, she said that she felt more secure facing the monitor than with me at a distance using the camera and no monitor. The distance shooting without monitor left her with no feedback other than the glassy-eyed

lens. With her performance extended into the monitor, she was, to use McLuhan's phrase, "participating in her own audience participation." Feedback was immediate and self-supplied. She could use simultaneously her expressive abilities as an actress and the set of responses she had as an ordinary theater goer. She could take in her own performance. Enter the talented audience. Add to this the dimension of instant replay and a new kind of performer is bound to develop.

This actress's sense of security and confidence with the monitor seems akin to my whole experience with videotape. I am developing a different sense of myself. Very much like the sense of myself I have when I swim lazily. Very much like the Chi sense of myself I have when doing some Tai Chi. I feel more able to move in my own fullness. And this awareness extends beyond the actual use of tape. Confidence seems almost to be a function of communicating with oneself.

Heart Transplant by Videocorder

VT offers image and sound feedback that creates a field richer than ordinary conversation. A marriage counselor uses videotape to play back to couples their conversations. Often dimensions are revealed outside the perimeter of the spoken word. On replay they may hear themselves saying they don't want anything to do with each other while at the same time they can see their arms open to each other in a simulated embrace. The old heart to heart seems to be more possible with videotape. Indeed, the label on the machine (videocorder) has as its root *cor*—"heart"—in the full rich sense of Newman's dictum *Cor ad cor loquitur* (Heart speaking to heart). Compare this with television's "Peyton Place."

Communicating With Oneself

In the Langley Porter Youth Drug Clinic for psychedelic dropouts in San Francisco they allow patient videotaping sessions in private. The patient is free to erase the tape or show it to someone of his choice. The patients testify that "it's

a real trip." This kind of communicating with oneself has an implication of self-actualizing that goes far beyond mere self-discovery. A student, discussing the Columbia student strike with her fellows at lunch, ran up against such vehement cliched ignorance that she could not talk for fear of exploding into curses and tears. She went home and videotaped, without being monitored, what she would have said. Someone else played her fellow students' roles. Upon replay she was amazed but said little. The next day she spoke her mind at lunch calmly and firmly, without exploding.

Seeing herself speaking her mind live on tape opened up communication with herself about it. She could take in her own outside and consider it. The net result of this inner dialogue was the confidence to move in her own fullness, to actualize herself.

Videotape enables a person to be present to himself in a new way. This past summer an eleven-year-old black girl was hitching home from Star Lake summer camp. The counselor caught up with her. Her main complaint—"I'm ugly." He had the sense to take her to the VT setup and show her herself on tape. "Ooh, that's me, huh? Okay."

In a videotape marathon at Aureon Institute in the fall of '68, Steve Lawrence asked each member of the encounter group to introduce himself to the others while the camera taped him. He would play back the tape to the person immediately. This worked to open up inner communication, thereby facilitating communication with the group. Comments ranged from "I don't like what I see; I see a whining baby," to "I like what I see. I mean I always thought of myself as peculiar, but I can see I'm put together like other people. Like anybody you'd see in a subway."

Strategy for Schools Feedback Process

Given this feedback capacity of videotape, it seems the best strategy for its use in present schools is as an ever-present service for both teachers and students, much like a telephone or a mirror. Half-inch, one-inch, even two-inch systems could be utilized in this way. Productions for audience research

could be moved to more centralized locations where the budget is bigger and the talent thicker. This would free the TV studio to become a special space for infolding information. Portable units could provide the service in other parts of the building. Battery-operated units could be used for field trips and such.

Discussion groups, reading aloud, student performances, debates, cheerleading, dancing, self-evaluation for teachers (perhaps with the help of other teachers or students) — there is an inventory of processes in the school that might be enriched by the living feedback of instant replay.

The word "replay" is deceiving in a sense. As indicated previously in the student discussion of the Columbia situation at lunch, videotape can function as instant *pre*play, as a simulation service. Students going for job or college interviews, making a presentation before the class or a public speech, could use videotape in this way. Such a feedback service would "from many a blunder free us." The emphasis is on us. It's what's live, not what's on tape, that counts. The living process, not the product.

Between full feedback and packaged information lies a whole area of what George Hall, of the national Association of Educational Broadcasters, calls "interactive structuring of program materials," in which student response is itself part of the learning. With videotape this type of programming can grow much more sophisticated than the one stimulus, one response pattern. As Carol Headley, Director of the Fordham School of Education, points out, you must incorporate into your program the power the medium gives the student to "react to his own reactions."

Student Liberation by Information

Authority is based on information. Cybernetics and papal pronouncements have made that apparent. Upon introduction of a half-inch system into one school, the drama teacher complained, "Students are notoriously their own worst directors. If they start seeing themselves on tape, they'll start directing themselves." Her authority as director comes from a

tradition she knows and observation of the students' performance in relation to that tradition. With the feedback from videotape, the students can take in their own outside, can take in information that increases their control over their performance. The director's role shifts toward that of a consultant, someone who offers perceptions from what is now an alien tradition.

There is a very real sense in which portable VTR is a complete cybernetic system. It is not part of a system like an 8-mm camera that needs the drugstore developer; it is not like TV in your home which is only one terminus of a huge network. Portable VTR is a self-contained system for processing culture — family culture, classroom culture, therapeutic culture. It has input and output and can be operated without experts. It offers a completeness in itself. Those outside the closed circuit involvement are an audience once removed. Most likely, they are not interested in what is of vital importance to the "in" group. Steve Lawrence found that the broadcast ratings for therapy sessions on VTR in the Los Angeles area were abysmally low. With VTR it is wise to concentrate on the "in" culture and not harbor the secret hope that CBS might want to buy up rights for broadcast.

In the sense that a portable videotape recorder is a complete system in itself, it is structurally different from other VTR equipment. Much like the TV generation, which lives in radical cultural discontinuity claiming they must be father and mother to each other since they in fact have no cultural parents, so this small-user equipment is, from a user's point of view, completely new. It is its own baby.

Broadcast television in ten years will reap the fruit of the diversity and decentralization of portable video tape recorders in the hands of kids only to the extent that the centralized pattern is not stenciled onto these systems. One factor clearly works in favor of decentralization. The VTR systems of the different manufacturers are incompatible. There are fifteen or sixteen different formats. Electronic transfer can be made but only on expensive equipment. This will encourage small users to feedback to their own situations rather than feed off it for others.

Videotape in the Classroom

Classroom cultures can be revolutionized by VT. The shift in authority is one dimension. Students can take a much larger part in the processing of information. What the kids dig most about school is other kids. Videotape can facilitate the learning from peers.

The underlying analogue of the classroom culture is book: teacher as chapter title and the kids as gutengerber babies all in rows. The title controls the content. The teacher with his subject matter controls the kids. The teacher is the type font of all knowledge, imprinting on the blank pages of the students' minds a continuous sequence of prepackaged knowledge called a lecture. His notes become their notes. Finishing the course is more important than dialogue. He works under the burden of a body of information to be transmitted. He is slave to the syllabus. Only questions "on the track" of the curriculum are acceptable.

Contrast the videotape format of "Laugh-In." As opposed to focus on one font of information, there are many focuses and many fonts. As opposed to continuity and moving along, there is discontinuity and repetition. The attention span required in a classroom for a straight lecture is forty some minutes.

The humanities class at Newburgh Free Academy in New York is experimenting with class format and small videotape. By giving each student an index card with a short bit on it, teachers Bob Pritchard, Antone Aquino, and Thomas Fry turn the class into a laugh-in, learn-in cast. A student tapes each bit with the hand-held battery portable which frees him from tripod perspective. Then instant replay. So far, instant, insane success.

It is hard to say what will happen to content in a course transformed by VTR. The Newburgh Humanities Program is currently using random bits like selling toothpaste, calling the garbage man, doing an ad for yourself. Perhaps the syllabus could be turned over to students the first day to be scripted for VTR. It may work. Videotape, however, seems to have more potential for exploring environments. I took a battery videotape and three Born Losers from Spanish Harlem to Resurrec-

tion City the weekend of Puerto Rican Day. They were so into shooting with the video camera that they didn't even stop to eat. They looked and learned. One gave me an extensive comparison between the cops in Washington D.C. and the cops in New York that would stand up in any sociology text.

A teacher willing to bypass the lecture format in favor of a VT learn-in will find a deeper understanding of the commonplace tradition in oral cultures invaluable. Eric Havelock's *Preface to Plato* and the works of Walter Ong can be of great help here. John Cage's *Silence* and *A Year from Monday* tend to give one the courage to experiment with random compositions. It won't be long before the kids pick up on TV ads for clues as to how to present their bits.

"To Monitor or Not to Monitor"

The videocorder tends to divide process phenomena into those that lend themselves to simultaneous monitoring and those that do not. Putting on makeup, combing hair, shaving, *Spoon River* practice—these lend themselves to simultaneous monitoring. Other things, such as the classroom composition, work better without simultaneous monitoring. The monitor (from *moneo* meaning "warning") acts as a censor and inhibits the experience. In using videotape equipment, it is necessary to understand the process at hand in these terms.

Self-Erasing, Self-Effacing

Once upon a time I had a teacher who considered the eraser to be the worst thing that ever happened to the pencil. He liked things thought out before they were written out. This defender of the pure pencil was on to something. An eraser creates a different style of thinking. Videotape is erasable. We can redo it if we don't like it. Since videotape has become available, "live" TV is mostly tape, and it's different from television before videotape. Hugh Downs is among the many who defend pure television as the "now" medium.

"Live on tape" means all those tribal things we call living on a magnetic tape that permits detachment *a la* literacy. Adop-

tion agencies now use videotape. The parents see the child on tape first. The "live" child can be considered without the immediacy of his needs present. Sounder judgments can be made. If the child is old enough, the process is also reversed. High-level cultural exchange is possible via videotape— between blacks and whites, for instance. What about a direct exchange by tape between a group of Montessori kids in the United States and a group of Suzuki kids in Japan. Live on tape, tribe to tribe, three-year-olds may make the best ambassadors.

The mythology and use of mirrors deserves serious study by the users of videotape. "Mirror, mirror, up against the wall . . ." the ugly duckling, Narcissus. McLuhan's chapter on the Narcissus myth in *Understanding Media* is extremely important if we are to get beyond the gadget-lover stage with videotape. McLuhan's description of Narcissus applies perfectly to one three-year-old's experience with videotape. She felt compelled to imitate herself on the screen. If we were replaying her singing, she sang; walking down the stairs, she ran up and walked down again. McLuhan, in talking about Narcissus' reflection in the water, wrote: "This extension of himself by mirror numbed his perceptions until he became the servomechanism of his own extended or repeated image.... He was numb. He had adapted to his extension of himself and become a closed system" (McLuhan 1964: 68). As we grow more willing to contemplate "what's happening," this need not be the case with videotape.

Cable Television:
The Raw and the Overcooked

Three freshman boys on the remedial track at Bloom's High in Chicago Heights, Illinois are getting into their usual near fist fight. They are asked to go to the cooling-off room. Midway through their normal routine of figuring out who will go to the counselor first, one of them spontaneously flips on the half-inch videotape recorder in the room and begins to roleplay the "counselor." They replay it a few times, discuss it, and switch roles. Another series of replays, more discussion. Another changing of roles, replays, and discussion. They then decide to make a fresh tape with each of them taking a turn as counselor. With teacher Sandy Szelag's blessing, they show the tape to the class. The real counselor is invited and he leads the class in the dynamics that result from the tape. For the rest of the year, the three boys get along.

The TV Generation is Capable of an Inspired Use of Television Systems.

Cable is a distinct television system with exciting possibilities for education and for the TV generation. A community antenna or cable television system (CATV) consists of a super antenna to pick up broadcasted signals, a "head" or "headend" which processes these signals and can also serve to process locally originated signals, and coaxial cable which is strung via telephone poles or city ducts to the home TV sets of subscribers who generally pay five dollars a month for the hookup. Cable capacity is presently twelve or twenty channels. There are people who envision as many as four hundred channels.

There are over two thousand cable systems operating in this country now. Roughly another two thousand franchises have

been granted, and another two thousand or so franchises are pending. Six thousand or more separate cable heads mean six thousand or more separate information systems—the possible restructuring of communications in this country. We can wire according to the information contours of our culture. An entity as small as a city block can have its own headend, its own channel as a subsystem of a cable set up. Any cultural entity can now balance its television intake with input of its own. It can control the processing of its own information rather than be the passive participant in the broadcasted process. What was technically, financially, and politically impossible with broadcast television is possible with cable TV.

For schools, cable offers a unique opportunity to function effectively in the information environment. Before discussing cable TV and the educational system, it seems useful to talk about the difference between television and the kind of videotape television used by the freshmen at Bloom's.

There was no videotape recorder on board Apollo 11, only a television camera. Television has to do with moving information over distance, in this case a quarter of a million miles from the moon. Videotape has to do with infolding information, the kind of feedback that goes on in encounter groups. Working with encounter group leader Denis Walsh, I videotaped while a girl stood in the middle of the group with her eyes closed and described how she thought people were reacting to her then and there. The contrast between her negative description and the positive responses to her that the playback revealed were both illuminating and encouraging for her. This was information infold. What she and the group put out was taken by the tape and given back to them.

In some ways, the difference between broadcast television and the videotape recorder is the difference between hippies and yippies. As Abbie Hoffman has pointed out, the hippies are products of the mass medium, while the yippies create media events. Hippies take television as part of the service environment, merely an output terminal. Yippies, on the other hand, treat television as an entire information system into which one can input such things as police brutality. As has been pointed out, the cost of getting a message on televi-

sion for an honest man with little money is at least a few days in jail. That the yippies are willing to pay this price seems to me a small indication of the increasing demand of the TV generation to share in television systems.

While the living room or classroom television is merely the terminal of a larger system, videotape is a complete information system unto itself. It has input (camera and mike), storage and processing (the record/playback deck), and output (the monitor). The freshmen at Bloom's were treating their videotape as an entire information system enabling them to feed back to themselves the way they were behaving so that they could communicate about their behavior and enlarge their control over it. The videotape extended them as cybernators. By contrast, behavior induced by the output of a television set is merely the terminal behavior of consumers.

The Business of Cable

Confusion about the grammar of media, such as tape and TV, as McLuhan has shown, is par for the course. New media began by doing the job of the old media better. The car was a "horseless carriage." The radio was a "wireless telegraph" used for point-to-point communication until the Irish rebels used it for broadcast in 1916. IBM grew successful as it came to understand it was not in the business of business machines but in the business of moving information.

Cable TV is now transmitting broadcasted signals better. This "snowless" signal is not what a cable system is about. The basic business of cable is the cultivation of local culture.

This does not mean stenciling national network type programing on a local setting. Any culture is already programmed. That is to say, the life-style of the people is structured by the local environment with its interlocking system of roads, postal service, restaurants, recreational facilities, television intake, telephone usage, etc. The role of a cable system is to increase the community's awareness of their existing cultural system, thereby giving them more control over its development—to cultivate the local culture. Just as VTR extends man as a cybernator, so cable can enlarge the

capacity of the local culture to communicate about and control its development. This control can include some decisions about importing information.

Centralized production facilities in a cable setting that exploit the salable aspects of local culture for export will have a short life. This is to model the cable system on broadcast television before the invention of videotape. Packaging information for elsewhere on the stark vision-over-distance model of tele-vision amounts to strip-mining of local culture. Low priced portable videotape units make it possible for a cable company to take its whole district as its studio. Feeding back into the culture rather than feeding off it will insure lasting relations between cable and culture.

The Cable Company and the Educational System

If cable can effect a genuine awareness and cultivation of life patterns, it will find its best resources in the enriched and unique perceptions of its community. The information overload in our society is placing more and more of a premium on pattern recognition. Pattern recognition is a function of perception. A diverse pattern of unique perceptions such as is possible with the growth of cable in this country could turn CATV systems into so many think tanks. As readers of Peter Drucker's *Age of Discontinuity* are aware, our society is shifting from an economy based on capital to an economy based on information. Cable television companies are initiating policies within the dimensions of this transition. They are compelled to work out new relationships between capital and information. Once cable companies realize that local culture is in fact their business, it seems appropriate that they will want to develop a working relationship with the school system. Via cable, the educational system can function as a consulting institution to the developing culture. Conceivably, a cabled culture could develop to a level of enlivened awareness such that it could turn its perceptions into profit if it cared to. The process of brainstorming solutions to the problems of others — through a technique of "organized ignorance," using cable — is a source of revenue the cable industry has not considered.

The Educational System and the Cable Company

There is a Japanese composer, Joji Yuasa, who works with "white noise." Just as white is the presence of all color, so white noise is the presence of all noise. The "static" one gets tuning between stations on a radio is really white noise. Yuasa boosts up this sound to a rich fullness and surrounds you with it. His composition is a process of filtering out from the fullness of noise that which he does not want.

White noise is a perfect analogue for the world of total information we are approaching. Ideally, everyone will be his own composer. All non-private information will be available to anyone at any time and place in any mode he wants. Though there is no way of saying for sure, it seems likely that cable will be a major conduit of this information from the data banks to the home communications centers. People will have freedom to the extent that they control the filtering process. Hopefully we can move from a mass transit system of information such as we now have (you meet their schedules) to one of random access, of self-processing in a world of information movement. Education becomes the empowering of people to maneuver in a world of "white information."

Cable can serve not merely as a conduit to total information, but, more importantly, each separate system can provide the skeleton of an information structure in which students can build up the indigenous data base necessary for self-cybernation. Give them videotape, audiotape, and film and let them find forms for their own experience and their own environs rather than let the teacher take the data, inform it, and present it as a precooked packet to be warmed over and consumed in the classroom. Self-structuring of unprepared data develops the capacity to be your own information composer.

Some schools are using a technique for teaching an inclusive kind of anthropology. Students, insofar as is possible, live the life of another people for as long as a year. This includes food preparation, monetary system, education, etc. With cable it is possible to do this with one's own culture "live on tape." The near and the now can be put on tape in such a way as to

permit detached examination. The dictum that the unexamined life is not worth living is close to the concerns of an educational system based on the detachment possible with the phonetic alphabet. If you code experience in the phonetic alphabet, it can be examined. Videotape offers a different mode of detached examination. For example, there will soon be on the market an inexpensive VTR that takes a frame a second for twelve hours and can be played back in a half hour. Simply placing this at different meeting spots would reveal patterns of interaction. Documentary-type productions on the pattern of teenage car usage, etc., are possible. Regular exchanges could be set between sister cable systems: rural/urban, black/white, East Coast/West Coast, etc. Let teachers from the different disciplines function as commentators on the video verité.

Videotape vs. Film

Implicit in the structure of movies and broadcast television is a perceptual imperialism. You watch what others want you to watch to a large extent in the way others want you to watch it. When Fred Wiseman shows *High School*, everybody does see a different film, but it is of somebody else's high school. The kids in the actual school will not be shown the film. Others control access from camera angle through the editing process to the decision as to whether it will be shown. Film edits the experience of others for you. With videotape, on the other hand, you can pre-edit your own experience simply by setting down your script on audiotape and following it in front of a camera. Film is the packaging of information in cans. Videotape is involved in the feeding back of process. Film rips information away from a situation for use elsewhere. Videotape can feed back into a given situation and enrich experience. Film extends man as a spectator. Videotape extends man as a cybernator. Film imports information. Videotape implodes indigenous data. In describing the incident with the three boys on the remedial track at Bloom's, teacher Sandy Szelag said the class treated the tape presented by the three boys in somewhat the same manner as they treated a short

story. The difference is that a short story—or a film, for that matter—would be an information import and thereby run the risk of being another high-definition disaster characteristic of the school system. The tape done by the boys, on the other hand, was native to the group, low definition, cool. Portable videotape works with the raw, the uncooked data, the "static" of the surround. In the caldron of a cabled culture, this kind of data could be more exciting than moon rocks. It should be said that cabled cultivation of local culture can only proceed through a process of creative destruction. We do not yet understand the information contours of culture well enough to cybernate smoothly. In this condition, raw data is Dada.

Between the Recipe and the Reality

Talk of the wired white world, given the realities of cable, is somehow reminiscent of the political realism of Snow White and the seven dwarfs. Concern with cable is concern with the art of the possible. Those of the interface generation between the establishment and the new youth, who try to put portable videotape in the hands of students, will soon find themselves accused of running guns to the Indians. Harold Innis, a mentor of McLuhan's with a sense of political realism, saw social change as the result of the disenfranchised groups (in this case, youth) trying to gain control of the new communications media and thereby gain a form of social power. Providing high school students with portable videotape is like providing David with a slingshot. The broadcasted armor of the communications giants seems even less vulnerable than was Goliath's. Yet anyone who has experimented with portable videotape equipment knows that the potential of television has hardly been touched. Perhaps nothing that is really television will happen until those who were raised on it gain control of it.

New media like cable TV mean opportunity, not inevitability. The power gap opened up by this new media has attracted a host of contending parties and opened up a number of tricky questions. Educators who decide to enter the cable arena will soon find themselves involved with local politicians, media

barons, venture capital, the FCC, the Supreme Court, Congress, copyright lawyers, broadcast interests, computers that want to talk to other computers over cable, the possibility of a two-way system, the Joint Council on Educational Telecommunications wanting 20 percent of cable capacity for education, questions of local advertising, franchise questions.

This much seems clear: There is a natural alliance between the TV generation, educators who understand something of the implications of being raised on TV, and the cable television industry. From the side of the educator, there are a number of difficulties with such an alliance.

- Many of the franchises negotiated by the town fathers contain unimaginative, token provisions for education. The cable companies will have to be willing to give on this.

- Practically all of the possibilities I have talked about here are based on the use of portable half-inch videotape equipment and, to a lesser extent, super-eight film and audiotape. The industry generally is adopting a one-inch format which confines it to studio and mobile van production. Formulas will have to be worked out for transfer from half-inch to inch, and direct use of half-inch. There is also a question of the quality of the image yielded by half-inch. Standardization of line resolution for cable seems to me unnecessary. If the image is stable, it should be allowed. To make the definition of the image uniform would be as senseless as making the comic strips in the Sunday funnies of uniform definition.

- The ethical code of the National Cable Television Association reveals they have done little thinking about the TV generation. They conceive of their responsibility toward youth in terms of providing the "right kind" of information and withholding the "wrong kind" of information. Educators will have to show the cable industry the critical necessity for a systems approach to the needs of the young rather than a content approach. Part of this

dialogue needs be the critical discussion of the feasibility of possible ways of implementing a two-way system.

The world of white information and the outcome of contentions over cable seems far away, perhaps not worth the efforts of educators at this point. But educators cannot afford to defer their consideration of cable until it is too late to do anything but hold class discussion after the fact. The rules of the game are being drawn up now. Educators can now secure a share in the cable structure so critical to the TV generation, or they could "back up into the future", reading books about TV.

Both the FCC and the cable industry want cablecasting. Given the right combination of circumstances, portable video-tape, cable availability, and the will to do, educators may well declare themselves fed up with the overcooked, cafeteria curriculum and go roll in the raw data of the seventies.

Self-Processing

A Möbius strip is a one-sided surface that is made by taking a long rectangle of paper, giving it a half twist, and then joining its ends. Any two points on the strip can be connected by starting at one point and tracing a line to the other without crossing over a boundary or lifting a pencil. (See Fig.6, p. 96.)

The Möbius strip provides a model for dealing with the power videotape gives us to take in our own outside. With film, we are taking in the edited experience of others. What follows is a composition for video to be acted, edited, directed, and viewed by you in privacy. Feel free to bend, fold, and mutilate as you wish. It is not designed to peel your own skins off until you find some fiction called the true you. Rather, it is designed so that you might get a taste of processing yourself through tape, so that you might begin to play and replay with yourself. Hopefully it will suggest ideas for your own compositions.

Your Strip, Your Trip

Technically, this is the way it works:

Using an audiotape recorder, record the following series of cues, pausing after each instruction for as long as you would want to follow it out.

Set yourself up in front of the video camera for a head and shoulders shot.

Have the monitor off. Roll the tape. Follow/don't follow the cues.

Relax and breathe deeply, just relax and breathe deeply. Loosen up your face by yawning, stretching your neck, working your jaw. Now, explore your face with your fingertips. Touch the favorite part of your face. Close your eyes and think of someone you love. Remember a happy moment with

that person. With eyes open give facial responses to the following people: Don Rickels, Spiro Agnew, your mother, Huey Newton, Margaret Mitchell, you. For the next twenty seconds do what you want. Now let your face be sad. Turn your back to the camera. Now face the camera take a bow. REPLAY.

"Wow, It's Like Making It With Yourself."

As long as we adopt the Narcissus attitude of regarding the extensions of our own bodies as really out there, really independent of us, we will meet all technological challenge with the same sort of banana skin pirouette and collapse (McLuhan 1964: 68).

McLuhan understands all extensions of man as inducing a corresponding numbness and closure. Narcissus's image in the pool is a kind of self-amputation brought on by irritating pressures. To counter the irritant of amputation, his image in the pool produces a numbness in Narcissus which makes it impossible for him to recognize his extended self.

This mechanism is at work with people seeing themselves on tape. The most telling instance I know of is the replay I did for a three-year-old girl in a family setting described above. As noted, she felt compelled to imitate what she saw herself doing on the screen. This three-year-old seemed to be using real-time mirror ground rules to deal with her videotape experience. It seemed she was playing a mirror part for her video image — the part the mirror would ordinarily play for her. In doing so, she became a numb servomechanism of her extended image. The next time I brought the camera around, she ran. She refused to become spellbound by her tape-extended self. By contrast, I heard a children's sensitivity leader once brag that he had seen so much of himself on tape, that he was desensitized to it.

The Möbius video strip is a tactic for avoiding both servomechanistic closure and desensitizing in using videotape. Tape can be a tender way of getting in touch with oneself. In privacy, with full control over the process, one can learn to accept the extension out there on tape as part of self. There is

the possibility of taking the extending back in and reprocessing over and again on one's personal time warp.

> *There will be tape, there will be time,*
> *To prepare a face to meet the faces that you meet.*
> *Time to murder and create.*
>
> —after Eliot

It may be wise to invite a good friend to watch some of the replay with you. Yet avoid inhibiting word labels on what you're doing. The Möbius tape strip is a tactic for infolding information unto a fullness. As Blake said "Exuberance is Beauty...the cistern contains, the fountain overflows." To overflow, one need be infolding. The process of infolding cannot be frozen in words. Let go the formulations and take another trip round the Möbius strip.

Videotape is the "some power" that is answer to the prayer of Burns which people instinctively quote when talking about tape:

> *Oh wha some power the Giftie gie us*
> *To see ourselves as ithers see us*
> *It would from many a blunder free us*
> *And foolish notion.*
> *What airs in dress and gait would lee us*
> *And e'vn devotion.*
>
> *"It would from many a blunder free us."*
> It would enlarge our ability to self-correct.
> It would extend us in a cybernetic way.

With video we can know the difference between how we intend to come across and how we actually do come across. What we put out, what is taken by the tape, is an imitation of our intended image; it is our monkey. A video system enables us to get the monkey off our backs, where we can't see him, out onto the tape, where we can see him. That is the precise way in which we've been making a monkey of ourselves. The monkey has been able to get away with his business because he operates on the other side of the inside/outside barrier. The Möbius tape strip snips the barrier between inside/outside. It offers us one continuous (sur)face with nothing to hide. We

have the option of taking in our monkey and teaching him our business or letting him go on with his.

Taking in your own outside with video means more than just tripping around the Möbius strip in private. One can pass through the barrier of the skin, pass through the pseudo-self to explore the entirety of one's cybernet—i.e., the nexus of informational processes one is a part of. You can listen to the Beatles too much. You can turn a Möbius strip composition into a merry-go-round of ego tripping on a single loop. In fact, we live in multiple loops. Möbius composition can touch on these loops: Agnew-mother-Huey Newton. But to confine ourselves to this use of video is to confine a cybertool to closet drama.

> Cybernetics...recognize(s) that the "self" as ordinarily understood is only a small part of a much larger trial-and-error system which does the thinking, acting, and deciding. This system includes all the informational pathways which are relevant at any given moment to any given decision. The "self" is a false reification of an improperly delimited part of this much larger field of interlocking process (Bateson 1972: 331).

The cybernetic extension of ourselves possible with videotape does not mean a reinforcement of the ordinarily understood "self." Total touch with one's cybernet precludes the capitalism of identity at the expense of understanding process that the West has habitually engaged in. One's resume is not one's reality. Master Charge does not make you master of anything but involves you in an expensive economy of credit information processed by computer, your checking account, TV ads, long lines in banks, and busy telephones. The Master Charge card exploits the illusion of unilateral control over life the West has suffered with. The poet William Henley expressed that illusion very directly. "I am the master of my fate/I am the captain of my soul." We have yet to understand there is no master self. They are now putting photos on charge cards when they should be mapping the credit system the card involves you in. Video users are prone to the same illusion. It is easy to be zooming in on "self" to the exclusion of environmental or social systems.

Doing feedback for others, one comes to realize the necessity of taping and replaying context. I had the opportunity to do a kind of video meditation on the house of two friends while they were away. The replay served to deepen their sensitivity to their everyday surroundings.

A friend I know did a half-hour continuous tape of his family eating cold cuts in Chicago. Showing this tape to friends in New York was in effect using video to interloop two different pathways of "himself."

Guerrilla Strategy and Cybernetic Theory

To fight a hundred times and win a hundred times is not the blessing of blessings.
The blessing of blessings is to beat the other man's army without getting into the fight yourself.

—Sun Tzu, *The Art of War*

Traditional guerrilla activity such as bombings, snipings, and kidnappings complete with printed manifestos seems like so many ecologically risky short-change feedback devices compared with the real possibilities of portable video, maverick data banks, acid meta-programing, cable TV, satellites, cybernetic craft industries, and alternate life-styles. Yet the guerrilla tradition is highly relevant in the current information environment. Guerrilla warfare is by nature irregular and non-repetitive. Like information theory, it recognizes that redundancy can easily become reactionary and result in entropy and defeat. The juxtaposition of cybernetics and guerrilla strategy suggests a way of moving that is a genuine alternative to the film scenario of New York City urban guerrilla warfare, *Ice*. Using machine guns to round up people in an apartment house for a revolutionary teach-in is not what the information environment is about. All power does not proceed from the end of a gun.

We suffer the violence of the entropy of old forms — nuclear family, educational institutions, supermarketing, cities, the oil slick complex, etc. They are running us down, running down on us and with us. How do we get out of the way? How do we develop new ways? This ship of state continues to run away from its people and its planetary responsibilities, while efforts continue to seduce us into boarding this sinking ship — educational loans, fellowships, lowering the voting age. Where did Nixon come from anyway? How did that leftover

from the days of Elvis get to be captain of our ship, master of our fate?

How many Americans, once horrified by thermonuclear war, are now thinking the unthinkable in ecological terms with a certain spiteful glee of relief at the prospect of a white hell for all?

> *Psychedelic my ass: Children of A-Bomb*
> — Bob Lenox

Nobody with any wisdom is looking for a straight-out fight. We have come to understand that in fighting you too easily become what you behold. Yet there is no way on this planet to get out of the way. Strategy and tactics need be developed so the establishment in its entropy does not use up our budgets of flexibility. The efforts to enlist the young in the traditional political parties for 1976 will be gross. Relative to the establishment and its cultural automatons, we need to move from pure Weiner wise Augustinian cybernetics into the realm of war game theory and practice in the information environment.

The most elegant piece of earth technology remains the human biocomputer; the most important data banks are in our brain cells. Inherent in cybernetic guerrilla warfare is the absolute necessity of having the people participate as fully as possible. This can be done in an information environment by insisting on ways of feeding back for human enhancement rather than feeding off people for the sake of concentration of power through capital, pseudo-mythologies, or withheld information. The information economy that begins in a guerrilla mode accepts, cultivates, and depends on living, thinking flesh for its success. People are not information coolies rickshawing around the perceptions of the privileged, the well-paid, or the past. People can and do process information according to the uniqueness of their perceptual systems. Uniqueness is premium in a noospheric culture that thrives on high variety. Information is here understood as a difference that makes a difference. The difficulties of a negentropic or information culture are in the transformations: how do we

manage transformation of differences without exploitation, jam, or corruption that sucks power from people?

I am not talking about cultivation of perceptual systems at the expense of emotional cadences. Faster is not always better. Doing it all ways sometimes means slowing down. Internal syncing of all facets is critical to the maintenance of a flexibility and avoidance of non-cybernetic "hang-up" and "drag."

The bulk of the work done on cybernetics, from Wiener's guided missiles through the work at IBM and Bell Labs along with the various academic spin-offs, has been big-budget, establishment-supported, and conditioned by the relation of those intellectuals to the powers that be distinctly non-cybernetic and unresponsive to people. The concept of entropy itself may be so conditioned. Witness the parallel between Wiener's theoretical statements about enclaves and the enclave theory of withdrawal from Vietnam. One of the grossest results of this situation is the preoccupation of the phone company and others with making "foolproof terminals" since many potential users are assumed to be fools who can only give the most dumb-dumb responses. So fools are created.

The Japanese, the people we dropped the A-bomb on in 1945, introduced the portable video system to this country in 1967, at a price low enough so that independent and semi-independent users could get their hands on it and begin to experiment. This experimentation, this experience, carries within it the logic of cybernetic guerrilla warfare.

Warfare...because having total control over the processing of video puts you in direct conflict with that system of perceptual imperialism called broadcast television that puts a terminal in your home and thereby controls your access to information. This situation of conflict also exists as a matter of fact between people using portable video for feedback and in situations such as schools that operate through withholding and controlling the flow of information.

Guerrilla warfare...because the portable video tool only enables you to fight on a small scale in an irregular way at this time. Running to the networks with portable video material seems rear-view mirror at best, reactionary at worst. What is critical is to develop an infrastructure to cable in situations

where feedback and relevant access routes can be set up as part of the process.

Cybernetic guerrilla warfare...because the tool of portable video is a cybernetic extension of man and because cybernetics is the only language of intelligence and power that is ecologically viable. Guerrilla warfare as the Weathermen have been engaging in up to now, and revolution as they have articulated it, is simply play-acting on the stage of history in an ahistoric context. Guerrilla theater, doing it for the hell of it on their stage, doesn't make it either. We need to develop biologically viable information structures on a planetary scale. Nothing short of that will work. We move now in this present information environment in a phase that finds its best analogue in those stages of human struggle called guerrilla warfare.

Yet this is not China in the 1930's. Though there is much to learn from Mao and traditional guerrilla warfare, this is not the same. Critically, for instance, in an economy that operates on the transformation of differences, a hundred flowers must bloom from the beginning. In order to "win" in cybernetic guerrilla warfare, differences must be cherished, not temporarily suppressed for the sake of "victory." *A la* McLuhan, war is education. Conflict defines differences. We need to know what *not* to be enough to internally calculate our own process of becoming earth-alive noosphere. The more we are able to internally process differences among us, the more we will be able to process "spoils" of conflict with the entropic establishment—i.e., understanding the significant differences between us and them in such a way as to avoid processing what is dangerous and death-producing. Learn what you can from the Egyptians; the exodus is cybernetic.

Traditional guerrilla warfare is concerned with climate and weather. We must concern ourselves with decoding the information contours of the culture. How does power function here? How is this system of communications and control maintained? What information is habitually withheld and how? Ought it be jammed? How do we jam it? How do we keep the action small enough so it is relevant to real people? How do we build up an indigenous data base? Where do we rove and strike next?

Traditional guerrilla warfare is concerned with knowing the terrain. We must expand this to a full understanding of the ecological thresholds within which we move. We must know ourselves in a cybernetic way, and know the ecology so that we can take and take care of the planet intact.

The traditional concern is for good generals. What's desirable for us is ad hoc heterarchies of power, which have their logistics down. Cybernetics understands that power is distributed throughout the system. Relevant pathways shift and change with the conditions. The navy has developed war plans where the command in a fleet moves from ship to ship every fifteen minutes. It is near impossible to knock out the command vessel.

The traditional tricks of guerrilla warfare are remarkably suited for cybernetic action in an information environment. To scan briefly:

- Mixing "straight" moves with "freak" moves. Using straight moves to engage the enemy, freak moves to beat him and not let the enemy know which is which.

- Running away when it's too heavy. Leave the enemy's strong places and seek the weak. Go where you can make a difference.

- Shaping the enemy's forces and keeping our own unshaped, thereby beating the many with the few.

- Faking the enemy out. Surprise attacks.

- Count the cost. We need to develop an information accounting system, a cultural calculus.

- Use the enemy's supply. With portable video one can take the American mythology right off the air and use it as part of a new perceptual collage.

- Be flexible. In cybernetics, flexibility, the maintenance of a good guessing way, is critical.

- Patience. Cybernetics is inherently concerned with timing and time design. It is a protracted war.

We retreat in space, but we advance in time.

Q. Who are the enemy?

A. All conspiring with entropy. Ourselves insofar as we make trash of consciousness.

Q. Who are allies?

A. All who are developing self-referencing modes of sharing life on planet earth.

Do not repeat a tactic which has gained you victory, but shape your actions to an infinite variety. Water sets its flow according to the ground below; set your victories according to the enemy against you. War has no constant aspect as water has no constant shape.

—Sun Tzu

Attempting a Calculus of Intention

Calculus of intention was a concept developed over many years by the cybernetic wizard Warren McCulloch. He was in the business of brain circuits. McCulloch felt that dialogue breakdowns occurred largely because we lacked a logic that could handle triadic relationships. Here is his description of the problem of the calculus of intention.

> The relations we need are triadic, not diadic. Once you give me triadic relations, I can make N-adic relations; but out of diadic relations, I can't go anywhere. I can build strings and I can build circles, and there it ends.
>
> The great problem of the nervous system is the one concerning its core, the so-called reticular formation...This reticular core is the thing that decides whether you'd better run or whether you'd better fight, whether you should wait, whether you should sleep, whether you should make love. That's its business and it has never relinquished that business. It is a structure incredibly simple when you look at it...but the problem that I'm up against is the problem of organization of many components, each of which is a living thing, each of which, in some sense, senses the world, each of which tells others what it has sensed, and somehow a couple of million of these cells get themselves organized enough to commit the whole organism. We do not have any theory yet that is capable of handling such a structure (McCulloch: 1967).

I have not made a thorough study of McCulloch. That would take years. I do not know if what follows satisfies that criterion he established for such a calculus. I have maintained a certain organization of ignorance relative to formal cybernetics and formal topology. In fact, what follows would not, it seems, satisfy the kind of discreteness, one-two-three, that McCulloch seemed to want. However, such discreteness may not be necessary.

In the open Kleinforms that follow, rather than three discrete entities, you have a recurring variable three-fold relationship between *part contained, part uncontained,* and *part containing.* This gets you beyond the dyadic inside/outside

relationship and enables you to build self-referencing N-adic systems beyond strings and circles.

My approach stems from work with McLuhan that preoccupied me with the problem of how to maintain congruence between our intentions and our extensions. McLuhan talked of orchestration of media and sense ratios. Neither cut it. Orchestras just aren't around, and sense ratios, or *sensus communis*, is a medieval model, essentially a simile of meta-touch. Gibson's book on the senses considered as perceptual systems is richer in description of the process. It includes McLuhan's personal probing ability as an active part of the perceptual system.

While the following formulations may not in fact work as a calculus of intention, I put them forth both because they have been exciting and useful for me and because the calculus itself seems a critical problem in terms of cybernetic guerrilla warfare. Dialogue degenerates and moves to conflict without an understanding of mutual intent and non-intent. While it does not seem that we can work out such a common language of intent with the people pursuing the established entropic way of increasingly dedifferentiated ways of eating bullshit, it is critical we develop such a language with each other. The high variety of self-organizing social systems we are working toward will be unable to co-cybernate re each other re the ecology without such a calculus of intent.

This calculus of intention is done in mathematical topology. *Topology is a nonmetric elastic geometry. It is concerned with transformations of shapes and properties such as nearness, inside, and outside.* Topologists have been able to describe the birth of a baby in terms of topological necessity. There is a feeling among some topologists that while math has failed to describe the world quantitatively, it may be able to describe the world qualitatively.

Work is being done on topological description of verbs that seem common to all languages. Piaget felt that topology was close to the core of the way children think. Truck drivers have been found to be the people who are most able to learn new jobs. While driving a truck for Ballantine one summer, it became apparent to me why. Hand an experienced driver a

stack of delivery tickets, and he could route in five minutes
what would take you an hour. It was a recurring problem of
mapping topologically how to get through this network in the
shortest amount of time given one-way streets, etc. In topol-
ogy, a doughnut and a cup are congruent or homeomorphic,
since by an elastic twist the hole in the doughnut becomes the
place where you put your finger through the handle of the
cup.

I should say that my own topological explorations have a lot
to do with a personal perceptive system that never learned
phonetics, can't spell or sing, and took to topology the way
many people seem to take to music. The strongest explicit
experience with topology I've had came via a painter friend,
Claude Ponsot, whose handling of complex topological
patterns on canvas convinced me that a nonverbal coherent
graphic think was possible. The following transformations on
the Klein bottle—Kleinforms, if you will—I invented in the
context of working with Warren Brodey on soft control
systems using plastic membranes. Behind that are three years
of experience infolding videotape. I checked these formula-
tions with a Ph.D. topologist. He had not seen them before,
questioned whether they were strictly topological. As far as I
know, they are original. (See Fig. 10-15, pp. 98-101.)

There are three immediate areas where I think this
topological calculus of intention can be of use: acid metapro-
gramming, a grammar of video infolding and perceptual
sharing, and in soft control structures using plastic
membranes.

Relative to acid metaprogramming, I am not recommending
LSD-25 to anyone, nor am I endorsing Leary's approach. I am
simply looking at some of the work that John Lilly has done
and suggesting this calculus might be useful in that context.
Both in *Programming and Metaprogramming in the Human
Biocomputer* and in *Mind of the Dolphin*, Lilly uses the notion of
interlock to describe communication between people and
between species. In *Programming and Metaprogramming* he
describes a personal experience with acid that in some way
undercuts the metaphor of interlock, and to me suggests that
the Kleinforms might be a better way to describe the process

he calls "interlock." Here is Lilly's description of that experience, which he titles "The Key Is No Key."

> Mathematical transformations were next tried in the approach to the locked rooms. The concept of the key fitting into the lock and the necessity of finding the key were abandoned and the rooms were approached as "topological puzzles." In the multidimensional cognitional and visual space, the rooms were now manipulated without the necessity of the key in the lock.
>
> Using the transitional concept that the lock is a hole in the door through which one can exert an effort for a topological transformation, one could turn the room into another topological form other than a closed box. The room in effect was turned inside out through the hole, through the lock leaving the contents outside and the room now a collapsed balloon placed farther from the self-metaprogrammer. Room after room was thus defined as turned inside out with the contents spewed forth for use by the self-metaprogrammer. Once this control "key" worked, it continued automatically to its own limits.
>
> With this sort of an "intellectual crutch," as it were, entire new areas of basic beliefs were entered upon. Most of the rooms which before had appeared as strong rooms with big powerful walls, doors, and locks now ended up as empty balloons. The greatly defended contents of the rooms in many cases turned out to be relatively trivial programs and episodes from childhood which had been over-generalized and over-valued by this particular human computer. The devaluation of the general purpose properties of the human biocomputer was one such room. In childhood the many episodes which led to the self-programmer not remaining general purpose but becoming more and more limited and "specialized," were entered upon. Several levels of the supra-self-metaprograms laid down in childhood were opened up.
>
> The mathematical operation which took place in the computer was the movement of energies and masses of data from the supra-self-metaprogram down to the self-metaprogrammatic level and below. At the same time there was the knowledge that programmatic materials had been moved from the "supra-self position" to the "under self-control position" at the programmatic level. These operations were all filed in metaprogram storage under the title "the key is no key" (Lilly: 1970).

Relative to video infolding, it is nearly impossible to describe in words, even using Kleinform graphs, what I'm talking about. The following will mean little to anyone except those who have had some experience of taping themselves at different levels.

- Taping something new with yourself is a part uncontained.

- To replay the tape for yourself is to contain it in your perceptual system.

- Taping yourself playing with the replay is to contain both on a new tape.

- To replay for oneself tape of self with tape of self is to contain that process in a new dimension.

- Parts left out of that process are parts uncontained.

- All of this is mappable on computer graphic terminals.

- At one level that of reality that is left off the tape is the part uncontained.

- Raw tape replayed is part contained in the head.

- If it is somebody else's tape you are watching, you can to an extent share in this live perceptual system via the tape he took.

- To watch another's edited tape is to share in the way he thinks about the relation between his various perceptions in a real-time mode. This enters the realm of his intention.

- If you are editing some of your tape along with tape somebody else shot and he is doing the same thing using some of your tape, then it is possible to see how one's perceptions relate to another's intention and vice versa.

Relative to sharing perceptual systems, it is somewhat easier to talk about, since there are parallels with photography and film.

The most explicit experience of this mode of perceptual sharing came in the early days of Raindance when Frank Gillette, Ira Schneider, Michael Shamberg, and I shot twelve rolls of tape on Earth Day. Both in replay that evening (we laughed our heads off digging each other's tape while the old

perceptual imperialist Walter Cronkite explained Earth Day for us) and in the edits that followed, each of us got a good idea of how each saw and thought about the the events vis-a-vis the others.

Relative to soft control systems using plastic membranes, I am thinking mostly of the soft cybernetic work being done by Warren Brodey, Avery Johnson, and Bill Carrigan. The sense of the sacred and the transcendental that surrounds some of the inflatable subculture is to me a kind of pseudomythology. Consciousness might be better invested in designing self-referencing structures where awareness is immanent in the structure and its relation to the users; not by being invested in a religious way to a "special" structure that does not relate intelligently to the users.

A Kleinform couch is a suggestion of a possible way of moving in that direction. It could be built of strong polyurethane, filled with air, perhaps by a constant flow from a pump. People might interrelate kinetically through the changes in the air pressure. Design of the actual couch could be arrived at experimentally by combinations and transformations of the structure described above.

PART TWO: EARTHSCORE, 1972-1976

In May of 1971, shortly after I wrote "Attempting a Calculus of Intention," my father died. Though the doctors who diagnosed my father with cancer of the lungs had said he would live for at least six months, he was dead within ten days. The funeral mass was an atrocity of insensitivity and I bolted. Three days later, I went to the Raindance loft, replayed tape of my father I had made while he was alive and shouted and wailed and carried on in front of a recording camera all night long. In effect, I produced a spontaneous, twelve hour *Video Wake for My Father*. Wanting to make public my rage and grief, I then invited over a hundred people to see the unedited tape at my apartment in New York City. A friend showed the tape. I was not there. By my absence I wanted to underscore my father's absence by death even though he was "live" on tape. In part, I was playing on the paradoxes of presence and absence in death and videotape. Also, I simply did not have the emotional strength to view the tape in the presence of people I knew.

In the *Wake* tapes, I related my father's death to the potential death of the human species, using the disease of cancer as an index and metaphor for the ecological devastation that could kill us all. One thing I had hoped would come out of the *Video Wake for My Father* was a "tribe" of videomakers who would take the ecological crisis seriously. The *Wake* tapes failed to produce such a tribe.

After the *Wake*, I moved out of Manhattan to the Shawangunk Mountains about ninety miles north of New York City. I worked on integrating video into my perceptual system. For a while I lived near a broad beautiful stream of water that ran over an exposed bed of rock. I would crawl in the stream on all fours with the camera strapped in various configurations on my body. I studied T'ai Chi and linked my handheld

camera work with certain of its moves. I trained myself to do continuous half hour, hand-held tapes without stopping. I watched waterflow pattens in slow motion, over and over, until I could recreate them as events in my mind without watching the videotape. I stretched my perceptual system as far as I could.

After I moved out of Manhattan, I did not say a word on tape for the next five years. Twelve hours of talking on tape during the *Wake* had made me very distrustful of language. My distrust of language included a distrust of McLuhan's idea that electronic culture required the creation of new oral cultures with "tribal" social arrangements. In the Shawangunks I attempted instead to start an intentional community of videomakers who would organize themselves in response to their video perceptions of the natural world rather than in obedience to the language commands of any "tribal" leader.

As the reader will see, the first text in this section, "Earthscore as Intentional Community," is a kind of quasi-mathematical manifesto with religious overtones. The style of this manifesto combines mathematical phrasing (ex. *Let* $a = b + c$) with biblical rhetoric (ex. *Let* there be light.). The text uses my incomplete calculus of intention, presented above in the section on "Early Video," to configure an intentional community of thirty-six videomakers. Each videomaker was to be part of three different triads. The first triad was to care for its members, the second to take care of the business of supporting a community, and the third to produce video interpretions of ecological systems. My intuition was that if self-correcting teams of three people could be stabilized, a leaderless, thriving community could be stabilized. Of course, my own messianic attempt to *start* a leaderless community involved a personal contradiction that I became keenly aware of over the next few years.

In the early seventies, the idea of utopian communities living within ecological limits was in currency. Ernest Callenbach's widely read book about a breakaway state in the Pacific Northwest called *Ecotopia* appeared in 1975. In conceptualizing Earthscore, however, I did not rely very much on readings from the utopian tradition. My key text was the rule of Saint

Benedict, the founder of western monasticism. I drew on my experience of having lived in a contemplative preaching order of the Roman Catholic Church. I wanted to start a non-celibate, aesthetic order capable of interpreting ecological systems with video that would be as sturdy and long lasting as the celibate, ascetic orders of the monastic tradition.

The conceptualization of an Earthscore community came to me in a burst one day after two years of videotaping nature in the Shawangunk Mountains and the adjoining Hudson Valley. The name Earthscore indicates my assumption that ecological systems, like musical systems, were made up of "notes" and that humans can interpret these notes with video. In an attempt to recruit members for the community, I passed out over a hundred copies of "Earthscore as Intentional Community" to people I knew in the town of New Paltz and got two takers: videographer Steven Kolpan and artist Robert Schuler. We started working together in 1973, drafting an intricate set of triadic bylaws. We remained together until the summer of 1976 when we folded. Many factors contributed to this failure. We had no triadic decision-making process. We did not have enough clarity about gender relationships to integrate women into this triad of men. Perhaps most importantly, we started Earthscore before I had invented a "stabilized repertoire of triadic behavioral patterns" as called for in "Earthscore as an Intentional Community." Also, the money ran out. The grant support for my work with video and nature, which I had been receiving from the New York State Council on the Arts since 1971, was cut to zero in 1976.

In hindsight, the intentional community of Earthscore was for me a necessary cocoon. Its monastic-like character provided thick walls behind which I could heal from my father's death and meditate on ways of using video to reconnect our species with ecological systems. The fruits of my meditations were presented in a week-long one-man show I did at the Kitchen performance space in Manhattan in the spring of 1976. A brief explanation of this show, titled "Video Variations on Holy Week," provides a framework for contextualizing the five years of work I did between 1971 and 1976.

On the first evening of the show, a Tuesday, I gave a talk based on a paper entitled "Video as Evolutionary Tool," which presents a formal basis for evolving a new range of human behavior and perception using video. This paper is published here for the first time as the second text in this section. It explains how the open Kleinforms presented in "Attempting a Calculus of Intention" developed into the six-part Kleinform, which I call the relational circuit. The diagrams that accompany "Video as Evolutionary Tool," presented in this book as "The Development of the Relational Circuit," were on display at the Kitchen. This essay reveals how the ideas of Gregory Bateson, Warren McCulloch and Charles Peirce influenced my thinking-through of the relational circuit. Bateson's *Steps to an Ecology of Mind* had been published in 1972. McCulloch's *Embodiments of Mind* was available from MIT Press. Fortunately, the SUNY New Paltz library had both the collected writings of Peirce, the microfilm edition of his works and much of the secondary scholarship.

In rereading "Video as Evolutionary Tool," I was tempted to delete my reference to a "community of lovers." It is embarrassing for me to read this phrase, especially in a text where I maintain gender insensitivity in my choice of pronouns. After the failures of the late sixties and early seventies, the idea of a community of lovers is easily ridiculed. But it would be disingenuous for me to cover up the fact that I did entertain such a possibility in a time when people such as myself were reading Herbert Marcuse's *Eros and Civilization* with glee. Moreover, I cannot delete from my mind the fear that without communities of lovers, we may be unable to cultivate the high levels of motivation and desire it will take to turn around the situation that is destroying our species. Our present social arrangements don't allow us to care about one other enough to care about the planet that supports us all. We leave fellow humans homeless in big cities, allow children to grow up with lead poisoning, lock up members of our own species in prison, threaten each other with nuclear weapons and abuse each other in countless ways. Though the idea of a community of lovers is a remote one for me now, in the face of such manifest

indifference and hatred, it may not be so ridiculous to start talking again about the possibility of such communities.

On Wednesday and Thursday, the second and third evenings of the Kitchen show, I conducted workshops to practice a ritual of triadic relationships, a relational practice for three people I have subsequently named Threeing. The instructions for Threeing are given in a series of figures presented in this book. (See p. 104 ff.) Developing the practice of Threeing was partly motivated by a conversation with cultural historian, Thomas Berry, at the Riverdale Center for Religious Research (Berry: 1970). Berry explained that there was a time in Asian culture when myth and story provided cultural coherence. However, some people came to distrust the world of story and myth and turned inward to develop the non-symbolic disciplines of yoga and T'ai Chi. In the early seventies it seemed to me that the distrust of media in our culture was deep enough to merit developing unmediated, face-to-face disciplines of communication.

Over the five-year period I spent in the Shawangunk Mountains, I videotaped over thirty hours of people interacting in sets of three. Ninety-five percent of the interaction was non-verbal. Much of the tape was done with members of the Dancing Theatre in New Paltz, directed by Brenda Bufalino. I bartered videotaping their rehearsal and performances for their participation in my triadic video experimentation. I edited thirty hours of tape down to six hours, using a Gregorian chant sound track and showed it at the Kitchen and over Manhattan Cable during "Video Variations on Holy Week."

Also showing at the Kitchen and over Manhattan Cable was my *Earthscore Sketch*. This was a set of thirty-six, half hour continuous tapes of nature I made in the Hudson Valley between 1973 and 1976. In addition, I showed some excerpts from a year long study of the main waterfall in High Falls, New York, which I did in 1975. This study produced over thirty-five different sorts of waterflow patterns. My tapes of nature were contemplative and appropriate for inclusion in my video variations on a sacred liturgy.

On Friday, Good Friday of Holy Week, I did a live performance of the *Video Wake* I had done for my father five years

earlier. I based the performance on an edited transcript of the original twelve hour wake. The edit did not change a word, only deleted sections. I felt that I was strong enough to perform the wake before a live audience and not use videotape to absent myself from the people I was talking to, as I had in the original wake five years earlier. The performance took approximately three hours (Ryan: 1976b). It is a complicated piece about a complicated situation. I hope to someday recontextualize the tape for the general viewer in a way that makes it more accessible. As it stands, it is very raw and difficult to take. However, it has a validity on its own and was seminal for many other things I've done which are presented in this book. In "Video as Evolutionary Tool," I discuss the relationship between the *Wake*, the relational circuit, and videotapes I was doing then of the ecology.

On Sunday, working with the heartbeat pulse drumming of Tom Ehrlich, those who had participated in the Threeing workshops did a six-hour "Ritual of Triadic Relationships" as a video variation on Easter Day. In the traditional liturgy, Easter celebrates resurrection and release from the sufferings of Good Friday. In "Video Variations On Holy Week", the "Ritual of Triadic Relationships" worked to heal the double binds and contradictions in human relationships, exemplified by my own suffering as documented in the Video Wake. Part of the reason I risked performing the *Video Wake* live was to bring attention to the practice of Threeing as a way of healing tangled human relationships.

After the show, I tried to initiate using video to interpret the ecology of the Hudson Valley as a public work project. I thought that with support from the Labor Department, rather than the Arts Council, it would be possible to train people to make video in teams of three and actually produce a worthwhile interpretation of the ecology. The last text in this section, "Earthscore as Public Work," is a proposal to the local Labor Department in Ulster County. Unfortunately, I articulated the proposal in a poetic idiom and the manifest ignorance of the labor department vocabulary, despite poetic clarity, helped ensure that the proposal did not get funded. If Earthscore ever were to be undertaken as a public work

project, it would be necessary to sort out the countercultural afterbirth from the genuine. For example, working according to lunar cycles may strike the reader as mere hippie vanity left over from the counterculture, but many natural phenomena such as tides and animal behaviors are keyed to lunar cycles. Systematic observation of nature must somehow accommodate the systemic behavior of nature.

In any event, for me, the monastic/utopian cocoon was no longer necessary. I had formalized my understanding of how to use video to interpret ecological systems to the degree that I thought a successful interpretation could be accomplished in the world of work, without monastic walls. While the proposal never got off the ground in the Hudson Valley, my conceptualization of Earthscore as a public work project held out the hope, at least for me, that the *raison d'etre* for Earthscore as a utopian community, i.e., to interpret ecologies with video, could be accomplished without forming utopian communities.

Earthscore as Intentional Community

Video Prologue

Regarding black and white videotape we make the following assumptions:

- Videotape records a person's genetically determined uniqueness — that is, his firstness.

- Videotape records the way of a person's firstness — that is, the mode in which he has learned to segment the continuum of his experience.

- Through videotape feedback a person can learn to enhance his way and learn new ways.

- Through imitation of another on videotape, one can learn another's way.

- Videotape can record the given pattern of differentiation of many natural and man-made forms in such a manner as they can be understood structurally by man.

- Videotape feedback opens up channels of communication in a triad of people sufficient to enable them to stabilize a three-fold relationship in a self-corrective manner.

One formula for such stabilization is as follows. Three people do continuous tape without talking and without leaving the scanning field of the camera or cameras. This can be done with one camera on a tripod, three cameras on tripods, or ideally, with three cameras in the hands of skilled cameramen who care about the people involved. Tapes are played back simultaneously. This process is repeated with

appropriate time intervals, unto stabilization. Experimentation suggests that the richer the redundancy patterns the triad is able to create and share simultaneously, the more possibility there is for differentiation within the relationship.

Another formula, not directly dependent on video, is to outline a closed Kleinform on the floor. (See Fig. 17, p. 102.)

Members of the triad relate to each other as suggested by the form, one person playing each part. One or the other of the parts uncontained is always left empty during the sequence. Players shift parts as they will, searching for a high variety of modes of interrelation. When no one moves into the part contained, that particular sequence is complete.

Our bilateral symmetry has forced us into predominantly dyadic behavioral patterns. A person cannot look into four eyes at once. Our natural bent is to exclude a third party. Some Chinese counter this tendency by a conversational mode in which when red asks a question of blue in the presence of yellow, blue answers facing yellow as if yellow had asked the question.

The invention of a stabilized repertoire of triadic behavioral patterns must precede the formation of this intended community. This repertoire can be assumed to be secure when these patterns can be carried on without the presence of video equipment.

This score is conceived in a new form. The nearest known relation to this new form is the Klein bottle. Because this is its nearest neighbor, this new form has been called Kleinform. We begin by differentiating between a Klein bottle and Kleinform. Here is a Klein bottle with the parts named. (See Fig. 9, p. 98.) Here is a segmentation in Kleinform with the parts named. (See Fig. 18, p. 102.)

The Klein bottle outline passes continuously from part contained to part containing that part, and vice versa, without formation of a part uncontained. In Kleinformation such a passage is not possible. This is the essential difference.

The possible continuous oscillation between part containing and part contained can be mapped in a way other than the Klein bottle. This two-part pattern of thinking is called

inspin. It is like a dog chasing his tail unto exhaustion. Inspinning is not Kleinforming. Kleinform maintains a three-fold differentiation of part containing, part uncontained, and part contained. If you have less than three self-differentiating parts, you are not Kleinforming.

In English the verbal formulation that best insures the mind of staying within the rigorous mapping of relationships possible in Kleinform is the injunction "Never Less Than Three." This we call the Canon of Self-correction. Regarding this canon, the following remarks can be made:

- The injunction does not use nouns, nor the ordinary subject-predicate construction. It is a non-dyadic negative, setting a lower limit of differentiation in order to maintain an economy of differences.

- "Never Less Than Three" is a reformulation of the command of paradise. "From every tree of the garden you may eat; but from the tree of the knowledge of good and evil, you must not eat; for the day you eat of it you must die." That is to say, thou shalt not know the world in dyads of good and evil. Whatever wisdom was coded in the command of paradise seems accessible in Klein-formation according to the Canon of Self-correction.

- No one person alone, no two people together, can properly interpret this canon.

That which cannot be decoded or commanded according to the Canon of Self-correction must be accepted in its given pattern of differentiation. Any non-self-corrective process gives rise to a fixed morphology definable once and for all by a model of that process, a chreod that reveals its self-stabilized structure. For example, the growth of a tree cannot be commanded to happen in Kleinform. Similarly, the Canon of Self-correction cannot command triplets, a trisexual species, or undo our bilateral symmetry. Births as given, species sexual differentiation, and bilateral symmetry must be decoded and accepted as given restraints on Kleinformation. Similarly,

non-Kleinformed self-corrective processes must be related to with respect to their form.

Abiding the Canon of Self-correction, we derive the following injunctions for Earthscore.

- Let not planet earth be thought of except in relation to the sun and the moon.

- Let not the human species be thought of except in relation to possible extraterrestrial life forms and other terrestrial life forms that have more survival possibility than our own.

- Let no member of the community be thought of except as part of a self-correction cell of three.

- Let each member be part of three different self-correcting cells: chreché/chreod/work.

- Let the function of the chreché cell be the care of its members.

- Let the function of the chreod cell be the decoding of ecological process.

- Let the function of the work cell be to engage in all remaining processes necessary to maintain the community.

Sun/Earth/Moon

Let the biosphere of the earth be understood as operating self-correctively according to differentiating relations to the sun and the moon. For example, patterns of vegetation growth relate to time contained by the sun (day) and time uncontained (night). The waters of the earth shift relative to the moon.

Let us understand our relation to biospheric self-correction by recurrently decoding part of its process during each of twelve phases of the moon. Let the thirteenth phase of the

moon be a time of no formal taping activity. The following is Gregory Bateson's suggestion as to how this decoding might be done:

nonliving form: earth, water, air
living plant: three plants characteristic of the region
animal: three animals characteristic of the region
man: three technological extensions of man used in the region

Let there be a community of thirty-six adults so that each of the twelve ecological continua can be monitored by a self-correcting cell of three members.

Possible extraterrestrial life forms/humans/terrain forms with more survival probability than humans.

We recognize that as a species we cannot die for ourselves. Unless another accepts the gift of our life, that life is meaningless.

Let this endangered species have part in the coding of its experience of trial and error for other life forms that may survive its own, both terrestrial and extraterrestrial.

Let us code this experience, insofar as it is possible, in a logic of triadic relationships, so as to provide the possible recipients of this gift of human life with optimal fail-safe as learners.

Let this coding process be part of a way of life that is a ritual of readiness forming a budget of flexibility that will optimize all chances for our survival.

Let us engage in this process as part of our bond with our own kind, our dead and our unborn.

If survival is not possible, let us die gracefully.

Rules of Creché Formation

- To give a tape of firstness is to entrust one's firstness to another.

- To accept a tape of firstness is to accept responsibility for caring for another.

- Each gift of firstness must be accompanied by time limits: How long the gift can be held without forming a cell. How long the cell is intended to stay together.

- Every gift of firstness can be accompanied by negative restraints: This shall not be given to such and such.

- No gift of firstness can be accompanied by positive commands: Give this tape to such and such.

- Chreché cell tapes shall be considered tapes of firstness.

Formation of a Creché Cell

- Initiator, red, gives tape of red to yellow.

- Yellow gives tape of red to blue.

- Yellow gives tape of yellow to blue.

- Blue gives tape of yellow to red.

- Blue gives tape of blue to red.

- Red gives tape of blue to yellow. Yellow/red/blue make three tapes together.

Creché Family Formation

- Red/yellow/blue give one of their cell tapes to another initiator.

- This initiator forms cell, as above.

- This cell gives a cell tape to original cell.

- Both cells give cell tape to third initiator.

- Third initiator forms cell as above.

- Third cell gives cell tape to each of prior cells.

- Three cells give cell tape to fourth initiator.

- Fourth initiator forms cell as above.

- This cell gives cell tape to each of three prior cells.

- This completes the formation of the creché family.

Stabilization of Creché Family

- Let each creché cell make a self-corrective tape during each phase of the moon.

- Let creché cells in the same family exchange creché cell tape once during each passage of the earth around the sun.

- Let all creché cell tapes be kept by the family in order to allow self-correction by replay over long periods of time.

- Let any creché cell having difficulty self-correcting invite the other three cells to review their tape in order that they may do whatever is possible to aid the self correction process.

- Let any event that seems to make a difference for the creché family be recorded when possible.

Formation of a Community

- Creché family red gives set of red family tapes to creché family yellow.

- Creché family yellow gives set of red family tapes to creché family blue.

- Creché family yellow gives set of yellow family tapes to creché family blue.

- Chreché family blue gives set of yellow family tapes to chreché family red.

- Chreché family blue gives set of blue family tapes to chreché family red.

- Chreché family red gives set of blue family tapes to chreché family yellow.

To stabilize, let such an exchange take place once every time around the sun.

Formation of Chreod Cells

- Let the thirty-six members of the community form twelve chreod cells.

- Let this be done according to the wisdom of astrology in relating people according to birth signs.

- Let no chreché family members share the same chreod cells.

- Let the chreod cells form themselves into self-correcting groups of four cells corresponding to the categorization of ecological continuum described above.

- Let each chreod cell do a minimum of a tape a month decoding its ecological continuum.

- Let the chreod cells do an initial set of three form tapes to stabilize their relationships.

- After this, let the chreod cells do only as much form tape as is required to stabilize their learning relationship relative to the ecological process.

In the decoding of ecological continuum let the chreod cell members realize that their most treasured resource is in the

varied firstness of the members of the community. This forms a kind of "vocabulary" of differentiation, the understanding of which will make easier the decoding of the different chreods of the ecological process. Conversely, let chreché cell members realize that care of firstness is part with decoding the ecology in which the community lives. The wisdom of the ways in which members learn to relate to each other provides wisdom for understanding the larger systems of which the community is only part.

Let there be an appropriate celebration each phase of the moon configured by the chreod cell monitoring that part of the ecological process. Let that chreod cell produce a special tape to be shown to the community at that event.

Let the set of twelve such special tapes constitute the medium of exchange of the community with other groups trying to live in accord with ecological process. Under no circumstances shall this tape be sold into a money economy. The money economy is a monistic system that violates the Canon of Self-correction. To sell the fruits of whatever ecological understanding the community arrived at would be to live in intolerable contradiction.

Let the chreod cells, beyond these requirements, be primarily responsible for the coding of human experience in a triadic logic of relations.

Formation of Work Cells

• Let the community form twelve work cells.

• Let these twelve cells form into three self-correcting groups of four according to the relationships between the activity they engage in.

• Let the activity of the work cells be selected in such a way as to place minimum restraints on the community's budget of flexibility.

- Let the activity of the work cells conform strictly to the restraints in the ecosystem decoded by the order of chreod cells.

- Let no chreché cell mates share the same work cell.

- Let no chreod cell partners share the same work cell.

- Insofar as is possible, let no members of the same chreché family share the same work cell.

- Let work cell members do only as much self-corrective tape as is necessary to stabilize their activity.

- Let members of the community take turns at the different activities of the work cells in order to preclude specialization. Let these turns be taken according to the pattern of activity.

- Let the community interface with the money system, the legal system, and the government through the work cells.

Changing Earthscore

The above completes the formal structure of Earthscore. Let the community review this structure every twelve years in the three phases of the moon following the winter solstice.

Change requires unanimous approval.

Regulatory Chapters

Let there be a set of twelve regulatory chapters functioning as a necessary subset of Earthscore, a chapter of which will be subject to the review of the community in the phase of the moon following each winter solstice.

Change requires unanimous approval.

(What follows is a tentative coding of some of those chapters.)

Regulation of Birth and Death

- Upon the death of a member, let chreché cell mates configure an appropriate funeral service, offering tape of the departed to the entire community.

- In the period of mourning, until a suitable chreché cell mate can be found to replace the departed member, let the remaining cell mates spend an increased ratio of time with the children to avoid inspinning their relationship.

- As is proper to the function of the chreché order, let that order regulate the genetic code.

- Let no sexual relationships take place outside the order of the chreché family.

- Let no child be born without the consent of the community.

- Let the number of children be regulated in strict ratio to the number of adults.

- Let no child be conceived who will be unsure of who fathered his firstness.

Chreod of Intercourse

Humans are a bisexual species. Adult trisexuality runs against the given pattern of biological differentiation. The chreod of our biology allows Kleinformation of intercourse only if the third party becomes as a child in the womb of the woman. This role is totally trusting, accepting, and absolutely noncompetitive. When properly played in relation to the other partners, it becomes the sacrament of a member's rebirth. In this way chreché cell mates can regenerate one another. Actual children conceived would have a guardian who knows them in their firstness.

Children

• In configuring the community every effort should be made to include both natural parents of the children involved. This may necessitate debugging inspun relationships and providing special restrictions in order to preclude estranged couples sharing community from inspinning.

• Let children be cared for primarily by the chreché cell of the mother.

• Let the terminology "real father" and "stepfather" be dropped in favor of father of firstness and father of one's way.

• Let the community assume responsibility for the education of the children.

• Let each cell partake in this process by involving the children in their activity.

• At eighteen let the child leave the community for a period of six years. After that, if the person of twenty-four so wishes, let a place be found for them in the community, or let them be helped in initiating their own community.

• Let the random exploratory patterns of children be respected as long as they do not encroach on the essential order of the community.

• Let us learn new patterns from our children.

Ad Hoc Triumvirates

• In the event of unexpected occurences that require attention let ad hoc triumvirates be formed for limited times to handle the occurence.

- In matters of extraordinary difficulty, let the community form a group of four self-correcting cells of the proper order to handle the matter.

- Let these ad hoc triumvirates observe the three-fold order of the cells.

- All that is required for an ad hoc triumvirate is the consent of the remaining members of the cells out of which the members of the ad hoc triumvirate come.

- Rather than form ad hoc triumvirates, matters extraordinary may also be referred to the chreod cell currently in synchrony with the phase of the moon.

Departures from Firstness

- If in the ordinary course of self-corrective community activity a member consistently suffers chronic departures from firstness, let him make a continuous solo tape, for however long is necessary, demonstrating and articulating this experience of the negation of his firstness.

- Let this tape be shown to the chreché family.

- Let the chreché family take whatever actions it can to correct the situation, even to go so far as to ask for a recoding of chreods, if that seems wise.

- If all means of correction are exhausted without relief, let the chronic sufferer leave the community.

- If, before leaving, the chronic sufferer declares on tape to each of the cells in his chreché family not his own that his leaving is consequent on his not being cared for by his chreché cell mates, let the chreché family seriously consider the expulsion of the entire chreché cell.

- Even in the event that the departing member does not make such a declaration, the remaining cells should seriously consider the expulsion of the cell in question.

- In the event of chronic incorrigibility of firstness on the part of any chreché cell, let the remaining cells consider expulsion.

Video as Evolutionary Tool

*This is the figure and
not an evading metaphor.*
— Wallace Stevens

A conjecture: imagine that time on earth when there were no
trees. In some areas, the green events that sprang toward the
sun were threatened. Sudden shifts of weather and a growing
number of grass eaters put the very possibility of this sunward-
bursting in danger. Somehow, under the stress of this pertur-
bation, the idea of wood took shape. Cells restrained their
greening, organized in a fiber barked against the weather,
bypassed the grass eaters and leafed to the sun. Trees.

New forms seem to evolve in this manner. Particular ar-
rangements that organize life are no longer able to withstand
the increasing perturbations of the surround. Multiple
stresses in the environment initiate the phase of "sporting," of
rapid trial and error, a search for new forms in which life can
take habit. No guarantee is given. Sometimes new forms are
found. Sometimes they are not.

Here is an abstract, oversimplified example of this same
process. In a two-dimensional world of length and breadth,
consider three rods that loosely bound an area. Within that
area there is a relative freedom to organize, protected from
the random buffeting of the area outside the rods. Now, if the
outside random activity significantly increases, it could easily
scatter the rods and negate whatever organization they
bounded. Or, in the period of initial disturbance, the rods
might somehow hit on the notion that joining end to end in
equal lengths will yield the needed structural strength.
Indeed, such an equilateral triangle could easily withstand
perturbation of a magnitude much greater than that of the
initial agitation. The new forms that evolution has yielded
seem to be arrived at by a process roughly corresponding to

this kind of "hitting the jackpot." For whatever local reasons, certain small articulated animals having jointed limbs come up with a form that involves three legs, two pairs of wings, and respiration by trachea. The range of insects opens out, based on the potential inherent in this structurally stable organization. Another group arrives at an "archetype" of eight legs with no proper division between the thorax, head, and body. A host of insects called spiders takes shape (Waddington 1968: 30 ff.).

In the evolution of human culture, a similar pattern recurs. A new form will open up a range of possibilities that simply were not there before. In science, this happens through the emergence of paradigms: the analysis of motion by Aristotle, the computation of planetary positions by Ptolemy, the mathematization of the electronic field by Maxwell (Kuhns 1962: 23). In the history of art, a similar process takes place. The discovery of *contrapposto* by the Greeks initiated a sculpture of free-standing statues. The invention of perspective space in the Renaissance opened painting to realms previously unimagined.

In considering video as a tool of evolutionary change, I am not simply writing about the machines or the tapes produced by these machines. Alone, these items will yield no more than stone without an idea like *contrapposto* or pigment without an idea like perspective space. Indeed, in the context of evolution, the unbridled rush of videomaking that has taken place over the last five years has yielded little more than disparate heaps of unrelated tapes—video spaghetti. What I want to do here is cut through this spaghetti that has collected around video in its trial-and-error phase to present an idea analogous to *contrapposto* or perspective space. In scientific discourse, I am putting forth a paradigm. In other terms, I am constructing an archetype, if you will, that makes potential a reality that could not be there before.

The formal description of real possibilities properly belongs to the discipline of mathematics. Though original, the math that follows is not difficult. I am a complete amateur in math and never took a formal course in topology, the realm of math dealt with here that has to do with the relationships of position

and inclusion independent of measurement. I think the patient reader can work through the formal structuring of the archetype, regardless of math background.

Since impersonal formal structures arise out of personal struggle and can often be best understood in terms of such struggle, I would like to relate to the reader a brief account of how I came to make this effort.

It is in the evolutionary context of breakdown, sporting and search for a new way to take habit that I can best understand my own struggles. When the sporting time of the sixties hit the Catholic Church in the form of the Vatican Council, I was in a monastic preaching order. I had entered after high school in 1960 and stayed until February of 1965. I had gone in with the fullness of faith and enjoyed the life, the friendships, the men who taught us, the contemplative way. When the agitations of the sixties hit, the order reacted by reinforcing its authority over its members. As one friend quipped, "You look out the porthole to see where we're going and they accuse you of rocking the boat." When someone received a patently absurd order, such as to polish again an already polished floor, and was asked what he was doing, the stock answer was, "Oh, once again, I've been told to water the dry stick."

The humor of it all is somewhat diluted when I realize that I spent two years of that time on the shore of Lake Erie meditating on the crucifixion and death of someone who had died two thousand years ago, without ever perceiving that Lake Erie itself was dying.

When I left the monastery, the first thing I was up against was the draft board. Same business. Somebody giving me orders what to do, only this time it was not a matter of watering the dry stick. It was a matter of going to Vietnam. I got a Conscientious Objector draft status and managed to do my alternate service working with Marshall McLuhan and experimenting with the video medium. In terms of the present discussion, the most salient thing I've done has been to produce the twelve-hour continuous *Video Wake for My Father* in 1971, using a tape made of him while he was alive. This event has many more dimensions than are discussable in this

context. What I would like to note is that, in my mind, the burial service in the Catholic Church held for my father was insulting and invalid. I bolted in the middle of it and did the *Wake* three days later. The *Wake* was an attempt to perform a service that dealt with realities of my father's life and death through twelve hours of uninterrupted, recorded, speaking of the truth in the "live on tape" presence of my father. My hope was that showing my tape publicly would stimulate other people to uninhibited truth-telling performances on video and, beginning with what I said in the face of my father's death, a complete and believable body of recorded testimony could be built. I wanted to initiate a process that would lead to a set of complete and consistent sacred propositions, a set of "ultimate truths" that would guide us through the ecological crisis (Ryan 1973a: 133-138).

Such a hope went unrealized. In hindsight, I can understand that what I was attempting to do—to create a complete and consistent set of ultimate sacred propositions that would be recorded for all to see, question, and examine—was simply not possible for purely formal reasons. At the time of the *Wake*, I was ignorant of the fact that forty years earlier, the mathematician Kurt Gödel had formally proven the impossibility of constructing a complete set of unambiguous propositions (Gödel [1931] 1962). For propositions to be taken as true in an ultimate sense, they must be believed without question. To record statements on tape so they might be questioned was to undercut any chance they could be ultimate.

I had tried the impossible and failed.

Now, I would like to describe what I regard as real possibilities.

The prime form of mathematical communication is injunction, not description. In this, math is like music. The composer makes no attempt to describe the sounds in his mind or the feelings bound up with these sounds. Rather, a set of commands are given that, if followed, can yield a variation on the composer's original experience (Brown 1972: 77). The possibilities I have experienced in my nervous system in the eight years I have worked with video are available for re-creation in the archetype I am offering. This archetype is, in

effect, a formal description of real potential inherent in video. By setting up the following process of differentiation and injunction, I hope to make the archetype available in its entirety. An interested reader could follow the process and have the archetype become an event in his mind, like a fist in his hand. Once the archetype is an event in the mind, it can be used without reference to the set of injunctions by which it was made. Similarly, a cup can be used without reference to the art of pottery or manufacturing process by which it was made.

In what follows, I am a sort of evolutionary artist providing a formal basis for the use of video in human adaptation. In technical terms, I am transforming a Klein bottle into a six-part, unambiguous, non-orientable, intransitive circuit. It is interesting to note that, in a paper culture of the written word, the Klein bottle is a useless curiosity. One cannot Xerox on it anymore than one can mimeograph on a Möbius strip. In video, however, a transformed Klein bottle becomes the critical circuit.

The optimal way to follow the injunctions given is with video equipment. However, I have tried to design this set of commands in such a way that the reader without access to video equipment can grasp the idea through diagrams on paper.

To begin, it is necessary to differentiate between what is orientable and what is non-orientable. Orientation is that act of habit of mind in which relative positions are determined by the assigning of a direction. As you read these lines, you follow a habit of mind built up by many previous acts of reading from left to right. This direction is arbitrarily assigned to our minds by our culture through the school system in which we were taught to read. In writing, I follow the same convention, positioning my words from left to right on the page in a sequence of relations that I think best allows you, the reader, to follow my thought process as coded in words. If I depart from that sequence and, for instance, write the first ten words of this sentence without regard for the assigned direction and the relative positions it requires, I produce something your mind can hardly make sense out of: *Sequence the say that write*

and depart from I if. Left to right is, of course, a convention of English. Some languages, like Hebrew, assign a right to left direction.

In speaking, man also follows an assigned direction. Not on a page, of course, but in time. There is a time when he starts to speak and a time when he stops speaking. Some words are positioned near the beginning of a particular speech, others near the end. Played backwards on a tape recorder, speech makes no sense. Charlie Chaplin is reported to have been able to lay down a sound track on a tape recorder that, when played backwards, came out as intelligible speech. In effect, he chose to assign an opposite direction to his speech. Yet he still had to adhere strictly to the relative positioning of words required by the direction he had chosen. The orientation was reversed but it was still an orientation.

Non-orientation is that act or habit of the mind in which the assigning of direction makes no difference in determining relative position. Note that I have defined non-orientation in the form of a sentence that presumes orientation. To move from this negative definition to a structure of thinking that works without reference to an assigned direction is the burden of what I am attempting here.

In order to ascertain whether a patterning of relative position without assigned direction can be considered a habit of mind, I am using criteria established by the science of cybernetics. These criteria can be stated as follows:

1. There must be a complete circuit.

2. In order for the circuit to operate self-correctively, there must be at least one relation in the circuit such that more of something means less of something else. In the classic example of the thermostat, more heat in the room means less fuel supply going to the furnace which in turn lowers the temperature of the room. If more heat in the room meant more fuel for the furnace, this would mean more heat in the room, more fuel, etc. The circuit would not be self corrective. The system would explode.

3. The circuit must be capable of transforming differences that make differences. For example, differences in room temperature make differences in the thermostat which make differences in the amount of fuel supplied which make differences in the temperature of the room (Bateson 1972: 454-471).

Beside these criteria, I am including the criteria that the assigning of direction shall make no difference in the workings of the circuit. The orientable circuit closest to the one presented here is provided by McCulloch (McCulloch [1943] 1965: 40–45).

Not incidentally, Gregory Bateson has made a compelling argument for identifying the cybernetic circuit, the basic "unit" of mind with the basic "unit" of evolutionary survival (Bateson 1972: 454–471).

Author's Note, 1991: the following section of this essay describes the development of my non-orientable circuit in technical detail. The graphics that accompany this section appear immediately after this essay with explanatory captions under the title "The Development of the Relational Circuit (Graphics)."

We need the following: paper and pencil, a mirror, two video systems complete with camera, monitor and tape.

Set up a TV camera with a live feed to a monitor placed directly under the camera and facing the same direction.

Face the TV camera.

Point your right hand directly to your right.

Set up the mirror in front of you. Face the mirror. Point your right hand directly to your right.

Map the difference in the orientation of your right hand that appears on the mirror image and the video image using two-sided polygons (see Fig. 1 and 2, p. 94) or what are technically called "lunes." These two-sided lunes can be expanded to four-sided rectangles by introducing in opposite positions with opposite orientations, a and a*. This does not change the topology of the figure.

Introduce a and a* in opposite positions in the lune with opposite orientations. (See Fig. 3 and 4, p. 95.)

Since Figures 3 and 4 have sides given in pairs, and since these pairs have assigned orientations, each pair can be superimposed so the arrow heads coincide to form an edge. This being the case, these figures can be taken as plane representatives of polyhedra (Ringel 1974: 39ff.).

Construct the polyhedra in the following way:
For the mirror figure:
Join a and a*.
Join m and m*.
We get a doughnut or what is technically called a "torus."
(See Fig. 7, p. 97.)
For the video:
Join a and a*.
Join v and v*.

The sides v and v* cannot be joined without penetrating the wall constructed by a and a*. By penetrating the wall constructed by a and a*, we get a surface known as a Klein bottle. (See Fig. 8, p. 97.)

When every edge of a polyhedra uses the paired sides in both possible directions, the polyhedra is said to be orientable. If an edge is constructed by paired sides using the same direction, the polyhedra is said to be non-orientable (Ringel 1974: 41). By this definition, we can say that the torus is orientable and the Klein bottle is non-orientable.

From the polygon that maps the image in the video monitor, it is possible to construct another surface by joining v and v* first and not attempting to join a and a*. This is a Möbius strip. It is a one-sided non-orientable surface. (See Fig.6, p. 96.)

Now let us move from a consideration of a live video circuit to one that includes taping and playing back. When a person does video feedback on a standard video machine, he involves himself in three different modes determined by the device he is working with. The machine provides capacity to scan the user's activity, to store a record of that scanning, and to play back that record. Hence, the user is either in the mode of being scanned, in the mode of taking in a playback of his scanned activity, or an inactive state corresponding to the machine's storage capacity (a state in between being scanned and taking in replay of that scanning).

If we depart from the contemporary mathematical consideration of the Klein bottle as a strict topological surface and consider it instead as a tube encoding volume, we begin to understand positional differentiation in a way that will allow us to map these three user modes. The Klein bottle figure provides three positions according to the parts formed by the penetration. There is a part contained, a part containing that part, and a part that is neither contained nor containing which we call a part uncontained.

The threshold of passage left by the disc of the tube wall removed by the penetration indicates differentiation between the position in part contained and the position in part uncontained. If you were to pass the disc through the part uncontained with the circumference of the disc being contingent to the wall of the tube, there would be another threshold where the part contained precluded the disc from continuing contingent to the wall of the tube. This would be a threshold of differentiation between the position in part uncontained and the position in part containing. Position in this figure is not determined by simple closed boundaries as in the torus, but by a combination of boundary and threshold.

In mapping the experience of video feedback then, we can say that the part contained corresponds to being scanned, the part containing corresponds to taking in playback of that scanning, and the part uncontained corresponds to the user's inactive state in-between being scanned and taking in playback.

It is possible to maintain this threefold differentiation of position in figures that are not Klein bottles. I have called these new figures Kleinforms (pp. 98ff.). The difference between a Klein bottle and Kleinforms is that, in a Klein bottle, the outline passes continuously from part containing to part contained without formation of a part uncontained. In Kleinforms, this is disallowed.

Here is a Klein bottle. (See Fig. 8, 9. pp. 97 ff.)

Here are Kleinforms. (See Fig. 10-15, pp. 98 ff.)

The passage from part contained to part containing can be mapped in at least one other way beside that provided in the Klein bottle. This way is called inspin. (See Fig. 16, p. 101.)

Now let us go back to the mirror and the video. With your right hand, simulate shaking hands with yourself in the mirror. Notice that it does not work. It is as if a left hand and a right hand were attempting to shake hands from opposite directions.

With your right hand, simulate shaking hands with yourself in the TV camera/monitor set up. Notice that it works.

Now let us introduce a time delay.

Disconnect the monitor from the videorecorder and connect it to the second videorecorder. (This procedure can only be done on open reel machines that work without cassettes.) Set up a delay by feeding one reel of tape through the two decks, recording on the first and playing back on the second. Set the distance between the decks in terms of the time it would take for six simulated hand shakes to pass from record to playback.

Simulate shaking hands with the camera monitor set up.

Synchronize your live handshake with the delayed electronic transform of your hand.

Continue as long as you like.

In introducing this delay, what we have in effect done has been to take away from the user the mode of being uncontained. The scanned activity is fed back without allowing the user a mode in between being scanned and taking in the scanned activity. We can map this on a Möbius strip, on the surface of a Klein bottle, or in the figure we have called inspin. However, in these figures we cannot differentiate between the live hand and its electronic transform.

Let us set up a similar experiment that can be mapped in Kleinform.

Use one video system with the monitor turned off to record six shakes of your hand.

Rewind the tape.

With a second video system recording your relation to the monitor, replay the tape while you simulate shaking hands with the electronic transform of your hand which is yielded in the monitor.

When finished with the six shakes, rewind the tape on the second machine.

Replay that tape of yourself.

Now let us look at the figure we have developed in terms of the four criteria we set for ourselves at the beginning of this paper: a complete circuit, more of something means less of something else, capacity to transform differences, and non-orientation.

When we disallowed the continuous surface of the Klein bottle in favor of a tubular consideration, we lost our complete circuit. The simplest way to complete the circuit and abide by the injunction we gave ourselves, that the outline cannot pass from part containing to part contained without formation of a part uncontained, is to construct the following figure. (See Fig. 17, p. 102.)

This figure offers three different positions and provides us with a complete circuit. The difficulty is in terms of orientation. There are two parts uncontained. In order to differentiate between them, it is necessary to talk in terms of left and right. You must make some arbitrary assignment of direction to resolve the ambivalence. The figure is complete but it is inconsistent.

The open Kleinforms we have developed (see Fig.10-15, pp. 98 ff.) avoid this ambiguity of position because the parts uncontained are not uncontained in relation to identical parts containing and contained, as in Figure 17. However, the open figures require orientation in time. We must use time's arrow to assign a beginning position.

These difficulties are bypassed when we complete the open Kleinform as shown in Fig. 19, p. 103. Notice that the penetrations are positioned in such a way as to allow us to trap a torus in the part containing two parts.

Figure 19, I think, satisfies the criteria we set above.

1. It is complete.

2. The complete circuit bounds a realm of finite magnitude. When this magnitude is fixed, a ratio among the parts obtains such that more in any part means less in other parts. This ratio relationship is especially true of the parts that share boundaries.

3. The circuit yields an unambiguous ordering of six different positions such that a difference in position makes a difference in relationship.

4. The assignment of direction makes no difference in the relative positions of the circuit. That is to say that the six

positions obtain regardless of the direction in which one chooses to move through the circuit, regardless of reversals of direction.

In the tradition of C.S. Peirce, we can call the position in the part contained by two parts the position of firstness. The part that is contained and contains gives us a position of secondness. The part containing two parts gives us the position of thirdness. That leaves a position in between firstness and secondness, a position in between secondness and thirdness, and also a position in between thirdness and firstness. Peirce offers long explications of what he understood by these terms. I think the relationships that obtain in this circuit correspond to these terms with amazing fidelity. Briefly, firstness is the mode of spontaneity, freshness, feeling, of being such without regard to any other. Secondness corresponds to the other, to constraint, resistance, and reaction. Thirdness is the mode of moderation, of law, of correlation between firstness and secondness (Peirce: 1931—35).

Now that we have constructed this archetypical idea for using video as an evolutionary tool, we can ask what the idea makes possible that was not possible before. I think there are two interrelated possibilities: the invention and maintenance of a repertoire of behavior patterns that would work self-correctively for three people and the construction of an information transmission system based on shared perception of environmental realities.

In terms of the self-corrective triadic behavior, what it seems possible to develop is a "practice" in the Oriental sense of the word. In the Occidental sense, one practices in order to acquire a skill, i.e. to be able to shoot an arrow straight. That skill is then a new tool, which you, unchanged, now have. In the Oriental understanding, you practice in order to change yourself. By incorporating a discipline relevant to archery into yourself, you become, out of the practice, a different sort of person. It is in this Oriental sense that I understand it possible to use video as an evolutionary tool. Using the Klein-form as a figure of regulation, three people could incorporate video and video feedback into their interaction and change

the "normal" pattern of three party differentiation into an ongoing, self-corrective process. The people themselves would also change.

To date, I have accumulated enough tape of people inter-acting in threes (thirty hours) to have a rough idea of how such a practice might be developed. It would include the following approaches:

Recording ordinary activity done in threes, such as eating, and learning from the tape.

Outlining the figure given on the floor and learning to move through it in terms of its structure.

Coding the positions in colored scarves or other signs and interacting in terms of the relational understanding that develops as people change colors as they would change positions.

Using parts of the body to code the whole of the relation-ships. Fingers rubbing, pressing, tapping, etc. Using hand and voice together.

A rich repertoire seems possible given the unambiguous understanding of relationships that obtain in the Kleinform circuit. Through repeated attempts recorded on tape and referenced by the Kleinform, patterns of successful interaction can be identified and repeated. Erroneous patterns can be identified and eliminated.

Granting that such a triadic practice is a real possibility, what about triadic relations in terms of the bisexuality of our species? As of this writing, I do not know if the archetype given and the practice intended simply enable us to rebuild kinship systems, or to configure a community of lovers, or both. What follows is an initiate, partial, and rather random discussion of some of the issues involved. In considering the sexual dyad, there are only four cases of triadic combination possible: FFF, MMM, FFM, MMF. In each case, the patterns of interrelationship will necessarily be different. It is possible, though beyond the scope of this writing, to gather and organize kinship information in terms of instances of these four cases. For example: FFF; grandmother, mother, daughter: MMM; father, father's brother, and father's son: FFM; mother, sister (daughter), brother(son): MMF; father,

son, mother. Using this approach, it would be possible to make a complete list of the triadic relationships in a kinship system, understand the overlapping triads, and make use of video to develop a self-corrective practice appropriate to each instance. It is possible to expand the basic circuit to eight or ten unambiguous positions and this might allow for a clear understanding of situations that involve more than three people. However, a minimum of twelve positions would be required for six people to engage in coordinated, resonant oscillation.

To configure a community of lovers would not be easy. The kinship system precludes inspinning the genetic code through a combination of monogamy and the incest taboo. For a community of lovers to develop, some alternate means of precluding genetic inspin would be necessary. What do I mean by genetic inspin? If we grant that anyone conceived, simply by the fact of conception, has a firstness, a unique determination which begins in a particular act of meeting by two particular people, then we can say that incest results in people with reduplicative firstness. This reduplicative firstness makes it impossible to include that person in a consistent pattern of relationships. Relationships are a matter of difference. If the firstness of two parties are fused, the differentiation necessary to relationship becomes exceedingly difficult, if not impossible. If a father rapes his daughter and the daughter has a girl child, then the girl child's firstness, the event of her conception, is degenerate in the sense that her mother already embodies a firstness partly determined by the dual father. The difference between mother and daughter can never be secure. There is a fusion of firstness.

Of the four cases, only FFM and MMF are capable of conceiving a child. In the case of FFM there would be no confusion as to who the pair determining the firstness of the child would be. It is only in the case of MMF that the conception of a child would cause confusion as to who fathered the child. Moreover, the way our bisexuality is set up, one of the two males is superfluous in terms of nature's design for procreation. Another difficulty with this configuration is that the woman is without another woman to exchange mother

roles with in a way that might sensibly transform mother-child intimacy in infancy.

Some of these difficulties conceivably could be resolved in a community of lovers by reserving child-bearing to the MFF triads. Since any one person could take part in three triads, no one would be formally denied the possibility of parenthood. In this way, an accurate record of firstness could be kept and thereby preclude inspinning the genetic code by disallowing intercourse that tended to reduplicate firstness. Another interesting facet is that under such an arrangement with recombining triads, a community of only first-born children would be possible.

As opposed to some traditional kinship arrangements where women are exchanged by men in order to bond the tribes, a society operating on the triadic paradigm could not engage in the exchange of women. Each person, regardless of sex, would have to enter into the triadic combination freely. This could be done through a shift of firstness, a videotape in which a person embedded his or her own uniqueness. Red would give a tape of Red to Blue, Blue would give a tape of Red and a tape of Blue to Yellow. Yellow would give a tape of Blue and a tape of Yellow to Red, Red would give a tape of Yellow to Blue. A returning of the gifts in the inverse pattern would mean the dissolving of that triad. The bonding would have to be done with the understanding that if one person leaves, all will leave. Such an understanding would help prevent coalitions of two against one.

I hope from what I have said that the reader will realize that configuring ongoing triadic relations is not something to attempt lightly. Those who simply count to three and jump in bed will have difficulty sharing the toilet in the morning. The probable rate of failure is high. It is highly unlikely to succeed in the case where a couple adds another in the guise of triadic talk. The person added, the transient, in all probability, will be used to reinforce the original dyad. It is also difficult to see how such a process can be grafted onto the existing nexus of social relations. It seems it would have to take root in its own terms. In any event what may be accomplishable, given video recording, and a clear theoretical approach, is to disprove that

a triadic configuration of lovers is ever a stable possibility and lay to rest the destruction that accompanies illusion.

There are times when I think triadic practice may be an instance in evolution of Rommer's Rule. This rule states that the initial effect of an innovative practice is to allow the conservation of the traditional pattern under changed circumstances. If this is the case then initially the practice described would be used to rebuild kinship systems and only after a few generations would communities of lovers configure. The difficulty with this is that we may reach critical thresholds of irreversible ecological destruction before Rommer's Rule has a chance to play itself out. This being so, putting old wine in new wineskins may be unwise. It must be admitted that modes of life bound up in traditional family arrangements have simply not provided the majority of people with the basis to care about life enough to behave in accord with life. In a community of lovers, I do not think this would be the case. Rather than a random pattern of falling in and out of love and being captured by the hidden kinship system or suffering the isolation of lack of kin, it may be possible to maintain a steady state of love without falling. Members would organize interdependently to maintain a mutual caring that would preclude the bitterness in some out of which comes an insistence on breaking the limits for everybody. Willy nilly, on a large scale, it seems we are rapidly backing into a situation in which each is entirely dependent on what others do, if in no other way than through the proliferation of nuclear devices. The conscious relationships of care I am talking about are such that the care would not be operative unless each party became entirely dependent on what the others did in a positive sense. Looking at the history of how men and women have managed to hurt other men and women, it would be insane to approach a possibility that relies on interdependence with anything but extreme caution.

Given videotape, given Kleinform and given a triadic practice, it seems possible to develop a system of information transmission based on a shared perception of environmental realities. In rough outline, the way this could be done is as follows: One party would do a tape of an environmental phe-

nomenon from a position of firstness, that is, without regard for the video perception of the other parties involved. A second party would do a tape of the same phenomenon from a position of secondness, reacting to the first tape. A third party screens both tapes and does a tape and an edit that attempts to correlate all three perceptions. The three parties shift positions in regard to different phenomena.

The most convenient classification system to begin with as a search pattern seems to be an adaptation of that provided by Aristotle: non-living phenomena, living plant, animal, man. Tapes would be done of earth, air, water, three plants characteristic of the region, three animals in the area, and man considered in terms of three different technologies. This yields a minimum of twelve phenomena, one to be scanned in a shared way during each of twelve phases of the moon. Storage of the tape would be according to the relative positions of the sun/earth/moon. The intent that informs this search pattern is to find the chreods, the structures that describe and support the morphogenetic field of which our life is part.

I can give a modest indication of the sort of "corpus" of chreods that can be built up in terms of a current video study I am doing of a waterfall. So far I have been able to tentatively identify the following chreods: bubbles-foam, drops, sheets (stretching between edges, bent over edges), folds in sheets, water channeling through rock, water poured from rock, poured water capturing drops, rushing water split by rock, rushing water fantailing over impediment, water splashing on water, water splashing on rock, rushing water curled back on itself, raindrops on water.

Similar studies of fire and other phenomena, such as traffic flow, need follow. In the Kleinform, my scanning of the waterfall would be considered and corrected by two others to increase the reliability and organization on tape of the information. Anyone living in the region could check the tape against the waterfall itself.

The notion of chreods has been generalized by Thom (1975). As of this writing, I have only a rudimentary understanding of his work, but it seems his theory of models, based

on observables, would prove strong enough to inform the shared perceptual system outlined here.

Given a system of information transmission based on perception of environmental realities, it is possible to take an approach to the realm of the sacred different from that put forth by Roy Rappaport. Rappaport's approach is based on impressive fieldwork in New Guinea and his arguments are balanced and rooted in a well-developed understanding of cybernetic theory. Here I only want to mention aspects of his approach that relate directly to what I am advancing and to indicate a difference.

Rappaport uses the term "sacred" to refer to "the quality of unquestionable truthfulness imputed by the faithful to accept the transmission of unverifiable propositions" (Rappaport 1971: 29). According to Rappaport, the preparedness of the faithful to accept the transmission of unverifiable propositions as true is grounded in the early experience of the mother as "numinous." Through the ritual of recurring interaction with the mother, the pre-verbal infant learns to trust. In this state of trust, the child is taught symbolic communication, language. In ritual interaction, the signal is intrinsic to the referent, the soothing touch of the mother is intrinsic to her presence. In symbolic communication like language, the reference can be absent and it is possible to willfully falsify information. The mother can say to the child from another room, "I want to be with you, but cannot," when she could but doesn't want to.

Rappaport sees religious ritual as recreating for the participants the non-discursive, unfalsifiable experience of the numinous, which predisposes them to receive without question statements about an apparently eternal meta-order. Rappaport calls such statements ultimate sacred propositions and describes how the numinous relationship with the mother is transformed into support for religious truths. "The subjective affective validity of the numinous is transformed into what is taken to be objective discursive truth of the sacred proposition." Rappaport asserts, "the structure of mutual validation or support proposed here approaches the circular need not to trouble us because it does not trouble the faithful" (Rappaport 1975: 175-176).

Biologist C.H. Waddington, whom Rappaport draws from in his analysis of the transition from pre-verbal to verbal, was himself troubled by the way the faithful depended on language. Waddington saw the non-discursive realm as exemplified by the child whose perceptual system had not yet been intruded upon by language. At some point, an authority figure, usually a parent, will start telling the child, "No, don't touch, the oven is hot." In this way, the developing integrity of the child's perceptual system is stunted, numbed, and his behavior is linked up with the verbal commands of others. The child thus joins a species that requires authority over its members in order to transmit symbolic information. For language to be an effective transmitter of information, someone needs to be telling someone else what to do. When the contradictions of this process, the double binding of it all becomes too much, the faithful can retreat to those propositions that everyone believes without question. People are forced to stay within the tautology of the sort of symbolic language structure that numbed their perceptual system in the first place. Language is used to reinforce authority for the sake of authority. In the monastery, it was called "blind obedience." To repeat the quip I quoted earlier, "When you look out the porthole to see where we're going, they accuse you of rocking the boat."

As a way to break this tautological power of language, Waddington suggests it may be possible to develop perceptual information transmission systems based on environmental realities and free from intraorganismic authority structures in which one human mammal tells another what to do (Waddington: 1970). A formal design for such a system is what I am putting forth here. How it would relate to the other two systems of communication that the species now uses, genetic and symbolic, is difficult to say and beyond the scope of this writing. However, I do think such a system would relieve us of the burden of believing in unverifiable propositions. Instead, the sacred would be understood to be the relationships that obtain in a boundable infinity that includes both the firstness of the participants and the chreods of the morphogenetic field that supports life. Participants could

verify the "sacred" chreods with their own perceptual system. The Kleinform in which these chreods would be embedded, the figure in which behavior would be regulated, has a transparent logical necessity. Its logical necessity is complete in a fuller sense than the word is normally meant in cybernetic discourse. No part of the Kleinform circuit is severed from any other part. The "explanation" of the circuit is given completely in terms of the circuit itself. It need not be mapped onto anything else to be fully intelligible. Each part is explained unambiguously by the other parts. The difference between the parts is positional and the only explanation required is positional. There is only one part contained by two other parts; there is only one part that is contained and contains; there is only one part that contains two other parts. Similarly, the parts uncontained are positioned unambiguously.

The validity of the system I am putting forth is not, then, a function of belief in any propositions wielded by some hierarchy. Its validity rests on positional intelligence looped through perception and behavior, regulated and shared through an unambiguous figure. The system would allow us to deal with our current ecological crisis in terms of a heterarchic system of shared perception rather than through blind faith in a set of "ultimate propositions" that we know, since Gödel, can in no way be ultimate.

[Author's note: "Video as Evolutionary Tool" was a seminal essay for me, although it was unpublished until now. Its seminal character is evident in how often I reuse parts of it in subsequent texts.]

The Development of the Relational Circuit (Graphics)

This section is a graphic depiction of the development of the relational circuit with explanatory captions. The relational circuit began with the experience of seeing myself on video and using a Möbius strip to model that experience. The Möbius strip model led to using the Klein bottle as a model and to the original Kleinforms shown on the following pages. The Relational Circuit is a six-part Kleinform that satisfies the cybernetic criteria for a circuit. The graphic figures brought together in this section are referred to in different texts throughout this book.

Fig. 1. Mirror image reversal. If you attempt to shake hands with yourself in a mirror by presenting your right hand to the mirror, the mirror will return a left hand and your simulated handshake will not work. This reversal of direction can be diagrammed with arrows in a two-sided polygon called a lune.

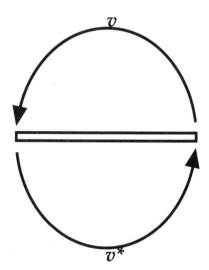

Fig. 2. Live video feedback. Set a video camera on top of a live monitor pointing in the same direction as the monitor so that you can see your hand in the monitor. If you attempt to shake hands with yourself by offering your right hand to the camera, the monitor will return a right hand and your simulated handshake will work. This maintenance of right-handedness by the camera/monitor can be diagrammed with arrows in a two-sided polygon, or lune.

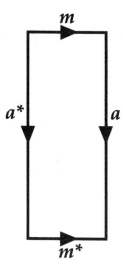

Fig. 3. Expanding the mirror lune to a rectangle. The two-sided mirror lune (m, m*) can be expanded to four sides by introducing two new sides (a, a*) that are opposite to each other with opposite orientations.

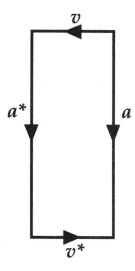

Fig. 4. Expanding the video lune to a rectangle. The two-sided video lune (v, v*) can be expanded to four sides by introducing two new sides (a, a*) that are opposite to each other with opposite orientations.

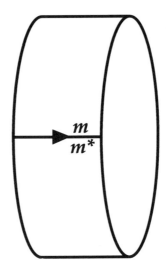

Fig. 5. Building a loop from a four-sided mirror rectangle. This mirror rectangle can be used to produce a loop by placing one of the two original arrow heads on top of the other.

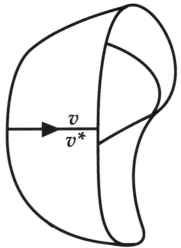

Fig. 6. Building a Möbius strip from the video rectangle. The video rectangle can be used to produce a Möbius strip by placing one of the two original arrow heads on top of the other. Another way of saying this is that if you give a strip of paper a half twist and join its ends you produce a surface with no inside or outside called a Möbius strip. The Möbius strip can model the return of the right hand by a camera/monitor. Rather than reverse the extended right hand as a mirror does, the camera/monitor 'twists' the right hand along the Möbius strip and returns it with the same right handed orientation.

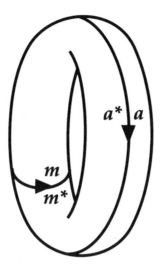

Fig. 7. Building a torus from a loop. A torus can be built from a loop by joining the opposite sides so that the arrow heads coincide.

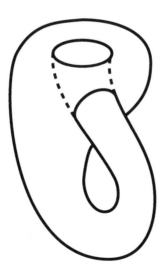

Fig. 8. Building a Klein bottle from a Möbius strip. A Klein bottle can be built from a Möbius strip by joining the 'opposite' edges so that the arrow heads coincide. The half twist in the Möbius strip creates a puncture in the side of the Klein bottle.

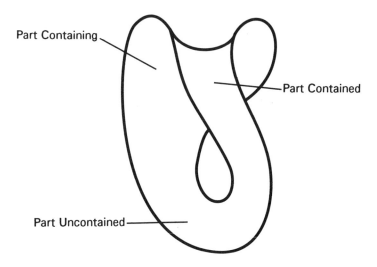

Fig. 9. A cross section of a Klein bottle with its three parts labeled: part contained, part containing, and part uncontained. The three part Klein bottle can be expanded into a series of open Kleinforms some of which are depicted in figures 10-15.

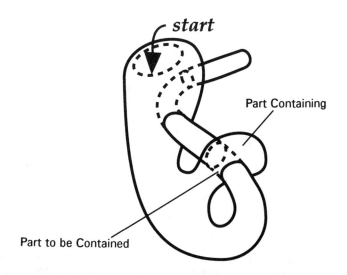

Fig. 10. An open Kleinform in which a part containing anticipates a part to be contained.

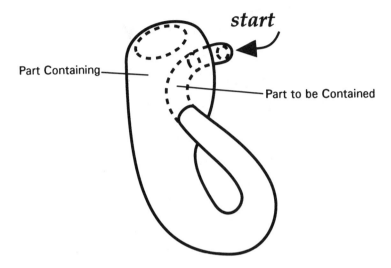

Fig. 11. An open Kleinform in which a part to be contained anticipates the containing.

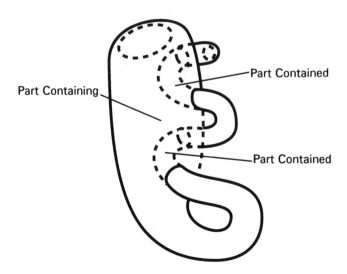

Fig. 12. An open Kleinform in which there are two parts contained.

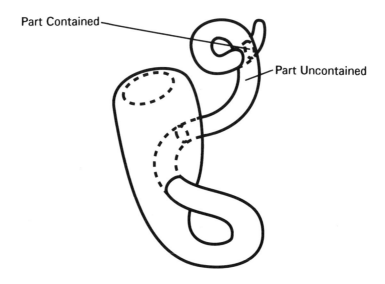

Fig. 13. An open Kleinform in which a part uncontained becomes a part containing.

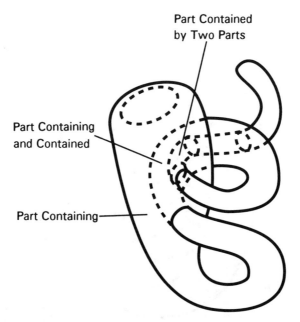

Fig. 14. An open Kleinform in which there is a part containing a part that contains another part.

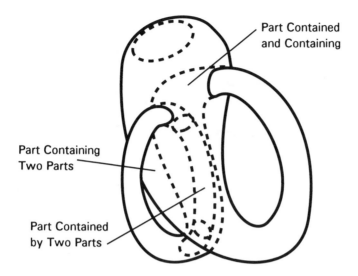

Part Contained
and Containing

Part Containing
Two Parts

Part Contained
by Two Parts

Fig. 15. A second type of open Kleinform in which there is a part containing a part that contains another part.

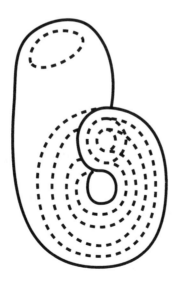

Fig. 16. Inspin. Part containing continues containing itself *ad infinitum*. The part uncontained is omitted and inspin results. This is a kind of pathological Kleinform.

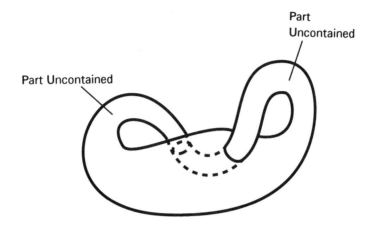

Fig. 17. A four-part closed Kleinform can be built in which there are two parts uncontained, one on the right and the other on the left.

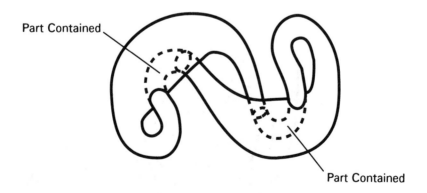

Fig. 18. It is also possible to build a closed Kleinform with the two parts contained but not by each other.

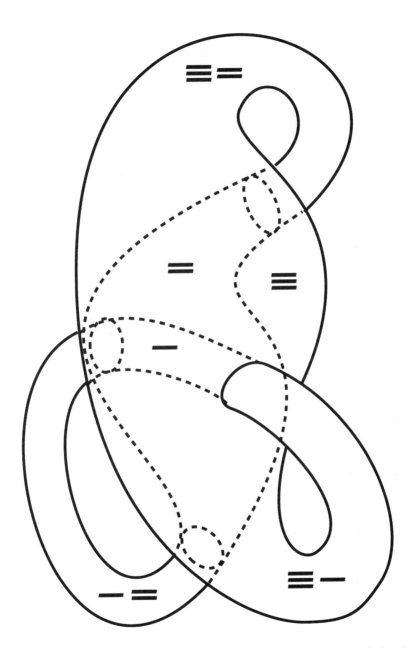

Fig. 19. The Relational Circuit (a six-part closed Kleinform) with its six unambiguous positions labeled. There is a position of firstness (−), a position of secondness (=), and a position of thirdness (≡). In addition, there are three in-between positions; (−=), (=≡), (≡−). The relational circuit is the core of the Earthscore Notational System presented in the final essay of this book.

Threeing

What is Threeing?
Threeing is a way of being with two others.

How does it work?

Not unlike T'ai Chi or Yoga. T'ai Chi and Yoga balance the well being of one with a system of changing postures. Threeing balances being three with a system of changing positions. In threeing you are never forced to choose between two other people. You choose different positions to maintain a balanced relationship among three. Threeing is a relational practice.

Why is Threeing based on changing positions?

Being three begins with being born. Child. Mother. Father. You balance your relation to your mother and father from one unchanging position, the position of the child. Threeing gives you six possible positions. You change your relationship when you change your position.

Relationships can be balanced the way a painter balances color. Relationships can be "composed" in movement, gesture, sound and stillness. Threeing is an art of relating.

Threeing can also be taken as a cooperative game and approached in a spirit of play. Threeing can be taken seriously and approached as a ritual of relationships. In addition, there are ways a group can use Threeing to organize work and learning which are too complex to specify here.

Can Threeing work with four people?

No. You need multiples of three to do threeing. Six is a good set to work with. With six one triad can monitor the

other triad and feedback supporting observations. Moreover, with six there are twenty different triadic combinations, as outlined below.

1 2 3	A B C	1 A C	2 3 B
1 2 A	3 B C	1 B C	2 3 A
1 2 B	3 A C	2 A B	1 3 C
1 2 C	3 A B	2 A C	1 3 B
1 A B	2 3 C	2 B C	1 3 A

1. Threeing --- Instructions

Threeing is performed by three people, each represented in the instructions by a different token. The tokens are: a circle, a pentagon and a triangle. Threeing takes place on a relational circuit outlined on the floor that has six positions. The smallest bold bar within the circuit is the position of firstness, the middle bar is the position of secondness and the longest bar is the position of thirdness. These positions have three inbetween positions indicated by the outsides of the circuit. The thin lines indicate the continuous path connecting the positions. Performers must follow the continuous path in changing positions. Only one performer is allowed in any position at any time. Threeing can be performed either with a seven foot square or a circle with an eight foot diameter.

2. THREEING...Choosing a figure.

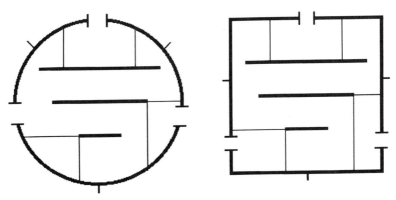

3. Beginning....

Each performer,
stands astride an
entrance marker.

When all three are
ready, they nod to
each other and enter
the circuit.

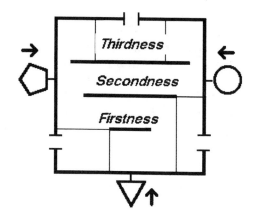

4. Face to Face

Any performer can
start moving back
and forth, facing
each of the other
performers in turn.

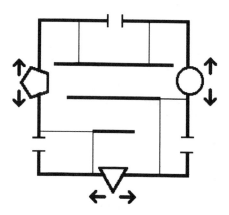

5. Face to Face

Once a performer
starts oscillating, the
other performers
move up to face the
performer who is
going back and forth.

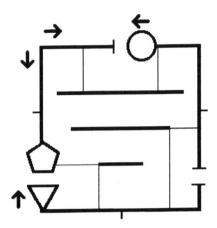

6. Face to Face

*Face to face is like
the game of monkey
in the middle without
the ball.*

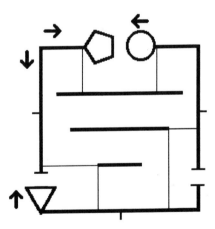

7. Face to Face

While facing the
oscillator, another
performer can turn
away from the
oscillator, and
become, "the monkey
in the middle", the
performer doing the
oscillating.

8. Face to Face

Face to face
continues until a
performer who is
close to the shortest
bar chooses to follow
the thin line to the
short bar.

9. Front and Back

The performer on the shortest bar faces away from the other two bars. The other two performers follow the thin lines to their respective bars and face in the same direction.

10. Front and Back

When the performer on the shortest bar is finished standing in firstness, all performers return to a part of the square that is different than the part they were on before going to the bars.

11. Face to Face Again

Performers can now
oscillate in Face to
Face interaction
again, until a
performer close to
the shortest bar
chooses to go there
and do Front to Back
again.

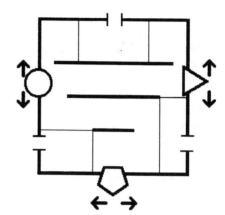

12. Flying and Holding

Performers repeat
Face to Face and
Front and Back. While
Face to Face they do
a slow flying motion
with their arms. While
Front to Back they
hold the performer in
front of them.

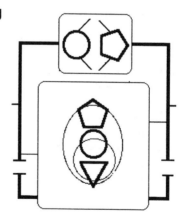

13. Soundings

In Soundings, the
patterns of Face to
Face and Front to
Back are repeated,
with or without Flying
and Holding.
When face to face,
sounds are made that
express whatever
feelings come up.

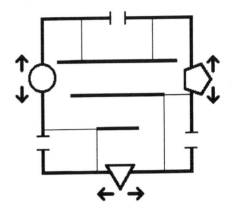

14. Soundings

When Sounding in
Front and Back,
performers make
sounds and
movements that
interpret their relative
positions of firstness,
secondess and
thirdness.

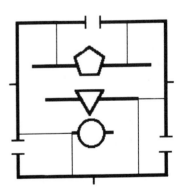

15. Completion

To signal completion,
performers go to an
entrance point, nod to
each other that
nobody wants to do
more and step out.
A minimum round of
Threeing provides a
turn in firstness for
each performer.

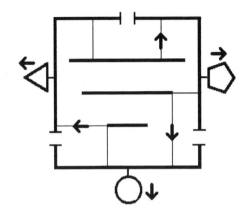

16. Advanced Threeing

The same rules as
above apply with one
difference. The
movement from the
square to the bars
and back can be
intiated by any
performer, not just
the one going and
coming in firstness.

Earthscore as Public Work

You must become an ignorant man again
And see the sun again with an ignorant eye
And see it clearly in the idea of it.
— Wallace Stevens

The Idea of It

Earthscore is an abstract description of a possibility. To see clearly the idea of it, one must understand two related notions: chreod and Kleinform.

The notion of a chreod was arrived at by the biologist, C. H. Waddington, to describe embryological development. "Chreod" comes from two Greek words *chre* meaning "it is necessary" and *ode* meaning "path" or "way." The term was coined to describe a developmental pathway in embryology that is equilibrated in the sense that the system will tend to return to this particular pathway after disturbance. The term was generalized mathematically in catastrophe theory to mean the support of a morphogenetic field. Any process, including those involving discontinuous or abrupt change, gives rise to a fixed morphology, definable once and for all by a model of that process that reveals its structural stability, i.e., by a chreod.

Earthscore assumes that the morphogenetic fields, of which our lives are part, can be described as chreods, the forms of which are best understood by catastrophe theory. Since catastrophe theory is based on observables, it is assumed that these chreods can be embedded in any instrument which records observations, such as videotape. To insure reliability in the video search for chreods, this activity would be organized according to a self-corrective pattern of tape production. This pattern is based on the non-orientable, positional intelligence of the Kleinform, a circuit proper to video. (See Fig. 19, p. 103.)

The Kleinform provides a position of firstness (–) from which one scans without regard for the video perceptions of others; a position of secondness (=) from which one scans in reaction to tape done in firstness; and a position of thirdness (≡) from which one scans in such a way as to correlate the perceptions that occurred in firstness and secondness. Three parties can take turns in the different positions and so coordinate their video observations systematically.

As the practice of video scanning in a given region continues, two things would develop. First, the accumulation of chreods embedded on tape would allow for intelligent consideration of the actual syntax of restraints inherent in the ecosystem of that region. Secondly, human practices that transgress these restraints would be identified. A large share of such transgressive practices are expected to derive from patterns of transitive human interaction, that is human interaction that does not resolve itself in the interaction itself, but spills over into environmental destruction.

To some extent, transgressive practices could be reduced by presenting edits of the accumulated tape in a selective way. Moreover, since the Kleinform practice of Threeing is intransitive, i.e., any action initiated is played out among the three parties without environmental spill-over, this practice would serve as a model whereby transgressive practices might be reshaped. Furthermore, videotape feedback and documentation could be used to discover and support practices of healthy interaction among people and with the environment.

Feasibility as Public Work

The work tradition in the West can be traced back through the Protestant ethic to monastic orders that arose as the Roman Empire declined. While the orders did do tasks formerly done by slaves, such as road repair, their major work was the *Opus Dei*. The *Opus Dei* was the work of God; the public work of worship. This was liturgy, an activity removed from the arena of politics and profitmaking, done to insure man's proper participation in the economy of grace. Out of these work patterns, medieval cathedrals were built.

Presently, as the global monoculture of industrialization declines in concert with the dying Western tradition of monotheism, job assignments within its structure become increasingly meaningless. What Earthscore proposes is a public work project that would coincide with the larger meaningful process of planetary reinhabitation. The project could be undertaken in any region of the biosphere. As opposed to the language-based liturgy of the monastic orders, where intelligence is propositional and myth-generating, Earthscore is based on positional intelligence and shared observation and could be done by people in the Hudson Valley. Since the Kleinform is one continuum with many possible positions, there is no necessity to depart from or divide up the one in order to consider the many facets of the ecosystem. This form allows for the development of a coherent and sharable video perception of patterns of restraint indigenous to varied regions of the biosphere. Concurrently, this intelligence, which is based on positional relations, allows for the development of self-corrective practices that would respect those processes which support the life of planet Earth.

What follows is an outline of activities for nine people over three years. By relating to each other using the positions provided in the Kleinform, they can learn to relate better to their actual position or place on the planet. Their positional intelligence would ground their video production for a three-year period which would yield an information base that could support regional reinhabitation. This information base would be the result of work done by the nine people organized in groups of three over thirty-nine lunar cycles in three modes of videotape production. The lunar cycles mark time in a way that humans cannot manipulate. Accepting such temporal markers will help insure that the video production is not manipulated for purely human ends.

Twelve lunar cycles of every solar year are considered production cycles. The activity of each production cycle is organized in terms of a category in the environment which is to be decoded. The twelve basic categories are earth-plant-animal-technology; air-plant-animal-technology; water-plant-animal technology.

It is important to note that during the thirty-nine lunar cycles every group will be involved in decoding each category in every video mode, that the group's relationship to the video mode follows the recording/editing/presentation cycle, and that no single group moves through a complete video mode of production in any category. For example, one group might record a particular animal species, another group would produce an edit of those tapes and the third group would show the edited tape to a local high school class in biology.

These characteristics of the process, as it moves through time, reveal considerations that have been mentioned above. A group moves from one video mode to another every three lunar cycles. It passes through one decoding category every lunar cycle. Cohesion is implanted by giving groups enough time in one video mode to work through the informational possibilities of that mode. Diversity is ensured by having the groups engage in actions to decode three categories in the same mode.

Implicit in this production process is the acknowledgement that the information on the tape (in any video mode) is shared and used by everyone within the organization. The quality of all the tapes produced and presented rests on communication through and about the shared perception of the information on the tape. Supporting this communications process are the formalities of the overall process which result in a working organization and structure that allows for ongoing self-correction, in and between groups.

It is fair to assume, then, that a group of trained people with an "idea" (a method of ecological decoding and an organization that is configured to undertake such a program) could begin to uncover new perceptions of the environment that support the ecological reinhabitation of a region.

PART THREE: BIOREGIONS, 1977-1980

In 1973, at a video conference in Vancouver, I had met Peter Berg. Peter had been traveling around the continent with his family and a video portapack for two years, nurturing a visionary movement that would become known as bioregionalism. Bioregionalism is a movement that cultivates strategies for sustainable living in the context of local ecologies. After my failed effort in 1976 to start Earthscore as a Public Work Project in the Hudson Valley, I went to California, reconnected with Peter, and got involved with a bioregional group called The Frisco Bay Mussel Group. In effect, I laid aside my video camera and became a bioregional activist. Apart from producing a few documentary tapes, teaching a workshop and generating some proposals, I would not work with video again in any serious way until 1982. This was partly because after "Video Variations on Holy Week" and the folding of Earthscore, I needed a break from my own work. I feared that maybe I had done so much video during the Earthscore period that it was distorting my thinking and addicting me in a way I did not understand. I wanted to reactivate my own perceptual system without video.

When I arrived in California, I tried to connect cybernetic theory with the goals of bioregionalism as a theoretical contribution to this nascent movement. I wrote an unpublished essay during this time called "Positional Intelligence Planetary Culture" which has since been lost. As I remember, my attempt to connect cybernetics and bioregionalism in that paper was unsuccessful. Later, with the help of the Gaia hypothesis, I would be able to make the connection between cybernetics and bioregionalism (pp. 262ff.). But before I could say anything theoretically useful about bioregionalism, I had

to do some political work in the movement. The Frisco Bay Mussel Group gave me that opportunity.

In October of 1977, the Group sponsored a full page ad in the *San Francisco Chronicle* headlined "Stop the Peripheral Canal." A map with accompanying text explained how the canal being proposed in the California legislature would skirt the periphery of the delta that feeds the estuary bay of San Francisco, shunting enormous amounts of water from the Sierra Watershed south toward Los Angeles.

In California, water is a critical political issue. There is a huge imbalance between precipitation patterns and population concentrations. While eighty percent of the population lives in the southern two thirds of the state, seventy percent of the precipitation occurs in the northern third. The rich farmlands of the south depend on an elaborate irrigation system and, if left alone, southern California would be a desert. Los Angeles has an average yearly rainfall of only fifteen inches. The large and growing population in this city depends on a complex system of dams, reservoirs and aqueducts to import its water.

In 1977, Southern California imported over sixty percent of its water from the north. Half of the rest came from the Colorado river basin. The proposed peripheral canal—forty-three miles long and equivalent in width to a ten lane highway—was to be the next major step in an overall government water plan that regarded the water in the north as surplus available for export. The canal would have had the capacity to carry off the entire flow of the Sacramento River, enough water to cover twenty-six million acres of land at a depth of one foot.

In California, feelings about water run high. During a two year drought while I was there, people living in the north of the state were forced to cut back their normal water usage as much as fifty percent while they watched television clips of people in the south who showed no concern, washing their cars and dousing their lawns. One native of San Francisco, a filmmaker who grew up fishing the bay with his father, viewed the proposed canal as totally disastrous to the salt water/fresh water balance of the estuary. Without batting an eye, he told

me, "This peripheral canal business could turn me into a terrorist."

A comprehensive strategy for protecting the environment and resolving the water dilemma has not developed in California to this day. Organizations, such as the Sierra Club, lobby to get specific results they can show their members. Given the mood and composition of the legislature, their efforts were, and still are, characterized by trade-offs; in exchange for the protection of a certain marsh the club promises not to oppose the building of a certain dam. Given this context of compromise and trade-offs, the peripheral canal bill looked like it would pass quietly through the legislature. No group was speaking for the ecological system of San Francisco Bay as a whole until the Frisco Bay Mussel Group stepped forward with their full page ad. The ad generated enough public opposition to defeat the bill in the 1978 legislature. The group's opposition to the canal sprang largely from the logic of the bioregional vision that bubbled up in the minds of Peter Berg and his associates, Judy Goldhaft, Gary Snyder, Ray Dassman, Freeman House, David Simpson, Jane Lapier, and others. This victory was possible because the Frisco Bay Mussel Group shared the bioregional vision of a watershed as a whole ecosystem. They would not trade off one part of this ecosystem for another. For me, it was a wonderful feeling to be part of a victory for an ecological system.

The bioregional vision is a potent combination of scientific data about ecological systems and extant folklore. Data about the salmon-run on the North Pacific Rim is fused with native tribal understanding of totem salmon. People are understood not in terms of their nation-state identities, but as people of the coast, of the mountains, of the plains, or as island people. City/country dichotomies melt into watershed consciousness. As opposed to a human monospecies perspective in which all other species are seen to exist in order to support human life, a multispecies perspective of equal participation in planet life has been developed. Emphasis is placed on rediscovering and inventing habits of living that accord with the biogeographic "carrying capacity" of particular places. Global monoculture is

opposed by a strategy of living-in-place, bioregion by bioregion.

Living-in-place involves becoming native to a place by developing awareness of the particular ecological relationships that operate within and around it. Reinhabitation means learning to live in place in an area that has been disrupted and injured through past exploitation. It means developing strategies for sustaining cultures of place. The three R's of bioregionalism are: Resistance to further disruption of natural systems, Restoration of ecosystems, and Reinhabitation of place in long-term, sustainable ways.

After I had absorbed an understanding of bioregionalism through working for over a year with the Frisco Bay Mussel Group, I returned, in 1979 to New Jersey, to the lake region of my boyhood. This move was made partly for personal reasons and partly with the intention of initiating a reinhabitory movement in New Jersey. My strategy of reinhabitation was to start a bioregional magazine called *Talking Wood*. I am proud to say it was the first such magazine in the Eastern Woodlands. With the helpful expertise of my brother Ken, I established a non-profit organization and got Labor Department money through the Comprehensive Employment and Training Act (CETA) and hired twelve people to produce the magazine. From my brother Jim's writing group, I enlisted a core of writers. We produced four quarterly issues — over 350 pages — and distributed over 15,000 copies.

I had a great time reimagining the place of my boyhood in bioregional terms. At the time of *Talking Wood's* inception, I was reading Michel Foucault's book, *The Archeology of Knowledge*. His understanding of the internal coherence of discourse informed my transplant of the bioregional discourse from California to New Jersey. I also used Peirce's categories of firstness, secondness and thirdness to organize the contents of the magazine in each of the three selections from *Talking Wood* reprinted here. The first selection consists of five editorial statements that appeared in the magazine. In these mission statements, I explain Peirce's categories by example without resorting to philosophic terminology. The second selection is "Relationships," an article I structured in terms of firstness —

native tribal relationships; secondness—relationships between citizens in an industrial state; and thirdness—relationships among bioregional reinhabitants. "Relationships" articulates the practical value of Threeing in the context of reinhabitation. It is a mature discussion of the relational practice for three people first presented as part of the "Video Variations on Holy Week" show.

As the editor of *Talking Wood*, I also used Peirce's categories to structure the Watershed Watch, a public activity designed to connect people with various parts of the Passaic River Watershed. The texts republished here as the third selection were originally published as part of a large folded poster with maps and photos that could be pulled out of each magazine. In "Watershed Watch," firstness, secondness, and thirdness correspond to feelings, facts, and long-term ecological patterns understood while out observing the watershed. The watershed is a whole ecosystem in bioregional terms and I wanted people to experience this system as directly as possible. I wanted their bioregional "authority" to be based on shared observations of the bioregion. In the Watershed Watch I organized for the City of Paterson, I connected the observation of the watershed to a program for making Paterson a "Green City". The Watershed Watch arose out of my preoccupation with perception based on my work with video, but does not depend on the specific medium of video as a mode of perception. To indicate the connection between the Watershed Watch and video, I include a brief description of a workshop I did with videographers at the Great Falls in Paterson.

I thought *Talking Wood* was a great success as a feat of the imagination and as work experience for many of the people involved. We were effective on two counts. We were trusted because we were locals, some of us were sons and daughters of locals. As trusted locals, we were given information that led to two important news stories. The first detailed how Ford Motor Company had been dumping toxic waste into an abandoned mine shaft three hundred yards from the largest reservoir in North Jersey. After we broke the story, this site was immediately put on the Federal Superfund cleanup list. The second story was about how major oil companies, such as Shell

and Exxon, had been surreptitiously test drilling for uranium in the Ramapo mountains of North Jersey, which they found. By the time we uncovered this story, the Labor Department had cut off our funding. But Jeff Rothfeder, our investigative reporter, got the story published in the local papers. The result was an astonishing example of the political power of people united to resist the destruction of their local ecologies.

Politics in West Milford, the township where the drilling took place, are conservative. It is the only township in Jersey to have voted for George Wallace when he ran for President. Yet over three hundred people attended a meeting at the high school gym about the uranium mining. At that meeting, an Exxon official, dressed in a worker's jump suit, admitted the company had been secretly drilling and that a vein of uranium richer than that in the southwest had been found. He said he knew there had been "outside agitators" in the town stirring up trouble but that as good Americans they knew that uranium was needed for defense and was sure the community would support the company. A woman jumped up from her seat and said, "Listen, I haven't been talking to anybody but my neighbors. We don't want our kids drinking water polluted by uranium tailings. Get your goddamn company out of here!" The audience hooted the oil company representative out of the gym. Within six months, citizen efforts had pushed a ban on uranium mining through the New Jersey State Legislature.

While working on *Talking Wood*, I made an effort to start a television channel dedicated to the environment. "Channel W: Your Wire to the Watershed," included in this section, is a proposal I made to a local cable television station in Nutley, New Jersey. The cable company rejected the proposal and when *Talking Wood* was shut down, I went to Gloucester, Massachusetts for some rest. During the next six months, I developed "Video Score for the Coast of Cape Ann," published here. I composed the score so that I could produce it as a solo video artist, but I was unable to raise the funds necessary for production. In that score I make use of Charles Peirce's tenfold sign classification in order to interpret, in video, different commonplaces of coastal life such as rocks, boats and buoys.

The last piece in this section is a dialogue with Gregory Bateson, my mentor in cybernetic theory. We explored the philosophical underpinnings of my work with video and the ecology. While not a bioregional piece, this dialogue did take place during the bioregional period and was published in 1980 in the journal *All Area*, edited by Roy Skodnick, a colleague at *Talking Wood*. While in California, I had been able to spend some time with Gregory. As I mentioned in the general introduction, meeting Gregory shortly before my father died had been important in shaping my commitment to work toward an Ecology of Mind. While in California, I was delighted to have further exchange with him. As was Gregory's practice, the dialogue we did took the form of what he called a "metalogue", that is, a dialogue in which the problematics of the subject discussed show up in the verbal exchange itself. The metalogue we did does not achieve the level of reflexivity evident in the metalogues that Gregory published in *Steps to an Ecology of Mind*. Nonetheless, the metalogue itself, the introduction and the postscript help clarify how I developed my logic of relationships in part by challenging the theory of logical types.

It may be useful to the reader to know that in my Catholic imagination, I saw McLuhan as the prophet of the electronic age and Bateson as the pope. Similarly, in the area of ecology, there was a parallel between the prophetic, bioregional voice of Peter Berg and the papal voice of Gregory Bateson. Bateson's adherence to the theory of logical types, which explains things by a hierarchy of classification, made me bristle with memories of the Roman Catholic hierarchy and the vow of obedience I had taken in the monastery. Yet Bateson was brilliant and clear-minded and understood things in a rigorous way I needed to learn. Fortunately, he was also honest. Though he himself was committed to ordering his thought in logical types, he acknowledged the challenge to logical types posed by his friend Warren McCulloch in *Embodiments of Mind*. Through reading McCulloch, I found Peirce. I developed the work Peirce had done with triads into a logic of relationships that differs significantly from Bateson's logic of classification. Our metalogue reflects this difference in approach. Had I

been working from Gregory's logic of classification rather than my Peircian logic of relationships, I don't think I could have imagined the reinhabitation of New Jersey.

Talking Wood

The name *Talking Wood* comes from a story. Nobody's quite sure whether it's fiction or fact, but the story goes that Talking Wood and his friend Standing Bear spent their lives walking these woodlands, visiting every tribal village they could find. During their visit, when the time was right, Standing Bear would carefully unwrap a set of wooden plaques with pictures carved on them. The pictures, or pictograms, were stained with red berry juice and were known as the "red score" or "Walam Olum." While Standing Bear showed the score to the villagers, Talking Wood went into a trance and spoke of the history and migration of the tribes. Everyone paid close attention. They understood that what he was talking about had to do with the continuing survival of the people.

With these maps, photos and words in your hands we are inviting you to take part in telling the story of Talking Wood in a new way. The pictograms are mental pictures of the patterns of life in the Passaic Watershed. We're learning about the system of rivers and lakes carved out by the glacier. About the history of the forest. About how other species of animals make this Watershed their nest. We're learning the native plants.

The talk is starting to take shape. Awkwardly—on many tongues—often with humor—as with any new sense of reality. Rediscovering native names for places: Cupsaw—Preakness—Secaucus. Looking up "aquifer" and "watershed," exploring with caution such words as "resource" and "forest management." Liking the sound of "web of life" and "living in place."

The mood is here to make sense out of the term "reinhabitation." This word brings an understanding that the pictograms and the talk must come together with new practices, new habits. Habits that will insure survival as people.

Editorial Statement

Passaic. The only county in New Jersey that has a native name. Passaic. Peaceful Valley.

Passaic. The River. Over ten thousand winters ago a glacier scraped this valley floor like a snowplow. It left a huge bank of deposits blocking the river's easy southern passage to the Atlantic. So the Passaic turns around, winds its way north through the wetlands and the Watchungs, taking the outflow of the Whippany and the Rockaway rivers. Twisting toward the ocean it takes the flow of the Pompton River, full with the highland waters of the Pequannock, the Wanaque, and the Ramapo. Then the river pours through the gorge at Little Falls still twisting. Sudden downturn. The Great Falls. A full seven subbasins dropping seventy feet. A multitudinous song, once and for all. Easy now, its song well sung, the river moves further north, makes a hairpin turn, takes on brooks with names like Goffle, Molly Ann and Diamond. Seaward now, taking Saddle River to Newark Bay where the waters move with the moon.

The Passaic Watershed. Catchbasin for rains that come chest high each time we go around the sun. The gathering ground for the river system looks like a single cell animal. There is an indentation between the headwaters of the Pequannock and the Ramapo, as if pushed in by the winter storms from the Great Lakes. There is another indentation between the headwaters of the Passaic and Newark Bay, as if the watershed were pushed in by the summer and fall thunderstorms and hurricanes from the tropics. This is no desert. There are no broad grasslands here. Here the biosphere lives in terms of its woodlands. To live in the Passaic Watershed is to live in a falling leaf forest.

This woodland works with the waters. On a hot summer day a mature tree will heave a ton of water into the air. As the sun shifts south and the trees can no longer bear their water burden, they let their leaves go as nutrient and ground cover against cloudbursts. Budding again in the spring, the trees will share the water burden with the river. Each time around

the sun, leafing toward the light, letting the leaves fall. Leafing toward the sun, letting leaves fall.

Over five hundred generations of human beings lived here before Europeans came from across the ocean. We know little of their life in this Watershed. We know they did not destroy the woodlands. Trees would be killed by bark stripping to clear land for planting and sometimes fire would be used. But for the most part natives would wait and take only trees that were standing dead and dry. Free of its water burden, the wood spoke in swift flame to all the warm blooded gathered round. Talk story into the night about life in the sun.

Only twelve generations of new people have been here and there is serious trouble. Deforestation for the iron furnaces of war, deforestation for urban charcoal, thousands of houses built on floodplains, wetlands abused, industries that foul habitats, housing developments that disable the watershed, fossil fuel machines that pollute air and water. The habitual destruction of this woodland watershed is catching up with us. Among people living here there is a growing realization of this stark fact: If we destroy our environment, we destroy ourselves.

In the face of this realization people in this region have been making changes. There are urban areas now green with houseplants. Runners and hikers are suddenly common sights. Outdoor photography, organic gardening, solar energy experimentation, wood burning stoves and interest in local history are all on the increase. Mothers in Bloomfield have been fighting for access to the river for their children. People in the lake regions are fighting sewers and questioning growth. Native Americans in the Ramapos are reclaiming their tradition. Voters in New Jersey said "yes" to two hundred million dollars for the Green Acres Program. Paterson is engaged in a serious program of restoration. The Passaic River Coalition effectively blocked a huge dam project and the Army Corps must now conduct a major study of flood control in full public view. People are paying attention to the current shift in weather patterns and trying to imagine this land in long term biological continuities. There is a concern for finding roots, maintaining kinship systems and learning to

live in place rather than be tossed about by the illusions of an inflating global economy. People are growing in a willingness to take part in the necessities and pleasures of life as they are uniquely presented by this watershed rather than curse this area and look for utopia elsewhere.

We see these changes as part of a process of caring for our life in this land after its disruption and injury, of taking responsibility for the habitat that we hold in common. We call this process reinhabitation. *Talking Wood* is about the rein-habitation of Passaic.

Reinhabiting Passaic starts with a feeling for the combina-tion of factors that constitute the uniqueness of Passaic. The sense that arises at the Great Falls: that Paterson could be restored and learn to live a life resonate with the richness of this watershed. Daydreams that come while watching the river: daydreams of the Atlantic salmon returning to spawn again in the Passaic. Fantasies that come while walking in these woodlands: fantasies that generations to come could walk here among five hundred year old trees as natives once did. This feeling that comes to us when we take the time to talk with old timers who have a sense of this place. We're publishing oral history, remembrances, poetry, geology photos — anything that resonates with the firstness of Passaic.

Secondly, we are interested in particulars. Specifics that tend to undo the quality and feeling possible here. An asbestos dump on the upper Passaic. The cluster of leukemia cases in Rutherford. Paint sludge in the Ringwood Mines. Automobiles and highways that link us to a global monocul-ture indifferent to place. The history of our cities. This brokenhearted life. That divorce. The harshness of the job economy. The nuclear threat. The energy crisis. The brutal facts of living here. That which resists our efforts to be resonant with the life of this place. That which must be strug-gled with. The secondness of our situation.

Thirdly, we are working with generalizations that might enable us to develop different habits, habits in keeping with the long term biological continuities of this region. We have no easy recipe. We have questions and a strategy. Questions like how we can rethink industrialization in terms of appro-

priate technology? What place does Native American tradition
have in the future of this region? What is the maximum
number of diverse species this watershed can carry? How can
we develop the positional intelligence proper to this part of
the planet? The strategy is a relational practice that could
enable us to know this watershed in a new and watchful way.
We want to become fully alive as members of this biotic com-
munity. We want to make peace with the life of this valley.

Section Introduction for Oral History (Firstness)

The young are discouraged about living in this place. A
daughter out West with three young children and a marriage
in trouble will not return to her parents' home in Passaic
because she has trouble breathing here. A twenty-two year old
will come home to Clifton only for brief visits—"Just too many
people live here." A sixteen-year-old in Pompton Lakes
chided by her mother not to eat junk food replies, "What's the
difference? We'll probably all die of cancer anyway." She has
read the high statistics on cancer in Jersey and has heard
predictions of skin cancer for one out of three people in
twenty years because of the weakening ozone layer.

The anthropologist, Gregory Bateson, tells this parable
about people and places. Bateson lived with a tribe in New
Guinea that built their houses on stilts. When they wanted to
crap, they simply pulled a board from the floor and did it.
One day Bateson asked them what they do when the shit piles
up to the floor. "Oh," they said, "We simply go someplace else
and build another house."

In terms of the problems of this Watershed, such a parable
holds tempting advice. And for some of us, probably the
better part of wisdom is to leave. But the degeneration of the
biosphere is not like piling-up shit. It's more like cuts and
bruises on the skin of an apple. Healing is essential if we are
to avoid rotting to the core. The young hardly know this place
well enough to care about healing. The TV and the times
have estranged them from the local landscape. So we asked
some of our grandparent generation, folks with a glint in their
eye, to tell us what they remember about living in this place.

Section Introduction for Energy (Secondness)

Whether it's the waterfall at Paterson or the windfall profits tax now before Congress, money, political power and energy have always been linked. And we, the living, pay. But the price is getting too high. There is a quiet terror that underlies our dependence on the nexus that brings us the non-renewable resources of oil, gas and nuclear power. It's no longer only a matter of polluting rivers and high cancer rates—the specter of a nuclear melt down at Three Mile Island or Indian Point raises the very possibility of evacuation. You can't live in a place wasted by radiation any more than you could live in this watershed if the glacier returned.

In this issue of *Talking Wood* we bring you the first Passaic Watershed Energy Study. What we did in this initial study is simple. We asked this question: how many people could live here without oil, gas and nuclear power. Answer: if by conservation we cut our use almost in half, two thirds of the people here could be supported on water, wind, biomass, wood, solar energy and photovoltaics. If there are breakthroughs in solar technology, it may be possible to provide energy for all inhabitants.

Section Introduction for Reinhabitation (Thirdness)

Energy is one thing, communication another. There is a theory that the extinction of the dinosaur was directly linked to the fact that it took seven minutes for a message to get from its tail to its brain. Not only is it nearly impossible for ordinary folks at the tail end of this huge central government to get a message to the top, but they have to contend with interference from the big guys. At a recent nuclear forum in Wayne a member of the "truth squad" financed by the big utilities was so disruptive that he was asked to leave. Later he was spotted taking down license plate numbers in the parking lot.

To share an understanding and a life with others that live here. It seems such a simple thing. To know this place and live here. Where do you live? In New Jersey. Okay, but if

you think that way you are locked into a mind set that begins with the thirteen original colonies and goes nowhere. Think of living in the Passaic Watershed on a woody spine of Pangaea, the last super continent on planet earth. Think of living in between precambrian rock and an ozone bubble weakened by man's industrialization. We need to know this place in a way it's never been known. That means knowing each other in new ways. With this writing we invite you to consider a way of knowing that has never been tried before. Anywhere. Something new under the sun. It could be tried. Here in the Passaic Watershed.

Relationships

What God had joined together came asunder before my daughter had been around the sun once. She lived with her mother who lived with a painter. I took her often. We played together. When she reached the babbling stage I read to her from *Finnegan's Wake*. She played with the words "...Kyra run past Eve and Adam from swerve of Bay Shore to bend of little beach..."

Once upon a bright fall day at little beach she had me stand outside the gazebo, the little pavilion, "the women's church." While I waited, she went inside and prayed. After her prayer she led me to the parking lot, "the man's church." She put me in the corner, said I had to listen 'cause she was the preacher. I sat against the fence while she strode up and down the parking lot babbling. Out of the babble came the words, "God is Relationship."

"What did you say, Kyra?"

"God is Relationship." And the babble went on.

When the sermon was over and I had supposedly learned my lesson, she took me back to the women's church. On the way, we gathered an imaginary group of children, each carrying a leaf. All went into the women's church to wait for God.

The word "relationship" comes from a Latin verb

fero — I carry
ferre — to carry
tuli — I have carried
latus — to have been carried

The word "difference" comes from the same verb. The verb was used to mean "to bear" or "to carry" a child. Your relatives are those you differentiate yourself from in terms of events of childbearing. Your cousin, your mother's sister's child, is the one who was carried by a woman who was carried by the woman who carried the woman who carried you.

How can we relate? How can we organize the differences between us?

Native-Kinship System

Natives in the Eastern Woodlands organize the differences between themselves in terms of the kinship system. The kinship system works through exchange. A man takes a woman away from a man (her father or brother) in order to have a child. The exchanged woman is available for child-bearing because she is protected by the incest taboo. Brothers cannot have sex with their sisters. Fathers cannot with their daughters. Likewise, mothers cannot have sex with their sons. Nor can close cousins have sex.

A Northern California poet told me he had talked to eight or nine people who had committed acts of incest. None of them felt guilty.

"Yes," I said, "but what would happen if they gave birth to children?"

The movie *Chinatown* involves incest. "My Sister My Daughter. My Sister. My Daughter!" is the confused cry that comes from a father/daughter incestuous act. The differentiation in terms of childbearing becomes impossible, since there is a missing person. Instead of a mother and a sister, there is one person who is both. That leaves two parties, two *relata* — daughter and sister/mother — where there should be three. The confused daughter cannot understand the difference between herself and her sister and herself and her mother because there is no difference between sister/mother. Incest confounds the kinship system by a reduplication of *relata*. "My Sister My Daughter!"

Look at the differences between children, parents and grandparents in a family system that works. Children can bear no children. The mythic story of a girl-child born pregnant is not an account of actuality. In their actual life, children are biologically free to pay attention only to their own sense of life, they do not have to hold in mind offspring that need care. We can say that children are in position of firstness; that is, of freshness, of spontaneity, of being such as they are without regard for any other. Parents are in no such position. They

must react to the needs of their children, resist some of their carefree ebullience, contain their activities. Parents are in a position of secondness.

Grandparents are in a position to contain the interaction between parents and children. Their understanding of both the position of firstness and the position of secondness from experience enables them to balance the interaction between parents and children, to keep it from getting caught up in confusion. There is often a special bond between grandparents and grandchildren. The grandparents, freed of the burden of interaction with the world by the parents, can renew their sense of wonder and share the freshness of life with their grandchildren. The grandparents are in a position of thirdness.

The course of one's natural life is a continuous passage from the child's position of firstness through the parents' position of secondness to the grandparents' position of thirdness. Hopefully, the grandparents' position of thirdness is blessed by healthy contact with loving children. The relational circuit (see Fig. 19, p. 103) gives us a clear understanding of relationships in terms of unambiguous positions. The three positions of firstness, secondness and thirdness are clear and there is but one part uncontained connecting firstness with secondness, one part uncontained connecting secondness with thirdness, and one part uncontained connecting thirdness with firstness. The differentiation obtains not in terms of child carrying but in terms that are wholly positional. A difference in position makes a difference in relation to other positions. We will return to this way of ordering differences.

Tribal societies develop when the kinship system is not confounded by incest, generations work out their relationships, and other factors are favorable. Tribes establish patterns of communications that reinforce their basic social organization. For example, just as childbirth involves the whole being of both mother and child so the healing ceremonies of the false face society in these Eastern Woodlands involves the whole being of both the healer and the healed.

The most striking system of communication developed by natives on this continent that I know of is the pulse drumming of the Southwest. As the musician Tom Ehrlich explains, the

rhythm for their ritual is based on the heartbeat. The raising and dropping of the drumstick is synchronized with the beating hearts of the participants. Night-long full moon rituals with such pulse drumming creates a common understanding that pervades the entire organism of each tribal member.

Communication is the creation of a redundancy pattern. The word "redundancy" comes from *unda*, a Latin word meaning "wave". The image is of waves breaking on the shore again and again. Always happening, each time differently, providing a common referent. So with the pulse drumming. The hearts of the living are always beating, each time differently. The heartbeat supplies a common referent continuing from birth until death. The drumming ritual takes the heartbeat as a figure of regulation for tribal life. It establishes a redundancy pattern that all can share. When I took part in a heartbeat ritual with Tom Ehrlich drumming, the awareness of my heart beating carried for hours after the ceremony.

Invader-Nation State

The invaders from across the ocean were not organized in tribes: they were organized as nation states. England, France, the Netherlands and Spain competed for "The New World." By the time they hit these shores the nation state had a long and complicated history. Its decisive struggle with the kinship system happened in Greece. There was a definitive shift from a matriarchal society in which the ritualized event of birth meant participation to a patriarchal society in which public speech and acts constituted membership. This basic shift found reinforcement in the communication modes. Ritual gave way to drama. The oral culture gave way to literacy. The story telling of Homer yielded to the categories of Aristotle. Later, literacy was simplified and extended by the printing press that visualized vernaculars for the French, the Germans and the English; and strengthened the one man, one vote arrangement through the ideal of universal literacy. The nation-state, imported from Europe, with its civic and economic organization of our life, is clearly the dominant organizational mode on this continent.

The nation-state works in terms of classifications, not relationships. Kinship systems are not encouraged. Nepotism clauses abound in state regulations. If any one of your relatives is in a position of power in this or a closely related state agency, then you cannot have the job. You are ineligible. The basis of choice in the state must be in terms of agreed upon classification systems. People are not brothers and sisters, they are G-8 or G-11.

The proper classification systems are arrived at and agreed upon by men sitting in Congress and voting. One man, one vote. Who will go to war? Who gets welfare? Who must retire from the work force? Who is eligible for CETA? Who must pay taxes? The answer to each of these questions is a certain class of people, all those who can be put in one to one correspondence with the laws and regulations agreed upon by the cumulative choice of those voted into congress. Sorting and dividing the population.

Such sorting and dividing extends to the landscape. The state assumes eminent domain and allows its citizens and other legal entities to buy and sell the land in terms of lines on paper with little regard for the web of life that exists in this Watershed and elsewhere. Passaic County was mapped out for the convenience of the business community, not because of natural boundaries. Only recently have we begun to realize that the system of ownership and rights of exploitation supported by the state may be as destructive to the landscape as its laws and regulations are to the kinship system. Our deeds of ownership deal us pieces of land as if the land were a puzzle that could be boxed and unboxed or a warehouse full of resources that could be bought and sold. Such "property rights" are paralyzing our efforts to reckon with the ecocycles natural to the landscape regardless of ownership.

Consider this. There's a house in Wayne, the Colfax House. It's been in the family for eight generations. Eight. That's a rare exception. Real estate people in Wayne will tell you with glee that people there move on the average every three to five years. When you move that much you can't possibly care for the landscape you live in. What happened to all the family farms in Wayne? Generations can care for a place, grandpar-

ents to grandchildren, in a way that "owners" cannot. Affection for favorite places can be passed on. When a grandfather takes a grandson on a day-long hike to the Great Falls, that's an event to be remembered for life.

Part of the problem is that there's been a double migration. Many people came from the countrysides of Europe to the industrial city of Paterson. Across the ocean and from country to city. The Dublin ghetto of Paterson was a different cup of tea for the Irish from the familiar city of the Emerald Isle, or the farmland that had failed to yield the critical potatoes. Similarly, the Hispanics now in Paterson cannot but be confused by the cement landscape that threatens kinship relations once nurtured in a variety of native ecosystems.

No ongoing correlation between kinship and landscape has developed in this watershed with the notable exception of the Ramapo Mountain people. It's a common problem for the Eastern Woodlands. There are no Connecticutians or New Jerseyites the way there are Bretons, Celts and Basques in Europe. Twice in this century our young men have gone back across the water to fight on European soil. Immigrants understood the family feuds of Europe and fought. Part of my generation's resistance to the war in Vietnam was that it had no such resonance. But World War I and World War II did little to help us understand long term living in place in this landscape. The land was looked at in terms of natural resources for munitions, not in terms of biological cycles. Iron mines in the highlands were reopened for both wars. Families lost their young men and their continuity. My grandfather was gassed in WWI and spent the rest of his life in and out of VA hospitals. He was never reconciled with my grandmother in Bloomfield.

A large part of the reason the state has been so successful is that an accommodation was worked out with Christianity whereby the vitality of tribal emotions has been successfully contained. This took place largely during the time of the Roman Empire. Christianity is a slave religion. The cross of Christ, so central to the emotional configuration of Christianity, is a Graeco-Roman torture instrument. It became central to the organization of emotions and attitudes known as Chris-

tian. "Not my will, but Thine be done," said Christ in his agony in the garden. And so Christians are disposed to subject themselves to authority. Contradictory commands within the family system were reckoned with by identifying one's suffering with Jesus; similarly with political struggles such as those in modern Ireland and Spain. The Church diffused resistance. So powerful was the imprint of the Judeo-Christian slave morality on West that it was only revealed as exhausted in the last century by Nietzsche in *The Genealogy of Morals*.

I am not talking off the top of my head. I spent four and a half years in a monastic order of the Roman Catholic Church dedicated to preaching the doctrine of Christ's Crucifixion. Part of the obedience to the Sacred Scripture they espoused involved cutting off your perception of the living environment so that you could preach the Word. I spent two years on the shores of Lake Erie meditating on the death of a man that occurred 2000 years ago. I never realized that Lake Erie itself was dying. This sort of appropriation of perception by mythology is chronic in the West and increasingly dangerous. When I was a child the nuns said that the flecks of red on the white dogwood flowers were the blood of Jesus. The reason the dogwood does not grow straight was that dogwood had been used by the Romans to crucify Jesus and since then the tree refused to grow straight. Only recently have I realized that the twisting growth of a dogwood has to do with a search for the sunlight slithering through the tall oaks and maples. Leafing toward the sun to stay alive. Talking Wood.

Reinhabitory-Human Species

It is tempting to think that simply by working to restructure the kinship system and reorganizing the state in terms of environmental law we could redress the balance between these two systems and reverse environmental destruction. I think such efforts certainly should be made by those in a position to try, but I do not think such efforts will be sufficient. Let me indicate what I mean through two sorts of environmental problems in the Passaic Watershed.

toxic waste

Four out of five people you talk to about the problem of recycling and taking care of toxic wastes in the watershed will tell you there's nothing you can do about it because the waste haulers are Mafia controlled. No serious investigation has been done—I tend to think people have seen too many movies about the Mafia—but for the sake of discussion let us assume that the allegation is true. As an immigrant group some Sicilian kinsmen have maintained a viability living outside the law of the state. It's common practice for immigrants; many do it. Such an adaptation permitted them to continue their genetic line on this continent, indeed in this Watershed. But when their outlaw activity involves the destruction of the environmental support system for their descendants, then there is a contradiction involved that cannot but catch up to a group of people known for their love of children.

flooding

It's been over a century since government bodies in the Watershed started studying and arguing about flooding. The Army Corps has been in on it officially since 1936. Currently they have a $12 million budget to do a five year study of what to do. The study must be conducted in full public view by order of Congress and nothing will be done unless a consensus of agreement is reached among the governing agencies including the 112 municipalities in the watershed. At a recent meeting in Oakland where many people vented their frustration over the endless studies, the colonel in charge of the project said that he recently had to tell a congressman there was no reason to expect a consensus in 1985 when the 12 million dollar study was complete. Competing constituencies in the Watershed would still be issuing contradictory commands as to what should be done and, consequently, nothing would be done.

Environmental problems in the watershed such as toxic wastes and flooding cannot be resolved in terms of either kinship or state organization. The unit of survival is not a specific kin group or a particular municipality. The unit of

survival is a species-in-its-environment, a flexible species achieving interbalance with a changing environment.

How can the human species organize?

Certainly in terms of the positional intelligence proper to the diverse parts of this planet. People of the woodlands live differently than people of the plains or people of the coast. Place specific. We live in the Passaic Watershed on a woody spine of Pangaea, one of the oldest land formations on planet Earth. The seasonal fall of leaves, the butterfly cycle of fresh water lakes left by the last glacier, the storm waters from the tropics and the Great Lakes that find their way over the Passaic Falls, migrating ducks and geese, sycamores by the rivers, muskrats multiplying, the possibility of the Atlantic Salmon returning to spawn at the foot of the Great Falls; all of this is becoming part of our understanding about living in this place. Out of this understanding appropriate ceremonies to celebrate life here can develop.

While place specific intelligence and organization is desirable and necessary, I don't think that sort of organization is sufficient. There are a host of difficulties in human interaction that such organization does not address. What I want to present here is a way of organizing our differences that does deal with many of the difficulties left out of the reinhabitory approach as it has developed thus far. Others who agree on reinhabitation may well disagree with me on this. However, I think that without the sort of backup that I'm talking about, reinhabitation could be reduced to rhetoric by the end of the eighties. In the remainder of this essay I will explain how I arrived at this approach, what the approach is and what difficulties I think it resolves.

> *And I saw two insane little boys*
> *Who wept as they leaned on a murderer's eyeball.*
> *But two, that is not a number!*
> *All it is is an agony and its shadow.*
> *It is the guitar when love feels its desperation*
> *It is the demonstration of someone else's infinity*
>
> *It is a castle built around a dead man*
> *And the scourging of the new resurrection that will never end.*
> — Lorca

My father died of cancer at age 57 in Saint Joseph's Hospital in Paterson, New Jersey, May of 1971. After he died I went to the Hudson Valley above the Passaic Watershed and worked simultaneously on human interrelationships and our relationship to the biosphere. Support from the New York State Council on the Arts enabled me to work on these problems from 1971 to 1976 with portable video equipment.

I trained myself to do half-hour continuous tapes of the environment in a Zen state of mind. I did a set of thirty-six such tapes dealing with earth, air, water, plants, animals, and man considered in his technologies. I also did a year-long study of a waterfall that yielded a vocabulary of over forty water flow patterns.

Doing video by myself seemed insufficient, so I used video replay of human interaction to figure out ways people could work together on ecological tape. I did 45 hours of tape with people interacting in sets of three. I set out to "invent triadic behavior," that is, behavior that could stabilize long-term relationships between three people. I had a hunch that came from an understanding of how Yoga and T'ai Chi had started. At a certain point in the history of Eastern cultures the meanings held in its mythologies of birth and death, hero stories and tales of paradise lost common to the symbol systems of tribal cultures didn't work for people. Somehow there arose these practices, disciplines that if taken seriously created an understanding independent of symbol systems. Like many others experiencing the death of a parent in this culture, I had found the symbol systems surrounding death just did not work for the relationship I had with my father. Given the possibility video gives us of recording and playing back our interactive patterns, I thought it might be possible to invent a relational practice that could hold meaning apart from symbology.

In addition to the video work I did extensive reading in the work of the American philosopher, Charles Saunders Peirce. Peirce is the little-known giant behind William James and John Dewey. He died in obscurity in Milford, Pennsylvania, where he spent the last thirty years of his life studying and writing, sometimes in the attic to hide from bill collectors. He

is generally acknowledged as the most original philosopher this continent has produced.

In the 1860's Peirce was saying that Western culture had about another hundred years to go before it would fall apart. It would fall apart because it was based on an exhausted logic of classes developed by Aristotle. What we need to survive, said Peirce, is a logic of relationships, not classes. Such a logic could provide us with the basic architecture with which to build a new richer understanding of living. Peirce spent his life clearing the ground so that such a logic could be realized. In working with video and Peirce simultaneously, I arrived at what I regard as the logic of relationships Peirce was after. That logic is wholly evident in the figure I used earlier in talking about generations. That's it. If you've understood that then you've understood the basis for the approach to relationships I'm putting forth.

The Approach: A Relational Practice

In three-party interaction (ABC), the normal pattern is for two parties to combine against a third party so that one dyadic relationship (AB) is strengthened and the other two (BC and AC), are weakened. This pattern is based in part on our bilateral symmetry. You cannot look in four eyes at once. Some Chinese counter this tendency in conversation with the following technique: if A asks B a question in the presence of C, B answers the question as if C had asked it.

The relational practice is a recurring intentional nonverbal interaction between three parties (ABC) that reinforces all three dyadic relationships (AB, BC, CA).

The core set of interactive patterns are presented here. A relational figure is placed on the floor and moved through according to the traffic pattern described. I will present the instructions for the traffic pattern in a flat formal way, much like one presents a music score or a cake recipe. This is because the ultimate interpretation of what I am presenting is not in the reading of the instructions any more than the ultimate interpretation of a cake recipe is in reading the instructions. For a cake recipe or a musical score the ultimate

interpretation is the experience of eating the cake or listening to the music. One does not even attempt to describe the taste of the cake or the musical experience. For the relational practice the ultimate interpretation is the living experience of the relationships, which I will not attempt to describe beyond passing on these comments by participants. One participant commented that when you finished the practice you knew quite clearly where the relationship with the other people stood. Another person said that when he did the practice at a public session his mind went back to a dream he often had as a child. In the dream, his left half was going down a tunnel and his right half was going up a stairs. The tension that was never resolved in the dream was resolved in the relational practice when the tunnel met the stairway.

The Relational Practice (Threeing, pp. 104ff.)

Draw an outline of the relational circuit on the floor, making it large enough so that people can move through it. The outer boundary of the parts uncontained should correspond to the circumference of a circle with an eight foot diameter. The practice begins with each of three parties entering a part uncombined.

The fecund minimum for establishing this practice is a set of six people, three males and three females. Such a set allows the participants to take part in all four triadic combinations possible to our bisexual species: MMM, FFF, MFF, FMM.

The core set of non-manipulative interactions presented here is based on simple realities common to all members of our species. We each have a front and back. As infants, our arms will open in a backward fall (Moreau reflex), and contract with a loud noise (startle response). The principle pattern of interaction Front and Back is based on the fact of our dorsal/ventral bilateral symmetry. With this pattern secured, Flying and Holding transforms the Moreau reflex and the startle response into a practice of symmetric flying and complementary holding, soundings introduces a variation that allows the subtleties of voice and movement to enter the interaction. These modes can be considered core to a non-manip-

ulative interaction between three parties that reinforces all three dyadic relations. Other modes could be developed or rediscovered and used in conjunction with the patterns given here.

The relational practice would enable us to build a communications system based on shared perception of the environmental realities we live in.

The kinship system has enabled this species to transmit genetic information from generation to generation. Language as shaped by literacy has allowed the nation state with its complementary religions to perpetuate itself over generations. Both the kinship system and the nation state/church operate in terms of language. The child is told, "No, don't touch! That's hot!" The developing integrity of his perceptual system is stunted and his behavior is linked up to the verbal commands of others. When the competing commands of other speaking organisms become contradictory, the child's behavior can be distorted in relation to other members of the species and in relation to the environment. Extreme cases of such distortion are evident in some victims of schizophrenia who are paralyzed by hearing voices that issue contradictory commands. This paralysis in individual behavior has its complement in the species itself. Inhabitants in the area of Three Mile Island were paralyzed by the confusing and contradictory information coming from different news sources and different government agencies. In a less dramatic way competing contradictory commands about flooding in the Watershed leave us not knowing what to do.

Talk among people now beginning to face the music is that the chemical waste problem will make the nuclear threat seem like child's play. It may not be possible to live in this place if chemicals waste our water supply. It is not science fiction to think that toxics in this heavily industrial place could, in effect, slowly "melt down" the biological life of this Watershed and force us to evacuate. How will we do it? How could we avoid false alarms? Could we act to restore the biological life? Experience at Three Mile Island and with flood problems suggests we would be paralyzed.

By linking up the relational practice with video, cable TV, and other electronic media, a reliable communications system could be built based on shared perception of environmental realities. Such a system would give us the capacity to store and transmit information to future generations and the capacity to respond to real situations. It would have an integrity free from the contradictions of language, and draw figures of regulation for a reinhabitory social order from the bioregion itself.

The system would operate in a way that is analogous to the reticular core of our nervous system. The reticular core is the thing that decides whether you'd better run or fight, whether you should wait, sleep or make love. The reticular core has evolved so that it provides an organization of many components each of which is a living thing that senses the world and tells others what it senses. Each of our lives operates in terms of a few million of these nerve cells getting organized enough to commit the whole organism to act in a coherent way on a regular basis. Individual survival depends on it. An electronic communications system that used this relational practice at its core could provide inhabitants in the Watershed with a similar survival capacity. The system would have a redundancy of potential command. Whatever the ecological situation "dictated" could be met by a range of ready responses rather than paralysis and panic. Including participants from the various kinship systems and classes of people would enhance the possibility of consensus.

The actual construction of such a communications system in the Watershed through the use of video, cable television, etc. could resolve some of the employment problems in the region. Just as kinship communicates primarily with the oral tradition, nation states with literacy, so electronic communication is the proper reinforcement for ecological cultures. Fifty percent of the gross national product is now tied in with the communications industry. As the heavy industry of the northeast winds down and the chemical industry is increasingly challenged, such a project could train significant numbers of people in marketable communications skills. Building such a system would be a much healthier enterprise for workers and communities alike than building nuclear power plants.

The relational practice would encourage long-term living in place.

The relational practice is what the philosophers call intransitive. Transitive relationships are of this sort. The biggest child shoves the next biggest child. The next biggest shoves the smallest child. The smallest child does not shove the biggest child but goes out and kicks things. Intransitive relationships are like the child's game; paper-rock-scissors. In this game each of three children throws out a hand: flat for paper, fist for rock, and forked fingers for scissors. Then they swat each other on the wrists according to the formula: scissors cuts paper, paper covers rock, rock breaks scissors.

Long-term living in place requires the capacity for intransitive relationships. The current transitive relations we have with each other and with the landscape such as indicated by the statistics of moving in Wayne tend toward the ignorant destruction of the landscape.

The relational practice would free the ecosystem from the burden of human confusion about relationships presently resolved through gift giving, market exchange, and political favors.

I drop a book on the street and go on. You come by and pick it up. Two separate events. I drop the book. The book is picked up by you. Lost and found. There is no relation between us.

I want you to understand how I feel about you because an ambiguity has grown up over the year. I select a gift, a book to give you for Christmas. The book I select and the way I give it to you and the context of the exchanging of gifts at Christmas all work to describe and define the relationship between us. But the books and the items of exchange have to come from somewhere. Trees are cut down for paper, etc. When people start buying cars for each other and competing in gift giving the toil on the ecosystem can become huge. In a similar way, the nexus of political favors and deals can also take a large toll. He did this for us, we'll do that for him;

regardless of transgressing the ecosystem. He supported our preservation of this marshland, so we will not oppose the building of that dam he wants.

The relational practice clarifies relationships without taking a toll on the ecosystem.

The relational practice could stop the Watershed from turning into a behavioral sink.

Behavioral sink is a term coined to describe what happens when rats are crowded in a small space. Population people use the term to describe the effects of overpopulation on humans. With rats there were random fits and fights. Extreme withdrawal on the part of some. Natural bonds disintegrate. Mothers grew disinterested in their young. Abandoned them. In some instances, ate the young.

The population in the Watershed is now 2.4 million people. That's up from 1.8 million in 1970. Last year the crime rate was up fifteen percent in this area. Cancer rates grow apace of the deteriorating environment. Divorce doubled over the last decade. Our emotional life sometimes resembles a game of bumper cars.

This watershed is now more densely populated than Japan and it does not have a traditional culture with ceremony to fall back on and orchestrate the crowding. Tea-drinking ceremonies and care of bonsai trees are not common in Jersey. I think there is a correlation between high density and the ritualization of interaction. Ritual allows caring relationships at close quarters. The Watershed need not be a behavioral sink.

There is another more formal sort of reason why I think the relational practice could offset the pressure of populations. Population people work with large numbers—statistics like those used by insurance companies and television networks in their polling of political preference. Large numbers allow statistical prediction and are very useful that way. Statistical math is a well developed field.

Another area of math that is well developed is the area dealing with equations. Equations allow us to understand

sides very well: a = b, b = c, a = c. We can work the two sides of an equation with enormous sophistication. However, in the area of from three to a hundred where statistical patterns begin to operate, current math has not been successful. Outstanding is the three-body problem in physics. Physicists don't know how to think about the relation between three bodies. They use equations to deal with two of the three and then cheat by using more equations. The best understood system that deals with the realm of three to a hundred is the kinship system. If I am right about the logic of relationships, it formalizes our understanding of this realm. I don't claim that the three-body problem could be solved by the relational figure, though it would be illuminating to try. I am only saying that the statistics now used to account for human inter-action would have to be rethought if people took this relational practice seriously.

The relational practice could stabilize an organization of differences between men and women.

I met a Persian in Spain. We hit it off, hung out together for days. One afternoon in Barcelona we got quite drunk. He said, "In the last ten years, I have been all over Europe. I have been with many women. I have seen many men and women together. Because men and women have not made it on this planet—*finito*—it's over!"

Schizmogenesis

In the 1930's the anthropologist Gregory Bateson worked with the Iatmul people in New Guinea. The tension between males and females was so strong that Bateson wondered why the culture simply did not explode. What the Iatmul had worked out was an elaborate transvestite ceremony called Naven that muted the tensions by shifting roles at critical points. In studying the Iatmul, Bateson arrived at the notion of "schiz-mogenesis." The word means "growth of a split."

Bateson saw dyadic splits as resulting from the cumulative interaction between two parties. He identified two sorts of interactions that tended toward progressive change. One sort

he called symmetric, the other, complementary. People in a symmetric interactive pattern do similar things that tend to reinforce each other. Two boxers standing toe to toe and slugging it out are in a symmetric relationship. Other examples of symmetric interaction would be keeping up with the Jones or the armaments race.

People in a complementary interactive pattern do dissimilar things that tend to reinforce each other. An exhibitionist is encouraged by the applauding of a spectator. Dominant people are encouraged by submissive people to be more dominant. The interaction between a dependent child and a succoring mother can grow progressively monstrous.

Originally two parties may find in each other the possible resolution of a difficulty in relating. As they continue to interact, however, the differentiation demanded by the complementary or symmetric mode will tend to distort the personalities of the participants. Discomfort will follow. Ambiguities of interaction will accumulate as misunderstandings grow. Mutual resentment toward the other as the source of the distortion enters. Jealousy develops as each sees overdeveloped in the other that part of themselves that has been suppressed by the pattern of interaction. No longer does the resolution originally sought hold sway. Each party simply enters into a pattern of reacting to the emotional reactions of the other party and the relationship moves exponentially toward a split. Facility in switching from complementary to symmetric modes of interaction hold in check the runaway of either mode. The trouble here, however, is in developing reliable context markers to indicate whether the relationship is in a complementary or a symmetric mode. If A thinks he is helping B, but B thinks A is being competitive, pain and confusion will result.

In the relational practice, complementary interaction takes place in the positions of firstness, secondness and thirdness. Symmetric interaction takes place in the parts uncontained. The interaction keeps shifting back and forth so that neither pattern becomes cumulative. Schizmogenesis is precluded. A steady state of interaction develops, like in the Balinese culture as described by Bateson.

The Relational Anomaly

In the triadic video studies I did, one pattern kept recurring: two parties combined to extrude a third party. "Two's company, three's a crowd." It was clearest in the instances where one party was blindfolded and the other two were sighted. What happened recurringly was that the two sighted combined against the blindfolded party and reinforced their relationship at the expense of the third party.

An experimental study with baboons in the fields of Ethiopia revealed the same extruding pattern. There are no "free" females in a baboon troop. The males possess the females and will fight to hold onto them if necessary. Much fighting is avoided, however, since the "rival" male is generally inhibited by seeing the male/female pair. When such a triad is put together, the social behavior of the rival is inhibited while the social behavior of the pair is enhanced. In the presence of the rival, the pair bond matures rapidly. The rival "outsider" is extruded in the process.

In Western society, the "rival" has been institutionalized as eunuch, celibate priest, or starving artist who threatens to run away with the possessed woman but could not afford to support her childbearing. The rival female becomes the childless nun, the whore, or the mistress without property rights whose children are bastards. The function of the triad is to reinforce the dyad, the third party is extruded in the process.

What is going on relationally? On the one hand you have the schizomogenesis of dyads and on the other hand you have a pattern of dyads extruding third parties. Two's company, three's a crowd, but two can be hell. Two is somehow incomplete, but three is inconsistent.

As individual organisms we make choices between incompatible acts. You cannot both sleep and not sleep. You cannot both fight and not fight. You cannot both make love and not make love. You cannot both stay and leave. Acts of choice are in the realm of individual control and individual survival.

In a relational nexus, individuals make choices that involve other individuals. I will make love with this one and not that one. I will fight with this one and not that one. Consider this

simulation of human interaction done at a research center in California. Three people are seated at a round table with partitions so they cannot see each other. In front of each is a two-minute timer. Each has two buttons on the table in front of him. Only one button will work at a time. Each button closes an electric circuit that includes getting time on the timer, a light, and one other participant if he is also closing the circuit. The object for each participant is to be in contact for more time than either of the other two parties. A choice must be made between the other two in order to score. Only one dyadic combination can be scoring at any one time.

By contrast with individual choice, relationship involves the ongoing organization of difference between at least two individual organisms. However, in a two-party interaction it is impossible for the two parties to understand and correct their relationship qua relationship without the presence of a third party that interacts with both

A understands how his relation to B differs from B's relation to C, because A is in relationship with both B and C and can compare. All three dyads are required in order to understand and organize respective differences. When the mechanism of choice inhibits two of the dyadic relations in a triad and extrudes the third party, it leaves the selected dyad severed from the very relational interaction that would allow that dyad to balance and correct. This is the relational anomaly. To say it succinctly another way: relationships are routinely subsumed by acts of choice.

This anomaly generates a cluster of partial solutions to relational balance for dyads, among them risking periodic interaction with an outsider that allows the parties in the dyad to renew their mutual choice of each other. In effect, they are saying that whatever the ambiguity that has grown up within our relationship, it is at least clear that each of us prefers the other to the third party.

The relational practice presented above resolves the relational anomaly by neutralizing the effect of choice on relationships. Choice is exercised not between incompatible acts nor between mutually exclusive partners but between unambiguous positions. The unambiguous positions are part of a figure

or regulation that balances a triadic relationship. No one is extruded. The relational practice consistently reinforces the complete set of dyadic relationships, AB, BC, CA. It does not reinforce one dyad at the expense of the other two.

Jealousy

If you attempt to shake hands with yourself in a mirror, the simulation will not work. The image the mirror holds is a separate reduplication of yourself. It is not continuous with your self-perception, your integral sense of all possible body positions. The mirror image is a spectral image, separate from your introceptive sense of self. It is by way of a spectral image in the mirror that we first understand as children that we can be seen by others, that what they see is distinct from our sense of ourselves. This spectral image becomes the basis of our social identity, our mask, our persona. By means of this spectral image others can tear us away from our introceptive self, confiscate us and force us into alienating interaction.

Watch two children playing together. Often the more dominant child is the one providing the social persona while the other is the onlooker admiring and reinforcing that persona. It is a master/slave relationship with the master dependent on the slave for acceptable feedback to the persona. The slave, meanwhile, has not the feedback and attention necessary to do spectacular things and feeds vicariously on the achievements of the master, all the while growing resentful at his failure to fulfill himself. Both master and slave conspire to maintain this arrangement. Third parties are seen as threats to their mutually reinforcing blindness. Each one's identity depends on the other.

In the relational practice the persona of the spectral self can be dropped. The practice works in terms of presence to each other while maintaining the introceptive self. There are no fixed identities as in the master/slave arrangement, since people take turns in the various relational roles. Because the persona is dropped during this practice it is important that the practice be done with clear thresholds of beginning and ending. The openness to others involved in the practice would make participants very vulnerable in normal social interaction.

Sexuality

It does not necessarily follow that a relational practice which could give the species a shared perceptual system could also be used to regulate the propagation of the species. Certainly work on building and maintaining a shared perceptual system could proceed without sexual discrimination simply by organizing the work in accord with the four possible cases of triadic combination for a bisexual species: MMM, FFF, MFF, FMM. As for propagation, that is a different question.

The various restraints on triadic interaction inherent in a bisexual species could not be arbitrarily overridden. There is a difference between ovulation and ejaculation of sperm that has consequence. Account must be taken of the fact that in any potentially fertile male/female relationship a third party is implied. The desirable and necessary fusion that results in a fresh offspring would have to be given proper place in a triadic social order. Pair bonding protects the possibility of a new generation and it may be a grave mistake for any one generation to attempt to undo this mechanism for its own gratification. Our American cult of youth could be reduced to the absurdity of geriatric trisexuals with no young.

It may be that the introduction of the relational practice as a means of developing shared perception, which seems to me to now be critical to species survival, would only have indirect effects on the kinship system and propagation. For instance, the incest taboo, exchange of women, and pair bonding could be maintained at the same time a kinship system used this practice to clarify relationships between and among generations. Grandmother, daughter, granddaughter; father, uncle, cousin; sister, sister, brother, etc.—all possible triadic combinations in a kinship system could engage in this practice. Step families could benefit.

On the other hand, if the kinship system were to be replaced by a triadic community of lovers, the status of women as a class of people to be exchanged by men would dissolve. Such organization could, it seems, do much toward freeing women from oppression. In a triadic social order women could enter and leave triads as freely as the men—they could not be reduced to pieces of property.

There is no formal reason I can see why a completely relational social order, a community of lovers, could not in fact develop. Much can be learned from experiments already tried. For instance, the Oneida Community survived for thirty five years without monogamy, breeding children. The way they did it was to have all acts of copulation mediated by a third party. No one could be approached directly, male or female. The constant go-between prevented people from getting caught up in confusing schizmogenic relationships.

Biologically, copulation is reversible capture. Let me explain. To stay alive, the human organism must capture and ingest other living organisms. To capture other living organisms the predator must undergo a discontinuity from self, must allow the self to be dominated by the image of another, must temporarily become the prey. A temporary fusion with the prey is made possible by the predator's nervous system which enables it to dance outside itself, to become something that it is not. The human mammalian nervous system can be seen as such an organ of alienation. Plants have no such organ with which to achieve capture. The capture process is at work in courtship and copulation. However, it is reversible. Both parties can walk away from the act.

The morphology of reversible capture does not map onto the figure of regulation for the relational practice. However, in a strictly formal way, reversible capture could be accommodated in the gaps between the parts uncontained in the relational figure.

Of the four cases of triadic combination, only FFM and MMF are capable of conceiving a child. In the case of FFM there would be no confusion as to who the pair determining the firstness of the child would be. It is only in the case of MMF that the conception of a child would cause confusion as to who was the father. Moreover, the way our bisexuality is set up, one of the two males is superfluous in nature's design. Another difficulty with this configuration is that the woman is without another woman to exchange mother roles in a way that might sensibly transform the situation in infancy.

Some of these difficulties could be resolved in a community of lovers by reserving childbearing to the MFF triads. Since

any one person could take part in more than one triad, no one would be formally excluded from the possibility of parenthood. In this way an accurate record of the firstness of each newborn could be kept and combinations encouraged that precluded weakening the genetic code by disallowing arrangements that tended toward the reduplication of *relata*. Another interesting fact is that under such an arrangement with recombining triads, a community of only firstborn children would be possible.

I hope from what has been said that the reader will realize that configuring ongoing triadic relationships that include sexuality is not something to attempt lightly. As I've said, those who simply count to three and jump in bed will have difficulty sharing the toilet in the morning. The range of human behaviors having to do with capture, schizmogenesis, jealousy and the relational anomaly, as well as other things not now apparent, would have to be reckoned with before a community of lovers could configure. My own sense is to get on with the relational practice to share perception and leave the sexual possibility to later generations.

The initial effect of an innovative practice is usually to allow the conservation of a traditional pattern. The creatures who first learned to live on land were scurrying from dried up water holes to more viable water environments. Land was an obstacle to their desired habitat, just as the deterioration of the biosphere is an obstacle to the perpetuation of family systems. Perhaps in like manner, the relational practice described in this paper could be initially used to conserve the family pattern common to all men and women. It might take a few generations of using this practice to stabilize families and share perceptions before a triadic social order could develop in its own right.

> *Who, who will be the next man to entrust his girl to a friend?*
> *Love interferes with fidelities;*
> *The gods have brought shame on their relatives;*
> *Each man wants the pomegranate for himself.*
> —Pound

Watershed Watch

For more than three generations flood problems in the Passaic Watershed have been the object of study. The current Passaic River Basin Study will be the ninth major report on the Watershed. It is an advanced engineering and design study being undertaken by the Army Corps of Engineers. The objective of this plan is "the development of a feasible and publicly acceptable basin-wide plan for meeting the flood control and other associated water and related land resource needs of the people of the Passaic River Basin."

Since study of the basin started, no major recommendation has been implemented and it is doubtful that this new $12 million study will result in any major implementation. Why?

There are 112 municipalities in the basin, each with competing demands on the watershed. Various interested parties have made recommendations that contradict each other. The Corps publicly admits that its own list of planning objectives contains serious contradictions. Recently, the ecological movement has made people in the basin aware of a larger contradiction. Somehow, we have misidentified the unit of survival as the human species itself. This is a grave mistake. For us the unit of survival is not the human species itself, but the human species in its environment. If we destroy our environment we will destroy ourselves.

But just what does constitute environment destruction? There are some scientists who seem to have a fairly clear idea, yet other scientists will disagree with them. The public is left with an array of contradictory "authoritative" statements.

To speak immediately of water, land, pollution, and other problems amid this cluster of contradictions is to misidentify the real problem. The real problem is that it is impossible for the Army Corps, or anybody else, to carry out contradictory

commands. No feasible, publicly acceptable plan can come from such a situation.

To resolve this problem, *Talking Wood* is initiating a watershed watch. The watch relies on shared perception of the watershed by people living here. Perceptions are embedded in film and video so that they can be shared with others and passed on to succeeding generations. The design of the watch varies from being as tight as a musical score to being as loose as enjoying a place with a camera. To go on watch is to look for those patterns that are necessary to the major development of watershed life. The figures that regulate its underlying structural stability. Just as a child learns language by collecting a vocabulary of words and then discovering the syntax of their relationships, so the watch is designed to amass a "vocabulary" of patterns and thereby figure out the syntax of how this watershed is working. Such a syntax could then constitute an agreed upon system of restraints that would regulate the way people live in this watershed. Such a system would be married to observables in the environment and not to competing civil or scientific authorities. Given that these observables would be here for anyone to examine, it can be anticipated that such a system will achieve broad agreement, be stable and ongoing, and provide a common context out of which specific proposals for "flood control" etc. could be considered.

Watershed Watch Calender for Pompton Lakes

Looking at the clouds out of the kitchen window, noting changes in the neighborhood while walking, enjoying the change of seasons: watchfulness is part of living. With this *Watershed Watch* we are suggesting a way of coordinating our natural watchfulness to yield a mosaic perception of the place we live in. Eleven sites in the Pompton Lakes area have been identified by our scouting team. People are invited to go to these sites, with or without cameras, for the lunar cycle beginning with the solar eclipse on February 26, 1979.

During the week of the new moon we suggest paying attention to the feelings that arise in each site visited. In the week

of the quarter moon, we suggest paying attention to the facts presented by each place. Guides will be available during this week to point out specific features of each site and to answer questions. The week of the full moon is a time for going back to these sites and thinking about the future, about ways to ensure living in this place on a long term basis.

Picture taking is encouraged during each moon phase. Please write your name, the site and date on the back of each photograph and drop off the photos before March 23 at the *Talking Wood* office. Photos will be organized into a mosaic and displayed at the Pompton Lakes Library during the month of April.

Paterson as Green City

The Great Waterfall fooled the founders of Paterson. The founders saw the falls in terms of "industrial power." They used it to run cotton and silk mills, to make locomotives and revolvers. But industrialization killed the life of the river. The salmon that native people took from the foot of the falls with their hands have been gone for generations. Now you're lucky if you can catch a few small bottom fish by the falls.

The power of the great falls is only part of a greater power. That greater power is the web of life in the Passaic River Watershed. The Passaic Watershed is a weave of falling leaf forest life. The seasonal fall of leaves and the steady fall of water are part of the same powerful life process.

The Seal of Paterson shows a boy kneeling to plant a silk mulberry tree. You don't know a place until you know its plants. The silk mulberry never would grow in this climate, despite the efforts of industrial planners. Above the image of the boy are the words, etched in Latin, "With Hope and Work." Paterson was Silk City. But the strike that broke out in 1913 and the competition from synthetic fibers crippled the industry. Silk City failed. The industrial power of Paterson failed.

Yet something else can happen. The web of life, though weakened, is still with us. We can work with the greater

power of the watershed to cultivate a Green City. Here, in Paterson. Here, where the water splits the rock. We can:

- Clean up the river so the Atlantic salmon can spawn here again.

- Learn about the native plants of this region.

- Return organic wastes to the soil.

- Plant community gardens in vacant lots.

- Organize food co-ops.

- Use the area colleges to develop urban/suburban agriculture and aquaculture.

- Plant trees.

- Develop a health care delivery system proper to this place.

- Develop technology proper to a green city.

- Develop work programs appropriate to a green city.

- Use ecological and energy principles for housing programs.

- Minimize the use of the automobile.

- Build jogging and bicycle paths.

- Develop solar energy applications here.

- Reopen the hydroelectric power plant at the falls for cheaper, non-polluting energy.

- Use the hydroelectric power plant at the falls for a cable TV network dedicated to educating people about the web of life in the Passaic Watershed.

- Organize hiking and canoeing trips throughout the Passaic Watershed for the children.

- Organize a Watershed Watch the children can participate in.

- Teach photography and video to the children so they can record and share their observations.

- Develop committees of correspondence between the children in Paterson and children in other parts of the watershed.

- Teach the children the difference between the ecology of the Passaic Watershed and the ecologies of the different places their grandparents come from.

- Develop more parks by the river so people can sit in peace and watch the river flow.

When the Onondaga Indians of the Eastern Woodlands are asked why they do things that give them no immediate reward they answer that they do these things "for the seventh generation." Why cultivate a Green City? For the Seventh Generation.

Watershed Watch: Video at the Great Falls

This is a report on the formal watershed watch work done at the Great Falls during the fall of 1978. At the invitation of Roy Skodnick, Director of the Pascack Valley Video Project, I agreed to orchestrate a video sketch of the Great Falls for the group of six Roy is working with. Roy's interest in working at the Falls grows out of his love for William Carlos Williams's poem, *Paterson*. My own approach to landscape study is based on five years of exploratory video work with Earthscore Foundation in High Falls, New York. Part of that exploration was a year long observation of a waterfall in which I collected between thirty-five and forty different water flow patterns on videotape.

The first thing I did in Paterson was to identify six different sites around the Falls that would give us camera access to as much of the phenomenon of falling water as was physically possible. I then showed the group three different modes of videotaping: scanning, selecting, and a combination of scanning and selecting. The orchestration involved each participant taking a turn with the portable video camera in each mode from each site. Such turn-taking is designed to yield a mosaic perception more reliable than perception provided by individuals working separately.

As expected, different people on the project had different perceptual strengths and we learned from each other. Eileen Greenfield is especially good at selecting and consistently added to our collection of water flow patterns. Jim Krell and Bethany Jacobson are strong in paying attention to their own feelings while moving with a camera, and this makes for good scanning. Once Curt Schlenker let go of cinema cliches, his scanning became interesting and his experience with photography was helpful in terms of selecting. Both Roy Skodnick and Francesca Lyman have the sort of patience and comprehensive awareness that makes for good scan/select tape.

Roy's strength in select/scan comes partly from having studied Aikido for three years. Aikido is in the same family of exercises as T'ai Chi which I have studied for years. The optimum scan/select mode that I have been able to develop comes from a move in T'ai Chi known as four corners. In four corners, you turn 360 degrees shifting weight from one leg to the other. By scanning while the weight is on the back leg and selecting while shifting to the front leg you can blend the intelligence of T'ai Chi with video camera work.

The scanning mode is similar to the trance-like state brought about by ordinary television viewing, except that in scanning the mind stays alert and alive, is not passive and "spaced out." The selection mode is similar to the sort of thinking associated with quick eye movements or reading. By combining and orchestrating these modes in six visits to the Great Falls, we worked out a method and got a good sample of material. The seven hours of tape that we took constitute a

sketch. Given time and resources, this sketch could be developed into a full-fledged video study of the water flow patterns at the Great Falls.

The Great Falls constitute the richest single source of patterns in the Passaic Watershed. The vocabulary of patterns that can be collected there will enrich our understanding of other configurations in the watershed.

Channel W: Your Wire to the Watershed

At ABC, Arledge used broadcast to bring sports to the spectators. Channel W will bring the watershed to the waterdrinkers.

There are 2.4 million people living in the Passaic Watershed. This gathering ground for the Passaic River system encompasses 935 square miles and has nine major subbasins. In the Wanaque, Ramapo, Pompton and lower Passaic subbasins, UA Columbia has built sizable cable systems.

From present and potential subscribers, a significant audience could be developed for a round-the-clock watershed wire. The programming would not be designed to compete with other channels. It would be shaped for a second "background" television set, to provide images of the watershed at all hours of the day like a painting on the wall, and to be focused on when watershed issues are hot. Channel W will not present local news, but will nurture an emerging understanding of cultural context. It would support current efforts to find new roots and help ground people's understanding of their communities in the local landscape.

Channel W Programming Concept #1
Nutley Waterflow Symphony

The Nutley Symphony is a well-respected orchestra ranked twenty-sixth in the nation. The Passaic Falls, upriver from Nutley, is a national landmark that draws over a hundred thousand visitors a year. Edited tape of the waterflow patterns would be shown to individual musicians and small sections of the orchestra. They would produce interpretive sound tracks with their instruments. Conversely, favorite prerecorded pieces of the symphony would be interpreted by special edits of waterflow patterns.

This idea was worked out with support from the New York State Council on the Arts by myself and Brenda Bufalino, a leading tap dancer. Sample tape, *Tapping on Water* (5 minutes), is available. This tape presents Ms. Bufalino interpreting waterflow patterns on video with her tap dancing rhythms.

This work would be the background for round-the-clock viewing. Upwards of a hundred different flow patterns can be expected from the Falls. Water patterns, especially enhanced by music, bear a high degree of repetition and could become as familiar to viewers as a favorite painting.

Channel W Programming Concept #2
Talking Water

This would be an ongoing show using an original format as suited to TV talk as debate is for public speaking. The format is simple. An initiator speaks about an issue for a limited time, say two minutes. A respondent, after viewing the tape, responds in the same time frame. A third party, after watching the interaction on tape, seeks to balance the interaction in terms of the issue. Parties could go round in this format taking the different roles for as long as the issue demanded. Using this format, a citizen, a water engineer and a public official could clarify complex issues.

The best case would be to initiate this series in conjunction with coverage of the upcoming Water Conference, "Water and the Public Interest,"at Ramapo College.

Channel W Programming Concept #3
"Where The Sassafras Grows"

The native Lenape name Wanaque means "Where the Sassafras Grows." The Wanaque subbasin contains the largest reservoir in North Jersey. It supplies water to most towns downriver, including Pompton and Nutley. Extensive landscape studies with video will be done in this subbasin. The studies will yield a sense of place similar to landscape paintings. Specific problems such as erosion and eutrophication of

lakes will be documented. Also the figures of regulations that maintain the dynamic equilibrium of the subbasin will be rendered. For example, the four season cycle of fresh water lakes and the regenerative cycles of the falling leaf forest will be shown.

Channel W Programming Concept #4
Reinhabitation

This show would provide a cultural context. Life in the watershed would be seen in terms of native, invader, and reinhabitory cultures. A deliberate reinhabitory stance would be taken. That is to say that acknowledgement of landscape destruction in this region would be combined with an acceptance of responsibility for restoring and maintaining the land. Instructive tapes will be made that present practices appropriate for living in this place. For example, tapes might show how to cut wood without violating the regenerative capacity of the forest, how to maintain lakes, how to deal with solid waste and solar installations.

In effect, reinhabitory programming will take the content of *Talking Wood* magazine and transform it for cable.

Video Score for the Coast of Cape Ann

a coast
is not the same
as land
a coast
is not the main
a coast means
travel by horse
along beaches from
Saco south
via Ipswich to,
crossing Annisquam,
Gloucester
or by shallop
(long boat) across
Ipswich Bay
as such the Thatchers,
minister preparing to teach
Marblehead fishermen
got wrecked going
from the settlement at Ipswich
didn't make it around
north promontory of
Cape Ann. A shore
life.
　　　　　　　—Charles Olson, *Maximus Poems*

Place

Cape Ann is on the Rocky Coast of the Atlantic in between Boston and Seabrook. The Coastline of Cape Ann runs

approximately fifteen miles from the mouth of the Annisquam River to the Blynman Canal.

Time

This score was composed during the spring and summer of 1980, the year of the coast. Actual production would require a full summer with a month and a half of pre-production and a month and a half of post-production.

Product

This score will yield a color videoscape of the Cape Ann Coastline six hours in length. The internal orchestration of the tapes will allow multiple viewing possibilities from single channel broadcast of ten-minute segments to six channel showings of the entire work.

Method

The method for this score is generated from a single figure original to the artist. Combined with the phenomenology and semiotics of the American Philosopher, C.S. Peirce, this figure makes possible two resonant modes of videotaping: continuous scanning, and semiotic selection.

Range of the Method

For the artist to produce this videoscape is to produce a scouting report for our species now endangered by its own environmental destruction. While such scouting is valuable, more is possible with this method. The same figure that regulates this score for the individual artist could regulate a relational practice for a group. A group of such practitioners, trained in scanning and selecting, could embed a shared perception of the coastline on videotape.

A shared perception of the coast could make a significant difference in current efforts to reorganize human activity in accord with coastal ecology. Without foregoing the aesthetic,

the educational and juridical systems could be impacted. A concrete local curriculum could be built up on videotape for and with students raised on television. A jury of observers could embed critical coastal processes on videotape and introduce this tape as evidence in court to help preclude transgressive coastal practices.

Continuous Scanning

Continuous scanning will be used to produce tapes at eighteen different sites. Taken together these eighteen ten-minute tapes will provide an overlapping line-of-sight, covering the entire Cape Ann coastline.

The selected sites are a combination of twelve single sites and six composite sites that move sequentially from the mouth of the Annisquam River to the Blynman Canal. The odd numbered sites in the sequence will be taped at low tide, the even numbered at high tide. At each of the single sites, a ten-minute unedited tape will be made. For the composite sites the number of edits will correspond to the number of sub-sites in the composite. For example, four sub-sites from Pigeon Cove in to Rockport might result in a ten-minute tape with four two-and-a-half-minute segments.

The Sites

1. Babson Jutty
2. Davis Neck
3. Plum Cove/Flat Rocks
4. Folly Cove
5. Halibut Point
6. Andrews Point
7. Pigeon Cove (tide in)
8. Rockport (tide out)
9. Straitsmouth Island
10. Whales Cove/Lands End
11. Brier Neck
12. Bass Rocks #1
13. Bass Rocks #2

14. Bass Rocks #3
15. Brace Rock
16. Lighthouse
17. Gloucester Harbor #1
18. Gloucester Harbor #2

Composite Sites

Tapes produced by continuous scanning will exhibit an integration of movement from T'ai Chi and camera experience over ten years. Attention will be paid to a sense of place, the specifics of each site and coastal ecology. The sound track will be a two channel combination of waves and the heartbeat of the cameraman.

Semiotic Selection

Eighteen ten-minute tapes will be produced by semiotic selection. Twelve of these will be semiotic arrays of ten commonplaces of coastal life. The other six will be more exploratory, dealing with tidal zones and tide pools.

The exploratory tapes will use a close-up lens to provide an understanding of tide zones and tide pools in terms of the methodology, at times combining scanning with the semiotics. Three ten-minute tidal zone tapes and three ten-minute tide pool tapes will be produced.

The ten commonplaces that will be arrayed semiotically are: rock, water, alaria, light, sand, boat, wind, lobster, fish, and oil. Rock and water will be arrayed twice in keeping with the rocky shore line.

Peirce presents his semiotics, or doctrine of signs, in technical language that can be bypassed here. His three trichotomies of signs results in a tenfold classification and the possibility of a sixty-six fold classification. One possible consideration of rock in terms of the ten classes would be as follows:

I. Rock considered in itself
II. Camera moving with grain of rock

III. Surf indicating rock
IV. Buoy marking a submerged rock
 V. Drawing of Rock
VI. Rockweed
VII. Rocks tumbled down, positioned by gravity
VIII. Printed word "stone"
IX. Printout of Wallace Stevens's line "The boat was made of stones that had lost their weight"
 X. Printout of Coastal laws for quarrying stone

This list does not exhaust the multiple aspects of rock nor Peirce's classification system which, theoretically could handle all aspects. Yet it does indicate the sort of selecting possible and the various affinities between classes that make coherent editing possible.

Six Monitor Showing

Each monitor would show an hour tape composed of six ten-minute segments.

Tide Zones #1	Whales Cove/Lands End
Babson Jutty	Sand
Davis Neck	Water
Rock	Brier Neck
Water	Bass Rocks #1
Plum/Flat Rocks	Tide Pool #2
Folly Point	Tide Zone #3
Halibut Point	Bass Rocks #2
Alaria	Bass Rocks #3
Light	Lobster
Andrews Point	Rock
Tide Pool #1	Brace Rock
Tide Zone #2	Lighthouse
Pigeon Cove (in)	Fish
Rockport (out)	Oil
Boat	Gloucester Harbor #1

Wind Gloucester Harbor #2
Straitsmouth Island Tide Pool #3

Sequential Showing

The proper order for sequential showing is given below.

1. Tidal Zone #1
2. Babson Jutty
3. Davis Neck
4. Rock
5. Water
6. Plum Cove/Flat Rocks
7. Folly Point
8. Alaria
9. Light
10. Halibut Point
11. Andrews Point
12. Tide Pool #1
13. Tide Zone #2
14. Pigeon Cove (tide in)
15. Rockport (tide out)
16. Boat
17. Wind
18. Straitsmouth Island
19. Whales Cove/Lands End
20. Sand
21. Water
22. Brier Neck
23. Bass Rocks #1
24. Tide Pool #2
25. Tide Zone #3
26. Bass Rocks #2
27. Bass Rocks #3
28. Lobster
29. Rock
30. Brace Rock
31. Lighthouse
32. Fish
33. Oil
34. Gloucester Harbor #1
35. Gloucester Harbor #2
36. Tide Pool #3

Metalogue: Gregory Bateson, Paul Ryan

The first time I met Gregory Bateson was at a Princeton Conference on Social Change in 1970. The conference of twenty people had no agenda and soon became a battle over procedure around a square of tables. After the others had gone to bed the first evening, a dissenting cluster of us scattered the tables and chairs about. The confrontation that followed the next morning climaxed with a prominent mental health official hurling a table at the video equipment. He missed. I heard myself shouting, "You guys are supposed to be the heavies. I'm the youngest here and I haven't heard a thing I haven't heard from my friends. You complain nobody listens. Okay. Come on. Let's go to it. Sit down your heaviest cat and we'll turn the camera on him and listen." All eyes turned to six foot five alpha male, Gregory Bateson. He sat in front of the camera and deftly asked if I could sit and talk with him. I found myself in a metalogue.

Metalogue is Gregory's mode. A metalogue is a conversation about some problematic subject. The conversation should be such that not only do the participants discuss the problem, but the structure of the conversation as a whole is also relevant to the same subject. For example:

Paul: What is a question?
Gregory: Why do you ask?

The problematic subjects that Gregory deals with are not trivial and his mode of thinking about problems is not easy to grasp. At the Princeton Conference, Gregory was passing out Xerox copies of a paper titled "The Cybernetics of Self, A Theory of Alcoholism." It took me over a dozen readings to

understand, yet the effort was well worth it. It was the clearest approach to understanding addiction I had ever seen and was very helpful to me in my efforts to understand what happens when someone sees him/herself on videotape. Yet I found that though the paper was highly suggestive, like so much of Gregory's writing, it did not quite resolve the question. I began to develop another approach based on extensive original experience with videotape.

In a nutshell, I see the difference between Gregory's approach and my approach as the differences between working from a logic of classes and working from a logic of relationships. To me, the key tool in Gregory's explorations has been the theory of logical types which states that "No class can be a member of itself. The class of chairs is not a chair. The name is not the thing named."

The theory of logical types was key in developing Gregory's understanding of schizmogenesis as discussed in the article on relationships and in formulating the double bind theory of schizophrenia. The schizophrenic is one who has habitual difficulty in discriminating levels of logical typing; he is constantly eating the menu card instead of the meal. This condition results from a pattern of upbringing in which contradictory, or double bind messages, are habitual. For example, a mother says to her child, "Go to bed, you're very tired and I want you to get your sleep," while the non-verbal message is, "Get out of my sight. I'm sick of you." The logic of relationships I am working with is not based on naming and classifying, but on positional differentiation in a unique figure. (See Fig. 19, p. 103.)

Over the years of working with this logic of relationships, I kept in touch with Gregory. He was generous and patient with his time and patiently responded to the somewhat muddled letters I sent. In October of 1977 we agreed to meet in San Francisco and metalogue. At the time Gregory was looking forward to going into retreat and finishing the book he was working on. We went to Rosebud's Restaurant ("good imitation English"). Gregory ordered beef, I ordered salmon and switched on the tape recorder.

G: Tell me what's on your mind, man.

P: Well, Gregory, I see the work you've been doing as having disclosed a host of felt difficulties in the human situation. Things like schizophrenia, confusion between complementary and symmetric relationships, map/territory confusion, misidentification of the unit of evolutionary survival, and so forth. All these things have been disclosed by the explorations you've made.

G: They tend to be pathogenetic pathways, so to speak. Not necessarily so, but potentially so, at least.

P: I've been playing around, working with video now for about ten years, dealing with perception and behavior...

G: And with Klein bottles and Rene Thom [author of *Structural Stability and Morphogenesis*] and all that. Yes, well, I began, more than I ever did, to get some idea of why you're playing with these things and what your stuff is about. I was formerly very puzzled by this.

P: There is a real dissonance between my video-correlated experience of these difficulties and your articulation of them, insofar as articulation might lead to resolution.

G: Solving is another problem as well.

P: Yes. And for the sake of this metalogue, I will challenge your way of thinking. In a Kuhnsian sense I will attempt a paradigmatic challenge. I will say that the terms of disclosure are not the terms of resolution.

G: That may well be.

P: What I would like to do is put up the work I've been doing as a possible resolution.

G: Well, I, at any rate, have not mainly had my eye on resolution in identifying these things; therefore, there was no primary reason why the way I described them should have been the right way for resolution. So, all right, good enough, let's try.

P: I thought the way to come into it would be put the Klein-form paradigm up against the criterion for a unit of evolution that you described in "Form, Substance and Difference."

G: Yeah, yeah.

P: If you would accept the following as a statement of criteria, I would enumerate three.

G: Okay, let's go.

P: First thing, it would have to be a complete circuit.

G: Yes.

P: Second, there would have to be in the circuit one relation such that more of something meant less of something else.

G: Right. Self-corrective circuit.

P: And the third criterion would be that it would have to transform differences that made differences.

G: Right. This is all my sort of criteria.

P: Right.

G: Only one I would add to that is something about logical typing.

P: Well, there's where we'd get at loggerheads.

G: Oh yeah. Good.

P: Can you say, in some way, what you would add about logical typing?

G: Criteria for what? Criteria for...

P: Criteria for a unit of evolution, for a unit of mind.

G: Well, the recognition of mind at work. That the phenomena that one is dealing with are on the whole mental phenomena. In your criteria you offered just now, there are complete circuits, self-corrective circuits, differences that make differences. Now in order for differences to be effective, you have to have an energy supply. This is one I would add, therefore. Metabolism, usually.

P: But that's not logical typing.

G: That's not the logical typing. Now, I'm not quite sure whether I would add the logical typing in the criteria for evolution. For mind, yes. For evolution, well now, wait a minute. If you look at an evolutionary series—this is really the first thing that people like Darwin saw, before Darwin, even, it was the fact of homology. Now there are two uses of the word homology. In one use we say that your front limb, which has a single bone in the upper arm, two bones in the forearm, three bones, then one,

then five in the fingers is homologous with the fore limb of a horse, and in a more distant way and in a more distant range with that of a fish, even. But by the time you get to the fish, you've lost the detailed structure. But the horse again has the single bone, the two bones, the one bone, and then it deteriorates into the single finger on which the horse walks. But that idea of an underlying pattern which is then modified from species to species, or genus to genus, that idea is the basic idea of homology. Now you also have it as an internal idea to the individual, in which your arm is the homologue of your leg. One bone in your forearm, one bone in your thigh, two in your forearm, two in your shin, etc. That is, it looks as if the mechanism of growth determination had in it somehow, the idea of a basic pattern and a modification of that pattern, and as if the evolutionary sequence had in it that sort of idea. And that, I think, is what I mean by logical types insofar as one can trace them in the evolutionary sequence. For the sequence to be characterized all over in that sort of way, I think, means that the DNA messages have to be classifiers and modifications of classifiers.

Now a unit of evolution, a unit of change, you see, you get into the Kuhnsian sort of problem at once. Are you going to change the paradigm, which might be the pentadactyl limb, or are you going to change the way it works at a given moment? These are different orders of change.

P: I'm thinking of resolution. It has to do with change itself. The change I'm thinking of can't be decoded in terms of logical typing. It's like the starfish having its own internal system of communication about morphology and behavior. The number five may not be necessary to the communication system, and when we say it has "five arms" the statement is partly false, although it makes something of a bridge between our way of knowing and the way of the starfish. The Kleinform is in some sense a starfish. It has its own internal communication pattern.

G: Um-hum.

P: Which does not need logical typing any more than the starfish needs the number five.

G: Let me say what I understand you to have said. The Kleinform does not need logical typing. Now, as I understand it, a Kleinform is important to us in that you suggest that we should map what we find in nature, we should map our phenomena onto tautologies based on this essentially abstract form.

P: Not . . . not really. The mapping phenomena is probably more successful with logical typing in terms of explanation. You can explain the limb more successfully than it could be evaluated by attempting mapping it on a Kleinform...

G: By mapping it onto some other...

P: By mapping it onto a series of logical types.

G: Which is another tautological system, perhaps an overlapping one.

P: Perhaps.
Okay, Russell would say that to treat the relationship "is a member of" as intransitive is what generates the paradox. Is that a fair statement?
(Laughter.)

G: I'm not sure that's right for Russell...

P: But that would be how you would think of it.

G: Yes. Um-hum.

P: I would contend that in the Kleinform, explanation itself is intransitive.

G: Oohh. Am I using explanation in the same sense you are? I'm not sure. By explanation I would mean mapping a bunch of phenomena onto a tautology. The tautology being such that you cannot doubt the steps contained within it. The propositions you can doubt, but the steps you cannot. If P...then P...all right. This means that what is contained in the tautology is relations, only relations

P: Right.

G: In order to explain, we build a tautology and map the things onto the tautology. And in order to strengthen

our explanation we shall then go into what Peirce calls abduction and find other cases under that tautology.

P: I would say that there is no territory or phenomena that we're attempting to explain within the immanent understanding of the Kleinform. That the Kleinform offers an explanation of itself.

G: So it's a geometrical quasi-special tautology within itself. Its connections within itself are undoubted.

P: Yes.

G: Undoubtable.

P: And perceptible.

G: Perceptible in presentations of Kleinforms.

P: Right.

G: You don't have to represent, it's a convenience, it's nice.

P: Now I'm not sure what you mean by representation.

G: Well, you know, it's a bottle with a thing.
 (Laughter.)

P: Gregory, the insistence that you have that the map is not the territory. Okay. Axiomatic in terms of a way of approaching things.

G: That's old Korzybski, right.

P: Yes. As I understand it, this axiom is an insurance that logical typing not be confused.

G: The territory not to be confused with the map. Right. Don't eat the menu card.

P: Now, in the Kleinform that I'm working with, there are times in which the map becomes the territory and the territory becomes the map. One part would be explained by being contained by two other parts.

G: Right.

P: And in that instance we could call that the territory to be explained.

G: Wait a minute. So you draw the pictures. But these are not pictures of something. These are pictures about something.

P: There's no something as far as I can tell.

G: Oh, then, I don't know what you're at. I'm stuck again. Well, I can say what I understood you to be at. At wanting to describe, what shall we say, a process of embryol-

ogy. And within the embryology, there would be relations such that there would be whatever it is, these sort of descriptive statements you'd need to make about the embryology. And they would be related, as these three parts of the Klein bottle are related to each other. It would then be suitable to map them onto a Klein bottle. That's not what you're at.

P: No, no...it's not.

G: Then I got you wrong. And I was so proud of myself. I thought I was getting...(Laughter)

P: I feel it's close, somehow, but...Let me try it this way. This is not propositional. The intelligence here is not propositional.

G: The intelligence of no tautology in the end is propositional.

P: I didn't realize that about logical types. There's more flexibility there than I'd thought.

G: I mean, yes, there's Euclid. A mass of ideas about space which are secondarily translated into axioms and postulates. But primarily...it's a big picture. A changing picture and a picture which has this way, that way, sorts of things in it all the time. We pull that out into axioms, postulates and definitions and what not. And we build theorems and we map this and that onto that Euclidean stuff. In my language it's called explanation of that which is mapped onto that.

P: In your language I don't see the admission of the possibility that something might explain itself. Where explanation would become intransitive.

G: The relation between the phenomena and the explanation is now intransitive so that this relation is the same as that relation.

P: Not the same. But intelligible in terms of.

G: If A explains B, then B explains A. Intransitive in that sense.

P: All right, but you need a minimum of three to understand something positionally.

G: Yes, I agree. To give it a direction, a twist.

P: It's directionless, really. Non-orientable. It does not require assigning direction.

G: I want to know what language you use to talk about these positions. It seems to me that language is going to be bloody important.

P: The best avenue to that language I can find is in Peirce's categories of firstness, secondness and thirdness. In his later writings he claims that these categories are based on observation, and not language. I think that where you, Gregory, talk about the dichotomy of form and substance as being an unconscious deduction from the structure of subject predicate, that always rang very right with me. As it seems that, in fact, is the case.

G: Um-hum.

P: And there's no way to break that dichotomy using...

G: Subject-predicate.

P: Using subject-predicate.

G: Right, right.

P: So that this kind of positional thinking, which is complete and consistent, observable within itself without jumping to language, seems to hold the possibility of dealing with things without that dichotomy.

G: I've been spreading out some new sorts of approaches lately, just beginning, really. It would seem to me that an addiction, which may take only one person and a bottle, not two persons; to that extent, perhaps simpler to think about; tends to have a characteristic that if you take the next slug out of the bottle your immediate discomfort is going to be relieved; but over the long term, this is lethal. And if you're going to look at the long term and refuse the short term, you run the risk of very considerable pain and suffering, deprivation, and so on. This is a sort of double bind of some kind. It's a double bind between this level of context and this level of context. You oscillate between them, and neither of them is tolerable. Now, it is interesting that there are people, indeed perhaps all people, who deliberately put themselves into situations having this structure. They, for example, go mountain climbing. If you're halfway up the mountain

and your legs hurt, and you're hungry, and you're tired, and you're getting an ache behind the eyes, and you're pouring sweat and what else, you know. Obviously, the sensible thing is to sit down, eat your lunch, and go home. But mountain climbers, for some reason, perhaps best known to themselves or to God, in fact go on sweating it out, and deal not with the minor gestalt, but with the major gestalt. They get to the top of the mountain and may leave their bones there, as my friend Leigh Malory did. He's now on the side of Everest, somewhere. But I don't doubt he knew this was worthwhile. Why is it worthwhile? Well, it's worthwhile because this is the formal isomer, a formal pattern equated to a formal pattern, of the double bind thing. Presumably, when climbing a mountain, there is some sort of learning which is felt to be relevant to human deep values in some funny way. These are not double binds into which somebody puts you. You walk in there with your eyes open, having been there before last summer when you climbed Mont Blanc. This summer, for some goddamn reason, you've got to get up the Matterhorn.

(Laughter.)

Waiter: Can I get you gentlemen anything?

G: Can I offer you a drink?

P: Sure, why not?

G: I would like a *creme de menthe.*

P: I'd like a rusty nail.

G: I'll have mine frappe. This is very interesting. It obviously does not require that they explain to themselves what they are doing.

P: Right.

G: Perhaps the contrary. It might be bad for them to explain what they're doing. Now set against this is a very interesting observation of Samuel Butler. He remarked that if the headache preceded the intoxication, alcoholism would be a virtue.

(Laughter.) This is not a trivial remark at all. This has to do with the whole topology of relations and suffering and

discipline, all this stuff. And even being nice to one's friends.

P: "If the headache preceded the intoxication"...

G: The intoxication, the "high."

P: "Alcoholism would be a virtue."

G: Be like mountain climbing.

P: Right. For Aristotle, virtue was a habit of right reason and ease about something to be done.

G: And ease. Yes? That's nice. What was the Greek for "ease", I wonder.

P: I don't know. So you get the "ease", the "high", without the habit. So what's that difference, Gregory?

G: It's very subtle. Now I throw this out because it ought to be relevant to something you're doing.

P: It is, yes. I'm not sure just how, but it is. An addict is not just playing around. He has to take his habit seriously.

G: Then we're in the same ball park, somewhere.

P: Yes, and I would like to...leave the Kleinform alone and pursue...

G: Pursue drunkenness.

P: I remember once you said that until we understood the relation between orgasm and addiction, we don't really know much.

G: That's right. Did I say that?

P: You said it.

G: For addiction I said it, yeah?

P: The relation between orgasm and addiction. I thought it was...

G: For orgasm and these cumulative interaction things; schizmogenesis and so forth. There's a new piece of data around, by the way, on orgasm. Going the rounds. (Laughter.)

P: What have they got now?

G: The gossip is that the state department put up some money for research in dealing with jet lags. And a research team was formed to investigate jet lag, and they came up with their reports and all that, aspirin and so on. But the actual answer that was never published was that

the way to get out of jet lag was orgasm. (Laughter.) I don't know whether the story is true, or apocryphal.

P: The gossip from the ground crews at airports is that the flight crews ball like bunnies.

G: It would be nice to know, wouldn't it? For those of us who travel. Is there a difference between orgasm when you are traveling East?

P: And when you are traveling to the West? (Laughter) Resolves the directional confusion by blowing out...

G: Blowing out...

P: The orientation mechanism...

G: Those tubes...(Laughter)

P: So where are you going with the mountain climbing stuff?

G: Well, I don't know where to go with that. I'm sure it's just around the corner there. We've never known why a culture goes uphill. We know why cultures degenerate. Very obvious. They degenerate through laziness, muddleheadedness...you know. But why do they ever get more elaborate, more beautiful, richer? It obviously always pays producers to deteriorate the taste of their consumers . . . Hence our public relations system.

P: And television.

G: And television and all that, that's right. If there is anything sacred around in the culture, obviously the thing to do is to attack it, and attach it to a chocolate bar.

P: That's right.

G: Sell it with chocolate, and so on. Now it sounds like that business of the mountain climbers and addiction might have something to do with how cultures go upwards.

P: Awareness of a very broad gestalt.

G: Very deep, unconscious influence of a very wide gestalt. I don't think it's conscious, and I don't think it's even desirable. It should be in a sense. You and I will go mix in and make it conscious for ourselves...

P: And the business of addiction gets taken care of...You allow a lot of flexibility to the variables. So you are not forced into...

G: A narrow pathway...maximizing a single variable. So where does one go with such a thing?

P: How to keep it away from chocolate bars.

G: Yeah. Wilson's vinegar.

P: I don't know that.

G: The story of Wilson's vinegar? He sold vinegar. And he advertised in various ways. And, finally, he was an Englishman, he attended an American conference of advertising men. And they said he didn't do it right at all. You should come to us. And for half a million bucks we'll put on a campaign for you. And he said, "A campaign?" And they said, "Sure, we'll get Norman Rockwell, somebody that paints sacred pictures, to paint a sacred picture for you." What's vinegar in the Bible? Sure, sure, see. Christ on the Cross, the two thieves, and the centurion with a sponge on a stick, and the words, "Take it away, it isn't Wilson's."

P: Jesus. (Laughter.) How do you keep ecology from becoming a myth?

G: Oh, ho, ho. I don't know. It will, without the aesthetics.

P: Become the myth?

G: The aesthetic thing has got to be solved. This is the most important point, I think.

P: This may just be a catholic take, okay, but . . .

G: Yes, go on, I know...

P: But I'm fearful at times that your work will become used, without an understanding, as a kind of Thomism of ecology.

G: Could be, easily could be.

P: And your own capacity for sensitivity and aesthetic will be left by the wayside.

G: Left by the wayside. Yeah, I think this is quite probable. Already my publisher on the back of the book says this is a guide to inner space. (Laughter.)

P: That's why I want to push you on some of this stuff. I saw what an orthodox Thomism can do, Gregory. It's not pretty.

G: Yeah, I know, I know. And Saint Thomas was a very clever man.

P: You know, before he died he said it was all straw.

G: All straw? (Laughter.)

P: He said, "It's all straw." And they wouldn't believe him.

G: Poor man.

P: I think that's why I rail against the hierarchy.

G: Oh, yeah — that hierarchy.

P: I think as description it's elegant.

G: But how do you get away from it. The main thing is to keep the top open, I think. The number of steps in the ladder is not to be finite.

Who was it, somebody was in the office the other day asking if there were any Taoist priests. They wanted to be married by a Taoist priest. I said, "Of course there are no Taoist priests, that would be against the rules." (Laughter.) But I've no doubt there are millions of them.

P: Probably. It's the institutionalized rival. The marriage needs an institutionalized rival.

G: Yes, right. In a sense, to be married by a Taoist priest is a terrible contradiction, isn't it?

P: Yes. I got to thinking about priesthoods a few months back with that case of the nun in Syracuse who had carried a baby to term in the convent and they found the baby dead and stuffed in a toilet.

G: God, I didn't hear about that.

P: She was acquitted on the grounds of being temporarily out of her mind, and not responsible. I was thinking about it in terms of the controversy over women becoming priests. Perhaps priesthood based on sacrifice has had to be reserved to males because if the culture allowed the possibility of a woman performing an act of human sacrifice it would release the hatred of mothers toward neonates and destroy the loving bonds necessary for nurturing.

G: When I was working with schizophrenia, I thought about the fact that with all mammals, except humans, when the relation between the mother and the newborn is seriously disrupted, the mother eats the young.

P: Eats the young?

G: Eats the young. I couldn't do much with it at the time. The human inhibition against this seemed to have something to do with generating schizophrenia. Perhaps with Thom's models, something could be worked out.

P: Thom has fairly clear models of the relation between predator and prey. He regards the nervous system in a sense as an organ of alienation. The predator must allow itself to be dominated by the image of the prey, temporarily become the prey in order to effect capture. He uses a similar bimodal model to account for gestation. I always thought it had something to do with your double bind theory.

G: Perhaps it does.

G: Did you notice that plaque over there?

P: About the Rolls Royce?

G: About how to convert your Rolls into an armored car.

P: It reminds me of a French film I saw recently about the Holy Grail. Lancelot du Lac...The guy shoots mostly armored torsos. It was amazing. The beginning of the metallization of the human personality. Body armor and all that.

G: Ah, E.B. White did a book on King Arthur. I don't know where he got the stuff, but he had Merlin teaching Arthur to be a king. Of course Arthur didn't know he was being trained to be a king. One of Merlin's main techniques was to have Arthur become the various wild creatures in the forest.

P: Wow, I have some friends who are now doing something they call reinhabitory theatre. All the characters are animals native to northern California. They have one with a lizard and coyote going back and forth about how to create man. It's great.

G: You should tell them the story of Tuan MacCarill.

P: I don't know the story.

G: It's in a book of Irish Fairy Tales by James Stephens.

P: The man who did *Crock of Gold* ?

G: Yes, that's the man.

P: What is the story, Gregory?

G: It seems the Abbot Finnian heard about a powerful man in Ulster named Tuan MacCarill who believed in the old gods and the ancient ways. This the powerful Finnian did not like, so he went to the castle of the Ulster gentleman to preach and prove the new God. The Ulster gentleman barricaded his door so Finnian could not get in. But Finnian sat down outside and went into a meditation and fast that he would only be released from by admission, or death. After many days Tuan relented and let Finnian in. Finnian proceeded to instruct Tuan on the majesty and love of the new God. And Tuan was indeed impressed with the new doctrine, and pressed Finnian for more and more. Finnian finally felt the need of instruction himself, knowing that to only give and not receive was to allow the spirit to grow faint, and wisdom itself to grow bitter. So he persuaded Tuan to tell him about himself, starting with his genealogy. Tuan was reluctant, but finally relented. "I am Tuan, the son of Starn, the son of Sera who was brother to Partholon...and I am Tuan son of Carill, son of Muredac Redneck." "But how can one man have two fathers, and how can you trace yourself back to Partholon? He came to Ireland not long after the Flood," said the Abbot. "I came with him," said Tuan. Well, Finnian mumbled his prayers and sat back and listened as Tuan told his tale. "There were 24 men and 24 women in all when we came after the Flood. From these 24 couples came 5,000 people living in contentment with the fishes and animals of Ireland. Then suddenly a wind came up that brought a plague lasting for seven days, and when the plague was over only one man was left alive, myself. I was alone, and lived for years as a beast—forgetting the ways of man. And when after a great time I saw a fleet of ships with more people coming to Ireland I wept to think of my old age and loneliness. But a great storm arose and crushed the ships before they could land, and beat me into slumber. Then I dreamed, and I saw myself changed into a stag, and I felt a new heart, a strong neck, and new limbs. I awoke, and I was that which I had dreamed. I bounded and ran.

The world was new. I met all that came. I became the beloved, the well known, the king of the stags. But the anguish of my loneliness came to me again in old age. And the wolves came and forced me into the cave where I had been as an old man. And on the edge of my doom, I sank into a slumber—and I dreamed I saw myself changed into a wild boar, with a new heart and a strong neck and new limbs. And I awoke and I was that which I had dreamed. And I tore the wolves to pieces and became a champion of the boars killing bears and wolves, beloved among my tribe. I challenged all the creatures but one. Man had come again to Ireland. And there was sadness in my heart when I remember the people of Partholon and how I was listened to and loved among them.

"Old age again took me and I went to the cave and dreamed my dream. And I awoke and I was a hawk. I learned every nook and cranny in Ireland from the air.

"Old age came again, and I dreamed my dream. And in the dream I became a salmon. I awoke in deep waters, and was that which I had dreamed. In all my changes I had joy and fullness of life, but none like in the deep water. I had no encumbrance of limbs or wings. I was complete from head to tail. I could move with one movement. And I became the king of the salmon. And I ranged with my multitudes the world over, deeper and further than any salmon had gone. But I remembered Ulster. And there came in an instant an uncontrollable anguish to be there. And I knew I must reach Ireland or die. The task of getting there was incredible. But the brave heart of a salmon and the love of Ireland bore me on. I arrived near dead, but triumphant in the waters of Ireland.

"My strength returned and I delighted in the waters of Ireland. But all sought to catch me, and I received many wounds, especially from the men. I got no rest. My life became a ceaseless struggle, and then I was caught.

"The fisherman of Carill, the King of Ulster, caught me in his net and pulled me from the water. The air was

like fire, and the light blinded me, and he took me to his queen. When she saw me, she desired me. I was put on a fire and roasted, and she ate me. And as time passed, she gave birth to me. And I was her son, and the son of the King. And this is how I came to have two genealogies. And two fathers. And all these things I remember."

Shortly after this metalogue, Gregory went into retreat to work on his book. Six months later, with the book still undone, he was diagnosed in a San Francisco Hospital as having near terminal lung cancer. At seventy-four years of age, he politely refused chemotherapy, went home, recovered spontaneously and finished the book. In so far as cancer somehow signals our desecration of this planet, *Mind and Nature* can be read in terms of recovery. The text turns the reader's mind toward understanding nature as a slowly self-healing tautology. The implication is that by a clear understanding of the patterns that connect perhaps we can learn to affirm our part in the consistencies of nature rather than involve ourselves recurringly in runaway ruptures.

This is not an easy book. Fifty odd years of thinking about patterns in partridge feathers, courtship, the armaments race, computers, schizophrenic families, alcoholic addiction, porpoises, gurus, and students has honed a singular intelligence now recognized as seminal in this century. Seminal thinking is never easy to understand, even when the thinker gives us as articulate and mature a statement as *Mind and Nature.*

Bateson recognizes the difficulty. He explains how originally he intended to write two books. One was to be called *The Evolutionary Idea.* It was to be a reexamination of the theories about biological evolution in the light of cybernetic theory. The other was to be an explanation of very elementary ideas. The explanation was necessary in order to create an audience that might be receptive to *The Evolutionary Idea.* Because the school system has failed to provide people with an understanding of elementary ideas, the second book was to be titled, ironically, *What Every Schoolboy Knows.*

What Every Schoolboy Knows became Chapter II of *Mind and Nature*. The "formal and therefore simple" presuppositions for thinking presented there are not exactly easy strokes to learn, although Gregory's explications are consistently lucid. Educators in search of "basics" will be fascinated by this chapter. The list includes:

- Science never proves anything.

- The map is not the territory and the name is not the thing named.

- There is no objective experience.

- The processes of image formation are unconscious.

- Divergent sequences are unpredictable.

- Convergent sequences are predictable.

- Nothing will come of nothing.

- Number is different than quantity.

Besides this chapter of formal presuppositions, Gregory also presents his cybernetic biology. The chapter entitled "The Great Stochastic Processes" will, I think, become a classic. The glossary explains stochastic in the following way:

> If a sequence of events combines a random component with a selective process so that only certain outcomes of the random are allowed to endure, that sequence is said to be stochastic. From the Greek, *stochazein*, to shoot with a bow at a target, that is to scatter events in a partially random way, some of which achieve a preferred outcome (Bateson 1979: 230).

While the lexicon and level of abstraction of this chapter are the most difficult in a difficult book, working through the text yields a rewarding clarity. For my generation such clarity seems enormously important, if for no other reason than to finally get over the dreamy romantic hangover from the

random sequences of the sixties and start working for preferred outcomes in the eighties. Woe to a generation that cannot dream. Indeed, true. But even more, woe to a generation that cannot die to its dreams.

To praise Bateson is not to suggest that his fundamentals and tools of thought should be adapted by a school system or even by a society on faith. Indeed there are college deans and at least one state governor (Jerry Brown) who seem to be nibbling at Gregory with just such a possibility in mind. I tend to agree with the growing sentiment that without adopting some ecological orthodoxy we will be unable to correct our runaway destruction of this planet. However, to make of Bateson's work a kind of Thomism of ecology would be, in my judgment, a mistake. Used by Bateson, his tools of thought are elegant and beautiful. Wielded by a state orthodoxy they could easily breed ugliness and oppression, particularly in America.

British born and bred, Bateson speaks of a difficulty "almost peculiar to the American scene. Americans are, no doubt, as rigid in their presuppositions as any other people (and as rigid in these matters as the writer of this book), but they have a strange response to any articulate statement of presupposition. Such statement is commonly assumed to be hostile or mocking or—and this is most serious—is heard to be *authoritarian*" (Bateson 1979: 26).

Modern poets in the American grain have been among those fighting the articulation of presuppositions from across the Atlantic. William Carlos Williams speaks of going after Greek and Latin with bare hands. He shouts at us, "No ideas, but in things." Charles Olson goes after the hierarchies that presuppositions support.

> There are no hierarchies,...
> there are only
> eyes in all heads
> to be looked out of

But the poets cannot gainsay the clarity of Bateson's discourse nor what Bateson has seen through his own eyes, eyes trained in the skills of observation common to British

naturalists. Indeed, one of the things Bateson has seen and documented is a hierarchy among dolphins, albeit in captivity (Bateson: 1974). In my estimation for a native of this continent to resist the Benedict Arnold complex re the American Experience and reckon with Bateson, it is necessary to situate oneself in the philosophic tradition of Charles Saunders Peirce.

Peirce attempted to deal with whatever was, in any sense, present to the mind. He considered his phenomenology broader and more fundamental than the English tradition, which considers "ideas" as Bateson does. The very fact that the British have the habit of saying "There is no such idea" while at the same time describing the phenomenon in question rendered their approach too narrow for Peirce.

Let me acknowledge the major objection to Peirce. It is true that while he called for an architectural structuring of theory, he left us a haystack of texts pitchforked together. He failed to deliver what he said was necessary. My stance is this. I claim to have arrived at the logic of relationships Peirce pursued. Given this logic, it is possible to build the architectural understanding that Peirce intended. Such an understanding of mind would differ significantly from Batesonian orthodoxy. I fear a Batesonian orthodoxy would be authoritarian and nominalistic in character and ultimately become blind to the mind of nature so obviously alive in Bateson himself. On the other hand, a Peircean orthodoxy that reckoned with, but was not subsumed by Bateson's work, could maintain an adaptive openness to the realities of the ecosystem and have more chance of evading an authoritarian political structure. The politics would be more in the vein described by Hannah Arendt in her comment on Duns Scotus, a man whose work had a major influence on Peirce (Arendt: 1978).

Let me repeat I am targeting a possible scenario occasioned by a man's writing, not the man. The logic of relationships I am presenting was arrived at in part through dialogue with Bateson, study of his work and the work of his friend and fellow cybernetician, Warren McCulloch. Moreover a sympathetic Peircean reading of Bateson is possible. One can read Bateson's *pleroma* in terms of Peirce's secondness (resistance,

that which one struggles with, the brutal facts we are up against). *Creatura* can be read as thirdness (the realm of law, of habit, of regulation). Also, Bateson's own subjectivity can be understood as an instance of Peirce's firstness (freshness, uniqueness, spontaneity; being such without regard for any other). Moreover, Bateson himself has regard for Peirce and Gregory's work continues.

The logic of relationships that I contend makes Peirce viable was presented in the introduction to the above metalogue. In that metalogue I attempted to state Gregory's criteria for a unit of mind so that the logic of relationships could be discussed in terms of his criteria. In *Mind and Nature*, Gregory himself articulates his criteria. This articulation makes it possible to present the logic of relationships as a "unit of mind" in a more formal way which I do later on in this book in the chapter called "'A Sign of itself'."

Bateson's insistence on logical types has to do, I think, with a lack of appreciation for what Peirce calls prescinding, and for the realm of topology before the arrival of set theory. In some way that I cannot quite put my finger on, this is linked up with his preoccupation with a Euclidean mapping of perception (Bateson 1972: 487ff.). In Gregory's mind there is a strong necessity for orientation. Peirce's categories of first-ness, secondness and thirdness preclude orientation and can not be mapped onto Euclidean space. The Kleinform works completely without orientation. It embodies a positional intelligence. Left and right, up and down, front and back make no difference. Once the mind is freed to think position-ally without orientation a logic of relationships naturally ensues. While Gregory is well aware of the ambiguity of left and right he seeks to resolve that sort of ambiguity through a zigzag of logical typing in which one cannot tell a zig from a zag without labels. I do not think it works. Moreover, to my mind, he has never successfully come to grips with intransitive relationships as articulated by McCulloch in his 1943 paper on heterarchic values. Intransitivity remains an anomaly in Bate-son's thinking. Nor has he fully reckoned with the tradition of C.S. Peirce, a tradition more suited to making sense out of the rough and tumble of American experience. However intelli-

gent and magnificent this man's discourse is, it remains the discourse of an honored guest and not an appropriate architecture for our experience and future.

Of course, Bateson lives. Happily, we have not heard the last from him. The final chapter of *Mind and Nature* (Bateson, 1979) is a metalogue with his daughter in which he talks about writing another book, this one about the region where angels fear to tread. That book would deal with consciousness, aesthetics, the sacred, and the relationships between them. In speaking of it Gregory says the question is "onto what surface should a theory of aesthetics be mapped."

When I visited Gregory in the Spring of '79 I asked how the book was coming.

"Oh, I've got about a hundred pages done."

"Did you start with a surface onto which to map aesthetics?"

"No," he said, "The book is a living thing. I water it every morning and every evening with my tears."

PART FOUR: ECOCHANNEL, 1981-1985

My bioregional work in the Passaic Watershed had been successful in imagining reinhabitory cultures of place, but I felt much more needed to be done to develop policies and practices that would make reinhabitory culture a reality. Television remained a powerful medium for making changes in culture, potentially much more powerful than a magazine like *Talking Wood*. In 1981, after my stay in Gloucester, I moved to Hoboken, New Jersey and began working on a full scale design for a twenty-four hour television channel dedicated to monitoring the ecology. I named this channel the Ecochannel.

The Ecochannel design was made possible by three formal breakthroughs in my understanding of how to use Peirce cybernetically, all of which occurred during the bioregional period. These breakthroughs were technical in nature and resulted in a series of proposals for organizing information more effectively. This part of *Video Mind, Earth Mind* consists mainly of proposals for information structures, rather than substantive essays presenting new ideas. The analogy I made in the introduction between my work and the work of architects is most apt in this part of the book.

My first technical breakthrough was the formulation of a triadic decision-making process that emerged from a struggle to institute successful decision-making procedures at *Talking Wood* magazine. Secondly, I was able to comprehend Peirce's tenfold sign classification schema. The third technical breakthrough involved understanding Peirce's sixty-six fold sign classification schema and mapping it onto the relational circuit (pp. 217ff.). By mapping this elegant and complex classification schema onto my circuit, I was able to combine semiotics and cybernetics in a very powerful way. These three

technical breakthroughs are incorporated into various proposals included in this part. Both the triadic decision making procedure and the tenfold classification schema are assumed as usable in the Ecochannel design. The framework for the design itself is my mapping of Peirce's sixty-six fold schema in the relational circuit.

The mapping of Peirce's schema onto my relational circuit originally appeared in *Video 81* as a accompaniment to an interview I gave to artist/curator Willoughby Sharp, reprinted as the first piece in this section. In the chronological sequence of articles published in this book, I think this interview comes at an opportune time because it both sums up my work to this date and anticipates the ecochannel design.

During the five years I lived in Hoboken, I supported myself primarily by teaching in a variety of places. Wherever possible, I used the teaching situation to learn about computers. Conversations with my brother Tom, a computer professional and entrepreneur, were also helpful. I was trying to anticipate the coming synthesis of computers and television so that my Ecochannel design would not be obsolete before it was built. My work with computers concentrated on using this technology to facilitate cooperative learning.

I taught mathematics, science and computers at the Hudson Middle School in Hoboken and a prize-winning computer course for children at Stevens Institute of Technology. Out of this work came the proposal called "The Circuit." At the undergraduate level, I taught a course on "Media and McLuhan" at Ramapo College in New Jersey. Later, when Ramapo would entertain proposals for redesigning their facilities based on electronic media, I proposed a design for an electronic classroom. Some of the text from that proposal has been incorporated into "The Circuit."

At the graduate level, I taught a seminar on Bateson to graduate students in the Interactive Telecommunications Program at New York University. Bateson characterizes our dependency on technology as a form of addiction. One of the questions we pursued in that seminar was how to break our addiction to communication technologies. Working with the Telecommunications Program and the Alternate Media

Center, I proposed "Melusina," an approach to communications and social action that was not dependent on either video or computers. I also taught a graduate course in the Media Studies Department of the New School for Social Research on Computers, Information and Society. While there, I participated in a panel titled "Is the Computer Revolution Real?" I argued that the essence of revolution is to reposition humans in the universe. The Copernican revolution had done just that. Based on this definition of revolution I argued that the only way computers could claim to be revolutionary was to help redefine humans as part of a living planet, in accord with the cybernetics of James Lovelock's Gaia hypothesis, i.e., that Earth is a self correcting, living organism.

"A Design for Consensus along the Hudson" takes all of my work using computers for cooperative learning and applies it to the Hudson River Foundation's efforts to build consensus about environmental policies for the Hudson River. While this proposal did not get funded, the exercise enabled me to think through a strategy for incorporating consensus procedures into my Ecochannel design.

While in Hoboken, I received funds form the New York State Council on the Arts to write a major essay entitled "The Work of Art in the Age of Electronic Circuitry," which would relate art, electronics and the ecological crisis. I thought of this essay as a kind of theoretical prologue to the Ecochannel. My strategy was to key off Walter Benjamin's classic text, "The Work of Art in the Age of Mechanical Reproduction." Following Benjamin's own suggestion about understanding texts, I copied his entire essay by hand, read everything written in English I could find about Benjamin's work and wrote and rewrote my own eighty-page essay more than twenty times. Despite these efforts, I could not come up with a presentable and coherent piece. Consequently, I do not include the essay in this collection. However, over the next five years this essay did go through a series of transformations which resulted in a number of pieces included in this book: "A Genealogy of Video," " 'A Sign of itself'," "The Earthscore Notational System for Orchestrating Perceptual Consensus about the Natural World," and "Aura and Threeing."

In addition to my theoretical work, I produced four video-tapes during this period:

A Ritual of Triadic Relationships was a thirty-minute piece that included fifteen minutes of excerpts from the triadic tapes done during the Earthscore Period and fifteen minutes of fresh triadic tape done with members of the Renegade Theater Company in Hoboken. This tape was shown as part of the "Primitivism" in the 20th Century Art show at the Museum of Modern Art in 1984. I am not particularly happy with this videotape as a presentation of Threeing. Though fascinating and valuable as a tape that records behavioral experimentation, it does not attain the status of a stand-alone video art piece. It fails to convey to the video viewer the rich experience of Threeing. Rather, it puts on display emotions released by the practice of Threeing.

Where the Water Splits the Rock is a five-minute piece that presents thirty-five different waterflow patterns found at the Great Falls in Paterson. The patterns are sequenced from the top of the falls to the bottom and appear in five sets of seven. The first set shows folds in waterflow. The second set shows free-flowing water droplets. The third set of patterns shows the interface of water and rock, the fourth set is seven scans of the main falls, and the fifth set shows the interface between water and air at the foot of the falls. The idea behind this tape was simply to present patterns, or what I call "chreods" (pp. 386ff.).

Coast of Cape Ann is a seventeen minute study of the coast done during a summer visit to Gloucester. I did not have the time or the support to execute my "Video Score for the Coast of Cape Ann", so I worked spontaneously, intuitively. Partly this was to prove to myself I could do spontaneous video without being addicted to the categories in the score and partly it was to display my own idiosyncratic, unscored perceptions as a sample of the sort of tape that could also be played on a twenty-four hour environmental channel. I used a camera with reversed color fields, so the white surf showed up black and black birds showed up white. Perceptually, the tape is very engaging.

Ecochannel Design is a thirty-three minute tape that I assembled to help me present the idea of the ecochannel in public. In addition to the tape of the Great Falls in Paterson, it includes a ten-minute study of the Hudson Estuary that moves up the river from Jersey City to Storm King Mountain using alternate sites along the river, selected because they provide continuous line-of-sight views of the river. I videotaped from the sites on the west side of the river at sunrise and sites on the east side of the river at sunset. A single, continuous, handheld camera movement, scanning the river, is shown. *Ecochannel Design* also contains computer generated images of "chreods" and a short piece titled *Mozart on Ice*, which uses a passage from Mozart as a sound track accompanying melting ice. In this piece, I was trying to combine the structure of classical music with video perception of the environment. I realized that there were many genres of musical intelligence such as classical, jazz, Latin, Native, and new music. I thought that if the intelligence embodied in the minds and hearts of those who appreciated these genres could be linked up to video perception of the natural world, it would go a long way toward enhancing people's appreciation of nature.

By the end of this period, I had developed a full design for a television channel dedicated to the ecology. The Ecochannel design itself was first presented in a lecture with accompanying videotapes at the Museum of Modern Art in 1985. The invitation to the presentation included the poem, "Living Between Ice and Fire by the River that Runs both Ways," reproduced here. *IS Journal* published "The Ecochannel Design" in 1987. As the reader will see, the design is presented as a kind of TV guide to programs on the proposed channel. But this guide is not a mere laundry list of desired programming. Each of the programs presented is keyed to one of the sixty-six fold sign classifications of Peirce that I mapped onto the relational circuit (pp. 217). In effect, by imagining programming for each of the sixty-six classifications, I generated a coherent set of programs. In addition to presenting my design for a television ecochannel at the Museum of Modern Art, I have presented it at the Cathedral of St. John the Divine in New York City, the First National

Audubon Society Conference on The Gaia Hypothesis, The First International EcoCity Conference in Berkeley, California, and The World Congress of Local Governments for a Sustainable Future, which met at the United Nations. Essentially, the Ecochannel is a design for a television channel dedicated to monitoring the ecologies of a region and developing consensus among inhabitants about sustainable polices and practices for that region.

From Teenage Monk to Video Bareback Rider

A Willoughby Sharp Interview

WS: Who are you, Paul Ryan?

PR: For the readers of *Video 80/81*, I'm someone who rode the video anomaly for nine years, from '68 to '76, and have had the last five years to think about it.

WS: What do you mean "video anomaly"?

PR: An anomaly is something that doesn't fit normal expectations...

WS: Like a five-legged dog?

PR: Like a five-legged dog. When I started with portable video it was brand new. You edited by developing the sync marks on the video tape with a chemical solution, cutting the video tape, lining the marks up on a splicing block and taping the two ends together. In that first rush it seemed that video would fit everywhere. In fact, it didn't really work anywhere.

WS: Can you be specific?

PR: Well, the normal expectations of the educational world were conditioned by the linear, sequential pattern of print. They didn't know what to do with the feedback loops video provided, so video equipment got locked in closets. The psychotherapeutic community was used to dealing with the "subconscious" based on dreams and interior monologues. Seeing evidence of the subconscious suddenly embedded on video tape by the movement and posture of the body was data that they couldn't deal with. Lots of grassroot radicals began gathering information on video that they felt was politically relevant, but the political procedures don't really include ways to handle replayable events, candid information, or

"on the street" interviews. Only the art world with its "tradition of the new" was willing to deal with video at all.

WS: Thinking of video and art then, it's probably fair to say that there were two basic brands: "Video Art" and "Art Video." People like Bruce Nauman, Terry Fox, Vito Acconci were established visual artists before they were videoists; they put their art before their video. The other group, the Raindancers, the Videofreex, People's Video Theatre and allied video makers, used video as their primary medium and came from video into art, rather than the other way around.

PR: Yes.

WS: You are among a whole group of early people who were devoted to video to see what it could do, and if it could be seen as an art, so much the better. What were the things you did with video then?

PR: I learned from working with video and Montessori kids for six months. I did a lot of feedback with myself, hanging the camera from the ceiling, running around, living with it for years. Worked with high school kids and cable TV. Worked with actors. Did a lot of consulting work. Did a piece in the Howard Wise "TV As A Creative Medium" show where people could see themselves on video in private, and then have it erased. Worked with the alternative video group, Raindance. Did a twelve-hour *Video Wake for My Father* when he died suddenly of cancer in the spring of '71. Later, in '76, I reenacted the wake—live—at the Kitchen Center.

WS: Was that all you did ?

PR: No, I also used video in an attempt to create an intentional community that would use video for self-correction. Ideally, the community would decode the ecology and feed it back to a local community over cable TV. I also invented a repertoire of behavior patterns that would work for three people the way Yoga works for an individual. I developed a method of video camera work based on T'ai Chi movement. Developed a video landscape methodology at the Great Falls in Paterson for six

people. Spent a year studying a waterfall with a video camera. Wrote essays about video for *Radical Software*. My writings were published by Doubleday Anchor in 1974 under the title *Cybernetics of the Sacred*.

WS: How did you get on to the "video anomaly"?

PR: I understand the experience in terms of evolution. When the forms that organize life no longer work, no longer hold things together, a sporting time ensues—a search for new forms. When the sporting time of the 'sixties hit, I was in a Roman Catholic monastic preaching order. I left in February '65, found my way to McLuhan and worked with him at Fordham University in '67-68. During that year, I got hold of some Sony portable video equipment and went sporting for new forms.

WS: You were in a monastery?

PR: I was a teenage monk. (Laughter)

WS: From a teenage monk to a video bareback rider. From something very old to something very new. Exploring anomalies is supposed to yield new paradigms. Have you a new paradigm, a new model?

PR: Yes.

WS: Tell me about it.

PR: Well, it starts with the piece in the Howard Wise show, *Everyman's Möbius Strip*.

WS: I remember your work first from Howard's show on 57th Street. Was that the first time you showed in an art gallery?

PR: Yes.

WS: How did that happen?

PR: I was reluctant to do it. I didn't think of myself as an artist but ...

WS: How did you get involved?

PR: Howard Wise called me at the suggestion of Nam June Paik, whom I had just met through his Bonino Gallery show. He was interested in me, partly because I was working with McLuhan and partly because I had equipment in my home and was doing work. So Howard asked me to exhibit a piece. That put me in a quandary because

I thought that showing in an art gallery was something not ...

WS: You hadn't done it before. And your work wasn't produced with that kind of installation in mind?

PR: No.

WS: So you had to decide what to do in that kind of a situation.

PR: Right. So what I constructed was this private booth, *Everyman's Möbius Strip*. A videotape of a person was fed back after the recording and then erased.

WS: You brought your own equipment into the gallery and put it in a confessional-type booth didn't you?

PR: Yes.

WS: Explain what the piece looked like.

PR: The participant walked into a curtained-off corner chair. An audio tape started that ran for two minutes taking them through some very gentle exercises like, "Touch your face," "Yawn"...

WS: They were on camera?

PR: Yes, but they couldn't see themselves. No monitor. "Touch your face." "Scratch your neck." "React to certain people." Things like that. Then the tape was stopped and played back for them alone.

WS: How?

PR: An attendant, who worked with the piece all the time, turned the monitor on and let them see themselves on a video tape. They understood that they were the only ones who would see it. I was very interested in the process and the possibilities that video seemed to allow.

WS: Then the next recording was taped on top of the first?

PR: And the other was erased.

WS: How did you decide upon the work?

PR: I was thinking about how TV could work as a creative medium; you know, "TV As A Creative Medium." I never went to art school. I don't know the jargon; I don't know the vocabulary. I'm not that interested. I am in a very deep sense but not in the ...

WS: Yes.

PR: So, it just seemed to me that that was a legitimate thing to do—to provide people with the experience of themselves rather than a painting one could do or an object.

WS: How is that an anomaly?

PR: People don't expect to go into a gallery and see themselves in private on a videotape that will be erased. It's an experience that doesn't easily fit into the art tradition. But the more subtle anomaly involved was the difference between video feedback and mirror feedback. If you attempt to shake hands with yourself in a mirror, the simulation will not work. If you attempt to shake hands with yourself in a video feedback situation, the simulation will work. There is no reversal of image. This manner of taking in your outside can be mapped onto the Möbius strip. The Möbius strip is what you get when you take a long piece of paper, give it half a twist and tape the ends together. Now, the Möbius strip is itself an anomaly—a mathematical curiosity from the last century that really doesn't fit. It has no orientation. No up/down, no front/back, or inside/outside. The model or formal paradigm I developed involved moving from the Möbius strip to a six-part relational circuit, a complete and consistent non-orientable circuit which makes it possible to use the phenomenology and semiotics of C.S. Peirce cybernetically, in communications and telecommunications applications.

WS: Can you give me a brief description of your take on Peirce's phenomenology and semiotics?

PR: I can, but it's pretty abstract stuff.

WS: Be brief.

PR: In Peirce's understanding, every phenomenon in the mind can be comprehended in three irreducible categories: "Firstness," "Secondness" and "Thirdness." Firstness is the category of spontaneity, freshness and originality. Secondness is reaction/resistance—being up against the "thisness" of something. Thirdness is the category of mediation between firstness and secondness— of law, regularity and habit. Out of these categories he developed semiotics, or the inquiry into signs. A sign is

something that stands in place of its object, for an interpretant. His three categories exfoliate into sixty-six sign classifications.

WS: What does Peirce, the American philosopher with his sixty-six signs, have to do with your idea of cybernetic communications?

PR: Among other things, communications is the creation of redundancy patterns. Cybernetics understands creating redundancy patterns partly in terms of self-correcting circuits. Self-correcting circuits allow one to identify and eliminate error in establishing communication. The more coherent and complex the circuit, the more capacity it has to identify and eliminate error. The six-part "circuit" I developed out of the Möbius strip anomaly makes it possible to use Peirce's three categories and sixty-six signs to create very reliable electronic communications systems. The "relational circuit" is both simple — in that it is based on three irreducible categories — and complex — in that it has, in effect, sixty-six subcircuits (pp. 217ff.).

WS: From "Everyman's Möbius Strip" to "Ryan's Relational Circuit." How long did it take?

PR: Over a dozen years.

WS: Why did you concentrate so much on relational circuits rather than on, say, producing and promoting your own tapes?

PR: It just seemed to me that without the development of some formal principles, the real cultural opportunities inherent in video would be lost. The real possibilities of video would stay mired in a spaghetti city of narcissism, careerism, mythology and madness. You don't get beautiful, free-standing Greek statues by chance. Without a principle like *contrapposto*, stone remains stone.

WS: Why do you think that you got hooked on the Möbius strip anomaly in video?

PR: Well, I was always fascinated by the non-orientation of the Möbius strip. The reflexes in my body are oriented in opposition to most people. I mean, I'm left-handed and in things like high diving I find it easier to throw my

chin up and flip backwards. Most people find it easier to tuck their chin and flip forward. For me, it's easier to do a full gainer-go off the diving board frontwards and flip backwards—than do a simple front flip. Somehow the fact that in the Möbius strip up and down, left and right, front and back didn't matter—somehow that fact got me going. Some of the early tapes I did with video infolding and feedback could be taken as a series of back flips with a left-handed twist. And, of course, I parachuted into the culture of the sixties from a medieval monastic life. I was on the alert for whatever clues might help me make sense out of what was going on. Anomalies are cultural clues.

WS: When were you in the monastery?

PR: I went into the Passionist Monastic Order after high school in September 1960 and stayed four and a half years, until February 1965.

WS: Why did you go into the monastery?

PR: I thought I had a vocation, a special calling in the Catholic sense. Andrew Ansbro, a preacher from this order, came through my high school with an incredible impact and I decided to apply there. In retrospect, I was looking for something challenging, something that would demand discipline. Partly, I think that I had an under- lying fear that without it I would have trouble with the drink, as my father had. Addiction and asceticism. The decision to go into the monastery lies somewhere in there.

WS: What was it like?

PR: Chanting for two and a half hours a day, including breaking your sleep in the middle of the night for an hour. The chanting was part of the liturgy, the Opus Dei, singing the praises of God. Meditation for another hour and a half. Solitary walks. Silence. Lots of studying, mainly philosophy and spirituality. Meals in silence, sometimes with a spiritual book being read aloud. After meals, brief periods for talk. One day a week for recre- ation, a day of manual work.

WS: Did you like it?

PR: Oh, yes, That's an old tradition, monasticism, they know how to get high and stay there. The order I was in had lots of good men. Real joy in community. I had a master of novices whose explanation of love included Aquinas's understanding of the role of charity in the pursuit of wisdom and Carson McCullers's insights in "A Tree, A Rock, and A Cloud." I was young; I believed it all. It all worked. I had a friend there who used to say, "Some people are called to serve God; we're called to enjoy Him."

WS: Did you take vows?

PR: Yes, temporary vows of poverty, chastity and obedience.

WS: Poverty?

PR: I owned nothing. Not even underwear. We shared the 'reggies'. Every week they'd issue you two sets of these great flannel European 19th century underwear that one wore under one's robe. The vow of poverty left your mind very free. No worry about rent, food, clothes, bills, etc.

WS: Chastity?

PR: No women. Out of sight, out of mind (mostly).

WS: Obedience?

PR: Worked great when there was faith. When the doubts came with the Vatican Council, it was rough. You'd be given orders just to reinforce authority. Blind obedience. We called it "watering the dry stick."

WS: Tell me more.

PR: There was also a special vow to preach the Passion of Christ. The order had been founded in the north of Italy in the 1700's by a man named Paul Daneo to preach to the poor. The ideal was six months of monastic contemplation and six months on the road preaching the Passion. The order was called "The Passionists," and its founder is Saint Paul of the Cross. The monks told a story about him I really like. As an old man, he was once seen shaking a stick at the garden flowers. "Quiet, quiet," he was saying, "you shout too loud of the Glory of God."

WS: Why did you leave?

PR: It was complex ... A group of us got radicalized by a new understanding of the Catholic Church coming out of the conflicts in the Vatican Council in 1964. Out of my original class of about thirty "postulants," only four were ordained.

WS: From a monk to an artist. From the ascetic to the aesthetic. If you were to found an aesthetic order now, Paul Ryan, what would it be like?

PR: The death throes of faith as the birth pangs of art—it's a good question. The ascetic orders of the West are a sort of holding action against the destructiveness of resentment. The hope that these orders hold is that the human species would someday be free of resentment, jealousy and revenge. Now these emotions arise mostly when one is excluded. The slave resents being excluded from the master's power. The jealous lover is one who fears his or her place will be taken by another. In a sense, a monk is a voluntary exile who would rather be cloistered than become what Nietzsche calls a "whirl of revenge."

WS: I see that you have read Nietzsche closely. Are there other authors who have influenced your thinking deeply?

PR: Besides Peirce and Nietzsche, Gregory Bateson, Rene Thom, Wallace Stevens, Warren McCulloch and Marshall McLuhan have been important to me. But, to continue this business of resentment and exclusion: it has deep roots in human interaction. I did over thirty hours of people spontaneously interacting in sets of three. One pattern recurred: two persons would combine to exclude the third. The function of the triad is to reinforce the dyad. The third party is extruded in the process. Now, in the face of this extrusion pattern, what I did was set out to "invent" triadic behavior. I can show you a series of tapes done from '71-76, The Triadic Tapes, five and a half hours edited from about forty-five hours of raw tape, they are half-inch black and whites and they embed the invention process. What I actually invented was a relational practice that works for three people the way yoga works for an individual. Yoga practiced on a regular basis can stabilize health. The relational practice,

done regularly, can stabilize a three-person interactive process in which no one is excluded. In normal experience, our health begins to break down without some exercise like yoga. In normal three-person interaction, the relationships are routinely subsumed by acts of choice. The dynamics between Tom, Dick and Jane are normally such that Jane is forced to choose between Dick and Tom. In the relational practice, the effects of choice on relationships are neutralized.

So, to begin to answer your question, Willoughby, I would base an aesthetic order on this relational practice. The practice is inherently aesthetic. It frees people from the fear of being forced to choose one over another and allows the sort of choices that go on in a painter's mind as he builds relationships among colors.

WS: Would there be a vow of poverty in this order? How would such an operation be supported?

PR: It would probably need an endowment to get going, but such an order would have to make its way in the information economy. Rather than a vow of poverty, engage in intransitive profit taking.

WS: Intransitive profit taking?

PR: We're moving from an energy/money economy to one based on information. Information is a matter of differences that make differences going around a circuit. Video production, to video distribution, to home viewing, to changes in habit that viewing makes, around to how these habits effect further video production. Each transformation of difference represents a possible locus of profit taking. But if the profit taking is such that you fail to cultivate the circuit or break the circuit, you're destroying your chance for long-term stability in the information economy.

WS: Say more about this information economy.

PR: It's just emerging. It's not clear what shape it will take, so in a way it's only possible to make broad generalizations that appear obvious. Certainty is at a premium and, as always, error is expensive. Creating coherent redundancy patterns generates certainty; identifying and eliminating

error saves money. For an organization to make it in the information economy, be it aesthetic order or whatever, it needs the sort of capacity to generate certainty and eliminate error that the relational circuit I described to you earlier makes possible.

WS: And would this aesthetic order have a vow of obedience? Would they water the dry stick?

PR: Obedience is a notion linked up to language commands. As children the developing integrity of our perceptual system is stunted and linked up to language commands. "No. Don't touch. The oven is hot." Using video and the relational practice, it would be possible to develop a system of information transmission married to environmental realities and not competing and often contradictory commands of various language authorities. The work of this aesthetic order would be to produce such a system based on a shared perception of the environment. They would take their orders from the figures of regulation they found in the ecology. They would not be wasting time watering the dry stick.

WS: What about sex? Would there be a vow of celibacy in this triadic aesthetic order?

PR: Only for you, Willoughby, only for you.

WS: C'mon, I thought I was in for a *menage a trois*.

PR: To work triadically to develop a shared perception of the environment is one thing; to fiddle with the propagation of the species is another. Pair bonding protects the possibility of a next generation, and to attempt to undo that mechanism might be just plain stupid. We could wind up with geriatric trisexuals without any young to care for them. We're not a trisexual species, that much is clear. Our bisexuality allows us four possible cases of triadic combinations: three males, three females, two males and a female, and two females and a male. Given these combinations, there are a number of ways people could organize their sexual differences triadically. One way would be celibacy, the way the Shakers did it. Another would be to preserve monogamy and let committed couples work in sets of three to reinforce their relation-

ships. The relational practice could also be used to help stabilize family interaction. Opening up a pattern of recombinant triadic relations that included sexuality is as explosive as it is fascinating. The closest that people have gotten to this as far as I know is the Oneida Community, which survived for thirty-five years and generated children without monogamy.

WS: How did they do that?

PR: Partly through the charisma of the leader, Noyes, partly through a mechanism whereby every act of copulation was mediated by a third party. No one was ever approached directly. One major question would be whether the relational practice could be used to restructure the primitive emotions to allow a group of people to engage in trisexual interaction gracefully. Yoga has its Kundalini; I don't know if this relational practice could have an explicit sexual extension. Don't even know if it's desirable. It's the sort of thing that could be explored in a context clearly marked experimental video art, but it's not the sort of thing to fool around with in one's life.

WS: So why not start an aesthetic order?

PR: It's certainly something to think about beyond being just a useful device for this interview. With James Watt now running the Department of the Interior, backed by the Moral Majority of Bible readers, it does seem that traditional religion and the Federal government are both courting the destruction of the world. We seem to need to try other forms of institutions that will take long-term responsibility for the ecosystem of the planet. An aesthetic order that produced an electronic signal system about the environmental limits might be worth trying.

WS: You have a heightened sense of our endangered planet that has motivated a lot of your work. If you had a cable channel at your disposal in an urban setting—say New York—what would you do with it? What difference might it make in dealing with our endangered planet?

PR: That would be a tough proposition. Since I moved to Hoboken, I've spent a lot of time down by the water thinking about this sort of thing. The problem is that

New Yorkers live on a space platform. They don't know that they live at the foot of the Manhattan fiord; that the Palisades were gouged by glaciers; that we have a salt water/fresh water estuary ecology to care for. New Yorkers think that the nuclear issue belongs to foreign affairs; they have no idea that the issue is in their backyard. At the top of the fiord is a precambrian rock formation loaded with high-grade uranium. That's something to reckon with.

WS: So what would you do with a cable channel?

PR: I would use Peirce's phenomenology and semiotics to make it possible for people to ground their intelligence in a sharable perception of the actual place we live in. I would use the wire architecturally to make sense out of the bioregion we live in. We're a coastal city at the foot of the fiord, in the Eastern Woodlands. The cable channel would address water issues, food sources, local energy issues, questions about living in this place in terms of long-range biological continuities.

WS: Most people aren't in touch with that.

PR: I agree, it's difficult. Part of the reason is that the media so far has induced us to forego the unmediated experience of each other and of our environment. I would use the cable channel to encourage people to get out and get to know the place they live in through their skin.

WS: You mean what people see on cable they could also go out and see live?

PR: Exactly. Gain some direct understanding of how the perceptible living biosphere actually functions here. The shared perception of the environment via cable could be verified by live perception of the real environment.

WS: That's very interesting. You can't do that with CBS. But if your community had a wire to the bioregion and a lot of programming had live parallels, you could choose between live and video and learn about the difference. Sounds hot. Final question. How would you locate your principal contribution to the culture?

PR: My chief contribution is the principle of the relational circuit. I would locate that principle in terms of cultural

evolution. I think that principle makes possible two things that were not possible before. One is the relational practice, which may eventually be able to free us from resentment. The other is the possibility of an information transmission system based on shared perception of environmental realities, something never before done in our evolution.

Mapping Peirce's 66 Signs Into The Relational Circuit (Graphics)

According to Peirce, a sign is something (a first), which stands in place of something else (a second), for somebody (a third). This definition yields ten divisions of signs each with three different modes.

1. Signs in Themselves
 a. Qualisign
 b. Sinsign
 c. Legisign

2. Immediate Objects in Themselves
 a. Descriptive
 b. Designative
 c. Copulant

3. Dynamoid Objects in Themselves
 a. Abstractive
 b. Concretive
 c. Collective

4. Destinate Interpretants in Themselves
 a. Hypothetical
 b. Categorical
 c. Relative

5. Effective Interpretants in Themselves
 a. Sympathetic
 b. Percusive
 c. Usual

6. Explicit Interpretants in Themselves
 a. Gratific
 b. Practical
 c. Pragmatistic

7. Connection of Signs with Dynamoid Objects
 a. Icon
 b. Index
 c. Symbol

8. Reference of Signs to Effective Interpretants
 a. Suggestive
 b. Imperative
 c. Indicative

9. Representation by Signs for Explicit Interpretants
 a. Rheme
 b. Dicent
 c. Argument

10. Assurances of Interpretants by Signs
 a. Assurance by Instinct
 b. Assurance by Experience
 c. Assurance by Form (Habit)

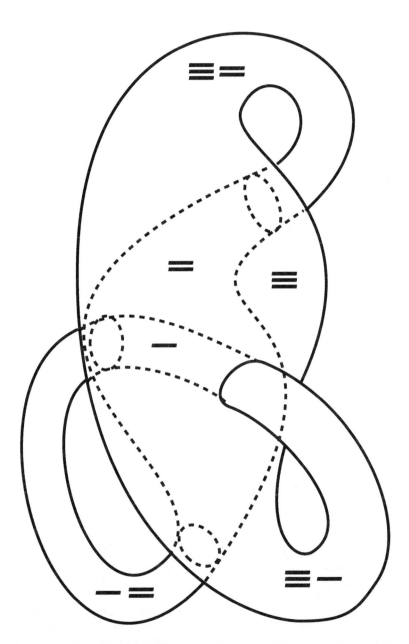

Figure 19. The Relational Circuit provides six positions including a position of firstness (–), a position of secondness (=), and a position of thirdness (≡). (This same figure also appears on page 103.)

	3	2	1	4	5	6	7	8	9	10
1.	a	a	a	a	a	a	a	a	a	a
2.	b	a	a	a	a	a	a	a	a	a
3.	b	b	a	a	a	a	a	a	a	a
4.	b	b	b	a	a	a	a	a	a	a
5.	b	b	b	b	a	a	a	a	a	a
6.	b	b	b	b	b	a	a	a	a	a
7.	b	b	b	b	b	b	a	a	a	a
8.	b	b	b	b	b	b	b	a	a	a
9.	b	b	b	b	b	b	b	b	a	a
10.	b	b	b	b	b	b	b	b	b	a
11.	b	b	b	b	b	b	b	b	b	b
12.	c	a	a	a	a	a	a	a	a	a
13.	c	b	a	a	a	a	a	a	a	a
14.	c	b	b	a	a	a	a	a	a	a
15.	c	b	b	b	a	a	a	a	a	a
16.	c	b	b	b	b	a	a	a	a	a
17.	c	b	b	b	b	b	a	a	a	a
18.	c	b	b	b	b	b	b	a	a	a
19.	c	b	b	b	b	b	b	b	a	a
20.	c	b	b	b	b	b	b	b	b	a
21.	c	b	b	b	b	b	b	b	b	b
22.	c	c	a	a	a	a	a	a	a	a
23.	c	c	b	a	a	a	a	a	a	a
24.	c	c	b	b	a	a	a	a	a	a
25.	c	c	b	b	b	a	a	a	a	a
26.	c	c	b	b	b	b	a	a	a	a
27.	c	c	b	b	b	b	b	a	a	a
28.	c	c	b	b	b	b	b	b	a	a
29.	c	c	b	b	b	b	b	b	b	a
30.	c	c	b	b	b	b	b	b	b	b
31.	c	c	c	a	a	a	a	a	a	a
32.	c	c	c	b	a	a	a	a	a	a
33.	c	c	c	b	b	a	a	a	a	a

Fig. 20. Following the general rule that a first cannot determine a second, nor a second determine a third, Peirce combined his ten trichotomous divisions of signs to arrive at an array of sixty − six signs (after Lieb: 1977).

	3	2	1	4	5	6	7	8	9	10
34.	c	c	c	b	b	b	a	a	a	a
35.	c	c	c	b	b	b	b	a	a	a
36.	c	c	c	b	b	b	b	b	a	a
37.	c	c	c	b	b	b	b	b	b	a
38.	c	c	c	b	b	b	b	b	b	b
39.	c	c	c	c	a	a	a	a	a	a
40.	c	c	c	c	b	a	a	a	a	a
41.	c	c	c	c	b	b	a	a	a	a
42.	c	c	c	c	b	b	b	a	a	a
43.	c	c	c	c	b	b	b	b	a	a
44.	c	c	c	c	b	b	b	b	b	a
45.	c	c	c	c	b	b	b	b	b	b
46.	c	c	c	c	c	a	a	a	a	a
47.	c	c	c	c	c	b	a	a	a	a
48.	c	c	c	c	c	b	b	a	a	a
49.	c	c	c	c	c	b	b	b	a	a
50.	c	c	c	c	c	b	b	b	b	a
51.	c	c	c	c	c	b	b	b	b	b
52.	c	c	c	c	c	c	a	a	a	a
53.	c	c	c	c	c	c	b	a	a	a
54.	c	c	c	c	c	c	b	b	a	a
55.	c	c	c	c	c	c	b	b	b	a
56.	c	c	c	c	c	c	b	b	b	b
57.	c	c	c	c	c	c	c	a	a	a
58.	c	c	c	c	c	c	c	b	a	a
59.	c	c	c	c	c	c	c	b	b	a
60.	c	c	c	c	c	c	c	b	b	b
61.	c	c	c	c	c	c	c	c	a	a
62.	c	c	c	c	c	c	c	c	b	a
63.	c	c	c	c	c	c	c	c	b	b
64.	c	c	c	c	c	c	c	c	c	a
65.	c	c	c	c	c	c	c	c	c	b
66.	c	c	c	c	c	c	c	c	c	c

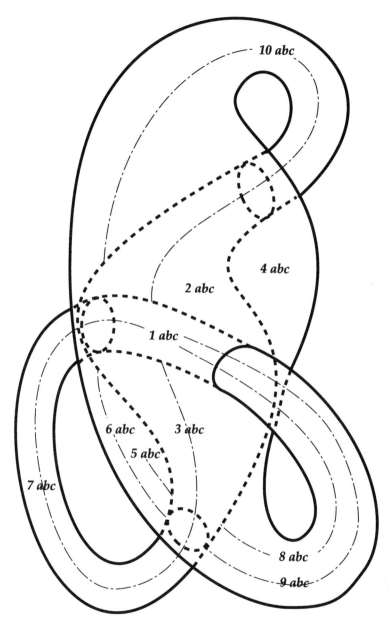

Fig 21. The Relational Circuit (Fig. 19) provides six different positions including a position of firstness (−), a position of secondness (=) and a position of thirdness (≡). Figure 21 shows how the sixty−sixfold sign schema, which Peirce exfoliated from the three categories of firstness, secondness and thirdness, can be mapped into the positions provided by the relational circuit.

The Circuit

A report to the education department of the New York State Council on the Arts about a pilot program in computer education

Since 1970, the New York State Council on the Arts has supported a range of video experimentation. In 1984, mindful that Governor Cuomo was considering dispersing educational funds through the Arts Council, the Media Program at the Council began asking what educational value the years of video experimentation might have.

With Council support, Earthscore Foundation had been initiated in the early seventies to research and develop ways in which a community could use a cable TV channel to understand their local ecology. Based on that research, as Director of Earthscore Foundation, I applied for and received a small grant in 1984 to explore the possible educational application of that research, especially as applied to the Hudson River ecology. Specifically, the grant was used to investigate whether an aesthetic form I developed in video could also be used as a learning circuit with computers.

During the Spring 1984, Earthscore Foundation matched the Art Council grant with a contract from the Hudson School for a classroom computer project. The project included giving middle school students hands-on use of computers and developing the school's computer curriculum.

"The Circuit"

The overall project was called "The Circuit." The name worked well. Students talked of "getting into" the circuit and "breaking" the circuit. Basically, The Circuit allows three students to establish stable roles for communicating with each other so they can learn together. Normally, interaction among three students will degenerate into two against one. The Circuit provides a framework for a practice, called

Threeing, that precludes such degeneration and reinforces three-party interaction. The practice is taught by outlining the circuit on the floor and showing the students how to move through it, much like hopscotch. The moves are simple. A sixth grade class learned them within a half hour. In discussion with that same sixth grade, it was clear that they readily understood the problems with two-against-one dynamics from experience with their friends and siblings.

An idea of how The Circuit would work with computer learning is given in the following hypothetical, interactive computer program:

Computer: Welcome to The Circuit. Please tell me your name.
Student: Mark.
C: Mark, is there anybody else on The Circuit with you?
M: Yes.
C: Please ask them to type in their names.
Students: Sara. George.
C: Welcome, Sara, George, and Mark. We'll get started by asking three questions, one for each of you. After you answer, type your name. Who is your report for?
S: The class.
C: Thank you Sara. What is it about?
M: The Hudson River.
C: George, will it be a report that is written, or spoken or both?
G: Both.
C: OK. Your assignments, should you choose to accept them are:
 Mark, research the Hudson River. Sara, find out what the class already knows about the Hudson River. George, present the report. OK?
Students: OK. OK. OK.
C: George, You're the one who will actually write and present the report to the class. Do you think that makes you the boss of Sara and Mark?
G: Yes.

C: No! Not in The Circuit. In The Circuit it takes three to be boss. The Circuit figures the three of you will be talking to each other and getting along. If Mark or Sara disagrees with you and convinces the other to disagree and they both convince the teacher that you are wrong, then those three are the boss of you.

If these three can't agree, then you are still the boss of applesauce, excuse me, the boss of the presentation. You make the decision. OK.

G: OK.

C: Now, here's how The Circuit works. Mark, you have a procedure called River Research. It will give you a menu to help organize your research. Sara, you have a procedure named Class Research. It will give you a series of questions to ask the class to find out what they know about the Hudson River. George, you have to work from Mark's research and Sara's questionnaire. What you will find is that both deal with the river in terms of feelings, facts and laws of the river. Your present program will help you organize your presentation in terms of feelings, facts and laws. Any one of you can get help on your part of the project by asking for help from the other two.

Here goes with your report. Good luck.

Results

The pilot project at the Hudson School resulted in the following:

1. Demonstration that middle school students could be easily taught The Circuit and the practice of Threeing.

2. Identification of LOGO as a computer language having affinity with The Circuit. Both LOGO and The Circuit are self-referencing for the learner. LOGO's primitive commands are FRONT, BACK, LEFT and RIGHT. If a student gets confused while programming in LOGO, he can step back from the computer and walk about, refer-

encing the computer commands with his own movement. Similarly, if The Circuit procedures on the computer get confused, students can repair to the figure of The Circuit on the floor.

3. Clarification of how The Circuit could be coded for an interactive computer learning program. See sample above and proposed courseware below.

4. Clarification of the difficulty of introducing a computer into a classroom as indicated by the following discussion.

Any teacher who has introduced a computer into a classroom knows it changes the ordinary rules of interaction in a classroom. Standard classroom behavior goes out the window and the kids act like they're in a video arcade. And why not? The classroom was a renaissance invention of Peter Ramus, designed to take full pedagogic advantage of the fact that the new printing press could turn out multiple copies of the same book. Textbooks, workbooks, and homework were all organized in a linear sequential curriculum that replaced the tradition of reading aloud from hand-copied manuscripts in small groups with a master teacher.

The computer is not a book. Present classroom format is not appropriate. Yet video arcade behavior is obviously not a viable substitute. Jockeying with other students for access to the computers, interacting spontaneously, waiting or fighting for your turn, have limited possibilities. So does working in book-like isolation, as if the computer could not be easily wired to other computer users and to various data bases. One eighth-grade student said the most valuable thing he learned in computer class was to work better with others.

Education based on The Circuit is designed to take full pedagogic advantage of the computer, just as the classroom is designed to take full pedagogic advantage of the book. Circuit education would optimize the pedagogic possibilities of electronic circuitry without forfeiting book intelligence. The term "circuitry" is being used in two senses:

1. Any interconnected set of telecommunications devices. This includes video, video discs, satellites, teleconferencing hookups, computers, local area networks, etc.

2. An understanding of mental processes realized by communications theory in studying the electronic circuit. In this understanding, a circuit is a self-correcting loop that can identify and eliminate error by responding to differences that makes differences. Any such organization of differences, any complete circuit, is considered a basic unit of mind.

Education based on The Circuit would satisfy the theoretical criteria for a unit of mind because technically The Circuit is a formal cybernetic unit called the relational circuit. The relational circuit allows students to establish stable roles for communicating with each other so they can learn together. The roles map directly onto the fundamental categories of America's premier philosopher, Charles Peirce. This means that a curriculum can be developed using the entire system of knowing Peirce developed. Different subject matter can be taught to different students in different ways at different times. In principle, Peirce's system can accommodate those differences.

A Generic Circuit

Like the circle, the relational circuit is a generic mental construct. It can be used to organize a whole group of learning experiences including:

* Structured interpersonal communication, both non-verbal and verbal.

* Perceptual learning through still photography, film and video.

* Learning from texts.

* Language learning.

- Development of video discs.

- Use of computerized relational data bases.

- Protocols and procedures for problem solving and decision-making in local area networks.

Because of its generic character, a curriculum based on the relational circuit would not be tied to obsoleting hardware, but could take full advantage of all present and future electronic technologies. The robust educational possibilities provided by The Circuit is suggested by the following description of appropriate computer courseware.

Computer Courseware

The core of the proposed courseware for The Circuit is a formal cybernetic, semiotic system. A technical discussion is beyond the scope of this report. However, the following points can be made.

1. The Circuit can exfoliate into sixty-six positions. Since its basic structure is triadic, this array can be contracted to just three positions or expanded to 3^{10}, or 59,049 positions.

2. The array is strictly positional and hence can be unambiguously color-coded for easy use.

3. The correspondence between the array and The Circuit is such that the rules of interaction in The Circuit can be programmed into procedures for moving in and out of the array in concert with fellow learners.

4. One of the critical problems of programming an interface between the essentially unambiguous logic of a computer and the infinite range of notions streaming through a child's mind is resolved in The Circuit. The Circuit provides categories that can, in principle, accommodate

any idea that a student comes up with. Moreover, a method of consensus decision-making for three students, backed up by the teacher, can help organize the ideas of any students in relation to the ideas of the the other students.

5. Because The Circuit is based on formal cybernetic and semiotic principles and has a method of achieving compliance through consent, it can be used as the basis of curriculum K through Graduate School. Moreover, it can be used in any situation where consensus is desirable, such as in ecological decision-making.

Organizing Differences

Education orders the relationship between generations. Today's teacher generation tooled its mind with books. The student generation is saturated in electronic sounds and images. Education based on the relational circuit addresses both generations. This is possible because Peirce's system of knowing encompasses both verbal and non-verbal signs in one categorical schema. Such a system calls for movement on the part of both generations. Teachers will be asked to deconstruct their verbal knowledge and reconstruct it in a new way. They will be asked to define themselves into the electronic classroom in ways that satisfy their own learning styles. Students will be asked to harvest their perceptual fields for language skills.

In the current multicultural context of education the combined knowing of the two generations could grow organically. Success in ordering the differences in ways of knowing between students and teachers can prefigure success in ordering the differences in local knowledge proper to various cultures.

Melusina

*A proposal to the Alternate Media Center of New York University
for allocating part of a general grant from the Revson Foundation
for community communications*

As Tsu-Gung was traveling through the regions north of the river Han, he saw an old man working in his vegetable garden. The man had dug an irrigation ditch. He would descend into a well, fetch up a vessel of water in his arms and pour it out into the ditch. While his efforts were tremendous, the results appeared to be very meager.

Tsu-Gung said, "There is a way whereby you can irrigate a hundred ditches in one day, and whereby you can do much with little effort. Would you like not to hear of it?"

The gardener stood up, looked at him and said, "And what would that be?"

Tsu-Gung replied, "You take a wooden lever weighted at the back and light in the front. In this way you can bring up the water so quickly that it just gushes out. This is called a draw well."

Anger rose up in the old man's face, and he said, "I have heard my teacher say that whoever uses machines does all his work like a machine. He who does his work like a machine grows a heart like a machine, and he who carries the heart of a machine in his breast loses his simplicity. He who has lost his simplicity becomes unsure in the strivings of his soul. Uncertainty in the strivings of the soul is something that does not agree with plain sense. It is not that I do not know of such machines, I am ashamed to use them."

Introduction

Federal funding in the seventies linked the Alternate Media Center's (AMC) efforts to particular machines and/or particular constituents. The Revson grant is free of these constraints.

It provides an opportunity to return to a "plain sense" of the current struggle for knowledge and power in our society. However, we are not a population of gardeners who can withdraw from the information environment that strikes from all sides. We must discover ways of using information technologies which do not rob us of simplicity. One possible method, The Melusina Method, is proposed here.

The Melusina Method

This method is named after the feminist organizer Melusina Peirce who worked in Boston during the nineteenth century. The method proceeds from principles first articulated by her husband, Charles Peirce, that base knowledge on observation and shared learning, not authority. Melusina's namesake was a medieval fairy who locked away her father authority figure in a mountain.

The method enables people to suspend their interpersonal politics so that they may gather the knowledge that will make a difference in their common struggle. This is done without establishing hierarchies, without introducing machinery and with a clear decision-making process that can encompass questions about the feasibility of introducing particular information machinery.

Before explaining this method further, it will be useful to cite an extreme example of the sort of apparatus of power Melusina is designed to counter. The example is the Panopticon, a "technology of power" invented in the nineteenth century by Jeremy Bentham to solve the problems of surveillance in prisons. This description of the Panopticon is provided by the French writer Michel Foucault:

> The principle [of the Panopticon] was this. A perimeter building in the form of a ring. At the center of this, a tower, pierced by large windows opening on to the inner face of the ring. The outer building is divided into cells each of which traverses the whole thickness of the building. These cells have two windows, one opening on to the inside, facing the windows of the central tower, the other outer one allowing daylight to pass through the whole cell. All that is then needed is to put an overseer in the tower and place in each of the cells a lunatic, a patient, a convict, a worker or a schoolboy. The back lighting enables

one to pick up from the central tower the little captive silhouettes in the ring of cells. In short, the principle of the dungeon is reversed; daylight and the overseer's gaze capture the inmate more effectively than darkness, which afforded, after all, a sort of protection ...the side walls prevent him from coming in contact with his companions. He is seen, but he does not see; he is the object of information, never a subject in communication (Foucault 1979: 200).

By involving people as subjects in communication, Melusina avoids objectifying people as objects of information. It stabilizes small group interaction and enables a group to generate a search pattern for information they don't know that will make a difference for them. Knowledge normally "disqualified" can be incorporated into the process. Common knowledge is organized to the degree that even the seemingly trivial becomes part of an effective information system.

This method is based on a single figure original to the author called The Relational Circuit. (See Fig. 19, p. 103.) This figure can be used by small groups to regulate shared learning in terms of the phenomenology and semiotics of C.S. Peirce. In brief, the phenomenology understands all that is present to the mind in terms of three fundamental categories: firstness, secondness, and thirdness, in common terms feelings, facts, and law. The semiotics draws from these categories a tenfold classification of signs which translate into the ten questions that appear below.

Scenario

Tenants want to produce information about their building with respect to heat. Four tenants agree to develop the information using Melusina. Bob undertakes to pay attention to the tenants' feelings regarding the heat. Carl agrees to track on the facts of the matter. Linda agrees to research the law. Francesca agrees to coordinate and to act the part of a fourth party to facilitate decision making.

Bob spends the time visiting and talking with people about the heat. They discuss windows with exposure to the sun, wearing sweaters, noisy radiators, etc. Bob does a set of drawings with the kids in the building about heat and sun.

Carl gets a manual and, with a few other people and a borrowed infrared sensing device, does a thermal inventory of the building. He inspects the furnace and studies the southern exposure to see if solar panels are feasible. Other tenants give him articles on projected oil cost and alternative fuels.

Linda checks out the heating clauses in the lease, talks with the landlord, and reads the city ordinances about heating. She gathers information about tax breaks for heating improvements and makes an initial estimate of what it would cost to have the building go co-op.

In their working sessions with Francesca, they organize their information in a "template" guided by a set of ten questions drawn from Peirce's semiotics. The guiding questions are as follows:

1. How do people feel about the building in relation to the heat?

2. What experiences are these feelings based on?

3. What experiences have forced a consideration of the heat?

4. What evidence is there about the condition of the heat (the infrared scan, sickness related to heat)?

5. What general models of thermal flow in buildings are available that apply to this building?

6. What things can you point at in the building that make a difference in terms of heat?

7. What pattern of specific things happen that make a difference in the heat for specific tenants?

8. What general terms besides "heat" might be useful in searching out relevant information?

9. What facts can be stated about the heat in the building?

10. What are the various arguments, legal and non-legal, being made or which could be made about the heat in the building?

In working out this "template" they educate each other as to what they are finding out. Carl explains to Linda technical terms about heat that appear in legal documents. Bob is letting Carl know about zoning regulations that may affect the construction of new buildings and thereby the amount of sunlight that falls on their building.

Out of this common understanding among Bob, Carl, and Linda comes a list of recommendations to the tenants group as a whole. Each person is able to make recommendations based on his or her part in the common organization of knowledge.

The assumption is that the other two of the three information-gatherers will concur with the recommendations. Disagreements about recommendations are decided in the following way: If Carl proposes something and Bob disagrees, then Bob tries to convince Linda to agree with him. If they both disagree with Carl and can convince the fourth party, Francesca, they are right, then the three can override Carl's recommendation. If the three cannot agree to override, then Carl's original recommendation will stand.

Melusina and Machines

The above scenario underscores what is evident in the principles of the method: Melusina operates by actively involving people in the gathering and organizing of information. The method can embody an operative political intelligence unmediated by machines. Politically, this is a distinct advantage. It means that groups can build a knowledge base using information technologies with a certain impunity. The machines and the apparatus of technical support and funding sources could be withdrawn without necessarily undermining the intelligence configured by live people using this method. This is not to ignore the enormous power in technologies like video, cable, and computer. It is only to avoid addictive dependency.

Revson Design

Given this methodology, the Revson project could consist of developing, diffusing, and evaluating this methodology in partnership with community groups. In effect, AMC would enter into an agreement with selected groups.

For its part, AMC would agree to train an organization to produce an information system about any subject/need/ problem for a certain purpose. AMC would also provide appropriate follow up and technical support in terms of information technologies.

The partner would agree to provide at least four trainees for a designated period of time. They would also agree to provide AMC with a written evaluation of the method and to allow a party designated by AMC to perform an independent evaluation.

No money would be involved; the barter would be in terms of information. It might make sense for AMC to reserve a percentage of the grant funds anticipating matching the expenditure of a partner to enhance the information system through hardware and technical support.

Four different groups would be a manageable number of partners to develop and test this methodology. Clear criteria for possible partners is in the process of being developed. One factor motivating these groups to participate would be a felt necessity for some organization of their information resources. Besides the partnership with community groups, the project would require four other components.

1. Dialogue between Melusina and Machines. In effect, this would be an AMC in-house staff dialogue so that accumulated expertise about the various technologies could be combined with the method used in the field.

2. Playing "GO" (wei-ch'i). While this component may seem strange because a full explanation cannot be given here, the Melusina Method is analogous to the "double eye" formation in the Chinese game of GO. The "double eye" is a stable formation that provides substantial strategic

advantages. Studying the game of GO will sharpen AMC's overall sense of strategy in the information environment, particularly in the use of Melusina.

3. Developing Melusina. In its present state Melusina works on a ten-fold template which was articulated by Peirce and should be adequate for this project. However, given that this project meets with reasonable success and becomes diffused, the power of the method could be greatly increased by exfoliating this template into the sixty-six-fold classification sketched out by Peirce. The optimal mode of doing this would be to provide a general computer program that could be adapted by various users in handbook or computer format.

4. Evaluation. Contract with an outside consultant or agency to evaluate the project. Preferably one which is fluent in understanding "technologies of power."

Conclusion

Given Melusina proves successful, it would add a dimension of formal assurance to AMC's capability. Good instincts and extensive experience are already in evidence at AMC. A general methodology, a formal procedure could help assure that the instincts stay healthy without degenerating into personality cults, and that the extensive experience in new information technologies does not degenerate into a scenario of pushing new information technologies without sufficient regard for the human context.

Design for Ecological Consensus Along the Hudson

A proposal to the Hudson River Foundation

Goals and Objectives

The overall goal of this proposal is the achievement of an ongoing consensus about the ecology of the Hudson River among interested parties, responsible regulatory agencies, and the general public. The immediate objective of this proposal is to produce a design for such consensus. The design would be based on a method for achieving ecological consensus which I, as principal researcher, have developed over a twelve year period.

In proposing this method to the panel of the Hudson River Foundation, I begin by comparing ecological consensus with environmental mediation. By opening with this explanatory tactic in no way do I mean to imply that such a consensus could replace mediation. Environmental disputes arising out of competing legitimate demands will continue to move toward adversarial legal proceedings, which, as a growing number of cases indicate, will be resolved by environmental mediation. What the method of consensus seeks to achieve is an ongoing circle or circuit of understanding that includes the entire ecosystem of the Hudson and all interested parties. In other words, for the inhabitants and other interested parties, it is a communication system about living in accord with the ecology of the Hudson on a long-term basis, which may help prevent unnecessary disputes from arising. Such a consensus would not preclude healthy disagreement over the environment, but would provide a context that would make it easier to talk about such disputes.

Comparison: Environmental Mediation/Ecological Consensus

Environmental Mediation is largely an ad hoc process. Ecological Consensus is based on formal principles.

While mediators such as Gerald McCormick have developed an intellectual framework for negotiating environmental disputes (Talbot: 1983), most mediation, including the Hudson River Settlement, has been ad hoc. This, of course, is in keeping with the case-by-case methodology of the common law tradition. McCormick's framework is based on an astute heuristic appreciation of the preconditions necessary for mediating disputes rather than formal fundamental principles.

By contrast, the proposed ecological consensus is based on "fundamentals" in the sense described by Gregory Bateson (1972: xvii ff). In this approach, research starts from two beginnings, each with its own sort of authority. There are principles taken as fundamental and there is the data of observation. The research must fit the data and the fundamentals together. It should be frankly said that the formulation of fundamentals for building consensus is original to the principal researcher and while it rests on a cybernetic rendering of the categories of the premier American philosopher, Charles Saunders Peirce, the formulation is recent, original and not yet widely known or accepted.

Environmental Mediation is based on the activity of a neutral third party. Ecological Consensus is based on a neutral tautology, a logic of triadic relationships.

Modern mediation originated in the field of labor/management disputes with the introduction of a neutral third party. Later, this approach was applied to environmental disputes (Talbot: 1983). A skillful, neutral third party is one who can mediate between the feelings of the various parties, the actual facts and the different positions taken by the parties. Russell Train was successful in mediating the dispute over the Storm King power plant because he took account of all these factors.

Ecological Consensus is based on a triadic logic, a formal and therefore neutral set of relationships, the internal consistency of which can be taken without doubt. The logic is designed to mediate between the realm of feelings, existing facts, and competing arguments.

Environmental Mediation must act within "the drama of advocacy science"(Talbot 1983: 10). Ecological consensus is based on a jury of observers which can preclude "advocacy science."

The competing arguments about whether fish kills in the Hudson resulted from practices at power plants were, of course, preconditioned by advocacy roles. In the building of ecological consensus, role relationships could be organized that neutralize adversarial positions at the level of data gathering. The possibility that such a procedure could orchestrate the activity of expert witnesses will be explored in the design.

Circle of Circuit of Understanding

The method for building ecological consensus employs a fundamental circuit logic that has three basic categories exfoliating into sixty-six subcircuits. The technicalities of this logic will be bypassed here and a sketch of its application to a Hudson ecology consensus offered instead. In this logic, information is understood as a difference that makes a difference (Bateson 1972: 457ff.).

- Differences in the ecology of the Hudson make differences in what can be represented about the Hudson.

- Differences in what can be represented make differences in what is represented.

- Differences in what is represented make differences in the possible interpretations.

- Differences in possible interpretations make differences in specific, actual interpretations by different groups.

- Differences in specific interpretations by different groups make differences in how the community as a whole interprets the ecology.

- Differences in how the community interprets the ecology make differences in how the community actually behaves towards the Hudson ecology.

- Differences in how the community behaves make differences in the long-term viability of the Hudson ecology.

The circuit also provides for ways of verifying the accuracy of how the ecology was represented such as by setting up a jury of ecological observers as mentioned above. There is also room for discussing how specific groups interpret evidence of the ecology and how that interpretation passes to the community as a whole. Moreover, there is provision for discussion of how to turn scientific knowledge into public policy and practices for living in accord with the ecology of the Hudson.

Additional Features

A number of additional features might be noted which recommend using this approach for developing a responsible way of living in the Hudson Valley:

1. There is provision in the consensus procedure for including aesthetic concerns as per the U.S. Court of Appeals ruling on the juridical validity of considering scenic beauty.

2. In addition to being able to reckon with traditional science, the circuit can also accommodate relatively new ideas of scientific modeling such as the notion of "chreods" that could prove valuable in considering and perhaps resolving questions such as fish kills. (Peirce was trained as a scientist and spent thirty-one years working professionally as a scientist for the United States Geologi-

cal Survey. His categories come partly from extensive experience in field observation).

3. The circuit of understanding could facilitate ongoing dialogue between participants with specialized vocabularies. Lawyers, engineers and biologists each have specialized brands of English and, as a result, difficulty in communicating with each other. The circuit approach to consensus nurtures a discourse that respects specialized knowledges but generates a workable common understanding.

4. The circuit of understanding is such that it could produce an architectural basis of an information management system useful for the purposes of the Hudson River Foundation. The logic of the method is such that it could be embedded in a generic computer program that helps orchestrate communication about the Hudson ecology and makes that communication available to anyone with a personal computer.

5. The method is such that it could gradually be expanded to include the general public through telecommunications media such as satellite, telephone, and cable TV.

6. The method could also be adapted to school curricula.

Living Between Ice and Fire
By the River that Runs Both Ways

The ice is gone. Dwarf pines sprang up as the glacier melted down.
Ten thousand cycles around the sun seasoned this land into
singular beauty.

The fire may come. By the hand of man. Bioregional burnout by
toxic waste.
Uranium in our precambrian rock mined into a vicious cycle of
nuclear accident or war.

Down from the highlands, rain upon rain, the river
Brings nutrients from the falling leaf forest.

Up from the ocean, day by day, tidewaters
Bring plankton from the web of coastal life.

The salt/fresh mix is magic. Witness the striped bass.
They've spawned here for centuries, spring upon spring.

People came from the forest, walking into the morning sun.
They called it The River that Runs Both Ways. After what they saw.

People came over the ocean, sailing into the evening sun.
They called it The Hudson River. After a boat captain.

Ecologists call it an estuary. Estuary.
Where the tide meets the current.
Estuary. From the root ai dh.
Ai dh meaning to boil or to burn.
Ai dh meaning fireplace or hearth.
Ai dh meaning dwelling place or temple.

This estuary is the hearth of our
Dwelling place on planet earth.
This dwelling place wants a people,
A people comfortable around this estuary
Like friends around a warm fire.

The Ecochannel Design

Program Listings for a Television Channel
Dedicated to the River that Runs Both Ways
(The Hudson River)

BULLETINS WATCHING THE RIVER FLOW
REGULARS ON THE RIVER INSCAPING THE ESTUARY

HISTORY OF THE HUDSON
OF SCIENCE AND THE RIVER
INVESTIGATIVE REPORTING
THE HUDSON AD HOC

CELEBRATING THE RIVER

LOCAL NEWS CELEBRATING RBW*
PLANET NEWS SPONSORING RBW
WEATHER NEWS POLICING RBW
 REGULATING RBW

CALL LETTERS FOR THE TV CHANNEL, RBW

NATIVE PEOPLES AND THE RIVER THAT RUNS BOTH WAYS

EUROPEAN HERITAGE AND THE RIVER AS FISHERY
 THE HUDSON
AFRICAN HERITAGE AND THE RIVER AS RECREATION
 THE HUDSON
ASIAN HERITAGE AND THE THE RIVER AS HEALER
 HUDSON
LATIN HERITAGE AND THE THE RIVER AS TEACHER
 HUDSON
 THE RIVER AS HOME

COMMON SENSE ALONG THE HUDSON
CRITICAL COMMON SENSE ALONG THE HUDSON

CONSENSUS ALONG THE RIVER: TERMS
CONSENSUS ALONG THE RIVER: EVIDENCE
CONSENSUS ALONG THE RIVER: ECOLOGY
CONSENSUS ALONG THE RIVER: FIGURES OF REGULATION
CONSENSUS ALONG THE RIVER: POLICY
CONSENSUS ALONG THE RIVER: PRACTICES

The programs listed above are described below under three headings: programming, format and rationale. The letters RBW are used to designate both the design for the ecochannel and the television channel itself. These "call letters" are taken from the native name for the Hudson River, i.e., The River that Runs Both Ways.

Ecochannel Design

What follows is a design for a television channel dedicated to monitoring the ecology of the Hudson River Basin and developing consensus about how best to live there on a long term basis. While the presentation is explicitly for the Hudson, the design could be readily adapted to other river basins and to other natural regions such as islands, coastlines and mountain ranges. Any coherent ecological system or "bioregion" would be appropriate. Basically, the ecochannel design outlines a way people can use television to understand and respect their local ecology.

Bulletins

Programming: When and where to hike, fish, swim, watch leaves turn, observe bird and animal habitats, observe duck and geese migration, observe estuary events and man-made environments. Notification of equinox, solstice, and other bioregional events.

Format: Clear instructional text with maps and light graphics. Concise. Run with appropriate frequency.

Rationale: First-hand familiarity with the Hudson, unmediated by television signals, is critical for maintaining an understanding and respect for the ecology. Smells, winds, sights, cold, sunlight: people need to know their place through the skin as well as through the electronics of television. Getting out on the river is the best antidote to electronic distortions.

Regulars on the River

Programming: Spending time with people who regularly relate to the ecosystem directly: Fishermen, boaters, birdwatchers, hikers, wildflower enthusiasts, long term residents.

Format: Follow the contour of their activity. Over the shoulder participation. Share observations, listen to stories, comments, folklore, oral history.

Rationale: Gain familiarity from those who are familiar. Turn over the folklore. Recognize and cultivate it.

Watching the River Flow

Programming: Wonder of the Basin. Ongoing systematic video studies of the bight/estuary/watershed phenomena. Live and taped, fed from satellite scanning of Hudson. Fixed camera monitoring key features of the system checked on regularly.

Format: Satellite and fixed cameras punctuated by Zen perception. Small teams trained in Zen, Ta'i Chi, and method of orchestrating perception to see what is there without judgement or comment. Single color camera work with live sound and minimal editing. Keyed to phases of the moon.

Rationale: Approach the basin with as few preconceptions as possible. Take advantage of advanced observational technology. Small trained groups can gain a more reliable perception than individual videomakers.

Inscaping the Estuary

Programming: Careful observational video studies of the natural patterns identified by scanning the basin. The self-

evident natural patterns or "icons" of nature's own "language." The iconography of the ecosystem. Examples: waterflow patterns, insect and animal behavior patterns, tidal dynamics, cloud formations, flower cycles.

Format: Formats that amplify the icons themselves. Camera angles, slow motion, time lapse, whatever arrangement of techniques serve to make each specific icon of the ecosystem an event in the mind.

Rationale: Connection between the reality of ecosystem and our understanding of the ecosystem found in these icons that are "first for us," in our instinctive perceptual ability to make sense out of the order of the ecosystem.

History of the Hudson

Programming: History of the people in the estuary/watershed. Rendering of Paleo-Indian, archaic woodland, colonial, industrial, and bioregional history.

Format: Follow nature of historic evidence and research. As little "talking-heads" stuff as possible. On site and with artifacts.

Rationale: Actual history of human cultures that occupied this region would improve our understanding of how best to live here.

Of Science and the River

Programming: Scientific inquiry into the ecosystem. Consideration of various species: biology, population distribution, physiological and ecological requirements. Study of nutrients, organic and inorganic contaminants and energy patterns. Investigation of physical, chemical, and geological processes and their effects on the ecosystem. Effects of pollutants on biology.

Format: Would follow the method of inquiry proper to science. Reckon with both on site studies, literature searches and laboratory experiments.

Rationale: Knowledge base from sciences critical for developing stable consensus. Any abduction or guess-at-workings of the ecosystem arrived at through observation of natural

patterns must be tested inductively by rigors of science. Accumulation of scientific expertise and data must be brought to bear, especially since so many toxins escape perception unaided by scientific instrumentation. Work toward establishing a scientifically valid, predictive model of the river ecology.

Investigative Reporting

Programming: Investigative journalism into issues that effect the river. Water quality, toxic waste, possible uranium mining, proposed developments, health/environmental issues.

Format: Emphasis on visible evidence gathered by video camera. Presentation of such evidence to responsible parties for comment. Care taken to present opposing views fairly. Context of investigation — consequences for basic ecology.

Rationale: Must monitor actual facts of ongoing situation. Gather evidence to identify and eliminate practices that transgress the ecosystem.

The Hudson Ad Hoc

Programming: Special programs that deal with specifics not considered within the range of normal programming.

Format: As appropriate to the specific.

Rationale: Don't want to miss anything. Also, this slot could easily be opened to independent production teams.

Local News

Programming: News stories that relate to the Hudson Valley.

Format: News show. Maximum on-site stories.

Rationale: Let people know what is happening in a bioregional context.

Planet News

Programming: Planetwide stories that have to do with bioregional goings on. Example: acid rain legislation in the midwest that effects the Hudson River.

Format: On-site as much as possible. Set up exchange of news services.

Rationale: Keep bioregional context in planetwide context. Learn from other places and peoples.

Weather Reports

Programming: Relate weather patterns to the ecology of the bioregion.

Format: Use satellite extensively and link up to planetwide weather patterns.

Rationale: On line to the ecology in terms of day-to-day.

Celebrating the River

Programming: Poetry, stories, theatre, interpretation of phenomenological tapes and icons in music and dance. Explore television as an artistic medium related to the ecology.

Format: Determined by artists.

Rationale: Aesthetic amplification of estuary ecology. Pure delight. Encourage regenerative and regenerating models of perceiving basin.

Celebrating RBW

Programming: Electronic video art, working with electronic signal itself, without river content.

Format: Determined by artists.

Rationale: Keep perceptions of the channel itself enlivened.

Sponsoring RBW

Programming: Advertisements for businesses, products, services, institutions in keeping with the health of the Hudson.

Format: Spots determined by advertiser. Arrangements would also be made to allow periodic inspection of operations by a video crew using ecological criteria, a crew could/would report their findings over the channel. Fair format would have to be developed.

Rationale: Encourage prosperity in keeping with the health of the ecosystem. Source of revenue.

Policing RBW

Programming: Self-inspection of physical basis of the station, electronic components, production practices, and so forth in terms of effects on the ecology.

Format: Determined by team of investigators.

Rationale: Electronic technology not innocent ecologically, 500,000 pounds of PCBs in river from dumpings by General Electric. Outside critics would certainly arise, but ought to self-police, as best station can.

Regulating RBW

Programming: Public discussion of station policies by management.

Format: As simple as possible to expose the governing process. Include open feedback channel, guest critics, and commentators. Use two-way capacity.

Rationale: Workings of the station open to the public for inspection and discussion.

Native People and the Water that Moves Both Ways

Programming: Reconstruction, celebration, inquiry into way of life of native peoples. Both the traditional way of life before colonialization and contemporary native American life.

Format: Determined by native people.

Rationale: Native cultural intelligence is a significant, if not critical, component in long term bioregional stability.

Heritage and the Hudson

Programming: Varied cultural interpretations of ecology of Hudson Basin, appropriate to various immigrant groups: European, African, Asian, Latin American. History of various ethnic groups along the river.

Format: Determined by heritage group.

Rationale: Amplify appreciation of river ecology. Identify possible pathologies in imported cultural attitudes.

The River As......

Programming: Series of presentations by special interest groups interpreting the ecology from the stance of their special interests: fishermen, energy companies, government agencies, educators, recreation groups, and so forth.

Format: Determined by the group.

Rationale: Any self-identified group with legitimate interest in the river has the right to present its views in process of developing consensus.

Common Sense Along the Hudson

Programming: Ordinary inhabitants talking about living in this place. Reasoning about best way to live here. Talking issues.

Format: On-site tapes. Go up and down the river and visit regions systematically. Different sub-basins and sub-tiers of the basin.

Rationale: Common sense of ordinary people can go a long way toward making sense out of how best to live here.

Critical Common Sense Along the Hudson

Programming: Discussion of data gathered about the ecology by people and groups with special expertise: scientists, engineers, educators, lawyers, etc. All talking from the base of their particular knowledge.

Format: Determined by each group in accord with data selected.

Rationale: Much critical information about ongoing health of the watershed is beyond realm of common sense and in the knowledge terrain of specialists.

Consensus Along the River: Terms

Programming: Open discussion of what natural patterns discovered by scanning, and what interpretations of those patterns, would be admissible in a general discussion of the whole community concerned with the ongoing health of the ecosystem.

Format: There are specific procedures for arriving at consensus about which videotapes of what natural patterns would be used in a general discussion. These consensus procedures are based on the theoretical information provided below. The procedures themselves will not be detailed here. The television programming about consensus of terms and other consensus programming described in what follows will have a format that reflects these consensus procedures.

Rationale: Community needs to come to a consensus about terms in which discussion of general health of the ecology can take place.

Consensus Along the River: Evidence

As above, only concerned with evidence. Draw on legal tradition for rules admitting evidence.

Consensus Along the River: Ecology

Programming: Arguments from terms and evidence by various parties, organized to arrive at a working syntax of the ecology of the Hudson Basin.

Format: Procedure for presenting arguments. Arguments heard by a consent committee. Use two-way capacity.

Rationale: Must base overall behavior on best common understanding of the ecosystem that the community can muster.

Consensus Along the River: Figures Of Regulation

Programming: Arguments from the syntax of natural ecology: If we do not do:

1. ?
2. ?
3. ?

then we can be assured that the ecosystem of the Hudson will be regenerative and life-supporting on a long term basis. What are the appropriate figures of regulation for the human species here?

Format: Argumentation before a consent committee. Use two-way capacity.

Rationale: Must identify common constraints on human species behavior in the ecosystem.

Consensus Along the River: Policy

Programming: Argumentation about how these basic ecological restraints translate into public policy about transportation, housing codes, food production, energy, extra-regional relations....

Format: Argumentation before the consent committee.

Rationale: Need to translate general constraints into specific policies.

Consensus Along the River: Practices

Programming: Documentation and development of practices that are in accord with the regenerative health of the river ecosystem.

Format: Follow nature of the practice. Instructional tapes on how to manage a woodlot, develop permaculture, garden, cook native, build bioshelters. Discussion of relative merits of various practices.

Rationale: Learning how to live in place requires a whole range of skills and habits we have yet to develop and learn. Reinhabitation.

PART FIVE: NEST, 1986-1991

A year after presenting my Ecochannel Design at The Museum of Modern Art, I moved to Manhattan, the island where I was born, and spent the next six years trying to initiate an Ecochannel for New York City. The title of my proposal for a city-wide television channel dedicated to the environment is "NEST", an acronym for both "New York City Ecochannel for a Sustainable Tomorrow" and "New EcoSystem TV." The aphorism I coined to accompany this title reads "New York City is a single nest for our separate lives." Ironically, in the six years from 1986 to 1991, the fragmentation of life in the "nest" of New York City forced me to articulate my ideas about communications and ecology in five separate spheres: religious, civic, educational, intellectual, and artistic. The texts presented in this part are organized accordingly.

Religious

"Water Wisdom" is a report on a liturgy I organized at the Cathedral of St. John the Divine during the spring of 1986. The Cathedral is an oasis for those concerned with ecology in New York City. At that time, I was a co-director of the Cathedral's Gaia Institute, the purpose of which is to explore the cultural implications of the Gaia Hypothesis of scientist James Lovelock. Simply stated, Lovelock argues that the Earth is a Living Organism. "Jesus Crucified, The Living Earth and Television," originally written for the Gaia Institute, is my effort to articulate a way of recycling Christianity to help solve our ecological crisis.

Sometimes, when I have discussed my work with triads and revealed my Roman Catholic monastic training as I do in this essay, people have suggested that my work is just a compulsive repetition of the traditional Catholic doctrine of the Trinity.

While it is certainly true that my monastic training has influenced me, the diagnosis of compulsive repetition is incorrect and I want to briefly counter it here.

In the monastery, meditation on the mystery of the Trinity was part of our training. For example, my Master of Novices led us through a reading of "De Triplica Via," *Concerning the Triple Way*, a guide to the spiritual life written by St. Bonaventure. I'm sure this opportunity to meditate on the Trinity is an important precursor to the triadic logic of relationships that I present in this book. But in my work with triads, I've originated a logic of relationships that could translate across traditions. I've not reshrouded a mystery peculiar to Christianity. This being said, I would also mention that there is a useful cross-reference to my triadic logic in the modern doctrine of the Trinity being explicated by Brazilian liberation theologian, Leonardo Boff (1988). In this modern teaching, the reciprocal relationships among the members of the Holy Trinity are taken as a model for a just society. It should also be noted that Catholicism has no monopoly on triadic thinking. Many traditions from Taoism to Buddhism to modern physics, with its unsolved problem of how to describe the relationship between three physical bodies, have addressed the puzzle of triads.

Civic

Through the Cathedral and working with Jean Gardner, Director of Earth Environmental Group, I got involved with the civic process in New York City. This involvement generated a number of proposals, three of which are included here: one for interpreting nature in Riverside Park called "Communications for the Riverside Park Community," another for training teenagers to do video interpretations of the parks on Staten Island called "Video Rangers," and the third proposal for a municipal television channel dedicated to the environment called "NEST." Drawing on Jean Gardner's knowledge of New York City, I was able to give these proposals a high degree of specificity. The Nest proposal became part of the platform for Environment 89−91, a coalition of

over two hundred and fifty groups in New York City, which I helped organize in response to the 1989 mayoral election. Subsequent to the election, and in response to the platform, the Office of Telecommunications in New York unofficially designated a cable channel for Health, Science, and the Environment. However, the budget crisis left the channel without startup funds.

Educational

"The Earthscore Curriculum" is a proposal that emerged from my involvement with The Dalton School in New York City. This conception for a multidisciplinary, multimedia curriculum has its roots in my work with McLuhan back in 1968. The work at The Dalton School also stimulated me to develop a computer version of my system. I taught myself the Hyper-Card programing language and produced a thirty-three stack generic program for generating consensus that could be used in education, environmental policy making and elsewhere. In the limited format of this book, I can only suggest how "Consensus: a Computer Program" works by providing a brief description.

Intellectual

Being back in New York City, where I had begun my work with video, spawned two essays about video art and its relationship to social change. *Leonardo* published the first of these essays, "A Genealogy of Video," in 1988. This publication resulted in an invitation to present a paper on "The History of American Video Art and the Future of European Television" at the Romanistentag Conference in Aachen, Germany in 1989. The Romanistentag paper discusses the prospect of using television as a tool to reinhabit Europe and the relationship between video art and the bioregional movement. For me, thinking about the relationship between art and various forms of social power originated not with video, but with literature. At New York University, I had studied with Conor Cruise O'Brien, George Steiner, and David Caute. From these teachers I had learned to be very sensitive to the relationship

between the literary arts and social power. This sensibility carried over into my video art. For me, the tension between using video as a medium of art and using video as a medium of enfranchising the disempowered is finally resolved in an ecological context with the creation of The Earthscore Notational System. I describe this notation in the last essay of this book, and discuss this system as art in an appendix.

One support for my intellectual life during this time in New York City came from the Reality Club, a loose assemblage of thinkers and artists founded by the author and agent, John Brockman. During the decade of the eighties, the group met twice a month in Manhattan for free-form discussions with invited speakers. I participated even while I lived in Hoboken. The Reality Club published my essay on "Video, Computers and Memory" in *Ways of Knowing*. Written in the late eighties, after twenty years of experience with video, it is an effort to synthesize some of my ideas and initiate thinking about the video/computer hybrid as a technology of memory.

My intellectual life in New York City was also nurtured by contact with Professor Myrdene Anderson of Purdue University. In 1988, she invited me to present my work on Peirce at the American Semiotics Conference. The talk I gave entitled "'A Sign of itself,'" was later published by Anderson and Floyd Merrill in their collection, *On Semiotic Modeling*. "A Sign of itself" is the most difficult and abstract essay I have ever written. It is not, however, abstraction for abstraction's sake. Successful abstractions can lead to practical successes. Most of the possibilities for using electronic communications presented in this book depend on the abstract integrity of the relational circuit described in this essay. Another way of saying this is that "A Sign of itself" is my effort to make the calculus of intention presented in the section on Early Video completely independent of my experience and useful to others.

At the beginning of "'A Sign of itself'" I reiterate that the relational circuit has been as important to me as *contrapposto* to a Greek sculptor or perspective to a Renaissance painter. The achievement of these formal codifications, as explained by my art history teacher at New York University, Horst Janson, had impressed me enormously. In my career as a video artist, I

saw a critical need to codify a formality for video analogous to *contrapposto* or perspective. I believe the relational circuit is such an achievement. The relational circuit makes it possible to approach both behavior and video perception in a radically new way.

In 1989, I attended the Peirce Conference at Harvard, where I showed a videotape I had completed that year called *Nature in New York City*, made according to Peirce's phenomenological categories of firstness, secondness and thirdness. This is the most important tape I produced during this period. My understanding of how to use Peirce's phenomenological categories to produce video came to me after crossing the Atlantic Ocean on a sixty-foot North Sea trawler in the summer of 1986. The ocean voyage took sixty days and during that time I did over seventy hours of videotape. It was the most concentrated videotaping I had done since the Earthscore period. I doubt whether I would have understood how to use firstness, secondness and thirdness to produce video as described in the final essay of this book without the duration of attention to videomaking made possible by this trip. Besides producing *Nature In New York City*, I began work on a videotape called *Mountain Waters* that interprets different water ecologies in the Shawangunk Mountains north of New York City, again using Peirce's categories. I taught others how to use video to interpret ecological systems through The Parks Council in New York City, Staten Island Community Television and the Visual Studies Workshop in Rochester, New York.

Artistic

During this period in New York City, I was active as an artist. As a Rockefeller Nominee for an Intercultural Arts Fellowship, I conceptualized "The Tricultural Tournament" in response to the intercultural tensions in New York City. Two other triadic proposals, not included here, developed as spin-offs from working on the Tricultural Tournament. One is a game called *Three of You*. The other is a proposal for the video production of a triadic narrative. The narrative would be a

story about the experience of Threeing, told by the three different participants, not unlike the narrative structure of *Roshomon*, the film by Kurosawa. I also developed a proposal for a Trilateral Liturgy at the Cathedral of St. John the Divine that would include religious texts and involve Arabs, Israelis and Americans on the eve of the Gulf War. This proposal is similar to the Tricultural Tournament and not included here.

Constant bad news about the degradation of the natural environment in the New York City metropolitan area also prompted me to develop various proposals for doing video art interpretations of natural sites. Four are included in this collection: *Mountain Waters* (in production), *Symphony for the Jersey Shore, Meditation on the Arthur Kill and the Kill Van Kull*, and *Forests Forever: the New York City Cycle*.

The final piece in this final part is "The Earthscore Notational System for Orchestrating Perceptual Consensus about the Natural World." *Leonardo* published this essay in 1991. NASA published another version in their 1990 conference proceeding for Earth Observations and Global Change Decision Making. This final essay is not attached to any particular place such as New York City but addresses our ecological difficulties in relation to language and perception. As I said in the general introduction, this piece compacts all my work with video and ecology into a notational system. The reader who has followed my spiraling journey from beginning to end will be familiar with the five components of the Earthscore Notational System and many of the references I use to explain these components. The purpose of this final essay is to distill the essence of what I have to offer into a formal approach for using video to reconnect our minds with the mind of the earth.

Water Wisdom

*A report on the 1986 spring liturgy at the Cathedral of St. John the Divine
for the Cathedral archives*

Acid rain makes spring dangerous. The winter snows of the Hudson Highlands, Catskills and Adirondacks accumulate toxic exhaust from factories and automobiles. Winter melts down and spring runoff brings a toxic shock to the life of New York City's watersheds. Ecologists cringe at the irony of spring bringing death to lakes, plants and fish.

Spring is Eastertime: time to celebrate the central Christian mystery of death and rebirth, time for Baptism. This spring the Cathedral community turned its attention to the waters of life.

The Lenten Sermon Series was titled "Vinegar for My Drink: the Waters of Purification and Pollution." Cathedral Canon Thomas Berry initiated the series by highlighting the symbolism of water in the cosmologies of different religious traditions. Bioregional author Kirkpatrick Sale spoke eloquently of the interconnectedness of all life on "Planet Water." Pulitzer prize winning poet Carolyn Kaiser addressed the poetics of water, bringing to the pulpit a fecund reading of world literature and the power of her own poetry.

After the eleven o'clock service, Ms. Kaiser chaired a roundtable discussion about water. Oriental scholar Donald Keene read haiku and delighted us with an account of the Japanese love of bathing, mountain streams and the ocean surrounding their islands. Architect John Woodbridge spoke of the buildings of the Middle East. Paradise was never lost to the Arab people, he explained. Paradise is the garden in the middle of their dwellings where a drop of water on the surface of a pond becomes a sacred event. Elizabeth Janway, Sharon Olds and Carolyn Kaiser treated us to elegant readings of their own poetic work that rippled with the wonders of water.

My own videotape meditation on the Great Falls in Paterson concluded the roundtable.

The Lenten Series continued with Connecticut gubernatorial candidate Toby Moffett challenging the congregation to take a more active role in civic struggles over water issues and detailing effective strategies. Substituting for the ailing author of *Acid Rain*, Robert Boyle, I preached a sermon on acid rain as a sign we are driving God crazy by failing to honor the Judeo-Christian covenant with all of God's creation.

On Palm Sunday, Dean Morton brought the series to completion with his sermon, "Blood and Water." "Lent is a time for rectifying our relationship with all of life," he said, "we must concern ourselves with self-purification *and* the purification of a polluted creation." He explained that the water that flowed from the side of The Crucified is a sign of the living creation. The blood is a sign of the conscious love Jesus brought to all, a love we celebrate during Easter week.

In the nave of the Cathedral, at the exact time of the spring equinox, 5:03 p.m., March 20, 1986 artist Bob Schuler made public his ocean burial project called Tethys. The thirty-six granite cubes unveiled by Schuler were buried in the Atlantic at hundred mile intervals from North Carolina to Morocco in May and June of 1986. His inscribed and painted images range from the history of modern physics to autobiographic anecdotes. Comments overheard at the opening: "He's dumping gargoyles in the ocean." "I don't get it." "It's the first art work mounted on the tectonic plates." "It's an eternal comic book, quite funny." Standing next to a white cube, Schuler himself quoted Revelations 2:17, "I will give him also a white stone, and on the stone will be written a new name, known to none but him that receives it."

On the Saturday of the vernal equinox, March 22, 1986, The Gaia Institute devoted a full day to the pursuit of Water Wisdom. Accompanied by musician Steve Gorn, Laura Simms opened the day with a spellbinding story of how the neglect of the beautiful water bird brought drought to the people and how a boy's love for the bird restored the rains only to have his father slay the bird, bringing drought again. Finally, the

people in the story understood the water bird's meaning and the rains returned.

Marcy Benstock, Director of the Clean Air Campaign, spoke of water and west side development. Her precise presentation led to a lucid exchange with the Dean about striped bass, Rene Dubois, and Westway. Jean Gardner, environmental historian, used slides to reveal New York City's misalignment with its waterways and suggested strategies of correcting the situation. Biologist Paul Mankiewicz talked about what local plants could teach our species about relating to water.

Cherokee Jimmie Durham gave a heartbreaking account of the water situation on Indian reservations. "Children commonly die of impetigo, a curable skin disease, because there is not enough water for washing," he said. He explained the work of the Indian Water Rights Tribunal now mounting a challenge to the Bureau of Indian Affairs on the basis of treaty rights.

In the afternoon, Nancy Jack Todd, editor of *Earth Annuals*, gave a wonderful presentation about water in the context of understanding the earth as a living organism. John Todd, Director of International Ark, then fascinated everyone with a slide show of "bioinventions," ranging from San Diego sewage treatment to plans for turning city streets into productive greenhouses and swimming pools.

James George of the Threshold Foundation reported on the dramatic decline in the tropical rainforests, the multiple difficulties in addressing the issue, and the growing political campaign to do something about it.

The day ended with mediative water music composed by Raphael Mostel and performed by the Tibetian Singing Bowl Ensemble. As the air filled with the sound of water being carefully poured from bowl to bowl around the circle of musicians, there was hope that by next spring the Cathedral Community might be a bit wiser about the waters of life.

Jesus Crucified, the Living Earth and Television

When I was a young man of seventeen, I joined a contemplative preaching order of the Roman Catholic Church called the Congregation of the Passion. The Passionists, as they were known, were founded in the north of Italy in the eighteenth century by a man named Paul Daneo. The order was dedicated to reactivating the memory of Christ on the Cross, especially among the poor. Besides the normal vows of poverty, chastity and obedience, the Passionists took a special vow to preach Christ and Him Crucified.

Paul Daneo became a saint in the Roman Calendar; his feast day is April 28. He is known as Paul of the Cross. According to the hagiography, Paul Daneo had a vision of the Blessed Virgin Mary in which she instructed him to found the order. In that vision, Mary showed him a white image of a heart with a cross above it, indicating the purity she wanted from men who preached about the sufferings of her son. To this day, black robed Passionists wear that white image over their hearts. The liturgy for the feast of Paul of the Cross quotes a line from the psalms, "Put me as a sign upon your heart and a seal upon your arm, because love is stronger than death."

In my fifth year of training with the Passionists (I was under temporary vows), the Roman Catholic Church was in the midst of upheaval occasioned by Vatican Council II. In the 1860's, the First Vatican Council had declared the Pope infallible in matters of faith and morals. In the 1960's, the Second Vatican Council of Bishops was struggling with this legacy and trying to respond to French and German theologians who were calling for significant changes in the organization and structure of authority within the Church. In my fourth year with

the order, I tried to start a student government in a monastery in West Springfield, Massachusetts.

During my fifth year, a friend of mine took me to see a visionary monk and theologian, a Passionist our immediate superiors had explicitly forbidden students to talk with. I felt privileged to be let in on the forbidden discourse. Five minutes into my first visit, the monk, my friend, and I were standing in our black robes with our white signs above our hearts, looking at a Zen painting of seven stones. The two of them were laughing a pure laugh of recognition. My laugh came out of camaraderie and uneasy learning. Suddenly, the monk said, "You know, this congregation would be a lot better off if we just forgot about the Crucifixion for a while." The laughter pealed off into a whiter shade of pure.

Shortly thereafter, I left the order and have spent the last twenty-odd years working on communications and ecology. The main fruit of that work has been the design of a television channel dedicated to monitoring the ecology of a bioregion and developing consensus about how best to live there on a long-term basis. The burden of this paper is to present that design in a way which accords with both the message of Jesus Crucified and with the scientific hypothesis that the earth is a living organism.

As for the monk/theologian, he has emerged as the earth's first 'geologian,' Thomas Berry. Fortunately, his radical laughter and love of the earth have touched many people. I don't know if he's given much thought to Jesus Crucified lately, but I've found myself coming around to meditate on the sufferings and death of Christ in relation to ecology. For me, it is striking that the logo of the First North American Conference on Christianity and Ecology is an image of the continent surrounded by four crosses. This image bears a strong resemblance to the image of a heart with a cross over it, the Passionist image that I wore for over four years. In remembering and rethinking the crucifixion, I have been helped by Elaine Scarry's discussion of suffering in *The Body in Pain* (Scarry: 1985). What I have to offer in this paper is as much indebted to Scarry as to the anonymous monks who taught me to meditate on the sufferings of Jesus.

Jesus Crucified

Christ Crucified has become a cliche. Once this image was a powerful archetype in the western world. Christ on the cross was *the* central referent for Christians. He was the only Begotten Son of God, God who so loved the world that He sent His Beloved Son to suffer death, death on the cross, for us. He was life's dancer savaged in mid-leap, a mother's son murdered in full bloom.

Jesus on the cross is a body in pain. Generations of people, with their bodies in pain, have gazed on Jesus Crucified and silently identified their pain with his. Sharing in the sufferings of Christ is a commonplace understanding for Christians. Identifying with the suffering of Christ is a way to cope with pain's inexpressibility.

Giving voice to physical pain is extremely difficult. Groans and cries are often all that come out. Physical pain shatters language. The "seven last words" of Jesus are precious, not so much because they were the last words, but because they were voiced from extreme physical agony. This agony was caused by the premier Graeco-Roman torture instrument, two pieces of wood and three nails. In spite of his physical pain, Jesus uttered his own words. Torture is designed to shatter the language of the tortured person and use the certainty of his or her pain to verify the words voiced by the torturer. Neither the scourging and crowning with thorns, nor the crucifixion itself, forced Jesus to submit to the will of the political authorities. Jesus did not comply with the words of his torturers. He shattered the believability of their creeds.

More importantly, by speaking his own words he broke the traditional relationship between pain and power. He was The All Powerful God, the ultimate authority and power. Yet he suffered physical pain. He gave his torturers the power to torture him. He did not end suffering. He did not end the injustice that often comes with political power. *What he did eliminate was the legitimacy of power at the expense of another's pain.* And in so doing, he ended this mode of legitimating power for God Himself.

In the context of pain and power set by the Old Testament, this is very dramatic. In the Old Testament, God has a voice but no body. Man has a body, but no voice of his own. The word belongs to God. God's power is verified by the sufferings of His people.

For example, when the people attempt to embody the unseen in a molten calf they can worship, God reasserts his own power over the people by ordaining a priestly class in blood.

> Thus says the Lord God of Israel, 'Put every man his sword on his side, and go to and fro from gate to gate throughout the camp, and slay every man his brother, and every man his companion, and every man his neighbor'. And the sons of Levi did according to the word of Moses; and there fell of the people that day about three thousand men. And Moses said, "Today you have ordained yourselves for the service of the Lord, each one of you at the cost of his son and of his brother, that he may bestow a blessing on you this day" (Exodus 32: 27-29).

The all powerful voice of God does not shy from calling for the blood of his people.

> I will spend my arrows upon them/they shall be wasted with hunger/and devoured with burning heat/ and poisonous pestilence...If I whet my glittering sword...I will make my arrows drunk with blood" (Deuteronomy 32).

God's willingness to injure does not stop at the physical bodies of his people. The land is also subject to his violence. Besides the great flood that temporarily obliterated the surface of the earth, God is willing to demonstrate his power over the land in other ways. "The uneven ground shall become level, and the rough places plane. And the glory of God shall be revealed" (Isaiah 40: 4,5). "What are you, Oh great mountain? Before Zerubbabel, you shall become a plain" (Zachariah 4: 7).

The Old Testament described a two-tiered reality. On the upper tier was the voice of God, who was unseen. On the lower tier was the physicality of the land and the people. The way from God's voice to man's body was mediated by divinely induced disasters and weapons. Any doubts about the existence of the unseen upper tier were greeted with flood, fire,

storm, whirlwind, plague, knife, rod, arrows, and sword. Bodies put in pain confirmed the power of the unseen God.

In the New Testament, Christ is the mediator. Christ substitutes himself for the weapon. As a mediator, he shatters the concept that the voice of God is verified by the physical pain of humans. That he himself replaces the weapon can be seen in how easily the torture weapon of the cross, in turn, comes to symbolize Christ in Christianity.

But how are things verified in the New Testament if not by the certainty of pain? If there is no longer any power in a disembodied voice causing pain, where is the power and authority? The disembodied voice causing pain yields to the power of verification by the senses. Rather than passive suffering, the New Testament is filled with the active use of perception as a tool of verification. The New Testament is filled with phrases like "come and see." God is suddenly eyewitness news. The senses become authoritative. No longer is there a demand for blind belief in words without flesh. Rather, Jesus is asking for more acute, responsible acts of perception. "Could you not watch for one hour" (Mark 14: 37). The doubting Thomas is not punished for his disbelief. Rather he is invited to "Put your finger here, and see my hands; and put out your hand, and place it in my side..." (John 20: 28).

What about the weapon? The torture weapon of the cross is altered into a powerful symbol against torture. All torture is torture of God. The sign of the cross means that political power should no longer be based on inflicting physical pain.

In the Christian dispensation, the cross becomes the metaphor for physical pain that cannot be co-opted. Peter was crucified upside down at his request to indicate that he was a believer in Christ but not worthy to imitate Him. The apostle Paul sought to know Christ and Him Crucified. The cross became the reference for people suffering under Roman rule who refused to accept the Roman voice of political authority. Rather, they built an authoritative community of witnesses to Christ, crucified and risen. Physical pain could not be used by the authorities to incorporate people into the imperial Roman way of life. Again and again the martyrs suffered publicly at

the hands of the Romans, willingly in the name of Christ. Witnesses of a crucified God, they lived in a community of love that understood that the certainty of pain could no longer be used by the authorities to confirm the fiction of their political power. The sign of the cross was the sign of new respect for human sentience.

By its nature, pain is unsharable. Torturers use pain to isolate people and confirm their own power. Divide and conquer. The sudden authentic shareability of suffering in the sign of the cross, invulnerable to Roman co-optation, created a community of sentience suffused with love. The texts of the early church, such as the feast for the consecration of virgins and the accounts of the martyrs, indicate something of that community of sentience.

Of course, we know the sign of the cross has failed to guarantee respect for human sentience. Here, I am not addressing Christian wars. What I am addressing are instances of torture in Christian history. To this day, Amnesty International can document torture in so called Christian countries. Perhaps the most poignant statement of this failure comes from the mouth of Dostoevsky's Grand Inquisitor.

Recall the story told in *The Brothers Karamazov*. During the Spanish Inquisition, Jesus comes unannounced to Seville, where in splendid "acts of faith," wicked heretics were being burned daily, *ad majorem gloriam Dei* (for the greater glory of God). Jesus is immediately recognized by the people. He makes a blind man see. He raises a young girl from the dead. The Grand Inquisitor, fresh from burning nearly a hundred heretics, recognizes him immediately and has him arrested. The monologue of the Inquisitor, in the cell of the silent Christ, is chilling to read. He hates Christ for having tried to free men from debased political power. He hates Christ for not having come down from the cross when the tormentors reviled him. "If thou be the Son of God, come down from the cross." He explains how the Inquisition is "correcting" Christ's work, in effect, reestablishing political authority based on torture in His Name.

While the sign of the cross has made respect for human sentience normative for Christians, it has failed to make that

respect operative. This is the case despite numerous efforts, like those of the Passionists, to reactivate respect for human sentience under the sign of the cross. Why this failure? More specifically, why is the sign of the cross subject to reversal by history's Grand Inquisitors?

The Weapon Metaphor

The cross is a metaphor for physical pain. Compared to all other interior states, physical pain has no referent. Other internal states have external referents: fear of x, hatred for y, love of z. Pain is not pain of or for anything. Because it has no objective content, it is very difficult to objectify in language. Ordinarily, there is no language for physical pain. Yet "languaging" pain, uttering words about pain in a painful voice, does help to relieve it.

Whether the language for dealing with pain is religious, medical, literary, or legal, it consistently uses the weapon as a metaphor. For example, "I feel as if I've been hit on the head with a hammer." The metaphor of a weapon provides a reference, where pain itself provides none. We use such metaphors to attempt to convey the experience of pain itself. The cross is a weapon of torture. It provides Christians with a referential metaphor for their pain.

Physical pain is invisible and unsharable with others. A weapon is a perceptible fact that can "make visible" the otherwise unsharable and invisible realm of pain. Pain does not sign itself for us. We recognize pain in the weapon. "When you cut your finger, bandage the knife" is the title of a sculpture by the artist, Joseph Bueys. The sculpture itself is a knife blade bound in gauze.

The image of the weapon to express physical pain works as long as the understood referents are physical pain and its attributes. But the metaphor of the weapon also permits a break from physical pain as referent. Bueys's sculpture could easily be retitled, "When you're bored, bandage the knife." There is no evidence of the cut finger in the sculpture. Only the words of the artist in the work's title insures the proper reference. Other words can break that reference.

The weapon metaphor can be used to transfer the attributes of pain from the physical body to something else. This is also the function of torture. The certainty of pain experienced by the tortured person is transferred to the uncertain fiction of political power associated with the torturers. Hence, the metaphoric language for pain is inherently unstable. It can express pain and thus help to relieve it. Yet these metaphors can also be used to transfer attributes of the body in pain to a regime in power. The certainty of Jesus' bodily suffering was appropriated by the Romans to stabilize their political power over the Jews. As we know, it did not work. Witnesses to the resurrected body of Jesus overturned belief in the certainty of Roman power.

Yet, as we have seen with Dostoevsky, the cross is not immune to the inherent instability of this metaphoric language. The metaphor that was meant by Christ to stop political power based on torture is meant by the Grand Inquisitor to create political power based on torture.

Circuit and Metaphor

How can we deal with this "break in the referent" that the metaphor of a weapon makes possible? Let us look again at the sculpture by Joseph Bueys. Wrapping the knife with gauze expresses the pain in the finger by making the weapon an analogy for the finger in pain. Wrapping the knife may express the pain, but it does not stop the bleeding. To stop the bleeding, the gauze must be wrapped around the cut on the finger. To eliminate the bleeding, a circuit of reference must be set up in the mind of the one in pain that precludes metaphoric breaks. That circuit of reference would be something like the following: Differences in the knife (sharp blade) make differences in my finger (the cut) that make differences in my blood flow (I'm losing the blood I need to maintain my body). The cut in my finger is the "error" that must be identified and eliminated if my blood flow is to be restored to its proper functioning. I have properly identified the error as the cut and can eliminate it by using gauze to substitute for my

skin until my skin heals. Wrapping the knife in gauze is irrelevant to this circuit.

Such a circuit of reference, or of differences that make differences, is considered an elementary unit of the mind in the understanding given us by cybernetic theory. Cybernetics seeks to understand how communications and control interact. The Greek word "cyber" means a steersman on a ship. How a steersman uses information from the wind and the water to control and correct his course is understood by cybernetics in terms of circuits of differences that make differences. These circuits of differences enable us to identify and eliminate error in our blood flow, the course of a ship, or in any other phenomena that involve self-organization and self-correction.

Circuits are figures of regulation for self-correcting processes. Take the example of a blind man walking with a cane. Cybernetically, the blind man walking with a cane is understood as a self-correcting process. Differences in the ground make differences in the cane. Differences in the cane make differences in his arm, which, in turn, make differences in his body, in where he steps next, and differences in where he puts the cane next. Differences in where he puts the cane next record differences in the ground and so on round the circuit. Any break in the route of reference around the circuit jeopardizes cybernetic understanding.

Metaphor works differently. Metaphor depends on the possibility of breaking the circuit of reference in order to set up understanding by analogy. This is a critical difference. Metaphors are figures of speech that express something by analogy with something else. By analogy, the blind man can be taken to mean a person who is not living in the state of grace. The song "Amazing Grace" uses this metaphor in the line, "Was blind, but now, I see." The difference between unsighted and sighted corresponds to the difference between ungraced and graced. The objective of metaphoric thinking is to understand the state of grace. The object of cybernetic thinking is to understand the blind man walking. Cybernetic thinking is best conveyed in diagrams. Metaphoric thinking is best conveyed in language. Diagrams are not suited to conveying metaphors. Language is not especially suited to

convey cybernetic thinking. However, in using language to discuss circuits, it is possible, by exploiting metaphor, to invite the reader to think cybernetically.

The Living Earth

Thinking in circuits, thinking cybernetically, has given us a rather startling and rich understanding of the earth. I am referring to the Gaia hypothesis of scientist, James Lovelock. To my mind, the Gaia hypothesis is a profound cybernetic meditation on the earth. Lovelock's story is worth telling. As an atmospheric scientist and inventor, he was hired by NASA to help figure out if there was life on Mars. Lovelock reasoned that if there was life on Mars, the life forms would use the fluid medium of the atmosphere to "make deals" that would sustain their differences. But since we know the atmosphere of Mars is uniform and without differentiation, no trading is going on. It's a boiled-down soup; there is no life on Mars

NASA didn't like the conclusion and promptly fired Lovelock. Returning to his countryside laboratory in England, Lovelock began thinking about the differentiation of the atmosphere of the earth. The atmosphere's peculiar mix of gases could not be explained according to the laws of chemistry. Twenty-one percent oxygen in the atmosphere was an anomaly in terms of how gases would ordinarily mix. Yet twenty-one percent oxygen was critical to maintaining life on the planet. Four-percent less and many forms of life would die of oxygen starvation. Four-percent more and most woodlands would burn up with the next lightening fire. Other such anomalies struck Lovelock. Three-percent salinity in the ocean supported many life forms which would die if that percentage were altered. A constant range of temperatures had been maintained over the history of the earth, despite a twenty-percent rise in the temperature of the sun.

Lovelock hypothesized that maintenance of all of these mechanisms could not be explained unless one posited that the earth itself is a self-regulating, self-correcting, "living" organism. Life is part of earth as feathers are part of a bird.

Stated simply, the Gaia hypothesis argues that the earth is a living organism. Not metaphorically, but cybernetically. As of this writing, Lovelock and others are busy identifying other mechanisms of planetary self-correction and a scientific consensus about the validity of this hypothesis is building.

Though I do think the Gaia hypothesis will hold up under scientific scrutiny, I am not suggesting building a religion on a scientific hypothesis. I regard the Gaia hypothesis and the excitement generated by the hypothesis in non-scientific circles as one of a number of new ethical gestures towards the earth. Because the Gaia hypothesis is based on cybernetics, I think it has a special status. I will return to that status in considering the television ecochannel. For now, I want to consider it as part of an ethical gesture in response to the current world situation. In doing so, I have been helped by Eric Gans's *The End of Culture* (1985).

Rising expectations around the world have brought our species to a dangerous threshold. Everybody desires the same dwindling resources. There is a collective fear that appropriation of resources by one group will lead to reprisals by others. Escalating military defenses are an index of this fear. However, in some quarters, this fear has led to a hesitation in the very gesture of appropriating the earth. Hesitation is turning itself into a gesture that designates the earth itself as worthy of the respect given life. In addition to the excitement generated by the Gaia hypothesis, we see such a gesture in a popular movement called bioregionalism, in green politics, in the reactivation of shamanic intelligence in indigenous cultures, and in the creation tradition within Christianity. Human conflict resolution, indeed, human survival, appears dependent on an ethic of respect for the living earth.

Designation of the earth as alive can be the beginning of a new ethical understanding. In building this new understanding, what can we learn from the crucifixion? Conflict resolution in the Old Testament shifted the focus from creating a "scapegoat" to humanizing the victim. Community errors cannot be dumped on a goat cast out into the wilderness. Community errors hurt some human member of this tribe. In the New Testament, the human victim is also divine. Jesus

was not just a human member of a tribe in pain. He was a human in pain who was also the God of all humans. He suffered to relieve all human sins. Any human sin hurts all humans. Universal reciprocity among humans is the message of the Gospels.

Heedless appropriation of the riches of the earth makes universal reciprocity among humans impossible. Ozone depletion, rainforest destruction, Chernobyl, acid rain, Love Canal, and urban stress on the web of planetary life are making it clear that Christians cannot sustain the norm of respect for human sentience without respect for the earth itself. To hurt the earth is to hurt others. To hurt the earth mocks the Crucified Christ.

Let us look more closely at what it means to designate the earth as alive. Is it a mere projection? Or can we look at the phenomenon of projection without using the pejorative adjective "mere"? How can we look at the projections of aliveness in the Christian tradition of respect for sentience?

> Man wends his way through forests of symbols
> Which look at him with their familiar glances.
> — Baudelaire

Poets, who dream for us all, project their own aliveness onto the external world as a matter of course. To see objects in waking life is one thing. To see these objects in dreams, it is as if the objects see the dreamer just as much as the dreamer sees the objects. The poet or dreamer transposes a pattern common to human interaction onto the external world. A person we look at looks back at us in return. The very work of poetry involves the projection of this reciprocity of gaze, this assumption of aliveness, onto the external world.

While artists may pretend or wish in all seriousness that the inert external world respects human sentience, it is the work of culture to make this a reality. Take as an example the chair you are sitting on. Standardized, manufactured, impersonal item, agreed. But the design of the chair is based on one human's perception of another person's discomfort, seeing someone in pain and wishing the pain gone. The wish for relief from pain becomes enacted, made into an artifact. The

artifact frees you from pain and frees you from the sustained good wishes of the chairmaker. We assume a certain amount of respect for sentience in our made world. If a chair collapses and someone gets hurt, the chair manufacturer can be sued. We have a complex legal structure of product liability that assumes respect for sentience in the made object.

Look at the designation of the earth as alive in these terms. Does it not involve the wish to deny the planet possibility of becoming indifferent to our sentience? To make this planet safe for humans? The naturally existing world is ignorant of the "hurtability" of humans. Sea storms, heat waves, viruses, and radon care not for human sentience. The human response to this is to "make" these phenomena in some way knowledgeable about human pain. We manufacture artifacts: boats that we can stabilize in storms, air conditioners, vaccines, and ventilation systems for radon. These artifacts demand from the external world respect for our hurtability and our sentience.

Respect for our hurtability underlies much of the current designation of the earth as alive. The bioregional movement began with the fusion of scientific data and local knowledge from indigenous cultures and generated a vision of how not to let the planet hurt people. Originally, the bioregional vision supported the efforts of people fleeing the city to reinhabit the land intelligently, without destruction. Currently, the bioregional movement is addressing the brutality of city life directly with dreams and schemes for Green Cities all over North America. Creation theology is drawing on the mystic sensibility of Hildegard of Bingham, Mister Echart and others to avoid the painful dead end of redemption theology and reactivate our direct relation with creation. Shamanic traditions have much to do with healing hurt.

What the Gaia hypothesis suggests is that we have—or can acquire in a reasonable frame of time—operative knowledge of the planetary mechanisms of self-correction. Based on that knowledge, we can learn to identify and eliminate errors in how we behave in relation to the processes of the planet. We can preclude wrecking the only human home we have. We can share the riches of a sustainable planet. Learning to abide

its mechanisms of self-correction can insure reciprocity among humans. Reciprocity with the Living Earth can become the basis of reciprocity with each other. The terms of earth life are terms which are not man-made and they resist political manipulation.

Cybernetics regards the Living Earth in terms of circuits, not metaphors. To take the Living Earth as a metaphor leaves us open to the problems of metaphoric language. A fascistic environmental movement could conceivably promote itself using Gaia as a metaphoric symbol. By relating to the Living Earth in terms of self-correcting circuits, we might be able to avoid the specter of biofascism, to avoid the Grand Inquisition in the name of Gaia. Human seeing-pain-and-wishing-it-gone without political manipulation found its most articulate symbol in a Crucified God. But this symbol, as we have seen, has been politically manipulated to cause hurt. Current projections of "aliveness" onto the earth are likewise vulnerable, and this is where I look to a cybernetic use of television as a safeguard.

Television

In referring to television, I distinguish from network television. Bascially, I am indicating a medium that enables us to monitor events simultaneously with other people. Whether it is the Irangate hearings, launching a space craft, following a wandering garbage scow, or a baseball game, television monitors events. I have designed a television channel that would enable us to monitor this ensemble of events in a systematic way and develop a consensus about how to behave in a way that respects this ensemble. The ecochannel would enable us, as a species, to maintain fidelity to the self-correcting life processes of the bioregions we live in.

The full design for the ecochannel has been presented elsewhere. What I want to stress in completing this paper are two things. 1) The channel is grounded in sharable perception and would support cultural changes that reconnect us with the ecology. 2) The entire design is based on a circuit that is a sign of itself.

Perception

Perhaps the quintessential achievement of a Christian in the realm of perception belongs to the poet, Gerard Manley Hopkins. Hopkins believed that the patterns of nature could be "inscaped" directly. By this he meant that direct perception of a particular event in nature could yield the underlying pattern. A few examples from his journals will remind us of his perceptual acuity.

> The next morning a heavy snowfall...looking at the elms from underneath you saw every wave in every twig (become by this the wire-like stem to a finger of snow) and to the hangers and flying sprays it restored, to the eye, the inscapes they had lost. They were beautifully brought out against the sky, which was on one side dead blue, on the other washed with gold (Hopkins [1870] 1953: 119−120).

> About all the turns from the scapings from the break and flooding of the wave to its run out again I have not yet satisfied myself. The shores are swimming and the eyes have before them a region of milky surf but it is hard for them to unpack the huddling and gnarls of the water and law out the shapes and sequences of the running (Hopkins [1872] 1953: 126−127).

Our capacity to inscape natural patterns has been enormously enhanced by film and video. Time-lapse study of desert flowers blooming and slow-motion studies of hummingbirds in flight are instances of inscape. Working from extensive video studies of the Great Falls in Paterson, I wrote the following description of the flow patterns:

> The Great Falls. A full seven subbasins (of the Passaic River Watershed) dropping seventy feet. Water over rock. A pure formal rendering of the figures that regulate the life of the Passaic Watershed. Droplets abound like microorganisms in the soil. Billows like the shells of bog turtles. Backcurls of water like muskrat slides. Fantails appear like the sudden flight of partridge. Small pools pulse like our wrists. Water cascades through rock formations like new trees competing for sunlight in an open field. A multitudinous song, once and for all (Ryan: 1979−1980a).

The ecochannel is based on a systematic inscaping of the natural patterns of a bioregion, using videotape. The natural patterns can be encoded in the mathematical models developed by Rene Thom. Thom's rigorous qualitative models can

be used as a notational system for ecological events. This frees us from expressing inscape metaphorically, as in the waterfall passage above, and allows us to use inscaping as part of a cybernetic understanding. In the context of the Gaia hypothesis, it is assumed that out of this ensemble of inscapes, we will come to understand the syntax of self-correction proper to a bioregion or sub-bioregion. This syntax will be continually monitored on the ecochannel, and interpreted for the whole community in various televised educational and discussion formats. The design organizes a way whereby the community can come to consensus about how best to respect the syntax of self-correction that supports its life.

The ecochannel will not just be devoted to monitoring ecological events but will support the necessary shift to a culture more in keeping with the syntax of self-correction which has been unconcealed by the video monitoring. The ecochannel design itself sketches this cultural programming. In many ways the cultural aspect of the ecochannel can be seen as a transformation of the bioregional material in *Talking Wood*, discussed above, into television formats.

A Sign of itself

The formal organization of the ecochannel design is based on a circuit that is a sign of itself. Because this circuit references only itself, it can organize information in such a way that any break in the reference would be immediately apparent. No meta-level of interpretation is necessary. I take this apparently paradoxical notion of a sign of itself from the philosopher Charles Peirce. Peirce argued that it is arbitrary to think that a sign must be separate from that which it signifies. A map of an island, on that island, must have a point where the map and the territory are the same. Similarly, Peirce said, there is nothing to prevent a play about the crucifixion from including a relic of the true cross. Peirce argued that we should be able to develop a sign of itself, where each significant part is explained by the other parts without recourse to explanation outside of the sign itself. Years of work with Peirce, video, and cybernetic theory have enabled

me to come up with a circuit that is a sign of itself. The circuit is simple; its parts are all perceptible. Essentially, it is a development of the Möbius strip into a six part, tubular figure. (See Fig. 19, p. 103.) I will discuss its implications under four headings: exclusion, forgiveness, certainty, and pain.

Exclusion

The message of the Gospels is universal reciprocity. No one left out. Once we have allowed human conflicts and contradictions to scapegoat God-made man, the very mechanism of scapegoating is deeply suspect. Jesus died on the cross once and for all. In principle, no one need be scapegoated again. The ideal becomes a universal fellowship of love which excludes no one and does not manipulate anyone's pain for political power. Universal reciprocity.

Exclusiveness begins when more than two are gathered together. The normal pattern is for two to combine and extrude a third, thereby reinforcing their relationship at the expense of the third party. Trinitarian theology describes an ideal relationship among three where this extrusion does not happen. Communication does not depend on reference to an extruded outsider. The circuit is a sign of itself which makes possible an operative version of the non-exclusive Trinitarian relationship for humans. What I am saying is that using the relational circuit as a figure of regulation, three people can stabilize the relationships among themselves without excluding any one party, and without creating a hierarchy. What it takes to do this is an ongoing, non-verbal relational practice that balances the relationships among three people. The reason this is important in developing a television ecochannel is that the two-against-one dynamic tends to drive our perception of nature into categories of competition and privatization. We need to neutralize this dynamic in order to come to an authentic, sharable and trustworthy perception. The ongoing video perception of recombinant triads of people, using the relational practice to self-correct their interaction, provides a neutral scaffolding from which to perceive the syntax of self-correction operative in any bioregion of the planet.

Forgiveness

Traditional Christianity has used the mechanism of forgiveness to eliminate conflict within the community. A large tolerance for emotionally accepting the failings and errors of other community members has been one of the ways Christianity has survived. Again, the sign of the cross has been central. If God so loved sinners as to die on the cross for them, who are we to hold a grudge? Judgement is deferred.

However, we cannot extend this forgiveness indefinitely to errors against the ecology. Gregory Bateson used to insist that the most difficult scripture to live with was the saying of Saint Paul, "God is not mocked." Bateson pointed to this saying to indicate that the larger system of which we are part has its own rules and tautologies. These rules operate to identify and eliminate errors that keep the system from optimal viability. If humans continue their present path of reducing to the absurd their viability as part of the self-correcting organism we call Gaia, Gaia will not be mocked, Gaia will not be able to forgive the human species, Gaia will eliminate the human species. There will be a judgement; no longer will deferral be possible.

In the present situation, adhering to emotional patterns that provide forgiveness no matter what is a dead end of Christian sentimentality, redemptive theology at its worst. Respect for human sentience is our norm, not the indulgent sentimentality Nietzsche scorned. Our ecological sins cannot be solved by scapegoating, even by scapegoating Jesus Crucified. We can make reciprocity with the Living Earth the basis for reciprocity with each other. Using a cybernetic relational practice to correct our interaction is a way to avoid the Christian illusion that we can extend indiscriminate forgiveness to ecological transgressions.

Certainty

As we have seen, the attribute of the body in pain that political regimes most covet is its certainty. Language alone cannot generate certainty. Recent close analysis of the structure of language by the mathematician Kurt Gödel reveals that it is

impossible to have a complete and consistent set of propositions (Gödel [1931] 1962). Either the set is inconsistent – that is, contains contradictions – or it is incomplete, unfinished. A set of propositions that is unfinished or contains contradictions cannot provide the certainty humans need. Creeds are language structures which acknowledge that their fundamental propositions are arbitrarily closed to questions. Fundamentalists all have their creeds. The certainty of the creed is a matter of belief, not of rational examination. Roy Rappaport has argued that this belief begins with the child's numinous experience of the mother and the unquestioning acceptance of what she says. Papal infallibility can be seen as an intuitive recognition of this instability of language. Inconsistency and/or incompleteness are emotionally expensive; they undercut certainty. Any creed needs an arbitrary mechanism to guarantee certainty, a religious version of the buck stops here.

The relational circuit at the core of the ecochannel design is both complete and consistent. As a perceptible sign of itself, it avoids the instability inherent in propositional systems and is open to being used as a figure of regulation for sharing perception. All six parts of the circuit are explained by the other parts in a consistent way. It is not unfinished, nor does it contain contradictions. This means that an information system built on this circuit could generate certainty without arbitrary mechanisms. Certainty would not have to be borrowed from the body in pain.

Pain

I am not claiming, however, that using this sign of itself will eliminate pain. Its use may deter the exploitation of pain's certainty by political authorities that misusing the metaphor of the cross has all too often brought about. The circuit that is a perceptible sign of itself makes it possible to develop certainty based on shared perception of environmental realities. The television Ecochannel is, in effect, a design for a system of information transmission based on perception. The Ecochannel would make it possible for the public to verify information about the ecology with their senses rather than relying on

metaphors such as the earth is our mother. The circuit that is a sign of itself gives a logic of self-correction other than forgiveness and is potentially free of manipulation by political authority. A logic of self-correction means that we can break whatever human conspiracy against nature lurks in the recesses of Christianity and link up to the self-correcting processes of the Living Earth. It is a way to avoid the potential travesty of allowing Christianity to conspire, in the name of the Son, against the creation of the Father. A culture that creates a perceptual code of verification for itself, in terms of a sign of itself, is more likely to respect pain without exploiting it to stabilize the latest political fiction, even if it is a biofiction. Such a culture would be likely to let pain find its own way into human sentience by way of the imaginations of the person in pain or those who care for that person.

I return to the imagination of poet Gerard Manley Hopkins. Perhaps as a community we can develop the acuity to inscape nature in the way Hopkins did. His sense of seeing-pain-and-wishing-it-gone extended directly to the "aliveness" of nature. In Goethe's phrase he had "exact imaginative sympathy" for natural phenomena. Hopkins wrote:

> The ash tree growing in the corner of the garden was felled. It was lopped first: I heard the sound and looking out and seeing it maimed there came at that moment a great pang and I wished to die and not to see the inscapes of the world destroyed anymore (Hopkins [1873] 1953: 128).

The television ecochannel is designed to make this perceptual capacity commonplace and to help heal the earth. Our many eyes can become one with the mind of the earth.

> I thought how sadly beauty of inscape was unknown and buried away from the simple people and yet how near at hand it was if they had eyes to see it and it could be called out everywhere again (Hopkins 1953: 126).

Communications for the Riverside Park Community

Proposal for the Design Phase

Today Riverside Park provides a taste of Paradise for the Upper West Side, as Frederick Law Olmsted hoped it would. In Paradise, there is no division between rich and poor, educated and uneducated, professional and unprofessional, old and young. Rather, there is one community of people who appreciate nature.

Like New York City itself, the Upper West Side is divided into rich and poor, educated and uneducated, professional and unprofessional, black and white, Hispanic and non-Hispanic. These multiple divisions often require hard decisions to maintain the body politic. Hard decisions can breed resentment. Olmsted understood these difficulties and envisioned the urban park as a place free of resentment, a place where all could recapture a sense of paradise. Current efforts at park restoration carry these hopes as well.

Riverside Park is at a particularly crucial point in its development. Charles McKinney, Director of the park, has developed a long-range plan for its revitalization that is exemplary among such plans in New York City. The recently organized Riverside Park Fund is preparing to begin fund-raising for the plan's implementation. The park users continue to be among the most ethnically and economically varied of any park user group in the city. At this point, the politics of hard compromise have not spilled over into the relationships between various park users. There is no history of divisive politics as yet, and no accumulation of resentments.

This is a proposal to preclude divisive politics from accumulating as the park enters this new phase of revitalization. The premise is that the various differences between all

the Riverside Park interest groups can be orchestrated to include all, not exclude some for the benefit of others. What is required is a communication system that does not exclude the validity of anyone's perception of the park and works toward consensus in decision-making.

Communication establishes and sustains community. As Olmsted envisioned, one person's appreciation of the river and the riverside can enhance another's appreciation. Each person's appreciation is different, yet the communication channels in a community can organize these differences in ways that resonate with each other. Different ways of perceiving nature can be orchestrated without creating division. Paradise along the river is possible.

Proposal

This is a proposal for the design of a television communications system for the Riverside Park community. The intent of the system is twofold: 1) to create an ongoing understanding of the river and the park for park users and other interest groups that will enhance everybody's appreciation of these natural and designed treasures, 2) to provide a framework for consensus about park decision-making.

Television is the most non-exclusionary medium of public communication available. Unlike print media such as books and newspapers, television does not require formal training. Television can be used to ground our understanding of the park and the river in a mosaic of community perception. Park users do not share a textbook about the park. What they do share are experiences of the same place. Video can be used to validate these experiences as part of a larger community experience. The intended communications system will enable the community to generate a mosaic of their perceptions that will provide a common ground for community understanding.

The design phase of the proposed communication system for the Riverside Park community will include:

1. Artistic studies of Riverside Park and the Hudson River using video.

2. A script for a video production that presents Olmsted's design vision and the views of Robert Moses and others involved in the history of the park.

3. A script for an educational videotape about the ecology of the park.

4. A script for a videotape that presents how different users appreciate the park.

5. The development of a program outline for training local youth as "video rangers" to do ongoing studies of the park and river as well as to provide regular video communication service for park users.

6. The identification of various outlets for the communication system: including schools, churches, synagogues, video stores, bars and restaurants with television, and public cable television.

7. The development of ways of using the communication system at meetings to support consensus decision-making about the park.

8. The organization of a plan of implementation.

9. The development of a financial prospectus and the determining of sources of funding.

Video Rangers

A proposal to The Parks Council to train youngsters to produce video interpretations of New York City Parks

Long-Range Objective

The long-range objective of this proposal is to create a sustainable Corps of Video Rangers for the public lands of New York City which would be modeled on the Park Rangers. In Frederick Law Olmsted's original conception of park rangers, their role was to educate the public to fully appreciate the land it owns in common. The Video Rangers would be trained to fulfill this role using the technology of television in a systematic way. Systematic use of television technology would include continuous, quality programming on a city-wide television channel dedicated to the ecology.

A special training program for city youth will be the basis for the Corps of Video Rangers. It will train them to be ecological videomakers for the city's public lands. The program will be replicable across the United States, not just for publicly owned city lands but also for state and federal lands. Ecological videomakers are people skilled in video production techniques proper to understanding and communicating about the ecology.

Besides job training, a major intent of the program is to provide a relatively small, elite corps of teenagers with the opportunity to take on a distinct identity that can become a source of pride and self-respect. The training would set up ongoing video production teams of three members. The teams would function like basketball teams. An on-site adult would function as the coordinator/coach. In some ways, training would be analogous to sports training with its routines and *esprit de corps*.

Immediate Objective

The immediate objective of this proposal is to gain support for a pilot training program. This pilot training could be organized in cooperation with some existing program or programs. Possible cooperative programs include:

- Coordinating the Video Rangers with the Natural Resources Group's "Adopt-a-Park" Program for Schools.

- Finding ways to link the Video Rangers with the NYC Public Schools.

- Developing a training program that combines the Parks Department's Summer Youth Employment Program with year-round part-time employment for high school students.

- Adapting the training of Park Rangers to the training of Video Rangers.

- Developing a training program that would teach Civilian Volunteer Corps members to be Video Rangers.

- Developing the Video Rangers in cooperation with scout explorer units and similar existing programs.

Training Programs

The purpose of the Video Rangers is to produce videotapes about the ecology of public lands, for the people of New York City, so we can understand and respect the city's ecology. The training program will be based on a simple cycle that reflects this purpose:

1. Training in video techniques.

2. Instruction in ecology.

3. Videotaping the ecology.

4. Editing the video.

5. Showing the video to an audience.

This five-part cycle is flexible. Depending on the final program configuration, this cycle will be repeated on a daily, weekly, or weekend combined-with-after-school basis. Perhaps extended day or work-study programs could be used. Summer programs are also a possibility. For instance, a summer segment could be an intensive three weeks at a sleep-over camp with the cycle repeated each day. Or the summer segment could be a day camp arrangement for eight weeks with the cycle being repeated on a weekly basis.

This cycle will be repeated with appropriate elaborations. For example, showing the tape to an audience will be elaborated into methods for showing the same tape to different audiences and developing a consensus of interpretation among the different audiences.

Video techniques that will be taught include:

1. Moves from T'ai Chi Tuan adapted for handheld camerawork.

2. Learning to work in production teams of three.

3. Learning how to monitor an ecosystem.

4. Learning how to see patterns in nature with a camera.

5. Learning to edit landscape video.

6. Learning how to use video to facilitate consensus.

After the initial training period, each team of three Video Rangers will be able to produce at least a half-hour program each week. The cycle of videotaping, editing and showing expands into a coherent cycle of ten different sorts of programming. After initial training, the Rangers will produce weekly programming in accord with these ten different sorts

of programming. Over the course of a year, each of the four seasons will see one tenfold cycle of programming.

Examples of the ten different sorts of programming are:

1. Bulletins that inform community television viewers of live events they may want to get involved with: viewing the migration of ducks, the turning of the leaves, hikes sponsored by various groups, etc.

2. Doing a line-of-sight study of a section of New York City coastline. Natural sound.

3. Time-lapse studies of the changing tides.

4. A study of the leaves changing color accompanied by local musicians.

5. Shows for community television based on the education programs of nature centers.

6. Shows that are a fair presentation of the position of different groups arguing over an environmental issue.

7. Collection and presentation of information about the ecology, to the community at large, that may help resolve an issue.

8. Production of programs that monitor the ongoing ecosystem of New York City.

9. Development of programming that supports long-term policy decisions about the ecosystem of New York City. Includes quality programming on ecology obtained from independent producers.

10. Development of programs that document and encourage practices that help insure the viability of New York City's ecosystem.

Each team of three Video Rangers will produce twenty hours of video each year. The nature of the tape will often be such that it bears repeating over a television channel. For example, line-of-sight video study of the coastline of New York City could be shown cumulatively over the years.

The ecochannel is not designed to compete with prime-time television but to be a window on the ecology, an ongoing scanning of the ecosystem. The expectation is that some people will have a second television tuned in to the ecochannel, like a painting on the wall, allowing them to monitor ecological events shown without voice over. When ecological issues heat up, the ecochannel will be there with reliable information and ways for citizens to get involved.

Video Rangers and the Community

While video is not a panacea for ecological problems and a pilot training program cannot be expected to produce wonders, the Video Rangers would fulfill a definite role for the community as it struggles to make ecological decisions. The Rangers role will be to use video to monitor the ecology of public lands for public education and to use video to facilitate consensus about its optimum use. They will offer a communications medium that does not exclude the validity of anyone's perception of public lands and works toward consensus in decision-making.

NEST: New York City Ecochannel for a Sustainable Tomorrow

*A proposal for a municipal television channel dedicated to
the environment of New York City.*

New York City is a single NEST for our separate lives

History

This is a proposal to create a municipal television channel
dedicated to the environment of New York City. The name
for the proposed channel is NEST, "New York City
Ecochannel for a Sustainable Tomorrow." An alternate read-
ing of this acronym is New EcoSystem TV. The purpose of the
channel is to monitor and interpret the ecosystems that
support New York City, so the citizens of New York can
develop ecologically sound policies and practices.

This proposal has been prepared by Paul Ryan, a member
of the Steering Committee of Environment '90. The sponsors
of Environment '90 are Audubon Society (NYC), Cathedral of
St. John the Divine, Clean Air Campaign, Coalition for the
Bight, Earth Environmental Group, Environmental Action
Coalition, Environmental Defense Fund, Environmental
Education Advisory Council, Green Guerrillas, Hudson River
Sloop Clearwater, Learning Alliance, Natural Resources
Defense Council (NYC), Neighborhood Open Space Coalition,
New York Public Interest Research Group, Project for Public
Spaces, Protectors of the Pine-Oak Woods, Radioactive Waste
Campaign, Sierra Club (NYC), The Parks Council, and Trans-
portation Alternatives. The sponsors of Environment '90
produced the first comprehensive platform for New York City,
a platform which received the endorsement of over 250
additional groups in the city.

One plank in the platform calls for a city-wide television channel to monitor the city's ecology. The very existence of the extraordinary coalition demonstrates the need for such a municipal television channel; the coalition proves that there is now a shared understanding of New York City's environmental predicament. This proposal is meant to initiate the process of building an ecochannel for the City of New York that can nurture this common understanding.

Before rationale, programming, and budget for NEST are presented, the Environment '90 platform and platform initiatives relating to NEST will be reviewed. This proposal will then 1) present reasons for dedicating a municipal television channel to the ecology, 2) sketch out sample programming, and 3) offer a budget estimate for operating expenses.

Environment '90 Platform and Platform Initiatives.

The Environment '90 platform contains a heading that reads THE CITY MUST PROVIDE ENVIRONMENTAL EDUCATION FOR ALL AGE LEVELS. Under this heading the platform plank that mentions an environmental television channel directs the city to do the following:

- Conduct intensive media campaigns about NYC's environmental problems and programs,

- Increase environmental coverage on WNYC and WNYE,

- Negotiate with cable TV companies for city-wide channel to monitor city's ecology.

To implement the Platform, the Steering Committee of Environment '90 developed a consensus among the groups cited above about specific initiatives for each plank. The initiatives specific to the above plank include the following suggestions for implementation:

- Initiate environmental programming immediately by directing the Commissioner of Cultural Affairs to provide

funds for a pilot project that will develop environmental programming over WNYC and WNYE, study audience response, and make recommendations for ongoing environmental programming.

- Direct the Office of Telecommunications to set up a city wide educational television channel to monitor and interpret the ecosystems that support New York City, so the people of New York can develop ecologically sound policies and practices.

- Commission a feasibility study for the television ecochannel.

- Use WNYC to initiate environmental programming and/or

- initiate other pilot programming that can be used to help determine the appropriate programming for the ecochannel.

- Establish a non-profit board of environmentalists, educators, government officials and media professionals to be responsible for the environmental channel. Direct board to choose an overall design for the ecochannel and then function on the model of a "television publishing house" as exemplified by Channel 4 in England, commissioning programming from community groups, educators, environmental groups and independent producers.

- Have the board be responsible for developing training programs for producers in methods of ecological monitoring and interpretation.

- Set up funding from diverse sources such as cable television franchise fees.

Rationale For NEST

Why does New York City need to devote a city-wide television channel to the environment?

New York City is located on the cusp of two large ecosystems: the Eastern Woodlands and the Atlantic Ocean. These systems meet and mix in the Hudson Estuary. Robert Boyle, author of *The Hudson River*, argues that the Hudson is in danger of being destroyed by "a thousand little cuts." So are the Eastern Woodlands and the Atlantic Ocean. Overdevelopment and acid rain threaten the Eastern Woodlands. Agricultural and industrial pollutants threaten the Atlantic Ocean. New York City itself suffers from problems of unreliable water supply, increasing traffic congestion, shrinking open space, toxic waste, mounting garbage, and the threat of an altered shoreline resulting from the greenhouse effect. If New York City is to avoid recurring environmental disruptions, it must monitor, protect, and restore its ecosystems.

Monitoring these threats to our habitat requires systematic, ongoing observation. Environmental monitoring must be constant and coherent to make sense out of the ensemble of events that constitute our complex ecosystems. These events include tides, changing seasons, shad runs, the migration of birds, leaks from sewage treatment plants, and thermal inversions that trap pollutants. As citizens in an age of environmental crisis, New Yorkers need an electronic window on city ecologies that provides a shared perception of how these ecologies work as well as an understanding of how not to destroy them. A television channel set aside for this purpose would enable us to monitor the ecology on an ongoing basis.

Could a public access channel be used to monitor the environment?

Public access is designed to extend First Amendment rights of free speech to television programming. This is important. However, access is structured to allow many groups to "get

their message" out to the public. The orchestration of programming appropriate to this electronic extension of free speech could not be mixed with monitoring since monitoring requires an uninterrupted and coherent system.

Why can't we rely on commercial television news to monitor the environment and educate the public?

Although some commercial news departments are beginning to do exemplary programming, it is unrealistic to expect profit-making entertainment organizations to provide us with an ongoing reliable interpretation of environmental issues. Beside the fact that the "news" is increasingly managed for entertainment value, commercial management would be presented with numerous conflicts of interest. For example, the automobile industry, one of the most environmentally culpable in our industrial consumer culture, will spend over three billion dollars in television advertising this year. One can hardly expect automobile manufacturers to replace those endless images of the latest model cars speeding down lovely country roads with serious environmental programming.

Why should this ecochannel be an educational channel?

The channel will provide the diverse language and cultural groups in this city with a shared perception of the place we live in. Also, the ecochannel will offer the generation raised on television a way to understand environmental issues in their own medium. It will generate and nurture environmental intelligence for all groups in the city.

Will anybody watch the channel? How will it compete for an audience in the New York City market?

It is worth remembering that in national polls, Americans consistently rate the environment as a very high priority. The channel will help citizens engage this priority by integrating programming with the activities of the community, as

described below. Moreover, some of the programming could become part of an environmental curriculum in the schools.

As far as programming based on systematic monitoring, the expectation is that people will turn the channel on for long periods without necessarily focusing on it. As interest in "keeping an eye" on the environment grows, some people may choose to use a second television set for the ecochannel. Whenever environmental issues directly affect citizens, they will be able to turn to the ecochannel for access to the most reliable information. The channel will become an important link between people and the ecology, eventually acquiring the kind of prestige now given to Cable News Network.

How will the channel be managed?

The most appropriate management structure for the ecochannel is provided by Channel 4 in England. Of course, a critical review of their experience would be necessary before the model would be actually adopted.

Programming for NEST

The purpose of the ecochannel is to monitor and interpret the ecosystems of New York so that policies and practices for a sustainable city can be developed. In keeping with that purpose, the station would carry three main types of programming.

1) *Monitoring Programs.* Fixed remote cameras that observe tides, sunrises, sunsets, heat patterns in the city (infrared cameras) etc. Data recorded by remote electronic sensors about air quality and water quality, to use two examples, would be translated into intelligible graphs and images appropriate for television presentation. Satellite scanning of the region would be shown regularly using real time and time lapse techniques. Also, small production crews trained in monitoring the ecology would create systematic programming on the ecologies in and around the city.

2) *Policy Programming*. Public debate and discussion about environmental policy would use the information provided by monitoring as a common reference. The programming would be structured to support an informed consensus about proper responses to environmental concerns among private citizens, community groups, community boards, various government agencies, the Borough Presidents, the City Council and the Mayor.

3) *Cultural Programming*. For New York City to become a sustainable city it must shift from being a culture of waste to become a culture of recycling. Moreover, it must grow from a disparate culture of immigrants representing every continent on the earth into a mosaic of peoples who know how to live in this place without destroying it. The ecochannel would support this shift with programming that weaves the cultural traditions of the peoples of New York into practices that are in accord with a sustainable city.

To suggest how these three broad types of programming would appear on NEST, a description of an ecochannel series about a hypothetical, but quite possible, tree planting project in Brooklyn is described below. This series of programming is given as an example because several planks in the Environment '90 Platform call for planting trees because of very real benefits to be gained in the character of open space, the reduction of ozone, dioxide and other air pollutants, and the cooler summer temperatures for city streets.

Sample NEST Programming
This is a hypothetical series of programs about a tree planting project called Trees Grow in Brooklyn. The series would include:

• Interviews with the people who initiated the project.

• Documentation of Urban Conservation Corps members from The Parks Council planting trees and school children's participation in the program.

- Interviews with neighborhood senior citizens who have agreed to care for the trees and report regularly on their progress.

- Techniques of tree maintenance.

- Discussions with people in different ethnic neighborhoods about the trees in their country of origin and the trees that are being planted in Brooklyn. Imported footage and family photographs are used to present the differences. Also included is footage of the different trees that grow along the Hudson River Valley.

- Edited footage that followed and supported the building of borough-wide consensus on the project from its initiation with a community group through discussions with the Parks Department, community boards, and the Borough President's office.

- A program in which the Mayor discusses tree planting with environmentalists and people from different neighborhoods.

- Report on a court case that developed when a neighborhood group tore up a sidewalk to plant trees.

- Investigative piece on the suppliers of plant material.

- Report on a new, community-initiated development in Fort Greene in which the architectural plans included preserving old trees, planting two stands of new trees, and rooftop gardens. The program would include video of the process of consensus that operated throughout the project.

- Coverage of the remote sensors of air quality in Brooklyn.

- Discussion with scientists, supported by clear graphics, about how the planting program will improve air quality,

lessen carbon dioxide, and play a part in the Global ReLeaf effort to reduce the greenhouse effect.

- NOVA special on the greenhouse effect.

- Discussion with scientists about how trees cool the temperature in the summer accompanied by infrared video studies of the heat patterns that surround different trees.

- Satellite scanning of Brooklyn's vegetation during the project.

- An artistic, music video interpretation of trees.

- Coverage of a multicultural festival in Prospect Park celebrating the Project.

- Time lapse studies of sunlight on new and old trees.

Budget for NEST

Total Operating Budget: $14,156,496. Even in this time of budgetary constraint, NEST is a sound investment in New York City. Besides encouraging small business and creating jobs, NEST is a preventive fiscal program that will contribute to the city's long term financial stability.

Supporting Small Businesses and Creating Jobs. With a total operating budget of $14,156,496, over sixty percent of this budget will go to small businesses, i.e., independent video production companies who produce original programming for the channel. Since this kind of video production is labor intensive, these contracts for independent producers will create over two hundred private sector jobs. Moreover, these contracts will contribute to creating a qualified work force for the telecommunications industry.

A Preventive Program. As it becomes increasingly clear that sound ecological policy makes sound economic sense, the potential fiscal savings for the city are enormous. Monitoring the city's ecology is a prevention program that will save the

city large sums of money in the long run. For example, NEST could create a context in which water conservation and recycling levels would increase dramatically. This would save the city the expense of developing new fresh water supplies and some of the cost of garbage disposal. Another obvious case is waterfront development in the city. How can such development proceed without solid information on how the greenhouse effect will change the shoreline? NEST could provide that information. The data base developed by NEST would also lessen the cost of Environmental Impact Statements.

Costs in Perspective. To put this budget into perspective, the total is less than thirty percent of what the cable companies pay the New York Yankees during a season. This is to say that the cost of the entire ecochannel is roughly equivalent to what the cable companies pay for the rights to cablecast forty-eight regular-season New York Yankee baseball games. Another instructive comparison is the advertising budget of the automobile industry which, as mentioned, will exceed three billion dollars this year.

Funding Sources. The logical source of money for the municipal ecochannel would be the pool of monies paid by the cable companies as franchise fees to the City of New York. Investing in a sustainable city makes sense for the cable companies. If New York City becomes increasingly uninhabitable, their assets suffer enormously. The value of a communication's cable passing an abandoned house is zero. Presently the value of a cable franchise in the city is placed at over three thousand dollars per subscriber. The cost of the ecochannel would be less than three dollars per New Yorker.

Unfortunately, such logic has legal impediments. The Federal Communications Commission presently limits the amount the city can charge a cable company to five percent of the fees they collect. In New York City, this money is allocated directly to the general treasury. Unless these legal conditions are changed the money for the municipal ecochannel would have to come out of the general treasury and other monies. The city-owned WNYC channel gets three million of its fourteen-million-dollar plus budget directly from the city.

The rest is raised in various ways. Perhaps a similar funding pattern could be developed for the ecochannel.

It may also make sense to tax the telecommunications industry that operates in the city. Other sources for funds would include the Job Training Partnership Act, the Board of Education Budget for collaborative environmental educational projects, private foundations, and penalty fees from companies found out of compliance with environmental legislation by the ecochannel.

Budget Calculations. The budget is calculated on the basis of producing twenty-four hours of original programming each week for fifty-two weeks. Production contracts would be drawn up with independent videomakers trained in ecological monitoring and interpretation. It is estimated that properly trained production crews could keep the cost of an hour program under $7,200 an hour. This low figure presumes a methodological way of producing the tape that is more cost effective than the usual production, and uses newer low cost video equipment. The normal yearly contract would be for a one hour per week production worth $ 374, 400.

Programming. Besides the twenty-four hours a week of original productions, other programming would be provided from the following sources:

1) Programming originated by local non-profit community groups, environmental groups and educational institutions.

2) Programming obtained through exchange with ecochannels in other cities.

3) Fixed cameras set up in remote locations, electronic sensors and regular transmissions from satellites overhead.

4) Quality environmental programming relating to New York City, produced by the Public Broadcast System, Commercial Networks and Independents that could be purchased outright by NEST.

5) Repeats of prior original programming in accord with seasonal changes and the natural history of the region. Examples: running last year's first snowfall along with this year's first snowfall. Doing a history of drought conditions over the past ten years, drawing on the archives.

In summary, NEST would provide all New Yorkers with a way to relate to their common ecology, regardless of their separate lives.

The Earthscore Curriculum

A proposal developed at The New Laboratory for Teaching and Learning at The Dalton School

The need for environmental education is immediate and far-reaching. Industrialization has brought on an ecological crisis that is forcing us to reexamine the way we live. Our students must understand and learn to deal effectively with this crisis, both now and as adults, using all the resources of traditional and modern technologies.

For example, archaeological evidence suggests that from our very beginnings we have always thrown our garbage "out." In the case of New York City, our last landfill, Fresh Kills, is nearly full. Where will we put our garbage when it is full? If we recycle twenty-five percent of it, as now legislated, what will we do with the remaining seventy-five percent? Burn it? Burning pollutes the air, water, and land as well as leaving a residue of toxic ash. Will burning our garbage create more problems than we solve? Every environmental issue raises similar questions. Reckoning with the ecological crisis means understanding the environmental consequences of our choices.

In the face of our current crisis, it is not enough to study ecology and do environmental projects. To educate effectively we must link our economic, social, and cultural understanding to the environment. We must free our minds from some of the habits of thought that came with industrialization. We must establish new ways of solving problems, new habits of mind that are in accord with the ecologies of the earth.

The Earthscore Method

The current educational system can be seen as a mirror of industrialization. Gutenberg made the book the first mass-

produced object. A Renaissance educator, Peter Ramus, invented the classroom to optimize the pedagogic possibilities of the book. Multiple copies of a single text allow the teacher to organize the classroom in neat rows of individuals, assign homework, and set up a curriculum based on a table of contents. The classroom became a factory for literate knowledge that fragmented the coherence of oral cultures.

Industrialization has triggered an environmental crisis that is forcing us to search out patterns of thinking and living that are not ecologically destructive. The Earthscore Method provides an experiential, interdisciplinary way of developing an ecology of mind, that is, patterns of thinking in keeping with ecological patterns. The ecology itself is taken as the prime text. Students are organized in self-regulating teams of three and taught formal roles for learning together using a variety of learning technologies including drawing, video, and computers. This is accomplished without the assumption that the format of the book should format the use of all learning technologies. The use of the learning technologies is determined by their appropriateness for interpreting various aspects of the ecology. The Earthscore Method uses local ecology as a common reference for all subject areas including science, mathematics, literature, art, and social studies. The Method has four components:

1. **An ecological setting**. The method requires at least one accessible ecological site. Multiple sites are desirable. In the pilot program described below, students from The Dalton School in New York City used The Black Rock Forest in the Hudson Valley.

2. **Three ways of learning about ecology.** These three ways are: learning by intuition, learning according to the facts, and learning about patterns and context. As demonstrated in the pilot project described below, these three broad categories of learning can be adapted by students to study any site using any sort of learning technology.

3. **The system of knowledge.** The Earthscore Method can weave these three ways of learning through all grades levels and all subjects. The method provides a framework which relates different subject areas to the ecology. Educators can be shown how to integrate what they are already teaching into an Earthscore Curriculum. A few examples from different disciplines will suggest how the ecology can be referenced using Earthscore categories. In mathematics, sketches are intuitive, measurements are factual and calculations reveal patterns. In science, a guess at a hypothesis is intuitive, induction proceeds from facts, and deductions reveal patterns or laws of nature. In literature, poetry may be intuitive, description can be factual, and reflective essays may reveal contextual issues. In social studies, many beliefs about an ecology are intuitive, struggle among groups about the use of an ecology are the facts of history, and setting policy is recognizing context.

4. **A Cooperative Learning Procedure.** In the Earthscore Method, students are organized in teams of three. Within each team, the students take turns learning by intuition, fact and context. The method provides both a simple system of taking turns and a procedure for making decisions in teams of three. Learning cooperatively becomes the rule. This cooperative organization of learning makes it possible to facilitate consensus among students and teachers about interpreting a specific ecology. Forums can be held in which the students debate and argue toward consensus. Such debates reinforce the interdisciplinary understanding built into the curriculum. No forced consensus is desired. In the Earthscore Method it is possible to identify the actual level of consensus reached and simulate decision-making based on the actual consensus.

These are the essential components of The Earthscore Method. The implementation of this method is possible with any level of learning technology from sketch pads to video and

computers. Since the method is not bound by any specific technology and uses the ecology as its prime referent, the examination of life this method encourages includes inviting students to think about questions concerning technology and the environment.

Pilot Program, Spring 1989

During the spring of 1989, fourteen eighth-grade Dalton School students monitored winter-to-spring changes in a Black Rock Forest stream. I supervised this program.

After six hours of in-school preparation, the students, known as the Black Rock Rangers, spent ten hours at the stream site and another ten hours back in school organizing their findings. They then gave presentations to a consortium of educators working with Black Rock, the Dalton Middle School Faculty and fellow students. A video document was made of the project.

The first phase of the project took place in the classroom. I taught the Black Rock Rangers the Earthscore Method of interpreting the ecology. The Black Rock Rangers divided themselves into four teams of three: the video team, the word team, the image team and the number team. The job of the video team was to scan four selected sites along the stream for aesthetic images, such as surface water, images of specifics, such as a particular rock, and images of pattern, such as the interaction between water and rock. The job of the word team was to interpret each site in poetry, factual descriptions and reflections on the forest ecology as a whole. The image team was to use drawing and photography to understand the aesthetics, the facts and the ecological context of each site. Using tape measures, PH kits, thermometers and calculators, the number team was to produce diagrams, measurements and calculations at each site.

Using the classroom as an example of an environment, I discussed with the students the various kinds of information necessary to understand an environment and how to organize that information. Out at the stream site, the students used their various technologies to interpret the stream. The learn-

ing that took place at the stream site was vividly evident when the Rangers shared their findings with each other back at school. The following scenes from students sharing their interpretations of the stream in Black Rock are included in this proposal to suggest the quality of their learning experience. The scenes are meant to complement the accompanying videotape of their experience in Black Rock Forest itself.

Video Team and Everybody: John, Ben and Jeremy are showing their video work from the first day. Shaky camera, scattered shots with no coherence. Pieces of trees. Rocks. Random, tough to watch. They don't know what they are looking for. Everybody is suffering through their experimentation. Suddenly the camera settles on the stream and smoothly pans with the moving water for about thirty gorgeous seconds. Everybody cheers.

Word Team and Image Team: Maya is delighted with Chatal's photograph of a site with a rusty pipe. She shows the photo to Sonia and Simone, her partners in the word team. They all love the photo and laugh about how Simone and Maya had both used the phrase "protruding pipe" in their poems. Sonia picks up a photo of rushing water and turns to Linda, the student coordinator, who had written a poem on her own. "Linda, look at this photo. It would go so well with your poem." Chantal reads Linda's poem out loud and the image team and the word team discuss how Linda's poem personified the stream.

Number Team and Image Team: Two members of the number team, David and Jefferson, have been trying to develop computer graphics that show each of the four sites the Rangers studied in Black Rock. They are looking through the photos with Linda, the student coordinator, and Amy from the Image Team. Jefferson spots a photo of whitewater against a rock. "Nice shot," he says, "we wanted to figure out how the chaos of the white water would erode the rocks, you know, use chaos theory

somehow." His remark is offhand and he goes back to looking through the photos. After a while it is clear that David and Jefferson can't find photos to help them with their computer graphic project. Linda and Amy go back and forth with them about what photo angles would be best for computer graphics. They settle on a set of angles for the image team to take photos from during the next Black Rock trip.

The pilot program demonstrated that teams of eighth-grade students can use technologies very effectively to interpret an ecology using the Earthscore Method. The pilot also demonstrated that experience at an ecological site made a significant impact on student learning. Rain-outs were a great disappointment, one student got his father to take him and another member of the number team on an extra trip to the forest so they could get more reliable data. In general, the experience of Black Rock was extremely important to the students.

Consensus, a Computer Program

Consensus is a generic hypercard program designed to help three or more people develop agreement about anything. In the context of education, Consensus facilitates cooperative learning. Consensus has three main parts: protocols, circuits, and signs.

Protocols are the procedures for relating to other members of the consensus team. These call for each participant to take turns playing three different roles: initiator, reactor, and mediator. The initiator moves from instinct or intuition without regard for the others, the reactor reacts directly to whatever is generated by the initiator, and the mediator balances the interaction between them.

Circuits are the storage systems for organizing the information gathered to generate consensus. When using consensus circuits, players do not interact directly with each other, but according to how the circuits are organized. The circuits are organized in terms of three recurring positions called firstness, secondness, and thirdness. Positions of firstness correspond to the initiator role, positions of secondness to the reactor role, and positions of thirdness to the mediator role.

Signs are a way of classifying the information gathered so that its degree of certainty can be evaluated. A sign is a "first" representing a "second" (its object) for a "third" (the interpretant). Example: Jill said to Jim, "Please give me the envelope." The sentence in quotes is a sign about an object (the envelope) created for an interpretant (Jim).

The Consensus program has many subdivisions of signs. Two such subdivisions are shown below (Fig. 22, 23; pp. 310, 311). These subdivisions are based on various combinations of firstness, secondness and thirdness. Perfect consensus, or absolute certainty on the part of everybody, is an ideal seldom reached. By considering the subdivisions of signs, a group can

work toward degrees of certainty in consensus building that are acceptable to all involved.

Learning Consensus is like learning any cooperative process. It takes some practice. This program is designed so that beginners with no knowledge of circuits, signs, or firstness, secondness and thirdness can use the protocols for consensus and gradually move through the circuits and sign systems as their consensus-building becomes more complex.

The Consensus program organizes information in unambiguous positions provided by a relational circuit and its various subdivisions. These unambiguous positions are depicted graphically on the screen of the computer so the user always knows where he or she is in the program. As mentioned, the program is written in hypercard and has thirty-three stacks of cards.

Fig. 22. Twenty—eight Subcircuits. This display is taken from 'Consensus', a generic computer program for developing consensus about anything, originated by the author using a cybernetic adaptation of the classification schema developed by Charles Peirce. Each block in this pyramid is read from left to right, starting at the top. If the panel is speckled white, then the object, sign or interpretant is categorized as firstness. Dark speckles indicate the sign, object or interpretant is categorized as secondness. Gray indicates thirdness.

Differences in the object (panel 1) make differences in possible representation (panel 2), which make differences in actual representation (panel 3), which make differences in possible interpretation (panel 4), which make differences in actual interpretation by specific people (panel 5), which make differences in the community of interpretation (panel 6).

Fig. 23. Sixty—Six Subcircuits. This display from Consensus further refines the twenty-eight subcircuit schema by building in four more panels that provide opportunities to check that the integrity of the categories of firstness, secondness and thirdness is maintained in the transformation of information from panel to panel in the twenty-eight fold schema. In effect, this display is another version of Figure 21 (p. 221) in which the sixty-six fold schema of Peirce is mapped onto the relational circuit.

A Genealogy of Video

The term "genealogy" indicates a particular sort of writing concerned with rediscovering struggles without shrinking from the rude memory of the conflict. It is an effort to establish knowledge, based on local memories, that is of tactical use to the reader. Whereas a history is generally written as if a struggle had been resolved, a genealogy assumes that the present resolution is subject to change.

The genealogies offered by Michel Foucault of phenomena such as modern prisons and medical clinics depend on extensive library research by a nonparticipant (Foucault 1980: 78ff.). By contrast, this genealogy is constructed primarily out of the rude memory of the conflict itself by a participant in the struggle. Hence it is *a* genealogy, not *the* genealogy of video. Other participants would have other versions. To go beyond the sketch I provide here, a complete genealogy of video would have to take account of other versions and place early video within the context of the wider array of significant social shifts going on at the same time. What I believe saves this piece from being a merely subjective memoir is that it is constructed in terms of a fault line, a discontinuity in video history that is in danger of being ignored. My contention is that any serious account of video must take account of that fault line.

Video itself mutated from a countercultural gesture to an art genre. When video was principally a countercultural gesture, it held the promise of social change unmediated by the art world. Now, whatever promise of social change video holds is mediated by the art world. This is a significant difference. People unfamiliar with the mutation find it difficult to appreciate the unlimited sense of possibility that early video held. The following anecdote might be illustrative. In the mid 1970's the author of *Independent Video*, Ken Marsh, ran a series

of video festivals in Woodstock, New York. During the course of one festival, in either 1974 or 1975, a plenary session of over a hundred people was stopped cold by a resonant voice with an odd, insistent quality: "I want to know what's going on with video. I just got $5,000 from the New York State Council on the Arts to do video and I'm blind. I'm a blind man! What is going on?"

Literally translated from the Latin, '*video*' means 'I see.' That the Arts Council would grant a blind man $5,000 to produce video demonstrates that part of what was going on was a powerful belief system. Perhaps through this wondrous new technology, the blind would see. The story indicates the extent to which the Arts Council, and many others, had willfully suspended disbelief to allow a new fiction, called "video," to be generated.

Today, critical discourse is replacing suspended disbelief. The following account of the preconditions that made video possible by someone who played a role in generating the original fiction is intended as a contribution to that critical discourse.

Toward Social Change or Art?

The genealogy of video is a history of the struggle between the drive to use video as a tool of social change and the drive to use video as a medium of art. Specifically, this version deals with video in New York City from 1968 to 1971. I settle on the term "drive" because during that period there were no clearly defined factions of art versus social change. There were videomakers who thought of themselves as artists and saw their work as promulgating social change, and there were videomakers working for social change who considered their work artistic. Activity in the video field tended toward one or the other of these diverging poles. Choices could be made according to an agenda of social change, and choices could be made that individuated oneself as an artist. As a participant/observer, I entered the fray with a bias toward using video as a tool of social change. In this report, I will trace the genealogy of the initial struggle around video in terms of its technologi-

cal, theoretical, political, institutional, economic, and cultural
dimensions.

Technological

In technological terms, the genealogy of video is best de-
scribed by distinguishing between processing signals for the
surface of the screen and using video as a system of communi-
cation (Gigliotti: 1983). The distinction between surface and
system can be clarified by considering a man cutting down a
tree with an axe. A systems-understanding pays attention to
how the differences in what the man sees make differences in
how he swings the axe. The differences in how he swings the
axe in turn make differences in the gashes on the tree. These
differences in turn make differences in what the man sees, and
so on, as the cycle repeats itself. A surface-understanding
frames that part of the tree where the axe repeatedly strikes
and concerns itself with the 'composition' within that frame.

Prior to the arrival of the Sony portable video system in
1968, "video art" was primarily a matter of manipulating
signals within the frame of the television screen. Magnets were
applied to TV sets, internal circuitry was altered and black
boxes were attached. Inspired by the music of John Cage, Nam
June Paik used these tactics to achieve a certain playful icono-
clasm. He broke down conventional expectations about TV
images and introduced a sense of possibility for the screen.
Eric Siegel, who was more knowledgeable about circuitry,
colorized the gray tone scale and processed images, such as
Albert Einstein's picture, synchronizing the processing to
classical music. Public television saw potential in this sort of
image processing. In 1968, WGBH in Boston commissioned
Alan Kaprow, Otto Piene, Aldo Tambellini, James Seawright,
Nam June Paik, and Thomas Tadlock to produce "broad-
castable" video works for a show called *The Medium is the
Medium*. With the exception of Alan Kaprow's *Hello*, which
broadcasted randomly switched signals from a system of
cameras and monitors set up around Boston, all these works
relied heavily on processing the image on the surface of the

screen. Only Aldo Tambellini's *Black*, about Black life in America, dealt with explicit social content.

Processed imagery also dominated much of the "TV As A Creative Medium" show assembled by art gallery owner Howard Wise in the spring of 1969. Tadlock, Siegel, and Tambellini were joined by Joe Wientraub and Earl Reiback in presenting processed image pieces. Paik's iconoclasm produced the *TV Bra*, an actual brassiere with monitors attached by electronic wires to respond to the music of the cello of the performer wearing the brassiere, Charlotte Moorman. Paik also showed *Participation TV*, which showed images of the viewer on separate monitors in different colors. While it can be said that Tambellini's *Black* and Paik's *TV Bra* effected social change by producing images that helped alter social mores about race and sex, the route of reference to social change was through symbol manipulation, not the systemics of communication.

Two works in the Wise show did concern themselves with the systemics of communication: *Wipe Cycle* and *Everyman's Möbius Strip*, which both grew out of experience with the Sony portable video system. *Wipe Cycle*, by Frank Gillette and Ira Schneider, involved a grid of nine monitors displaying broadcast images, prerecorded tapes and timed tape-delay images of the audience in front of the monitors. *Everyman's Möbius Strip*, the piece I did for the Wise show, provided a private feedback booth, where one could record oneself going through a series of simple exercises and see the playback in private before the tape was erased.

Wipe Cycle and *Everyman's Möbius Strip* were based on an appreciation of the new portable Sony as a communications system, complete with record, storage, and playback capacity. It allowed the user to 'infold' information and set up feedback circuits, not merely manipulate the TV terminals of the broadcast system. A generation whose childhood had been dominated by broadcast television was now able to get its hands on a means of TV production. The machine was relatively inexpensive ($1,500), lightweight, easy to use and reliable, and it produced a decent black-and-white image with acceptable audio. Tape was reusable and inexpensive. The

video portapak helped trigger a range of activity linking video with social change. These two "communication" works in the Wise show were only an indication of a growing video movement.

George Stoney came from the Challenge for Change organization in Canada to start the Alternative Media Center with Red Burns at New York University, which used the portapak as a primary tool for social communication. Among other projects, the Media Center midwifed an effective three-way communications system for senior citizens in Reading, Pennsylvania, using video and cable television. Alain Fredrickson, a high-school biology teacher from Pennsylvania, went to Santa Cruz, California, to develop community cable TV and published a newsletter for high-school students under the alias of Johnny Videotape. Ken Marsh and Howie Gutstadt, both painters, initiated People's Video Theatre in New York City, trying to invent ways of using video to mediate social conflict. Coming from a theatre background, with particular reference to Pirandello, Artaud, and Grotowski, David Cort began organizing what became known as the Videofreex. Ira Schneider, Michael Shamberg, Louis Jaffe, Marco Vassi, and Frank Gillette founded Raindance, a production group which also published a magazine for the alternative community called *Radical Software*. Started by Ira Schneider, Phyllis Gershuny and Beryl Korot, with Gershuny and Korot as the original editors, *Radical Software* quickly rose to a circulation of 5,000 and became the voice of the video movement. A sense of what the video belief system was like can be gleaned from reading Michael Shamberg's book *Guerrilla Television* (1971) and more succinctly from an editorial statement in *Radical Software*:

> In issue one, volume one of Radical Software (Summer, 1970) we introduced the hypothesis that people must assert control over the information tools and processes that shape their lives in order to free themselves from the mass manipulation perpetrated by commercial media in this country and state controlled television abroad. By accessing low cost half-inch portable videotape equipment to produce or create or partake in the information-gathering process, we suggested that people would contribute greatly to restructuring their own information environments: YOU ARE THE INFORMATION. In particular we focused

on the increasing number of experiments conducted by people using
this half-inch video tool: experiments in producing locally originated
programming for closed circuit and cable tv and for public access cable-
vision; construction of video information environments, structures,
assemblages as related to information presentation and audience
involvement...explorations of the unique potentialities of feedback
through video and audio infolding, and feedback as facilitator in
encouraging play between people in pursuit of new life styles and/or as
examination of the transformation of the director/actor relationship
implicit in video. Long theoretical discussions were printed concerning
such concepts as cybernetic guerilla warfare, triadic logic, biotopologi-
cal resensitization, nutritive contexts, electronic democracy (Korot et al.
1972: 1).

Theoretical

By the time the portapak became available, Marshall
McLuhan's work was being widely read. Other thinkers such
as Teilhard de Chardin, Norman O. Brown, Buckminster
Fuller and Herbert Marcuse were also being read, but
McLuhan's work was particularly relevant to video. The
Oracle of the Electronic Age, as he was called by many, had
published *Understanding Media* in 1964. His version of the
complex process of media history — from the oral to the literate
to the electric — was discussed in businesses, universities, the
media, art circles, and the counterculture. McLuhan's percep-
tions and language provided an instant framework of under-
standing both for those interested in processing imagery for
the TV screen and for those interested in the social change
possibilities of the portapak. McLuhan was quoting John Cage;
Cage was quoting McLuhan. Eric Larabee, then head of the
New York State Council on the Arts, was on a panel inter-
viewing McLuhan on public television. Frank Gillette taught a
course on McLuhan at the Fourteenth Street Free School in
New York.

McLuhan himself offered no formal theory of art and no
agenda for social change. When pushed for an opinion about
what could be done in the electronic era, he would say only
that it was too early to tell. He invested his energy in probing
for new and useful perceptions of the situation created by
electronic media. In concentrating on perception, McLuhan

was appropriating a strategy from the art world, a strategy only apparently radical: exploit new media for the novelty of the perceptions they yield; take no responsibility for acting on those perceptions.

For those interested in social change, the popularist McLuhan proclaimed—in the tradition of Harold Innis—that the technologies of communication, not economics, were the real keys to social change. Marx had, in McLuhan's provocative phrase, "missed the communications bus" (McLuhan: 1967-68). By gaining access to new communications systems, the disenfranchised minorities—such as teenagers, the elderly and various ethnic minorities—could gain social power. McLuhan also proclaimed with poet Ezra Pound that artists were "the antennae of the race." They could anticipate the blows to the human psyche wrought by the new technologies and provide mappings of how to integrate these blows. He declared, to the consternation of many, "Art is anything you can get away with" (McLuhan: 1967—68).

Political

Prior to his reelection campaign in 1970, the incumbent governor of the State of New York, Nelson Rockefeller, increased the State Council on the Arts budget from two to twenty million dollars. Rockefeller had chartered the New York State Arts Council, the first such council in the United States.

For those interested in the medium of video as art, i.e. career artists, this move was in keeping with a tradition they were familiar with from Nelson Rockefeller's famous patronage of the visual arts, so abundantly evident in the Museum of Modern Art. The New York State Arts Council could provide support for experimental work in a new art medium that had not yet developed a market for its products.

For those interested in social change, this seemed the action of an extremely wealthy man developing a state apparatus to carry out a function analogous to traditional patronage of the arts. Moreover, it was a way for Rockefeller to win reelection support from his traditional, wealthy supporters by giving

state money to major cultural institutions, such as Lincoln Center, which were patronized by the wealthier classes.

As the person who originally mediated the Rockefeller Arts Council money into precedent-setting video grants, my glee at getting the money allocated was balanced by a nagging doubt that perhaps modern art was merely a process whereby the pain of the poor becomes the perceptions of the rich. The rich need these perceptions to maintain their power because they are out of touch with the shifting sentiments of the majority of people. Artists, in touch with the alienating experience of industrialization suffered by most people, translate that experience into an idiom or code (modern art) useful to the few who profit from that alienation. I was asking myself if refusing to make art would result in a more just society. Moreover, since art legitimizes wealth, it contributes to a status quo that can effectively ignore the pain of the poor. To contribute to this process is, in some sense, a betrayal. The September 1971 killings at Attica State Prison did nothing to allay these doubts.

At the same time, it was an opportunity to secure money for social change projects. Art, after all, was "anything you could get away with." When a budget jumps from two to twenty million dollars in one year, there is a lot of "funny money," i.e. money with no real specification as to its use.

Institutional

In one year, 1969, the New York State Arts Council went from being a family style organization to an agency dispensing twenty million dollars. During that year, the Council allocated over half a million dollars for video. The handful of then extant video groups—Videofreex, Raindance, People's Video Theatre and Global Village—competed for the money. A series of complicated machinations ensued, which included a battle over a quarter million-dollar plan for a "Center for Decentralized Television" to be administered through the Jewish Museum under Carl Katz. The notion was to distribute portable production capacity to twenty diverse groups in New

York State, including upstate farmers and urban ghetto dwellers. The center would then facilitate the exchange of tapes and public showings. In the end, each of the four groups got $35,000. The balance went to museums and public television stations.

While the Arts Council is the only state agency chartered to make discretionary judgments, in the case of the original funding of video groups it did not exercise its discretion but gave equal money to all groups. This was partly because video was new, partly because of the growing pains of the Council and partly because the money was available. In effect, the Council followed the sort of hands-off policy toward art funding that had been instituted in England after World War II with Keynesian economics. As Peter Fuller reports:

> The Arts Council, established in 1945, was one of the first components of the welfare state. Its architect, and first chairperson, was Keynes himself. Married to a ballerina, a Bloomsbury habitue, he had spoken of the prostitution of the arts for financial gain as one of the worst crimes of present-day capitalism. In the welfare state, all that was going to change. In 1945 Keynes wrote: "The purpose of the Arts Council... is to create an environment, to breed a spirit, to cultivate an opinion, to offer a stimulus to such purpose that the artist and the public can each sustain and live on each other in that union which has occasionally existed in part at the great ages of a communal civilized life." He claimed: "The artist walks where his spirit leads him. He cannot be told his direction; he does not know it himself." But he expected new work to "spring up more abundantly in unexpected quarters and in unforeseen shapes when there is a universal opportunity for contact with traditional and contemporary arts in their noblest form" (Fuller: 1981).

Mutatis mutandis, this is the manner in which the New York State Council on the Arts first funded video. The half-million dollars allocated set a precedent and became a prime source of stable funding for video through the seventies and into the eighties. As a state arts council, the institution developed an alliance network that included television stations, museums, universities, small experimental video groups and individual artists working in video. Other funding institutions also supported video. The Rockefeller Foundation, with Nam June Paik as a consultant, supported video art. The Markle Foundation supported the Alternative Media Center in using video as

a tool of social change. Only the New York State Council on the Arts has had the courage to ride both horses.

For advocates of social change, the opportunism of going to the Arts Council in the first place meant that eventually the resulting compromises with the art world would spell defeat. The context of a state bureaucracy defined in terms of art would ultimately defuse and erode efforts at social change. Yet the imposed dialogue with art forced a much deeper consideration both of the role of art in social change and of the whole relationship between art and politics. For artists, the Council was a godsend in terms of a career-support system, but a mixed blessing in terms of being forced to compete with social change advocates for funds available through the paperwork and panels of a state bureaucracy.

Because the grant money was available, the spontaneous origins of the video movement maintained some of the character of a 'gift economy'. Equipment, information, skills and tapes were freely shared, often between social change advocates and artists. There was an 'information free' ethic not unlike the early computer hacker culture (Levy: 1984). The marketplace was held at bay. Yet given the absence of a clear pattern of discretionary art judgments, the video/ New York State Council nexus appeared at times to be a welfare system for eccentrics caught up in various video solipsisms.

Of course, a gift economy could not be long sustained through state bureaucracy. Over the years, the trust and faith necessary for a gift economy yielded to the mechanisms of mediation and regulation. Such benign regulation has taken place over the years as the movement failed to regulate itself. Like many similar movements, it fell prey to the internal dynamics that tend to split up non-hierarchic small groups. As the original groups tended to break up, so the funds tended to go more toward individual artists, media equipment centers and large institutions. While the context was such that there was discussion in *Radical Software* of an information economy (Ryan: 1971c), that is, a non-money economy based on knowledge as value, no viable realization of that notion matured.

Cultural

In large part, the original video movement can be seen as a transformation of the waning counterculture of the sixties. Given the pervasive influence of broadcast television on the mass culture of America, it is logical that video would be appropriated as a tool of resistance, protest and change by the counterculture. The alternate video group, Raindance, was conceived of as a countercultural think tank—an alternate to the Rand Corporation. People's Video Theatre had a popularist stance associated with the counterculture. Many of the Videofreex were former teachers who involved themselves in the counterculture. Two of the principals, David Cort and Parry Teasdale, met at the Woodstock Music Festival. At Woodstock they were introduced to Don West, then assistant to the president of Columbia Broadcast System (CBS). With the assistance of Don West, Cort and Teasdale, along with Curtis Ratcliff, organized the Videofreex to produce a portapak-style pilot tape for broadcast on CBS. The program was to render the Woodstock experience and the values of the counterculture. The pilot was played through Eric Siegel's color synthesizer for a group of CBS executives including Michael Dann and Fred Silverman. At the end of the showing, Michael Dann thanked the Videofreex for their efforts and said it would be a long time before such programming found its way onto the air. The next day CBS dismantled the project and fired Don West (Gigliotti: 1983). The subtext for this meeting is articulated by social scientist George Gerbner, who said: "If you can write a nation's stories, you needn't worry about who makes its laws. Today television tells most of the stories to most of the people most of the time" (Gerbner: 1982). Such storytelling configures a symbolic environment that controls modern society the way religion used to control society. Violence-laden drama, for example, "shows who gets away with what, when, why, how and against whom" (Gerbner 1976: 370).

Along with his associates at the University of Pennsylvania, from 1967 to 1982 Gerbner analyzed over 1,600 primetime

programs and interviewed large samples of both frequent and infrequent television viewers in the U.S. They documented very skewed perceptions of reality on the part of frequent viewers in relation to sex roles, jobs, races, minorities and crime. For example, fifty-five percent of the characters shown on prime-time television are involved in violence once a week. In real life, the comparable figure is less than one percent. Frequent viewers grossly overestimated the chance of violence in their own lives and had an exaggerated distrust of strangers. Gerbner argues that such distortion functions to maintain the status quo of the industrial state in America:

> ...television is the central cultural arm of American society. It is an agency of the established order and serves primarily to extend and maintain rather than alter, threaten or weaken conventional conceptions, beliefs and behaviors. Its chief cultural function is to spread and stabilize social patterns, to cultivate not change but resistance to change. Television is a medium of the socialization of most people into standardized roles and behaviors. Its function is, in a word, enculturation (Gerbner 1976: 366).

Gerbner's work on enculturation allows us to see this entire genealogy of video, with both its aesthetic and social change aspects, against the background of the religion of broadcast television. The values and beliefs associated with video have not supplanted the values and beliefs associated with broadcast television. Video did not make the blind see.

Conclusion

In 1987, there is little willingness to suspend disbelief. The fiction of video is coming under increased scrutiny and a reconsideration is in order. One wonders how the art world, with its tradition of the new, will deal with video as it grows old. What of real value can be distilled from what has happened under the cover of video? Who will do the distilling? The New York State Council on the Arts? The museums? The American Film Institute? Broadcast television? The academic world? Private patrons? The Library of Congress? What criteria will be applied? The field of video is particularly vulnerable to cannibalization because the state of suspended

disbelief has lasted overlong and no critical discourse has been cultivated that would justify to the world at large the selection of certain video works as having lasting value.

At the core of the difficulty is the fact that there has been no resolution of the problematics underlying the industrial culture promulgated by broadcast television. Video originally addressed those problematics. For the most part, a sense of this context has eroded from the video field. Moreover, the conditions that gave rise to the genealogy of video have shifted. Technological improvements in video equipment have shifted the emphasis from process values to production values. Personal computers have displaced video as the electronic medium of possibility in people's imaginations. McLuhan's discourse is outdated, and no comparable discourse has replaced it. Ronald Reagan is dismantling the welfare state, and the marketplace increasingly determines video production. In New York State, the Arts Council funding has not kept pace with either inflation or the number of videomakers. The counterculture has long since lost power. Video itself has mutated from a countercultural gesture to an art genre. How this genre articulates its genealogy remains to be seen.

The History of American Video Art and the Future of European Television

This paper is a revised version of a paper presented at a symposium on The Politics, Sociology and Aesthetics of Audio Visual Media, chaired by Dr. Rolf Kloepfer at the XXI Romanistentag, in Aachen, Germany, 1989.

In this talk, I will offer some suggestions about the future of European television based on the history of North American video art. Specifically, I am speaking to Europeans concerned with their local cultures who object to the Americanization of European television as the common market becomes a reality. In fact, video in North America began in opposition to American commercial television but was domesticated as "video art." This discussion is based on my involvement with American video since 1968. I will begin with a very brief account of the history of video art in America.

The video movement in America began in 1968 as part of a resistance to the American military-industrial complex that was fighting the war in Vietnam. Since broadcast television was the major means of maintaining the ideology of American industrial culture (Gerbner 1976: 370ff.), it was fitting that those resisting this ideology should begin to use the small inexpensive portable video systems arriving from Japan to facilitate and document the creation of a counterculture. Countercultural video production became known as "guerrilla television" (Shamberg: 1971). Though the historic circumstances are different, the spontaneous richness of guerrilla television in America during the late sixties finds parallels in the current use of television by video guerrillas in the Middle East, Poland, and Russia.

One striking example of American guerrilla television activity was "Lanesville TV." During the early seventies "Lanesville TV" was an outlaw television station that functioned in upstate New York as the smallest TV station in the world. The station was run by a group that called themselves the Videofreex. The group used their television channel to cultivate local culture. In insisting on using television to support the culture proper to the place of production they were resisting broadcast television's tendency to annihilate any sense of place (Meyrowitz: 1985). The Videofreex were not interested in producing material for broadcasting anywhere and everywhere, but thought of their channel as a way to enrich the life of their specific community.

As the Vietnam war ended and countercultural resistance faded in the late seventies, the art world in America distilled art out of the video movement. In elevating some video works from the video movement to the status of art, the art world in America stripped this work of its relation to living culture in a manner similar to the way tribal artifacts have been appropriated into museum taxonomies. In effect, during the late seventies and eighties, video underwent a mutation from countercultural gesture to art genre. For the most part however, this new "art genre" has failed to successfully grapple with either the nature of art itself or the nature of television. In a rush to legitimate video in the art work, video was attached to standard art disciplines and shown as "landscape video" or "video sculpture."

To suggest directions for the future of European television based on this history of American video art, I will discuss three questions that address the nature of television and the nature of art:

What does television do that no other medium does?
What does art do?
How can art be made using the medium of television?

In addressing these questions, I speak in broad terms in an attempt to say something useful about a very broad topic, the future of European television. The ideas expressed here are

not common to American video artists but come out of my own work as an artist using video to address the ecological crisis.

I begin with the question "What does television do that no other medium does?" My answer to this question is based largely on an article by philosopher Stanley Cavell called "The Fact of Television" (1982). Cavell argues that what television does is allow us to monitor events simultaneously with others. The event can be of any sort: sports, a state funeral, a rocket launch, an earthquake, and so on. The mode of perception proper to television is monitoring. A security guard watching multiple television screens that monitor the various entrances to a large building can be taken as an icon of the sort of perception that is unique to television.

We watch events on television. Television alerts us to unusual events. By contrast, we view film. Film projects a world view, whether it's *Gone with The Wind* with its romantic view of the post Civil War period in the South, or *Star Wars* with its technological universe of good against evil. In film, just like in painting, there are individual works that can be considered masterpieces. With television, the real aesthetic achievement is in the format, not in any particular episode that exemplifies the format. It is not any specific show or episode of the American weekly dramatic series "Hill Street Blues" that the audience values, but the ongoing series of events conveyed through a consistent format. The format is successful because it acknowledges the condition of monitoring proper to television. Using a format constructed for television, the audience monitors an unending series of dangerous events through a complex web of strained relationships among officers in an inner city police station. "Be careful out there" is the daily admonition. "Out there" events happen. Television monitors and allows its audience to monitor events.

What does the term "monitoring" mean? Etymologically, it comes from the Latin verb *monere* meaning "to warn." Technically, television provides an early warning system for events that might prove dangerous. Please note the parallel between this understanding of television and the traditional function of the avant garde artist, i.e., to provide advanced warning about cultural change. Certainly, broadcast television in the United

States has not fulfilled the function of the avant garde. It is an open question whether current American video art, severed from its countercultural roots, is genuinely avante garde.

Now let me move on to the question, "What does art do?" I will begin by summarizing an argument I make elsewhere (pp. 394ff.). My argument proceeds from an understanding of the central core of our nervous system. This is the part of our nervous system that governs our gross behaviors, that is, behaviors that require the commitment of the entire organism. Examples are fighting or fleeing, having sex or sleeping. In my view, the practice of art can be understood as an exercise in survival behavior removed from actual survival commitments. Though not necessary for the hunt itself, early cave painting transformed hunter intelligence. Drama thrives on combat and courtship and provides insights into these patterns of behavior. Art can exercise survival behavior for groups as well as individuals. Temples, cathedrals and mosques can all be taken as fortresses, though seldom used as such. Art is created *as if our lives depend on it.* Art cultivates perceptions and behaviors useful for survival. Art enhances our ability to survive just as training enhances our ability to fight. Indeed, it can be said that without art, human survival would not be possible.

It is interesting to think about the connection between art and immortality in the Western world in relation to this connection between art and survival. The artist produces art as if the life of the artist depended on it. The artist aspires to immortality by encoding in his or her art a pattern of understanding that somehow reckons with mortality. The work enlivens perception and provides critical insights. The work produced, for example, a Rodin sculpture or a Cezanne painting, becomes important for people who live beyond the life cycle of the artist. However, immortality for the artist, encoded in traditional genres such as sculpture and landscape, may become a moot question as humans endanger their species by proliferating an industrial culture that is destroying our rainforests, seas, ozone, rivers, soils, and oceans. The species that destroys its environment destroys itself. Television is the monitoring device on which we are seeing our species

destroy its environment in living color. The Chernoybol nuclear accident, the Exxon Valdez oil spill, the burning of oil fields in Kuwait, satellite images of the ozone hole—images of devastation go on and on.

Regarding television and environmental destruction Stanley Cavell makes an interesting point. In trying to explain the disapproval and fear of television that is evident in certain educated circles, he points to highly literate people who claim they don't watch television and severely restrict their children's TV diet. He argues that this is clearly a case of "kill the messenger," a displacement of the fear of what is being monitored onto the monitor itself. Cavell points out that what is actually being monitored is the increasing "uninhabitability of the world."

In answer to the question "What does television do?", I said that television enables us to monitor events simultaneously with others. In answer to the question "What does art do?", I have said that art quickens our capacity for survival behaviors. Now to the question of how to make art using television. To rephrase the question based on the above discussion, "How can we activate survival behavior for the human species using a medium that enables us to monitor events simultaneously with others?"

My answer to this question is direct but not simple: use television as a tool of reinhabitation. Let me explain. I began this talk by indicating that video in America was originally part of a countercultural movement against the destructiveness of industrial culture. Video art resulted from what has been called by some videomakers the "museumification" of the video movement. One part of the counterculture in North America which I have been involved in that has avoided integration into the taxonomy of industrial culture is the bioregional movement.

Briefly, the bioregional movement recognizes that, on the North American Continent, there were indigenous cultures supplanted by an invader culture from Europe. This invader culture then became industrialized. Bioregionalists argue that what is required now is to resist further destruction by indus-

trialization, restore ecosystems, and learn to reinhabit the land on a long-term basis. The land is understood not according to the territory claims of different human jurisdictions, but according to the natural ecosystems: watersheds, woodlands, prairies, coastlines, mountain ranges.

Bioregionalists are redrawing the maps of industrial nation states in terms of bioregions that require reinhabitation. For example, California may be one state but it is two bioregions, or life places: a wet Mediterranean climate in the north and a dry desert in the south. There are bioregional reinhabitants who have spent the last twelve years in Northern California developing a new culture of place, doing everything from restoring salmon runs to creating a dance company whose choreography is based on the lives of the non-human species inhabiting the area.

Since the early 1970's, the bioregional movement has grown from a small group in San Francisco called Planet Drum to include over one hundred and fifty groups on the North American continent. The movement has authentic alliances with Native Americans, ties with like-minded people on other continents including Europe, and is presently doing seminal work on how to green the cities of North America.

The bioregional movement is important to my discussion because it has effectively transformed the fear Cavell associates with television, the fear that what we are monitoring is the irreversible destruction of earth as a human habitat, into a very promising, albeit still fledgling culture of reinhabitation. This movement is not paralyzed by the specter of "irreversible pollution" but has formulated a genuine response that redefines the human as part of a thriving planet. The bioregional movement suggests the possibility that art can be made with television by shaping the medium into a tool of reinhabitation.

To conclude this paper I will address three topics in order to tie together art, television, and the reinhabitation of Europe. These topics are: American video art; the question of art, propaganda, and advertising; and the question of language and video perception.

American Video Art

Given that American video art has been developed apart from any culture of reinhabition, that it has, in a sense, failed to monitor what it should have been monitoring, what possible connection is there between American video art and European reinhabitory television? I return to Cavell's insistence that the genuine aesthetic achievement in television is its format, not the individual "masterpiece." Obviously, in arguing for a reinhabitory television, I am downplaying the value of individual video art works presented in a museum context. However, in generating formats for reinhabitory television, much can be learned from more than twenty years of experimentation with video art in America. A sample of the appropriate questions for a given video art piece from the position of reinhabitory television might include:

Is there a unique style of monitoring in this use of video?
Is there a method of monitoring exhibited by this videotape?
Can this method be used by others to interpret ecological systems?
Does this video installation suggest an intelligent configuration for monitoring ?
What kind of intelligence about events is encoded in this work?

Art, Propaganda and Advertising

To answer the question about how to make art using television, as I have above, by recommending using television as a tool of reinhabitation raises the related question of how to distinguish between art and propaganda. If the television being exported from America is really propaganda for a destructive industrialization, is it not also undermining the role art may play in survival and opting for mere propaganda to urge the use of television as a tool of reinhabitation? Am I simply substituting "ads" for reinhabitation for "ads" for industrialization and calling it art?

I don't think so. In answer, let me briefly take up the issue of ads and then propaganda. There are those in the art world

who claim that advertising agencies are, in fact, now producing high quality art. They claim the commercialization of European television will result in a proliferation of this kind of art and that this is a cause for rejoicing. However, in the context of art activating survival behavior for the human species, this is nonsense. Those who make this claim fail to understand that on commercial television ads are part of a good news/bad news cycle that has nothing to do with solutions to the bad news. The good news on American commercial television is that some members of our species are able to afford stunning items such as a Mercedes-Benz car, ocean cruises, and expensive perfumes. The bad news is that in order to be able to produce such items for some members of our species we are destroying the life support system of the entire species. Commercial television is addicted to this good new/bad news cycle, even at the level of inexpensive items for mass consumption. The good news is that we can go to McDonald's or Burger King and have a happy time eating cheap beef. The bad news is that, in order to have such a happy time, we have been cutting down the rainforest. While individual ads might be, in themselves, stunning icons for industrial/consumer culture, to focus on these icons extracted from the continuous current of television's monitoring of events is to misread the context entirely. It is analogous to celebrating the fact that a desperate alcoholic is drinking the very best cognac.

Regarding the suspicion of reinhabitory propaganda, let me respond as follows. Television enables us to monitor events. Ecologies are ensembles of recurring events: the cycle of a fresh water lake, the falling leaf forest, the migration of birds, etc. Using television to monitor an ensemble of ecological events, simultaneously with others whose life is sustained by these events, would provide the grounding for any serious reinhabitory use of television. A community that grounded its reinhabitory activity in a formally-constructed, shared perception of their ecosystem would not be generating propaganda for particular interests. They would be grounding their perception in the place they lived in. In effect, with television we can systematize what the impressionist painters sweated

blood to do, see the world without words (Waddington: 1970). Beside monitoring dangerous hot spots in the ecosystem, reinhabitory television can be used to unconceal the beauty of ecosystems. Such a system of public perception could provide a common reinhabitory referent for the different language families of Europe. Television could facilitate developing consensus about long-term policies and practices for living-in-place across Europe.

Language and Video Perception

As communications theorist Marshall McLuhan pointed out, the primary medium for shaping the different language families of Europe into national cultures was the printing press (McLuhan: 1962). The printing press was the forerunner of industrialization. Obviously, industrialization cannot be summarily condemned and jettisoned. It needs to be rethought in reinhabitory terms. But the point I want to insist on here is simply that the television medium is not print. Any serious strategy for reinhabiting Europe must think through the difference between print and television. It is not inconceivable that the nations of Europe could come up with ways of using both print and television as tools for reinhabiting the diverse ecologies of the European continent, avoiding Americanization.

I don't think moving in a reinhabitory direction will leave the national language cultures of Europe unchanged. The flexibility of communications possible with electronic technologies such as television and computers goes far beyond what has been possible with the printing press. In principle, more flexible communications means cultures that may accommodate more diversity without losing coherence. I think it is possible to support the reactivation of the diverse cultures of place proper to Europe while at the same time using television and other electronic technologies to maintain a coherence proper to the intent of the common market. The diverse cultures of place in Europe that I am talking about have some articulation in natural bioregional boundaries such as the Pyrenees, and further articulation in indigenous groups such

as the Basques, the Bretons, the Catalonians, the Cornish, the Welsh, and so forth. In short, Europeans could use reinhabitory television to structure a complex pan-European coherence out of a richer diversity than that provided by their tradition of nation states without capitulating to the global monoculture being promulgated by American television.

In the scenario I am presenting, enormous creativity will be released in the interface between nation-states with a rightful pride in distinct languages and literatures and a reinhabitory television that unconceals the bioregions of Europe. Television forces us to consider the relation between perception and the multilinguistic groupings in Europe. The questions are numerous and tantalizing. If electronic perception frees language from some of the functions it has habitually performed, such as symbolizing perception in words or providing a common reference through images that need no translation from one language to another, then what becomes possible for literature? What is post-television language like? If traditional myth and story encode the shared perceptions of a community, what happens to myth and stories of individual cultures when television provides an electronic *sensus communis?*

In this post-industrial period, humanity has become an endangered species. As an endangered species, we must shift our mode of perception to reckon with the dangers of environmental devastation if we are to survive. Television presents the possibility of shifting to a mode of shared human perception that monitors the dangers and cultivates strategies of reinhabitation. The role of art vis-a-vis television is to quicken this shift. American video art has not assumed that role. With careful examination of the pitfalls, a reinhabitory television art could mature in Europe. In the context of humanity as an endangered species, it is impossible to think about the European Common Market without also thinking about the European Common Ecology. The cultures that built cathedrals for eternity must learn to use television to build "electronic cathedrals," which are grounded in shared perception of sustainable European ecosystems.

Video, Computers, and Memory

Recently, Sony Corporation ran an ad for its Handycam video camera that targeted middle-aged, male baseball fans. The close-up photo shows an old bat, a ball, a glove, and a Handycam. On the ball you can read the inscription, 1958 City Champs. The boldface ad copy below the picture reads: "They all bring back memories of your old baseball pals. But with the Sony, there won't be a single error." The rest of the ad bemoans the fact that the reader of the ad can't recall some of the players on his championship team and instructs him to purchase a Handycam so his son can relive his baseball memories free of error. The copy ends, "The Sony Handycam. It's everything you want to remember."

Video is a technology of memory. There are other technologies of memory. Other ways to create a "remembrance of things past." It will be a while before video finds its Proust, but the need is already evident in Sony's ad. The ad is symptomatic of what happens when video caters to "everything you want to remember." Celebrating video as error-free memory has its pitfalls. Simply by selecting material for later showing, the camera person "conceals" other material that may be important to remember.

What about the involuntary memory Proust cultivated? What about those things you may not want to remember but need to remember? Is not catering to desirable memories a prescription for living in a video cocoon of nostalgia? What is the consequence of preselecting memory? How can we remember what we conceal with the camera? What happens to perception if the camera is used primarily to gather material for memory—does it not atrophy? Moreover, the old baseball glove may have a smell that triggers memories video simply cannot match—what about them?

A full understanding of video and memory would require a rigorous comparison between video and other technologies of memory, such as oral recitation, print, and holography. It would also require linking these technologies to the human sensorium. Such a study is beyond the scope of what can be accomplished here. In this exploratory essay, I can only suggest ways of approaching the issue of video and memory. I begin by focusing on the fact that video memory is currently being joined with another odorless memory technology, the computer. After twenty years of experience with video, I am nervous about this marriage of convenience. Let me say why.

Computers digitize knowledge. They transform it into information stored in binary units. Once knowledge is digitized, it can be manipulated in an incredible range of ways. For example, video images are now being digitized and manipulated by computer to show people what they would look like if they wore this or that hairstyle. Computers can alter photos or simulate video images of real things in ways that are undetectable. In itself, this is a technological achievement to be applauded. But soon we will no longer be able to trust that the recognizable image on videotape was made when someone pointed the camera at something real.

I'm not against the simulation of possibilities by computers. I think imagining possibilities is all to the good, especially if it involves all the complexity at our command with computers. My concern is that the computerization of video information will detach video images from reference to what we see in our daily lives. Odorless electronic memory systems will create powerful information banks in arbitrary digital storage devices with no grounding in the world familiar to our senses.

So what to do? Obviously, there is no way to call off the liaison between video and computers. But there are other connections to be made with video that could keep the video-computer hybrid from becoming a loose cannon on the rolling deck of memory. What I have in mind is developing patterns that connect video with perception, ecology, mortality, and relationships. In so doing, we can help ensure that the mediation of memory by video in a computerized culture does not

trap us in a smog of digitized nostalgia but helps us gain some freedom for a human future.

Perception

A video camera enables you to push the envelope of your perception beyond anything premeditated. Because the video recorder assumes full responsibility for remembering what is perceived, the videomaker can take perceptual risks: he or she can forget to remember what is being perceived and cultivate a Zen state of watchfulness for whatever can be found through the viewfinder. While this watchfulness can also be cultivated to some extent with film, other factors come into play with video. I am thinking of the alpha state of brain waves associated with the electronics of television for videomaker and viewer alike. One pioneer video artist, Al Robbins, now deceased, developed a technique of punctuating the tape he shot with trigger cuts every few seconds. He explains this technique as a way to keep himself from becoming mindlessly fascinated by what he saw in the viewfinder—as if he were repeatedly slapping himself on the head to make sure he wasn't dreaming. Robbins did not trust the Zen/alpha state. He cultivated a meta-Zen state. The beauty of the tapes he made demonstrates that meta-Zen is not a contradiction in terms, at least in the case of Al Robbins. He kept his mind active and alive behind the camera by constantly interrupting himself. To watch his tapes is to learn a different way of seeing.

In my own tape making, I developed a different approach. I learned T'ai Chi Chuan and developed a handheld camera style based on continuous T'ai Chi movements. The T'ai Chi enabled me to "meditate in motion" through the camera. I was challenged by the sheer capacity for duration of perception a half hour or more of videotape makes possible. About twelve years ago I did thirty-six continuous half-hour tapes in a variety of sites, T'ai Chi-style, without any trigger cuts. I was pushing the envelope of video perception, trusting the camera to remember for me. My Zen state was not perfect, but good enough that I could "be there" for maybe eighteen

minutes of a half-hour tape done while standing in the middle
of water flowing over rock. It was a quite wonderful thing to
do. I was able to free my perceptions from the burden of
memory and attach my attention to flowing water. I doubt if
any computer could simulate the singularity of such percep-
tual risk-taking. Moreover, the video record of what I saw
could be shared with others. Video invites the development of
a whole range of such techniques for enlivening and sharing
perception.

Ecology

The ecology is an ensemble of recurring events: tides chang-
ing, leaves falling, birds migrating, and so on. Video and
television can be used systematically to monitor the recurring
events of a local ecology for the people who live in that
ecology.

The traditional technology of oral memory has worked
through the centuries in terms of what are called common-
places. In Shakespeare's oral culture every schoolboy wrote
about the question of "To be or not to be." There was a finite
set of recurring themes to which everybody referred, which
was the glue that held the community together. A shared
perception of the recurring ecological events that are common
to a place could, in fact, become the commonplaces of an
electronic memory. Falsification of these commonplaces by
computer would be very difficult, since people could go out
and have a look for themselves anytime they wanted. Video
could record and store these events as they recurred and
changed, over generations. Marrying our electronic memories
to the ongoing perceptible events of the ecology would give us
a reliable reference system, free of the arbitrariness and
contradictions possible with digitized, computerized authority.
With an electronic memory married to ongoing ecological
events, human mortals would stand a better chance of thriving
from generation to generation. Such a memory system may
even help us regenerate our despoiled planet. Once such a
memory system was in place, computers could be used to sim-

ulate the consequences of different policies and practices for our ecological systems, before we risked implementing them.

Mortality

The species that destroys its ecology destroys itself. Clearly, humans can now destroy the ecologies of the earth. We are an endangered species. This status changes our approach to immortality. No human is immortal if the species goes extinct. "Immortality" depends on the human practice of remembering the dead. This practice is part of what makes us human. Different cultures have remembered their dead in ways that range from the burial mounds of Native Americans to the realistic busts of the Romans. With video we have the image of the deceased "live on tape." Such an image is much more powerful than any computer simulation of a person or any computer readout about a person's life. As home video becomes increasingly diffused through the culture, more and more people will be dealing with the fact of death remembered through video replay of a deceased family member. How do we configure the emotions unique to this new condition? My sense is that we need to ritualize video replay of the dead. The video presence of a deceased loved one can be overwhelming and severely disorienting. It is one thing to chance across a photo of you and a loved one now gone. It is another to find yourself live on tape with someone you loved, now deceased, during a replaying of random videotapes. Ritual sets up a situation where emotions can be experienced in a crisis-proof context, one that is usually supplied by a secure cosmology, an overarching story in which the life of the deceased finds meaning and that meaning is shared by the living. In this context of shared meaning, emotions of loss can be fully experienced. The fact that we are now an endangered species has shaken the security of every traditional context of shared meaning. We need to develop a new cosmology, a new story that reckons with our ecological situation and allows us to organize our relationships accordingly. It seems to me that only in the context of such a new story can we invent stable rituals that allow us to replay the dead live on tape. Given the

flexibility of electronic information technologies, we have the possibility of telling the story in a non-narrative way that avoids the patterns of dominance associated with logocentric "master narratives." Another way of saying this is that we can encode cosmology in a way that is sensitive to chaos and responsive to local knowledge.

Relationships

Depth psychology is said to have begun with photography. I think video is initiating a new dimension of understanding that as yet has no formal name or discipline. But it has to do with relationships, ways of interacting, the sorts of issues that family therapists have worked with since the fifties.

As we work to find proper ways to balance our relationships with the living, we will continue to suffer the deaths of those we love and hold live on tape. Records of interaction kept in a family over generations could help untangle family knots, keep the children from repeating the errors of their parents. Maybe.

Humans care about their relationships. Birth and death are catastrophes that drastically change patterns of relationships. Video replay offers us a way to help balance relationships among the living. This possibility was never more apparent to me than in an extraordinary video experiment I made with a friend.

My friend and I recorded a conversation between us using full-body shots on a split screen. We were seated facing each other. A week later we played the tape back using slow motion and no sound. We sat facing the screen, each of us imitating the gestures of the other on the screen and creating conversation on the basis of the motions. Holding my head and rocking back and forth in imitation of my friend, I found myself saying, "Yeah. I'm listening to what you're saying, Ryan, but I'm really getting ready to strike back. " Following my imitation of a diminutive hand gesture, I said, "Let me make it nice and small, Ryan, so that you can understand it." My friend was articulating my nonverbal attitudes in a similar way, and we were laughing our heads off. What was even

more extraordinary was that when I woke up the next morning, I felt as if I was wearing his body. I called him up and started telling him how I felt about the relation between his/my stomach and shoulders, stomach and torso, torso and legs, and so forth. In each case he confirmed that my feeling was accurate. For the next few weeks I could recall the sense of his body whenever I wanted. Video replay had made possible an extraordinary degree of imitation and empathy. Such empathy can make a real difference in balancing relationships, well beyond that made by computerized programs of interaction.

Developing patterns that connect video with perception, ecology, mortality, and relationships can neutralize possible adverse effects of the current video-computer hybrid. To work positively with this hybrid, we need to understand the fundamental difference between video and computers, which can be characterized by two words: complexity and contiguity. Computers enable us to order electronically a multiplicity of parts into a whole — that is, they extend our capacity to deal with complexity. Video, on the other hand, extends our capacity to deal with contiguity, the state of being in actual contact. Addressing contiguity will enable us to better understand the possible falsification of memory inherent in video itself. Heidegger's account of memory is useful here:

> Originally, a "memory" means . . . a constant, concentrated abiding with something — not with something that has passed, but in the same way with what was present and with what may come (Heidegger 1968: 140).

> Only because we are by nature gathered in contiguity can we remain concentrated on what is at once present, past and to come. The word "memory" originally meant this incessant concentration on contiguity (Heidegger 1968: 145).

We are in actual, continuous contact with both the past and the future. We are continually gathering ourselves together in terms of what just happened and what will happen next. This is what Heidegger means by saying that "we are by nature gathered in contiguity." Contiguity is a key to understanding video and memory. Videomaking puts you in conscious con-

tact with contiguity. A number of videomakers, myself included, are so struck by this condition that we insist on the value of continuous taping because it trains the mind in contiguity. What is originally felt as boredom develops into a capacity for concentration on what is past, present, and to come.

Contiguity helps explain other techniques of videomaking, such as fading one tape into another rather than making jump cuts, extensive use of slow motion, replaying tapes in reverse, and creating multimonitor pieces that deal with different temporal patterns. The relationship between video and contiguity is especially evident in the work of video artist Gary Hill. Hill did a videotape that is a dramatic rendering of a metalogue between the communication theorist Gregory Bateson and his daughter Catherine. Hill taught the actors who performed the metalogue to say the words backward for the video performance. He then edited this performance tape to correct this initial misorientation. He ran their backward talk forward. What the viewer heard was a strange-sounding but discernible performance of the metalogue. What the viewer saw was an interactive sequence in reverse. As the Bateson character puffs on his pipe, the smoke keeps curling back into the pipe. Hill's multiple reversals of time's arrow celebrate contiguity with an indifference toward the past and the future.

Of course, such editing of the past, present, and future is an artistic construct, not an actuality. Video makes the construct possible. The actual past and the actual future do not allow us to be indifferent to them. As we have seen in discussing mortality, the past is never more clearly the past than when we think about the dead. Those absent from us are absent, even if we have them live on tape. Death makes absence final. The brutal fact is that the dead are forever gone from us; our life with them took place in the past. The appreciation for contiguity inherent in video should not confuse this fact. Indeed, the appreciation of contiguity via video is not automatic. The contiguity of video ought not be confused with the contiguity of life itself. Just as literacy has given us an enormous appreciation of language, so video can give us an

enormous appreciation of contiguity. Unfortunately, literacy has blinded us to some of the consequences of its silent sequencing. It would be well to be as circumspect as possible about the consequences of video.

As we saw with regard to the Sony ad, there is a way in which video replay can create a false sense of the past for videomakers and viewers alike. This is true even if the camerawork is not predetermined. There is a tendency to remember only those aspects of events that have been recorded and replayed. The video replay begins to be the criterion for what is worth remembering and what is not worth remembering about events.

In addition to falsifying the past, video replay can falsify the sense of the present. In my own experience, after extensive replay of events involving human interaction—conversations, dancing, car travel—I began to expect that all human interactions were replayable. Unconsciously I was thinking, "Why get fully involved?" Save some emotion for enjoying (and examining) the replay. After all, an unexamined life is not worth living, and video allows us to examine life very closely. It took losing a close friend to reestablish my appreciation for unrepeatable, irreversible events in life.

The possibility of video's creating confusion about the present is especially evident in instant replay, which can blur the difference between present and past. This is clear in video art that uses open-reel recorders. The open reel allows replay after a delay of only a few seconds. The trick is simple: Put two video decks side by side. Because the tapes are not on cassettes, it is possible to thread one tape through both machines. You can then record on the first machine and play back on the second. Two artists, Frank Gillette and Ira Schneider, used this technique very effectively at the Howard Wise Gallery show, "TV as a Creative Medium" (1969). The piece they did for the show *Wipe Cycle* was complex. I will describe only the aspect of it that helps us to understand instant replay.

The first machine recorded people as they stepped off the elevator into the gallery. The second machine replayed the event to these same people eight seconds later, on a television

set in the gallery. Under normal circumstances, having an elevator door close behind you is an event that separates the past from the present. With the eight-second replay, however, past and present became confused; the past did not detach itself from the present. Video extended the sense of the present (being in the gallery) to include the past (being in the elevator) and an event that normally separates the two (stepping off the elevator and having the door close behind you).

To say it another way, instant replay established a continuity over a threshold that was normally a discontinuity. By recording and replaying the passage from one space to another, the artists scrambled the normal distribution of past and present. Strange. People stood watching themselves coming out of an elevator eight seconds ago, absorbing a past that had not been detached from the present.

It is this nondetachment of the past from the present that characterizes what we call instant replay. With instant replay the sense of the present can be extended far beyond eight seconds. Recording the kids opening Christmas presents and then playing the tape back before the excitement dies down can take a good hour. The hour is experienced in one gestalt that includes instant replay.

Video can include the past in a present that grows into the future. Using video to gain some freedom for a human future depends on deepening our understanding of contiguity. In a computerized culture without an understanding of contiguity, the danger is that the power of the computer to calculate complexity will be used to colonize the future. Life will not be allowed to unfold for the young. Managing time will become the be-all and end-all. Even now people have no time — no time for the memories that come with the smells of everyday, no time for friends, no time for family, no time for pain.

Computers cultivate an appreciation for complexity. Video cultivates an appreciation for contiguity. The question becomes this: how do we gather the wisdom to develop a culture that appreciates both complexity and contiguity?

'A Sign of itself'

Introduction

The phrase 'a Sign of itself' comes from Charles Peirce.

> But in order that anything should be a Sign it must 'represent' as we say, something else called its Object, although the condition that a Sign must be other than its Object is perhaps arbitrary, since, if we insist upon it we must at least make an exception in the case of a Sign that is part of a Sign. Thus nothing prevents an actor who acts a character in an historical drama from carrying as a theatrical 'property' the very relic that that article is supposed merely to represent, such as the crucifix that Bulwer's Richelieu holds up with such an effort in his defiance. On a map of an island laid down upon the soil of that island there must, under all ordinary circumstances, be some position, some point, marked or not, that represents *qua* place on the map the very same point qua place on the island . . . we shall, or should, ultimately reach *a Sign of itself* [my emphasis], containing its own explanation and those of all its significant parts: and according to this explanation each such part has some other part as its Object (Peirce 1931–35: 2.230).

In this chapter, I will present a 'Sign of itself' that, I believe, satisfies the intent of the above statement made by Peirce. For reasons that will become clear, I call this sign a relational circuit. I originated this circuit while working as an artist with video and reading Charles Peirce, Gregory Bateson and Warren McCulloch. Over the past twelve years since I originated the relational circuit, it has proven as valuable to my art work as *contrapposto* to a Greek sculptor or perspective to a Renaissance painter.

I think the value of the circuit is evident in two art projects, both of which I have presented at the Museum of Modern Art. 1) A relational practice that works for three people the way T'ai Chi or yoga works for an individual (pp. 104ff.). 2) A design for a television channel dedicated to monitoring the ecology of a particular region and developing consensus about how best to live there (pp. 243ff.). Both the practice and the

television ecochannel use the relational circuit as a "figure of regulation," and both use Peirce's phenomenological categories of firstness, secondness and thirdness. The ecochannel also uses the sixty-six fold semiotic array Peirce developed from his categories.

Of course, exposure in the art world does not insure that my claim to have originated 'a Sign of itself' is valid. I originated something. I think it is 'a Sign of itself'. Moreover, I think it constitutes the logic of relations that Peirce was after, but failed to get (Murphey: 1961). Is it really 'a Sign of itself'? Does it satisfy Peirce's quest for a relational logic? If so, why not argue on logical and scholarly grounds? Why cite the art world at all?

I cite the art world to indicate that I am talking as an artist to scholars. What I am presenting comes out of the phenomenological realm of firstness known as aesthetics. I arrived at the relational circuit by a process Peirce would call abduction. My process of abduction is documented in my video work and my writings. It is the fruit of that abductive process that I am presenting. Whether or not my guess at the riddle constitutes the relational logic Peirce pursued is obviously a matter for Peirce scholars to decide.

My paper will continue in the following order.

I. Presentation of the Relational Circuit.

II. Characterization of the Circuit.

III. Argumentation that the Circuit is 'a Sign of itself'
 A. Consideration of Gödel's Proof
 B. Consideration of Peirce's Text

IV. Discussion of the Circuit re Peirce's Philosophic Project.

I. Presentation of the Relational Circuit

The two dimensional drawing presented here (See Fig. 19, p. 103) is a rendering of the three dimensional form I call a relational circuit. The figure includes parenthetical markings

to expedite the characterization and argumentation that follows. These markings are not part of the form. The figure results from taking the relations of position and inclusion that obtain in the topology of a Klein bottle and developing these relations into a circuit. Respecting the circuit's debt to the Klein bottle, I have sometimes called it a Kleinform. A Klein bottle has three related positions: a position neither contained nor containing (the neck of the bottle), a position containing another position (the body of the bottle), and a position contained (within the body of the bottle). In the Kleinform, these three related positions are developed into a six part circuit. This circuit has three positions that are neither contained nor containing (-=, ==, =-), plus one position contained by two (-), one position that contains and is contained (=), and one position that contains two positions (≡). It took me seven years to develop the three-part Klein bottle into a form that satisfied the criteria for a circuit articulated below. Along the way, over a dozen attempts were discarded.

II. Characterization of the Circuit

The statements that follow are based on observation of the circuit Kleinform. In Peirce's language, these statements are abstractive observations (Peirce 1931–35: 2.231).

1. One
 There is but a single form.

2. Empty
 The form is empty. The emptiness itself constitutes the form.

3. Continuous
 The form is a continuum. It is possible to move from within any part of the form to any other part without crossing a boundary.

4. Bounded
 The form is bounded. The boundary limits the continuum.

5. Infinite

 The continuum is infinite. The continuum returns to itself without end.

6. Six-Part

 The form penetrates itself six times. This self penetration yields six different positions on the continuum. Each position is part of the continuum.

7. Positional

 The differentiation in the form is structured according to differentiation of position on the continuum. In contrast to any statement of description, differentiation in the form does not correspond to the differentiation implicit in the subject/predicate structure of propositions. Hence, the form cannot be fully explained in any axiomatic system of propositions. The form is positional, not propositional.

8. Unambiguous

 The six positions are unambiguous. There is but one position of firstness (-), but one position of secondness (=), and but one position of thirdness (≡). (For refined observation, thirdness can be described as the position surrounding secondness in which a stiff torus can be trapped. All the other positions are differentiated by the passage of the continuum through the thresholds created by the self penetration.) There is only one position on the continuum between firstness and secondness (-=), only one position on the continuum between secondness and thirdness (=-), and only one position on the continuum between thirdness and firstness.(≡-)

 The naming of these positions is not arbitrary. Firstness is a compact, empty position, free of any other. Secondness has another part of the form passing through it—something it is up against—the position of firstness. Thirdness contains both secondness and firstness.

9. Non-Identical
No position in the form is identical with any other position. No two positions can be equated.

10. Non-Orientable
Assigned direction makes no difference in determining the relative positions in the form. This can be understood by contrasting the orientation involved in reading. As a reader, your eyes are moving from left to right, down the page of print that is in front of you. If you turn 180 degrees, what was in front of you is now behind you, what was on your left is now on your right. In the conventional understanding of position, if you change your orientation, you change your referencing system for position. In the form, changes in orientation make no difference in determining relative positions. The form has no center, no front and back, no left and right, and no up and down. The six part differentiation of position holds regardless of orientation.

11. Intransitive
It is possible to understand each position in the continuum without going outside the bounds of the continuum. Each position in turn is explained by two other positions. The position of firstness is the position contained by secondness and thirdness. The position of secondness is contained by thirdness and contains firstness. Thirdness contains both secondness and firstness. Each of the "in between" positions on the handles is explained by reference to two of the three positions of firstness, secondness, and thirdness.

12. Complete
The form is complete. The term "complete" is used here in two senses.
 i) Nothing outside the form is required to make it whole. By contrast, the series of natural numbers is always incomplete. One can always move toward

completion by adding another number. Indeed, the sequence of natural numbers can be embedded in this six-part continuum in sets of six with remainders ad infinitum.

ii) Nothing outside the form is required to understand its wholeness. The form consists of an empty continuum of six positions. Each position is explained in terms of the other positions in an intransitive way. The form has all the parts necessary to explain itself. No meta-level of explanation is required.

13. Consistent

The circuit is one continuum with six positions. There is no position which is also not a position. There is no position which is simultaneously another position, as in the case when two people face each other and what is on one person's right side is simultaneously on the other person's left side. Although secondness simultaneously contains and is contained, the reference for each relationship is unambiguous. The form is internally consistent.

14. Relative

The form is absolutely relative. The six positions are completely determined by each other. To move from one position to another position is to change relationship to every other position. A difference in position makes a difference in relationship.

15. Non-Sequential

While it is possible to move sequentially through all six positions, the positions themselves do not depend on sequence for their identity. The positions of firstness (F), secondness (S) and thirdness (T) are indifferent to sequence. You can outline the form on the floor and move through the continuum in any of the following sequences without altering the positions themselves: FST, TSF, STF, SFT, TFS, FTS. (For simplicity of explanation, I am omitting the in-between positions.) In the last example, FTS, what is indicated is that you can go from firstness to

thirdness without passing through secondness. Firstness and thirdness are contiguous without reference to secondness. Relative position is detached from sequence.

16. Irreducible
 The form cannot be reduced and maintain its characteristics. For example, the only possible reduction of the figure that remains bounded would be a four part form with one part containing another part and two parts uncontained (two handles, See Fig. 17, p. 102). However, in such a reduction the two parts uncontained could not be distinguished from one another without going outside the form and referencing the left and right hand side of the viewer. Such outside referencing would violate the non-orientable characteristic of the form.

17. Non-compact
 The figure cannot be reduced to a ball and retain its identifying characteristics. Just as the "hole" is integral to the identity of the torus, the three "holes in the handles" are integral to the identity of this form.

18. Heterarchic
 Choices between positions within the form operate according to intransitive preference. That is to say, choices are not constrained by a hierarchy but can operate heterarchically. If I outline the form on the floor and stand in the position of firstness ($-$), I can move through an "in between" position ($-=$) to the position of secondness ($=$). But once in secondness I am not compelled to move to thirdness (\equiv), as if there was a fixed hierarchy of preference or choice. I can return to firstness ($-$). Any position in the form allows this pattern of intransitive preference. There are always two choices, and no choice compels an irreversible sequence of hierarchic choice.

19. Self Corrective
 To say that the form is self corrective is to say that it is a circuit. This characteristic is not self evident by abstrac-

tive observation. Rather the ensemble of characteristics given above must be seen in terms of the criteria for a circuit. The format I will use to demonstrate that the form is a circuit proceeds as follows. I will state each criteria and then describe how the circuit satisfies that criteria by referring to the eighteen characteristics established above. The six criteria for a circuit, employed below were established by cybernetic theory and articulated by Gregory Bateson (1979: pp. 89ff.). Bateson regarded any entity that satisfied these criteria as a 'unit of mind'.

i) A mind is an aggregate of interacting parts or components.

The circuit Kleinform has six parts or components.

ii) The interaction between parts is triggered by difference.

The form is relative. A difference in position makes a difference in relationship. Any interaction between parts takes place in terms of these positional differences. Hence interaction between parts is triggered by difference.

iii) Mental processes require collateral energy.

The form is empty. The form can be likened to a six part zero. It is empty of energy. Processing of differences in the form requires collateral energy.

iv) Mental processes require circular (or more complex) chains of determination.

The form is a continuum. The continuum is a circular chain determining unambiguous differences.

v) In mental processes, the effects of differences are to be regarded as transformations (i.e., coded versions) of the difference which preceded them.

Each difference in position is, in effect, a transform from the preceding position or positions. This can be made clear by using the television ecochannel cited above as an example. If we map Peirce's semiotic understanding onto the positions in the relational circuit we get the following: the sign maps onto first-

ness, the object onto secondness and the interpretant onto thirdness. The television ecochannel provides programming (sign) about the ecology (object) for the people who live in that ecology (interpretants) so they will not destroy it (ground of the sign). Differences in the ecology (object, position of secondness) make differences in the programming (sign, position of firstness), which make differences in the interpretation of the ecology (interpretant, position of thirdness), which in turn make differences in the ecology itself, (object, position of secondness). Each difference in position is, in effect, a transform from the preceding position.

vi) The description and classification of these processes of transformation disclose a hierarchy of logical types immanent in the phenomena.

While the heterarchic form itself cannot be subsumed by a hierarchy, transformations in the form can be described so as to disclose a logical typing immanent in the form. Firstness is at a "lower level" of logical typing than secondness. Secondness is at a "lower level" then thirdness. Moving from "level" to "level" is a transformation of relationships.

Now that I have given an extensive characterization of the form and shown how it satisfies the criteria for a circuit, I will now argue that the relational circuit is a 'Sign of itself'.

Argumentation that the Circuit is 'a Sign of itself'

This section has two parts. The first part discusses the circuit in relation to Gödel's proof. The second part discusses the circuit in relation to the text from Peirce quoted at the beginning of this chapter.

A. Consideration of Gödel's proof

Many mathematicians working to construct a complete and consistent logical system, a sign of itself, were discouraged by the publication of Gödel's proof (Gödel [1931] 1962). Gödel

proved that it is impossible to create a complete and consistent set of axioms. The relational circuit avoids being subsumed in the domain of Gödel's proof in two ways: 1) The form is positional, not propositional. 2) The relational circuit is topological, not arithmetic. Each way will be discussed in turn.

1) The form is positional, not propositional (Characteristic #7, p. 348).

Peirce did develop the categories of firstness, secondness, and thirdness in part from a study of the syllogism. Firstness corresponds to the term, secondness to the proposition and thirdness to the illative *if . . . then*. But firstness, secondness, and thirdness are categorically more general than the structure of the syllogism. Hence it is possible to move from these general categories back to the structure of the syllogism and derive a conclusion that way.

However, this is derivative from the circuit itself. You must first derive the structure of the syllogism and then derive the conclusion. If you stay within the intransitive, heterarchic, relational circuit itself, you cannot reason through the relational circuit and arrive at a logical conclusion. As a non-propositional form, the relational circuit is also formally inconclusive. There is no way to preserve the necessary relationships of position in the circuit and simultaneously draw a necessary conclusion from the circuit. In my opinion, Peirce's definition of mathematics as the science of drawing necessary conclusions, rather than seeing math as drawing necessary relations, was a factor in his failure to develop 'a Sign of itself'.

Because there is no way to derive a conclusion from the circuit itself, this condition precludes the generation of an excludable contradictory proposition. If I understand it correctly, Gödel's proof exploits the possibility of generating an excludable contradictory proposition from an axiomatic system. If you decide not to generate the excludable proposition, the system is incomplete. If you decide to generate the contradictory proposition, the system is inconsistent. Therefore, any axiomatic system has inherent undecidability. It will

either be incomplete or inconsistent. By contrast, the relational circuit is a system that is both complete and consistent (Characteristics #12 and #13, pp. 349, 350).

Because the relational circuit is formally inconclusive, it does not mean that it cannot be used as a figure of regulation for making decisions. The circuit does not suspend you in perpetual undecidability. The brute facts of life do call for decisions. I have developed a procedure for decision-making by consensus based on the circuit. The procedure is an extension of the relational practice called Threeing (see p. 104ff.) Briefly, the procedure works as follows. In a domain of decision making, each of three people, or multiples of three, takes a subdomain. For example, three editors each take a section of a magazine. Each editor is required to keep the other two informed of his/her decisions. If one of the other editors objects to a decision, convinces the third editor of the objection, and both of these editors convince a predetermined outside party to agree with their objection, these three can override the decision of the one. If these three cannot agree, then the original decision of the one stands. This procedure precludes two against one dynamics and preserves an intransitive heterarchy of decision making. Decisions develop from the dynamics of formalized relationships, not from syllogistic reasoning to conclusions. Of course, the formal relationships can, and should, include reasoned arguments.

2) The form is topological, not arithmetic.

Gödel's proof makes it clear that constructing 'a Sign of itself' from arithmetic units is impossible. The 'Sign of itself' presented here is not arithmetic, but topological. Topology is understood in the sense given the term by Riemann before the field was subsumed by algebra and set theory. For Riemann, topological study considered only relations of position and inclusion in continuous magnitudes. He explicitly excluded measurement. Subsequently, Peirce explicitly excluded magnitude.

While Peirce was able to free continuity from attributes of magnitude, he was not able to free the continuum from

attributes of sequence. I see this as a major reason for his failure to arrive at a relational logic. As Murphey reports, Peirce burdened the ordinal numbers with both expressing relative position and exemplifying position (Murphey 1961: 284). This cannot be done without confusion. As long as the ordinals are arranged in a sequence of first, second, third, etc., there is no clear way to distinguish between each member of the series and the serial relationship. A confusing duality between relations of position and examples of position results. Placing firstness as an example in a position expressed as secondness is more confusing than the Abbott and Costello comedy routine "Who's on first?".

Sequential positioning is a consequence of orientation, i.e., assigned direction. The form presented above is non-orientable (Characteristic #10, p. 349), hence it is also non-sequential (Characteristic #13, p. 350). The confusing duality of position and example in the use of ordinal numbers is resolved. There is no need to hold a double sequence in mind. Examples can be sequenced through an empty continuum of "ordinal" positions that do not depend on sequence. The positions obtain without orientation, hence without sequence. Once the mind is freed to think positionally without orientation a logic of relationships naturally ensues.

In concluding this section on Gödel, it can be noted that the logic of relationships inherent in the circuit is robust enough to generate a rich semiosis, as in the design for a television channel mentioned above (p. 352ff., v). This television channel makes use of Peirce's entire sixty-six fold sign classification system by mapping it into the relational circuit (pp. 217ff). As a formal system, the relational circuit combines cybernetics and semiotics. This is nontrivial, albeit non-axiomatic.

B. Consideration of Peirce's text

The relational circuit will now be discussed in relation to the text quoted at the beginning of this chapter that calls for 'a Sign of itself'. Of course, presenting argumentation in terms of one abbreviated text only begins the discussion of how the relational circuit relates to the body of Peirce's work. Indeed,

by omitting the section of the text that I left out in the quote, I am omitting discussion of the realm of signs that are other than their objects. This does not invalidate my basic argument. As demonstrated in the discussion of the ecochannel above (p. 352ff., v), signs that are other than their objects can be mapped into this 'Sign of itself'.

In the selected text, Peirce makes three points about a 'Sign of itself'. These three points will be reiterated with a discussion of how the relational circuit satisfies each point.

1) A sign need not be other than its object; a sign can be part of a sign.

The relational circuit is one continuum. There is not an 'other' object. All signing is part with this continuum. The phrase part with rather than part of is more appropriate for the intransitive character of the continuum. This sign does not designate something else. This sign shows itself.

2) 'The Sign of itself' will contain the explanation of all its significant parts. According to this explanation, each significant part will have some other significant part as its object.

Two characteristics of the relational circuit, unambiguousness (#8, p. 348) and intransitivity (#11, p. 349), insure this part to part explanation. The way Peirce words his statement seems to require that each part have but one other part as its explanation. In the intransitivity of explanation that obtains in the circuit, explanation does not take place in a one-to-one correspondence. Explaining position in this continuum requires that each explained position have not one, but two other parts to explain it. Any one part explanation would fall back on sequence: example, this part is the one that follows that part. Insisting on any one-to-one correspondence for explanation leads right back to the impossibility of working with arithmetic units. I do not think this two part explanation invalidates the relational circuit as 'a Sign of itself', regardless of Peirce's text, since the intransitivity of explanation remains complete and consistent.

It can also be argued that this "parts to part" explanation of positions, in terms of the intransitivity and unambiguousness of the form, is the only possible way to explain the positions qua positions. No other explanation of the relations of position and inclusion within the form appears possible. All other efforts reduce to the absurd. This argument is perhaps the weakest argument for taking the relational circuit as 'a Sign of itself'. Someone other than myself may be able to successfully imagine and argue another explanation of position. At the same time, it seems the *reductio ad absurdum* argument must be made in order to invite proper criticism.

3) Peirce also states that the 'Sign of itself' should contain its own explanation. I interpret this phrase, "containing its own explanation," to refer not to parts explaining other parts, but to the sign as a whole explaining itself as a whole.

Because the circuit has no more than six parts, it can contain its own explanation. Six is perceptible without counting (McCulloch 1965: 7). The whole form stays within this perceptible limit of six. Differences can be understood without arithmetic units. The perceiving mind can grasp this self differentiating form as a whole, without adding parts to parts. All that need be grasped are the six positions qua positions. To grasp the positions is to grasp the relations of position. The positions constitute the relations. To grasp the relations of position is to contain "its own explanation." All the form is, is relations of position. If you grasp the relations of position, you have grasped the form itself.

In the stoic term used by Warren McCulloch, I am describing a 'lekton', an event in the mind like a fist in the hand (McCulloch 1965: 390−395). A fist holds all fingers. To grasp the form is to hold all six positions. If the form becomes an event in your mind, you prehend all the relations of position needed for explanation. You prehend the explanation of the form itself, as a whole.

In Peirce's terms, prehension of the circuit is firstness of thirdness. It is iconic of the whole.

4) Discussion of the circuit re Peirce's philosophical project

It may be useful to end this chapter by attempting to state what prehension the relational circuit gives you in terms of Peirce's overall project. What is prehended when you prehend the relational circuit? What do you grasp when you grasp this icon?

The prehension gives you a continuum. Peirce argued that his entire philosophy was based on continuity, i.e., synechism (Murphey 1961: 379).

The prehension gives you correlated positions of firstness, secondness, and thirdness. No position could maintain its identity without the others. Hence, the icon gives you a non-degenerate grasp of firstness, secondness, and thirdness. These are Peirce's prime categories. The indexical function derives from secondness. The interpretive function derives from thirdness. This icon is transparent to any indexical function, and any interpretive function that respects that indexing. Both the indexing and the interpreting are pictured in the icon. Using Peirce's terminology, I can say that this icon prescinds from indexing and interpretation, but it is not severed from these functions. Hence, it is not degenerate. A supporting argument for non-degeneracy comes from cybernetics. Because the icon satisfies the criteria for a circuit, it is a "unit of mind." As a unit of mind it has thirdness, it combines differences in a non-degenerate way.

The prehension of this continuum of prime categories is given topologically, i.e., mathematically. This means that the prehension gives you the possibility of knowing whatever is knowable in the categories of firstness, secondness and thirdness. Peirce argued that there are no worlds which are not knowable in terms of these three categories. The categories provide a non-excluding approach to the infinitely cognizable world. In the architectural theory set out by Peirce, the relational circuit is an icon of all knowable worlds. As an icon that is a 'Sign of itself', it is a figure of regulation for any open process of semiosis that "explains itself by itself" (Eco 1979: 198).

The Tricultural Tournament

A proposal made as a nominee for a Rockefeller Intercultural Arts Grant.

FROM THE ONE CAME THE TWO,
FROM THE TWO CAME THE THREE,
FROM THE THREE CAME THE MANY.
— Lao Tzu

This is a proposal to produce a made-for-television event in which six performers from three different cultures compete to create an art of intercultural behavior. By an art of intercultural behavior, I mean wordless interaction that is composed by the performers like a painting is composed by a painter.

Only an intercultural team can win the tournament. Viewers will have the opportunity to identify with different intercultural teams seeking to create an art of intercultural behavior. People from different cultures could then use modifications of this multicultural behavioral art to organize tasks of mutual concern, particularly tasks having to do with environmental interpretation and restoration.

I. Overview: The Tricultural Tournament is a made-for-television competition for three couples. Each couple will be selected from skilled performers representing three different cultures. According to the rules of the tournament, out of the field of six performers, only a team of three can win. Hence, no couple representing a culture can win, only an intercultural team can win.

In International Olympics, viewers enjoy a one-to-one identification with their representative team. The Tricultural Tournament creates the possibility of something more. Because only an intercultural team can win, the viewer has the opportunity to identify with an intercultural team seeking to create an art of intercultural behavior. The essential tricul-

tural character of the tournament makes it an appropriate event for many intercultural settings. One can image the Tricultural Tournament as an artistic event at the Olympics, a sidebar at a Summit meeting, a regular pan-European program supported by the Common Market, a regular program in developing regions of the world, and an ongoing cable TV series in multicultural cities such as New York, Los Angeles, or New Orleans.

II. Composing Intercultural Behavior: The behavioral performance of each team of three is judged by a three member panel in a manner not unlike high diving or figure skating. Performers will be judged on their level of achievement in the "art of intercultural behavior," that is, their ability to "compose" their interaction in four different events. A clear understanding of what is involved in "composing intercultural behavior" for three people is most evident in the fourth event of the Tricultural Tournament, which is called Threeing.

Threeing is a non-verbal way for three people to relate simultaneously. It is a practice, invented by the artist, that works for three people analogous to the way T'ai Chi or Yoga works for the individual. T'ai Chi and Yoga balance a person's well being with a system of changing postures. Threeing balances the relationships among three people with a system of changing positions. When you are with two people, there is a tendency to choose one and exclude the other. For example, you cannot look into four eyes at once. Threeing provides a simple system of positional choices allowing you to balance your interaction with two people without anyone being excluded. This system of positional choices is like the frame that holds a painting. Within this system, performers from different cultures can balance their interaction the way a painter balances colors. Behavior can be "composed" in movement, gesture, sound and stillness.

Threeing provides a formal way of orchestrating behaviors from different cultures. Behavior is not based on gender, age, race, class or culture but on relationships that emerge from the positions in a geometric figure on the floor. The geometric figure necessary for Threeing can be mapped onto the floor with anything from masking tape to inlaid marble. A

performer can change his/her relationship to other performers simply by changing position in the figure. Each performer always has the option of changing positions. Within the figure, the core set of non-manipulative interactions for Threeing are based on things common to the human species, such as, we each have a front and a back, and we all can move and make sounds.

III. Television and the Tricultural Tournament: The Harvard Professor of Aesthetics, Stanley Cavell, argues that what is special about the medium we call television is that it enables us to monitor events simultaneously with others (Cavell: 1982). Cavell argues convincingly that unlike film, where a masterpiece has a unique status analogous to an art work, what is unique about television is the format of a show, not any specific instance of the show. Some shows, like sports and news, have formats that are designed to monitor certain kinds of events in the world. Other shows, like sitcoms and game shows, both generate events and monitor the events they generate. Events are generated that "work" in a certain format. According to Cavell, with television, the format constitutes the basic aesthetic achievement. The Tricultural Tournament will be an event generated specifically for television and video replay. The tournament will have the unity of time and place proper to an event. Within the overall event of the tournament itself, there are four competitive events. Each competitive event will be shaped according to a repeatable format designed for television.

IV. Selecting the Four Events: The four competitive events were selected by reviewing a body of videotapes I produced in the early seventies. In 1970, I worked with a small group at Roosevelt Hospital's Center for the Study of Social Change, exploring the effects of video feedback on interpersonal behavior. Al Scheflen, author of *How Behavior Means* (1974), was the leader of the group. I was the gamemaster, responsible for setting up different recording and replay situations. Based on years of research in association with Ray Birdwhistell, author of *Kinesics and Context* (1970), Scheflen has a very grim view of human behavior. He argued that it doesn't matter what poetry is going on in your head, your interaction

in small groups is controlled by a very restricted repertoire of behaviors that we share with other mammals: greeting, parting, combat, courtship, territory, etc. In reaction to Scheflen and propelled by personal dynamics, I thought that while he may be right, things need not be that grim. Given video's power to let us see our behavior patterns, perhaps we could "invent" behaviors that would provide more flexibility in our interpersonal relationships. From 1971 to 1976, I produced forty-five hours of video of people experimenting with three person interaction, trying to "invent triadic behavior." Threeing, described above, came out of this period of experimentation. The four events proposed for the tournament were selected by watching these tapes and identifying what sorts of interactions were appropriate for an intercultural tournament. In varying degrees, all four events are selected and formatted to provide "open scores" that allow the performers to behave with the same sort of improvisation possible in jazz music.

Threeing, selected as one of the events, has a history beyond the period of experimentation in the early seventies. Threeing was premiered in a 1976, one-man show at the Kitchen Performance Space. Since then, I have done a number of workshops and presentations of Threeing at places such as Optic Nerve in San Francisco, The Art Institute in Chicago, the Contemporary Arts Center in New Orleans, The Akerman Family Institute, The Milton Erickson Society, The Dalton School, and the Cathedral of St. John the Divine in New York City.

V. Description of the Tournament: Three judges familiar with performance and intercultural issues will be selected. The artist will walk these judges through the four events and explain the criteria for judging in a preliminary workshop. The criteria will include such things as reciprocity among all three, range of behaviors displayed, uniqueness of behavior displayed, respect for the choices of each person, and overall artistic composition.

Preparation: Established performing groups from each of the different cultures will train and rehearse separately for the

tournament. One male and one female will then be selected from each group. These couples, wearing simple costumes characteristic of their culture, will meet with their selected counterparts for the first time at the tournament. With six performers, there are twenty different triadic combinations possible. Of these twenty, twelve are not eligible to compete because they do not include a representative from all three cultures. Of the remaining eight triads, two are ineligible because they are single gender triads, i.e, all male or all female. Making single gender triads eligible would run the risk of confusing gender competition with intercultural cooperation. That leaves six triads eligible to compete in the tournament. These six teams are both tricultural and mixed gender. If we use M and F to represent Male and Female, and use A, B, and C to represent the three cultures, then the six competing teams can be designated as follows:

1. AF BF CM
2. AM BM CF
3. BM CM AF
4. BF CF AM
5. AF CF BM
6. AM CM BF

This is the order in which the teams will compete. Each performer is a member of three different teams. All six teams will compete in every event.

Opening Ceremony: The three judges stand in a triangle in the middle of the performance space with their backs to each other. The couples enter simultaneously and stand side-by-side at the vectors of the triangle surrounding the judges. They bow to the judge facing them, bow to their cultural partner, bow to each of the other couples, bow again to their partner and then bow to the judges once more. The judges retreat to view the tournament. The performers then join their first team and prepare themselves for the *Competition*.

1) **Flying Blind** challenges the ability of a team of three to maintain the communication necessary to balance inter-action. The challenge is a matter of disrupting normal communication patterns with blindfolds. In Flying Blind, members of the team will put on and take off

blindfolds as they interact on an open floor. The rule is that at least one member of the team must be blindfolded at all times. Each team is assured five minutes on the floor. After the first five minutes, any one of the three judges may signal the team to end their performance. If no judge signals an end to the performance, the performance will be limited to ten minutes. Total performance time, one hour.

2) In **Hands and Sound**, members of the triad will interact using only one of their own hands, while making sounds that accord with that hand's interaction. The camera will show only the hands interacting. Three positions from the geometric figure are used to position the hands. Each member of the triad will take one turn in the first position for two to three minutes. In the first position the performer moves his/her hand paying attention only to what he/she feels. In the second position the performer touches the hand in the first position from behind and reacts without thinking. The third hand is placed behind both hands and mediates their interaction. Total performance time, fifty-four minutes.

3) **Free Form** is formatted in recognition that behaviors codified according to the geometric figure do not exhaust the possibilities of intercultural triadic behavior. Other patterns need be generated and monitored. In Free Form, members of the triad will play together on an open floor. The intent of the play is to invent new behavioral patterns. In Free Form, at the discretion of the artist, unannounced props such as a tangle of rope may suddenly be thrown onto the floor or rules announced such as "hold your hands behind your backs." Each team of three is assured at least six minutes of performance time. After six minutes, any one of the judges may signal the team to stop. If no judge signals stop, then the event will be limited to twelve minutes. If an extraordinary composition is taking place, the judges may agree to extend the time for another eight minutes to allow a full

twenty minutes. Total performance time, one and a half
hours.

4) In **Threeing**, the members of the triad will interact
according to the formal relational practice called Three-
ing (II, p. 361). Fifteen minute time limit. Total per-
formance time, one and a half hours.

Closing Ceremony: After the judges announce the winning
team of three, video highlights from their performance are
shown. The winners and losers then recombine themselves
into new teams of three and perform Threeing until they
decide to stop. This final enactment of triadic behavior serves
to indicate that "the winning team" has won for all. Each
judge then reunites one of the original cultural couples as a
couple and walks them out of the space. Estimated time for
total event, eight hours. Estimated time of performance, five
and a half hours.

VI. Strategy: In effect, this is a proposal for a pilot program.
My ambition is to see tournaments devoted to an art of inter-
cultural behavior institutionalized in as many intercultural
settings as possible. My plan is to begin with a first-rate pilot
produced in New York City where I live. One possible site is
the Cathedral of St. John the Divine in New York which has
expressed interest in hosting the first Tricultural Tournament.
The Cathedral has an international reputation for intercul-
tural activity and I have already produced a number of events
there. Performers will be recruited through the Cathedral
network and from New York based groups such as the Alvin
Ailey troupe. Performers visiting New York, such as Japanese
Butoh Dancers, etc., may also be approached.

VII. Sample Submitted: The sample submitted, *Proposal for
a Tricultural Tournament* (12 minutes and 30 seconds), is an on-
camera explanation, by the artist, of the four events that
constitute the Tricultural Tournament. In explaining these
events, the artist shows four excerpts from the body of triadic
tape produced from 1971 to 1976. These excerpts are tapes of
record used for research in "inventing triadic behavior." They
do not have high production value. In effect, they are a

sample of the sort of "video sketches" that are behind the conception of The Tricultural Tournament.

VIII. The Video Composition: The tournament will be produced by a remote crew with four cameras and slow motion replay equipment, adhering to the highest production standards possible. Actual spectators at the tournament will be able to see the event simultaneously on four monitors and see instant replays. A one hour edit of the Tricultural Tournament will be produced. Careful blocking of camerawork will be worked out beforehand to accommodate the events. Post-production will use computer graphics to present the geometric figure, A/B roll, slow motion, etc.

IX. Tricultural Behavior and the Environment: Besides the value of developing an art of intercultural behavior, in and of itself, many useful spin-offs are possible. For example, Threeing is one of the five principal components of the Earthscore Notational System, which I have developed so videographers could generate a shared perception of the natural environment. New intercultural behaviors invented through The Tricultural Tournament would enhance the prospect of multicultural teams of people cooperating to interpret and respond to our environmental crisis. People from different cultures can use modifications of triadic intercultural behavior to organize tasks of mutual concern, particularly tasks having to do with environmental interpretation and restoration.

Symphony for the Jersey Shore

Proposal from Earth Environmental Group to produce a videotape about the coastline of New Jersey. Earth Group members include Video Artist: Paul Ryan; Sound Artist: David Dunn; Author: Jean Gardner.

Objective: The objective of this proposal is to produce and distribute a twenty-eight minute video work of art that interprets the Jersey Shore as a multispecies habitat. The proposed tape:

1) is part of a series of video interpretations of natural sites in the Hudson River/Mid-Atlantic Coast Bioregion,

2) will be produced according to a methodology designed for understanding ecology,

3) will be accompanied by a guide to facilitate using the tape to impact current discussions of how to achieve an ecologically sustainable role for humans on the Jersey Shore.

Because most of its coastal habitats are dominated by humans, New Jersey appears to have a monospecies shoreline. This symphony will use video to unconceal and celebrate non-human habitats from Cape May to what poet Robert Lowell called "the unforgivable landscape" at the mouth of the Hudson. Evidence of human dissonance with coastal ecology will be integrated into the tape. The expectation is that this project will make a contribution toward reconnecting humans with Jersey's multispecies shoreline.

A dozen types of non-human habitats, characteristic of the shoreline, have been identified and will be featured in the video.

1. Low Marsh	7. Seaweed Beds
2. High Marsh	8. Oak Gum Forest
3. Beach	9. Tidal Slough
4. Dunes	10. Holly Forest
5. Eel Grass	11. Sedge Islands
6. Cedar Forest	12. Mudflats

Based on such texts as Bennett's book, *New Jersey Coastwalks* (Bennett: 1987), characteristic examples of each of these types will be selected. These habitats will be taken as major themes for the Symphony for the Jersey Shore.

By definition, a symphony establishes order amid complex variety. To establish such order, a method of composition is necessary. This proposal is based on The Earthscore Method of composition, originated by the artist, Paul Ryan, who will be making the Jersey tape. A description of this method follows.

1. The Earthscore Method was designed specifically for understanding ecological systems. The ecology is understood as a complex, interrelated system. The method uses a sophisticated phenomenological and semiotic system to understand ecosystems. Fundamental to this method are the three comprehensive phenomenological categories described by Charles Peirce.

2. The Earthscore Method uses a self-organizing, cybernetic approach to communications. In principle, this method can be used to develop a consensus among concerned parties about appropriate policy and practices regarding ecosystems. The artist has articulated this possibility in a design for a television channel dedicated to the Hudson Basin.

3. The Earthscore Method allows any musical idiom to be used in conjunction with the video. The normal music-video hybrid starts with the music and then finds the video to "illustrate" the meaning of the music. The Earthscore Method starts with the phenomenology of the ecological system itself and edits the video in order to

allow many musical interpretations of the phenomena. Once the tape is edited in this way, it is then possible to interpret the ecology for any musical audience.

4. The Earthscore Method is teachable. The teachability of the method means that, in the future, other individuals or groups could produce a series of Symphonies for the Jersey Shore. The guide that accompanies the tape will explain the method so that it can be used by others. In the future, workshops could also be offered.

The Symphony for the Jersey Shore will be ordered in the following way. Six "corridors of perception" will be selected. By corridor of perception, I mean a strip with a continuous line of sight, transversal to the coastline, that contains at least two distinct habitats with transitional ecotones between them. Examples: A) beach/dunes, B) seaweed bed/low marsh/high marsh. Each strip of ecotones will be presented phenomenologically in thirty-six, six-second video passages. Each passage will have a four/four measure with a second and a half to each beat. The thirty-six passages will include twelve of firstness, twelve of secondness, and twelve of thirdness. These passages will be edited in various combinations, all with a dissolve edit on the fourth, transitional measure. The remaining six minutes plus will be edited to interrelate the six strips with the coastline as a whole and the human presence. Satellite photography of the coastline will be used to supply overall context. Close attention will be paid to tidal changes. Underwater video will be taken where appropriate. The tape will have upward of 250 dissolve edits.

The Symphony for the Jersey Shore is part of a series of video interpretations of sites in the Hudson River/Atlantic Coastline Bioregion. The series includes completed productions about The Hudson Estuary, The Great Falls in Paterson, The Bronx River Waterfall, a Stand of Trees in Inwood Park, Horseshoe Crabs Laying Eggs in Jamaica Bay, and The Clay Pit Pond on Staten Island.

The sound track will be produced by sound artist, David Dunn. Dunn will record microorganisms in the salt marsh

characteristic of the Jersey Shore using digital hydrophonic equipment. These recordings will then be modulated in accord with firstness, secondness, and thirdness. In the event other musical groups, such as the New Jersey Symphony Orchestra or jazz groups, express an interest in producing an original sound track for the video, both the method and the rights will be made available to them.

The guide will describe the ecology of each site phenomenologically, using the same categories as used in the video. These categories will help video viewers, site visitors, and decision makers understand the relationships between the unique qualities of the different sites, the facts about them and their context. This understanding will also be helpful in facilitating use of the tape in discussion groups and in the ongoing effort to develop a sustainable human presence on the coast of New Jersey.

The schedule is to do the taping while the Atlantic flyway is being used in the spring or the fall. Choice will depend on schedule and weather. After the initial taping, six months will be needed to edit the final product, produce the sound track, and publish the guide.

Distribution of the tape and guide will be directed at reinforcing existing concern for the Jersey Shore and at stimulating new interest. Organizations such as the National Audubon Society and the American Littoral Society have indicated that they will review the tape for inclusion in their programs. Gateway National Recreation Area, Project Use, Clean Water Fund, the Youth Environmental Society, Rider College, the New Jersey Conservation Foundation, the New Jersey Marine Science Consortium and related groups will be approached to determine if the tape can be useful for their programs. I will make myself available for presentations of the tape and discussions of the shore. Public Television in Philadelphia and New York will be approached as well as the Television Network in New Jersey. Cable systems will likewise be approached.

Earth Environmental Group is a non-profit arts and education collaborative dedicated to increasing public awareness of natural and architectural environments. Over the past twelve

years the collaborative has carried out extensive field investigation and research into New York City's bioregion. Studies have been conducted of vegetation, geology, wildlife, natural history, and human habitation. The findings of the Earth Environmental Group have been presented to the public in pamphlets, posters, filmstrips, radio programs, video, multimedia shows, and workshops.

Mountain Waters

A proposal to produce a half-hour video interpretation of water
ecologies in the Northern Shawangunk Mountains.

The Shawangunks are located less than a hundred miles up
the Hudson Valley from New York City. A thirty-eight square
mile tract of these mountains is held by Minnewaska State
Park, the Mohonk Trust and the Ice Caverns, a National
Natural Landmark. Preserved for the Megalopolis, the
Shawangunks offer a standing invitation for regeneration to
approximately twenty million people. Since 1971, the artist
has spent over six years living near and hiking the Northern
Shawangunks. The proposed tape will increase public
appreciation of this preserve during the year of the twentieth
anniversary of Earth Day, by inviting video viewers to let their
minds run with the various forms that water takes in this
mountain ecology.

The proposed interpretation will follow the water up the
mountain. The viewer will move from drippings in ice
caverns, to morning mist over bogs and swamps, up four
waterfalls, along many streams to rain falling into five sky
lakes. Sometimes this movement up the mountain will be
accentuated by editing the tape in reverse direction at
different speeds, as in the sample submitted. The tape will be
composed according to the Earthscore Method originated by
the artist to interpret ecological systems. Using the Earthscore
Method, it will be possible to appreciate the various surface
qualities of water, the obstacles water overcomes, the shapes
water takes, and the ecological context of its movement. I
anticipate over three hundred edits, many of them dissolve
edits. Dynamic tracking and other post production techniques
that can increase the viewer's appreciation of water will be
used.

Meditation on the Arthur Kill and the Kill Van Kull

A proposal to the NASA's Earth Observation System Program for knowledge transference in an urban setting.

This is a proposal to develop knowledge transference in urban settings using television. A television format will be created that combines remote sensing with ground-based video observations. This format will be useable in any city. The immediate objective is to produce a six-to-eight-minute prototype videotape about the waterways off Staten Island in New York City as a pilot program for policy discussions on public television that makes optimal use of images and data generated by satellites.

Rationale: The information payload of the National Aeronautics and Space Administration's (NASA) Mission to Planet Earth will have to land amid myriad human cultures with highly differentiated forms of local knowledge. Certainly the mission must find hospitable landing sites in urban settings. By the year 2000, an estimated six and a half billion people will be living in cities worldwide. If we are to solve our environmental problems, ways to transfer the data streams produced by Earth Observation System (EOS) into urban policies and practices must be found. The proposed project offers one solution to this problem of knowledge transference in urban settings by using television.

Long Range Objective: As a founding member of Environment '90, a coalition of over two hundred and fifty New York City based organizations, Earth Environmental Group is urging the Dinkins's administration to set aside a municipal television channel to monitor the ecologies of New York City. The City Office of Telecommunications is now in the process of determining how to allocate five city-wide cable channels.

The New York City Department of Sanitation and the Department of Parks and Recreation are actively supporting this proposal, as are many national and local organizations. Starting in 1998, the coalition anticipates that one of the principal sources of data and information for this television channel will come from the EOS project. Successful integration of a municipal environmental television channel with EOS would constitute a local/global model worthy of implementation around the planet.

Mid-Range Objective: The mid-range objective of this effort is to configure installations for urban public spaces that combine ground-based video observations with satellite imagery. Future proposals by Earth Environmental Group to the Environmental Research Institute of Michigan (ERIM) could further this objective by experimentation in New York City. New York has a host of concerned institutions with public spaces in which satellite images and video could be combined in informative displays. Places such as The Museum of Natural History, the New York Hall of Sciences, the Cathedral of St. John the Divine and the World Trade Center could become forums for displaying satellite information.

The television format developed in this proposal could be used to produce videotapes of a number of environmentally sensitive sites in the city. These tapes could then be displayed as multichannel video installations in combination with large scale, enlarged images of the city provided by satellite. Text for these displays would be drawn from EOS research findings.

Immediate Objective: The immediate objective is to produce a pilot video that combines ground-based video observations with satellite images. The satellite images will provide both context and specific information about the ecologies of New York City. A format will be codified that works both for public television presentation and policy discussion groups. Along with this six-to-eight-minute video, both a users' discussion guide and a producer's manual will be published. The producer's manual will be for videographers who want to make tapes using a similar format.

Proposed Site to be Interpreted: During 1990, over one million gallons of oil have been spilled into the Kill Van Kull and the Arthur Kill waterways in New York City. A local oil transport company has been shut down by the courts. The public is on alert. Yet most people have no image of the waterway in their mind and no regional, ecological context in which to interpret the headlines and the fleeting six o'clock news images. This project will make optimal use of remote sensing images, ground based video observations and relevant data to produce a coherent environmental interpretation of the damaged waterways.

Distributing the Video: A six-to-eight-minute video will be produced for showing over local television channels with copies provided to relevant government agencies and non-government agencies to help facilitate their work. Local television channels include WNYC, WNYE, and community access cable channels. These channels will be encouraged to use the video as a lead-in to televised discussions supported by the users' guide. Government agencies to receive the video include the Department of Environmental Protection, the Department of Parks and Recreation, and the Coast Guard. Non-government agencies include the Coalition for the Bight, the National Audubon Society and other members of Environment '90.

Forests Forever:
The New York City Cycle

*A proposal to produce a twenty-eight-minute video interpretation
of the Forests in New York City.*

The video will present the continuous self-regulating life of
native forest communities in a way that includes aesthetic
appreciation of their beauty as well as a recognition of the
disturbances that threaten these communities. Disturbances
range from exotic plants to excessive human traffic to arson.
All four seasons of forest life in New York City would be
presented using the Earthscore Method of video production. I
developed this method of interpreting natural ecologies over a
twenty year period. The proposed tape would be non-didactic
and use the power of imagery rather than voice-over to convey
the value of New York City's urban forest.

While the entire cityscape of forests will be presented, this
tape will concentrate on a few sites. This strategy will allow
the viewer intimacy with the cycle of the forest at specific sites.
Five minutes will be given to each season and eight minutes to
a medley of images from all four seasons.

The project will benefit all New Yorkers whose appreciation
of the urban forest will be enhanced by seeing the tape. Those
benefits can accrue over the years with repeated viewing.

The tape can be useful in five different ways:

1) As a broadcast and/or cablecast twenty-eight-minute video
 with a trailer which indicates where people can write or
 call for more information about the forest. Because the
 program would be dense with imagery it will bear
 multiple repeat viewings.

2) To support those doing technical, voluntary, and educational work with the forest. Copies of the tape will be made available at cost to these workers to be used to augment their work in whatever ways they see fit.

3) As a seven-minute, four-monitor video installation at nature centers and community centers as well as art institutions throughout the city.

4) As part of a classroom curriculum about the urban forest. Of course, this use depends on the structure of the curriculum itself. There are a range of possibilities. For example, a printed guide to the video could explain the way it was made and invite students to compare the video presentation of the forest with their actual experience of the forest. A more ambitious option would be to integrate the tape into an interdisciplinary, multimedia, interactive video disc.

5) As an incentive gift to funders to support New York City's forests.

Please Note: The tape will be produced using the natural sounds of the forest. However, it would also be desirable to have versions of the tape produced that use sound tracks from musical idioms enjoyed by different New Yorkers such as jazz, classical, ethnic, and new music.

The Earthscore Notational System for Orchestrating Perceptual Consensus about the Natural World

After a study of modern painters, the biologist C. H. Waddington articulated the following argument (Waddington: 1970). As a species we transmit information over generations both genetically and through speech and writing. Speech and writing inevitably result in authority structures, someone telling someone else what to do. The child is told, "No, don't touch, the oven is hot." His or her perceptual system is stunted and his or her behavior is linked up to the language commands of others. Based on his examination of how modern painters had learned to see nature without language, Waddington suggested institutionalizing this artistic achievement for the human species as a whole. He thought we could generalize the silent success of painters such as Monet, Cezanne, and van Gogh and evolve an information transmission system based on shared perception of environmental realities rather than language.

This chapter presents the Earthscore Notational System as a formal framework for evolving a shared perception of the natural world along the lines posited by Waddington. The Earthscore Notational System grew out of my efforts to use the video medium to interpret nature. I began working on the system in 1971 while living in the Hudson River Valley and trying to interpret the natural world as a video artist. It did not take long for me to realize that no matter how good I became at producing landscape video as an individual artist, it would have little effect on how people actually treated the ecology of the Hudson Valley. To make a difference, what was really needed was a cooperative group of videographers who could interpret the natural world and present it to the

community at large on an ongoing basis. In order to produce such an orchestration of perception, a notational system was needed. No such notational system existed. I was thus faced with the necessity of inventing the sort of information transmission system based on perception that Waddington had proposed.

The difficulty of inventing a video notational system suitable for the natural world becomes evident when we compare the two activities of recording nature with video and playing music on a piano. Video is a perceptual device with which we look at the natural world. The natural world can be a buzzing, blooming confusion. We have never codified a clear system of "notes" for reading nature. By contrast, there is a clear system of musical notes encoded in the piano. In fact, the piano was constructed according to specifications determined by these notes. We do not know the "notes" according to which nature was constructed. A notational system designed to interpret the natural world must somehow be based on clear "notes" elicited from the natural world. For example, in order for videographers to record salmon spawning in a way that is faithful to the spawning process itself, they must understand what I will call the "figures of regulation" guiding the "performance" of the salmon. Ecological videographers must know how to read these underlying figures of regulation, or notes in nature, just as dance videographers must know the choreography of the dance they are recording. Once the underlying figures of regulation for salmon spawning in a particular river are identified and put together, i.e. composed into a score, then videographers who know the notational system and that particular score can record and monitor the salmon run year after year, generation after generation. If a particular performance of the salmon as recorded does not comply with the score, then the videographers are in a position to scan the ecological system for perturbations and alert us that something might be disturbing the underlying figures of regulation for the spawning run. This should result in a revision of the score and/or a correction of some human activity that is ecologically destructive to the salmon run.

The five components of what I consider a suitable system of notation for evolving shared perception of the natural world over generations, i.e., the five components of the Earthscore Notational System, are:

The categories of firstness, secondness, and thirdness
The relational circuit
Threeing
The firstness of thirdness
A semiotic system for interpreting the firstness of thirdness

As of April, 1991, these five components have not yet been put together in an organized way to create an ongoing perceptual information system. In the space allowed, I will provide a description of each component and cite art work, workshops, and projects which I have been involved in that make use of these components.

The Categories of Firstness, Secondness, and Thirdness

Because I wanted a notational system for video that was responsive to the the totality of the environment, I was attracted by the comprehensiveness of the categories of firstness, secondness, and thirdness as developed by the American philosopher Charles Peirce (1839-1914). Following Kant, Peirce subscribed to the architectonic theory of philosophy (Apel: 1981). By architectonic, he meant the art of constructing systems, i.e., uniting manifold ways of knowing under one idea. The idea or concept of a formal whole determines *a priori* both the scope of the manifold content and the positions that the parts occupy relative to each other. This unity makes it possible to determine, from our knowledge of some parts, what other parts are missing, and to prevent arbitrary additions. Knowledge can grow organically, like the body of an animal.

For Peirce, knowledge corresponds to three modes of being: firstness or positive quality, secondness or actual fact, and thirdness or laws that will govern facts in the future. Peirce held that these categories of being are phenomenologically

evident to anyone who pays attention to what happens in the mind. Direct observation will produce these categories of knowledge.

Firstness is positive quality. The taste of banana, warmth, redness, feeling gloomy: these are examples of firstness. Firstness is the realm of spontaneity, freshness, possibility, freedom. Firstness is being "as is" without regard for any other.

Secondness is a two-sided consciousness of effort and resistance engendered by being up against brute facts. The "facticity" or "thisness" of something, as it exists, here and now, without rhyme or reason constitutes secondness. To convey the pure actuality of secondness, Peirce often used the example of pushing against an unlocked door and meeting silent, unseen resistance.

Thirdness mediates between secondness and firstness, between fact and possibility. Thirdness is the realm of habit, of laws that will govern facts in the future. With a knowledge of thirdness we can predict how certain future events will turn out. It is an 'if...then' sort of knowledge. Thirdness consists in the reality that future facts of secondness will conform to general laws.

When we attempt to interpret a natural site with a video camera, we are confronted with "everything." We need to make selections. If those selections are arbitrary, the final tape can leave out significant aspects of the ecosystem. Significant omissions can make the interpretation of the site faulty. Peirce's categories of firstness, secondness, and thirdness are, in effect, a theory of everything. Using these comprehensive categories, it is possible to make selections that are responsible to "everything" at the site. The way in which Peirce's categories can be used to organize video perception of ecological sites is evident in my videotape titled *Nature in New York City* (Ryan: 1989a). Consider the following list of the four sites in the tape and how my interpretation of the sites was guided by using Peirce's categories.

1. Horseshoe crabs laying eggs, Jamaica Bay, Gateway National Recreation Area, Brooklyn and Queens. Firstness:

eggs, signifying the possibility of new crabs; secondness: predator birds and meddlesome boys; thirdness: pattern of crabs mating and context of urban habitat.

2. Clay Pit Pond, Clay Pit Pond State Preserve, Staten Island. (Five phenomena selected: deciduous trees, evergreen trees, abandoned cars, grass, reeds.) Firstness: quality of five phenomena plus pond surface; secondness: facticity of five selected phenomena; thirdness: patterns of phenomena in the context of the pond.

3. Stand of trees, forest in Inwood Hill Park, Manhattan. Firstness: melting snow, bark surfaces and sprigs of green; secondness: burnt wood and litter; thirdness: children swinging on rope, pattern of tree crowns.

4. Waterfall, Bronx River, New York Botanical Garden, The Bronx. Firstness: quality of surface water and texture of turbulence; secondness; water turbulence; thirdness: explicit water patterns, geological context of the falls.

This twenty-seven-minute tape was edited in six second passages set up in 4/4 time for musical interpretation. Each passage corresponds to firstness (F), secondness (S), or thirdness (T) and the passages fade into each other. A given sequence might run FSFT, SFST, TSFS, TFSF.

The Relational Circuit

The *Nature in New York City* tape was composed using what I call "the relational circuit." The relational circuit organizes the categories of firstness, secondness, and thirdness in unambiguous, relative positions. The circuit is to the Earthscore System what the staff and bars are to classical music notation. I originated the relational circuit based on my own video experimentation and a study of Peirce's failed attempt to develop a logic of relationships.

Peirce thought that the organization of knowledge according to his three fundamental categories required a new kind of formal logic. During his lifetime he made four major attempts to construct a philosophic system, each attempt guided by new discoveries he had made in logic, but none succeeded.

The major difficulty Peirce had was with continuity. Peirce believed all things were continuous and that the concept of the continuum was the master key to philosophy. However, he was never able to organize his categories in a logical continuum (Murphey: 1961).

Working with video, I was able to construct a topological continuum that, I believe, supplies the formal logic necessary to realize Peirce's architectural dream. My purpose here is to present the circuit for the reader's inspection and show how it organizes Peirce's three categories.

The relational circuit is a self-penetrating, tubular continuum with six unambiguous positions. In figure 19 (p. 103) the circuit is depicted in three dimensions. There is a part contained by two parts (–), the position of firstness. There is a part contained by another part and containing a part (=), the position of secondness. There is a part that contains two parts (≡), the position of thirdness. The circuit organizes differences in terms of these three positions and the three "in-between" positions (–=), (=≡), (≡–), that connect them in the continuum. Peirce's three categories map onto this continuum. The positions are named to correspond to the categories.

The relational circuit provides the core of a notational system, which can regulate composing with firstness, secondness, and thirdness in a way that is analogous to the way the painter Cezanne composed with what he fondly called "*his little blues, little browns*, and *little whites*" (Lacan 1978: 110). *Nature in New York City* is an example of such a composition. However, since this tape was produced by me as a solo artist, it falls short of the ideal in which cooperating videographers interpret the ecology. Videographers can establish cooperation using the relational circuit through a process I call "Threeing."

Threeing

Before beginning work on a video notational system for nature, I was part of a video production team in New York City called Raindance. Raindance often created shared video perception of events spontaneously, without script, formula, fixed roles, or hierarchies. A limited number of portable cameras would be passed around based on affinities, shared sensibilities, and whatever was happening in range of the cameras. I was involved in making many videotapes in this manner. Whether it was the first Earth Day in New York City, a media conference at Goddard College, or a day on a California beach, recording and replaying with video involved spontaneous cooperation within a small group (Raindance: 1969–71).

Threeing is a formal, teachable version of the kind of cooperation that happened spontaneously within Raindance. In the summer of 1989, I taught a dozen young videographers in New York City to observe sites in Central Park using the protocols of Threeing. The youngsters went on to incorporate this cooperative way of observing sites into a series of tapes. One of these tapes won a national prize from the American Film Institute (Urban Conservation Corps: 1989). In the spring of 1990, I taught the three categories of the Earthscore Method to adult videographers on Staten Island. Together with sound artist Charles Potter and poet Alan Ginsberg, we then produced a videotape based on Walt Whitman's poem "Crossing Brooklyn Ferry" (Ryan et al: 1990b).

Unlike the tradition of filmmaking, in which each member of a production team has a fixed roles, such as director, camera person, or sound person, Threeing enables each member of a video team to play each of three critical roles. The roles correspond to the categories. The videographers take turns paying attention to a phenomenon in terms of firstness, secondness, and thirdness. As an example, if a three-member team—say, yellow, red, and blue—had produced the video interpretation of Clay Pit Pond mentioned above, it

would have worked in the following way. Yellow might do a six-second shot of the texture of bark on the evergreen (firstness), red might do a shot of the trunk of the same evergreen rising out of its ground site (secondness), blue might do a shot of the whole tree with the pond in the background (thirdness). When the team approached a deciduous tree, red would do firstness, blue secondness, and yellow thirdness. Another phenomenon, such as an abandoned car left in the pond, would find blue doing firstness, yellow secondness, and red thirdness. To augment this turn taking, there are protocols for decision making in teams of three. These protocols are too complex to specify here. Suffice it to say that videographers who practice Threeing would be capable of orchestrating their perception of the natural world without fixed roles and without a dependence on language.

In addition to incorporating Threeing into the Earthscore Notational System, I have been able to detach Threeing from that system and develop it as an "art of behavior" in its own right. As an art of behavior, Threeing is a way in which three people can relate to each other simultaneously without words and without cameras. Threeing works for three people analogous to how T'ai Chi or yoga works for the individual. T'ai Chi and yoga balance a person's well being with a system of changing postures. Threeing is a practice that balances the relationships among three people with a system of changing positions (pp. 104ff.). Just as the practice of T'ai Chi or yoga can prevent certain health problems such as lower back pain, so the practice of Threeing can prevent certain problems in human relationships that bedevil consensus building. In the essay above titled "Relationships," I discuss at length how Threeing works to preclude specific difficulties in human relationship, including the tendency of two parties to split apart and third party exclusions (pp. 134ff.).

To date I have had three opportunities to develop threeing as an art of behavior. In 1984, I produced a videotape titled *The Ritual of Triadic Relationships* (Ryan: 1984b) for the Primitivism Show at the Museum of Modern Art. With a commission from V'soske, a custom rug making house in New

York City, I have designed a rug for Threeing in collaboration with artist Michael Kalil. The rug, which codes the positions in terms of textures and graded rug pilings, is now in production. As a nominee for a Rockefeller Intercultural Arts Fellowship, I conceptualized a Tricultural Tournament for performing couples from three different cultures who would come together to "invent" cooperative intercultural behavior. In the rules of The Tricultural Tournament only an intercultural team of three can win. Viewers would identify with an intercultural team competing to create cooperation rather than a team representing their own culture against another culture (pp. 360). Ideally, the tournament would stimulate intercultural teams of three to build a perceptual consensus about the natural world using the Earthscore Notational System.

The Firstness of Thirdness

Video recording and playback, with its possibilities of time lapse and slow motion, enables us to understand natural patterns in a non-verbal way. Think of time lapse film studies of budding flowers and slow motion studies of insects. Watching these moving images, it is possible to understand the pattern presented in a single gestalt without rational inference using language. The moving image allows the natural event to occur in the mind like a fist in the hand. There is a sponta-neous, intuitive appreciation of a pattern in nature. Peirce would call this "the firstness of thirdness." This intuitive appreciation of natural patterns through perception is the fourth component of the Earthscore Notational System. It is important to understand how the firstness of thirdness relates to the categories of firstness, secondness and thirdness.

In Peirce's categories, firstness is not separated from sec-ondness, nor is firstness separated from thirdness. There is a firstness of secondness. The 'ouch' sounded by someone struck with a thrown rock is an instance of the firstness of secondness. The brute fact of the rock hitting the person is actually there, secondness. It is not constructed or determined by the

person's feelings alone. Yet for the person a feeling attaches to the brute fact, a feeling evident in the involuntary cry.

Peirce provided as well for the firstness of thirdness, that is, the immediate perceptibility of law. Muybridge's famous photos of a running horse, done on a wager about whether the four hooves were ever all off the ground at the same time, is an instance of such firstness of thirdness. The firstness of thirdness in nature can also be understood in a formal way using the catastrophe theory of the topologist, Rene Thom (1975). Catastrophe theory is a qualitative method for modeling discontinuous phenomena. The theory models the states of nature as smooth surfaces of equilibrium. When the equilibrium is broken, catastrophe or discontinuity occurs. Thom has proven that in natural phenomena controlled by no more than four dimensions, there are only seven possible equilibrium surfaces, hence only seven possible discontinuous breaks, i.e., only seven elementary catastrophes. Thom named these seven as follows: fold, cusp, swallowtail, butterfly, hyperbolic umbilic, eliptic umbilic, and parabolic umbilic.

Catastrophe theory is to the medium of video what Euclidian geometry is to the medium of paper. Television and video monitor and record events (Cavell: 1982). Just as Euclidean geometry offers a formal understanding of geometric surfaces and solid objects, catastrophe theory provides a formal understanding of events or changes from states of equilibrium, i.e, discontinuous phenomena. Based on Euclidean geometry, someone faced with tiling a wall knows with mathematical certitude that of all possible regular polygons (equal-sided, two dimensional shapes) only three (hexagon, square, triangle) can fill the plane packed edge to edge. Based on catastrophe theory, someone observing nature with a video camera knows with mathematical certitude that there are only seven kinds of discontinuity possible in any natural phenomena controlled by four dimensions or less. Just as the continuous relational circuit constitutes the "staff" of the Earthscore Notational System, so these seven elementary models of discontinuity constitute the basic "notes" of the system.

To suggest how these notes function in the Earthscore Notational System, I ask the reader to imagine a section of a

stream in which there is a continuous flow of smooth water. The flow of water has four dimensions: length, width, depth, and rate of flow. Changes in these dimensions occur because of changes in the shape of the streambed and variations in the amount of rainfall. Catastrophe theory can model how changes in these dimensions control changes in the way the water behaves. The models provide both a control surface for the changing dimensions and a behavioral surface for the discontinuous action of the water itself. For example, if the width of the streambed begins to narrow very gradually, suddenly a *fold* will appear in the water's shape. If both the rate of flow and the depth of the stream increases, the water may jump into the air as if jumping over a *cusp*. If a twig catches the water as it comes down, you may get a droplet forming at the end of the twig before it falls to the next surface. In catastrophe theory such periodic droplet formation in-between surfaces would map on the *butterfly* model. The butterfly is a like a cusp except it has another surface halfway between the upper and lower surfaces, a pocket, on which the droplet could form. The swallowtail and the three umbilical models function in a similar manner. Whatever way the four controlling dimensions change, there are only seven possible surfaces on which the corresponding changes in the behavior of the water can be mapped, only seven basic "figures of regulation" for the water's behavior. I should note in passing another way of modeling waterflow, which has developed recently called chaos theory (Gleick: 1987). Chaos theory is particularly useful in approaching turbulence, a domain in which catastrophe theory has not yet been very helpful. To my knowledge, the formal interrelationship of these two modeling systems has yet to be worked out, but in principle both could be integrated into the Earthscore Notational System.

In nature, the combinations of the basic seven catastrophes are multiple and not readily apparent. Yet the underlying structural stability of discontinuous phenomena in nature can be understood by careful observation. Each "event pattern" can be understood in terms of its 'chreod'. Chreod is a term taken from the Greek that means "necessary path": "chre"

meaning "necessary," and "ode" meaning "path." If any natural process is disturbed, it will return to the pathway necessary for its structural stability, like a flooded river returns to its riverbed. These necessary pathways of nature, or chreods, can be rigorously modeled using the seven elementary catastrophes and variations on these seven (Casti 1988: 149ff.).

In my own work as a video artist, I have repeatedly returned to moving water as the richest single source for developing a vocabulary of "chreods" in nature. Water takes so many different shapes such as billows, droplets, backcurls, waves, fantails, and cascades. Each of these shapes exhibits a different pathway in which water can flow, a different chreod. In 1975, I spent the year recording over thirty—five chreods on videotape at the waterfall in High Falls, New York.

In 1983, I did a study of the Great Falls in Paterson, which I edited into a tape with five sets of seven different kinds of chreods. In 1984, I did a study of the coast of Cape Ann above Boston. In 1986, I crossed the Atlantic Ocean on a sixty-foot North Sea Trawler and videotaped over thirty hours of ocean waters. Currently, I am working on a video interpretation of nine different water ecologies in the Shawangunk Mountains at the edge of the Hudson Valley.

Building up a vocabulary of chreods can give us an articulate set of notes with which to score natural phenomena. Horseshoe crabs laying their eggs in Jamaica Bay is a natural process regulated by a chreod. The crabs only lay their eggs in the wet sand during the ebb tides created by the full moon in June. This assures maximum protection for the eggs from predator birds and land animals. The birthing activity takes place within a necessary figure of regulation. If you destroy that figure of regulation, that chreod— by stripping the beach of sand, for example— you have destroyed the natural process of birthing in that site.

To sum up this section on the firstness of thirdness, I am saying that the difficulty of discovering clear "notes" in the buzzing, blooming confusion of nature can be resolved with systematic observation of an ecology by video teams trained in Threeing and schooled to identify the chreods of an ecosys-

tem. The systematic observation of "everything" would insure that we did not miss anything significant. By identifying the chreods we can rigorously model the underlying structural stability of the various events in the ecosystem. We can then find out, through more observation and study, how these various chreods relate to each other. The syntax of interrelationships between these chreods would, in effect, constitute the "score" for the ensemble of recurring events that constitute that particular ecosystem. We would be eliciting the score from the ecosystem itself by careful observation. Once we know the score we can observe and monitor how the ecosystem actually performs or fails to perform in compliance with that score. Failure to comply would mean that we need to reinterpret our score and/or to correct any behavior of ours that is making the ecosystem incapable of performing according to its natural score.

A Semiotic System for Interpreting the Firstness of Thirdness

The advantage of identifying the observation-based score of an ecosystem as the firstness of its thirdness is that we can then connect that score to Peirce's entire semiotic system. Semiotics approaches knowledge as a process of generating signs. Peirce's semiotics encompasses both perceptual and linguistic signs. Any kind of local knowledge, any art form and any scientific discipline can be incorporated into Peirce's semiotic system. The system is too complex to present here. In brief, it can be pointed out that for Peirce, semiotics, or the understanding of signs, is consistent with his categories. A sign (firstness) represents an object (secondness) for an interpretant (thirdness). This threefold division exfoliates into a sixty-six-fold classification of signs that is inclusive of everything from a smudge of paint to a syllogism. With Peirce's approach, it is possible to systematize both interdisciplinary and multimedia representations of ecosystems. In the spring of 1989, I organized a pilot project in the Black Rock Forest above New York City with fourteen eighth grade students from The Dalton School. The task was to interpret changes in a stream from winter to spring. In six hours I taught the students how

to think in firstness, secondness, and thirdness. I then organized them into a video team, a word team, an image team and a number team. Each team had three members and observed the stream at four different sites. Only the video team used video. The others represented the stream in language, images and numbers. The interpretation of stream changes, which the students presented to teachers and fellow students, was very successful and prompted me to conceptualize a K-12 environmental curriculum based on the Earthscore System (pp. 302ff.).

The most ambitious strategy I have for implementing the Earthscore Notational System is a global network of regional television stations, each responsible for monitoring local ecologies. My design for these television stations is based on a cybernetic adaptation of Peirce's entire phenomenological and semiotic system (pp. 217ff.). I have presented my "Ecochannel Design" at the Museum of Modern Art, the First International EcoCity Conference, and the World Congress of Local Governments for a Sustainable Future at the United Nations. As part of an environmental coalition of over 250 groups in New York City, I have proposed how such a channel could be implemented in an urban setting (pp. 290ff.). In effect, the television ecochannel design is an extension of the Earthscore Notational System. Humans and ecosystem are considered part of one interrelated circuit. The programming offered by the station is organized according to this circuit. Briefly, the circuit can be articulated as follows: differences in the ecosystem make differences in how the ecosystem is represented on television, which make differences in the actual interpretations of the ecosystem by specific people, which make differences in how the community as a whole interprets the ecosystem. This interpretation, in turn, makes differences in how the community behaves toward the ecosystem. By following this circuit, a community can identify and eliminate errors in its relationship to the ecologies that support its life. By linking regional television systems operating according to this circuit, humans could establish a global television network grounded in the perception of ecosystems. The easiest way to build such a global television network would be to integrate Earthscore

Notation into the Earth Observation System currently being developed as part of NASA's Mission to Planet Earth (Ryan: 1991c).

Conclusion

Linguist Derek Bickerton reasons that despite the vast powers that language has conferred on our species, some of the consequences of modeling reality with language threaten the continuation of our life on earth. Language can create dysfunctional representations of reality, representations that result in antibiological conduct such as a heretic who refuses to recant and is burned to death. In a sense, humans have become an heretical species. Orthodoxy upon this earth holds that any species which destroys its environment destroys itself. Humans are destroying their environment, hence destroying themselves. Humans are a heretical species. Bickerton ascribes this antibiological behavior to our capacity to misrepresent reality with language. He states, rather abruptly, "Perhaps language is, after all, terminally dysfunctional" (Bickerton 1990: 253).

Without necessarily agreeing with Bickerton's worst case scenario, I do doubt that our species will ever talk itself out of the trouble we're in. On the other hand, building a system of transmitting information grounded in the perception of environmental realities would help correct some of the dysfunctionality of our language-driven species. Hopefully, by referencing a common perception, created according to the Earthscore Notational System, we could negotiate an operating consensus about living life on earth in realistic ways that are not destructive.

Appendix I

Notes on Art, Survival and the Earthscore Notational System

Any species that destroys its environment destroys itself. The human species is now in danger of destroying its environment. We have mistakenly identified the unit of survival as the individual, a particular group of individuals or even the species itself. But as Gregory Bateson points out, the real unit of survival is the human-species-plus-its-environment (Bateson 1972: 454−471). Today the question of survival must be asked at a species-plus-environment level. What role can art play in this context?

Much of the practice of art can be understood as exercises in survival behavior removed from life-or-death survival conditions. Early cave paintings sharpened the intelligence of hunters. Egyptian tomb painting was meant to keep the soul of the departed alive. Drama thrives on combat and courtship patterns. Art can exercise survival behavior for groups as well as individuals. Temples, churches, and cathedrals can all be taken as fortresses, rarely ever used as such. *Art is created as if life depended on it.* The artistic enactment of survival behavior does enhance our capacity for survival, just as exercise enhances our ability to fight. Investing in poor art is a poor exercise of our survival capacity; it can lessen our actual chances for survival.

The link between survival and art can be made explicit by examining the circuitry for making choices used in creating art. In principle, the circuitry for making art has always been embedded in human beings. Evolutionary processes formulated the basic circuit in the reticular core of the mammalian nervous system. Humans are mammals.

The reticular core is that part of the nervous system which regulates the relationship between diverse ends necessary for mammalian survival—ends such as fleeing, fighting, and sleeping. Each of these ends requires the commitment of the entire organism. The organism cannot commit itself to any two such ends at once. You cannot both fight and flee at the same time. Hence there evolved a method of evaluation in which attraction to incompatible ends could be resolved. Choices could be made.

Using this method, an organism can choose fight instead of flight, sleep instead of sex. The method of evaluation is a circularity of preference best exemplified in male rats (a species of mammal) under experimental conditions. Deprived of food and sex for a specified period, a hundred male rats will all prefer food to sex, sex to avoidance of shock, and avoidance of shock to food (A to B, B to C, but *C to A*).

This heterarchic method of evaluating diverse ends contrasts sharply with that of a hierarchy where diverse ends are ordered by the establishment of a *summum bonum*, i.e., one end preferred to all others. Once this highest end is established, a ranking of preference occurs. Each rank has the right to inhibit all inferiors, and there is no circularity of preference. If A is preferred to B, and B is preferred to C, then A must be preferred to C (A to B, B to C, and *A to C*) (McCulloch 1965: 196).

The reticulated mammal appreciates survival activities not as means to other ends, but as ends in themselves. Survival activities are often characterized by humans as sacred, precisely because they are not linked to purposes that can be easily corrupted. A "holy war" can be an end in itself. The Biblical Exodus out of Eygpt was the beginning of a sacred journey, a sacred "flight."

The cybernetician, Warren McCulloch, first articulated circularity of preference. After presenting a topological model that used only six neurons to embody a heterarchy of values, he wrote:

> Circularities in preference, instead of indicating inconsistencies, actually demonstrate consistencies of a higher order than have been

dreamed of in our philosophy. An organism possessed of this nervous system—six neurons—is sufficiently endowed to be unpredictable for any theory founded on a scale of values. It has a heterarchy of values and is thus too rich to submit to a *summum bonum* (McCulloch [1943] 1965: 44).

While philosophers, with the notable exception of Charles Peirce, usually don't speculate about this "higher order," artists practice its consistencies. A Cezanne, faced with what he fondly called *"those little blues, those little browns,* and *those little whites"* (Lacan 1978: 110) allows himself to choose white instead of blue even though he has chosen blue over brown and brown over white. *Circularity of preference, freed of any immediate life-or-death situation, is the basic circuitry for making art.* The process of art-making proceeds from a circularity of preference. It is not controlled by a fixed hierarchy of values.

In discussing painting, artist Robert Irwin talks explicitly about the modernist struggle against a hierarchic value structure.

We're talking about a mental construct to which the whole civilization has deeply committed itself. And what it says, simply, is that as I walk through the world, I bring into focus certain things which are meaningful, and others are by degree less in focus, dependent upon their meaningfulness in terms of what I'm doing, to the point where there are certain things that are totally out of focus and invisible. We organize our minds in terms of this hierarchic value structure, based on certain ideas about meaning and purpose and function. And perhaps more than anything else, modernist art as a movement has arisen as a critique of that hierarchical structure. When art begins the process of taking all the pictorial out of the pictorial, taking all the symbolic meaning out of the mark, and the line, what it's really doing, essentially, is flattening the value structure (Weschler 1982: 108–109).

Irwin's experience as a painter led him to talk of "flattening that value structure." My experience with video art led me to create the Earthscore Notational System, which, as the reader has seen, is based on a heterarchic circuit. Before commenting on the the circuit itself and the other components of the Earthscore Notational System, I want to offer a brief discussion of notational art in relation to video. Video art is a new form. Many video artists have chosen to work with video in the manner of painting and sculpture. One artist, Frank Gillette,

has generated a private, subjective notation to produce video in the tradition of painting (Gillette: 1978). There have been major showings of this kind of work, such as *American Landscape Video* (Judson: 1988). This work is what the philosopher, Nelson Goodman, would call autographic (Goodman 1968: 113). Autographic art is produced by a single artist and the "signature" and style of that artist is a critical factor in determining the authenticity of the work. The painting *Guernica* had to be made by the hand of Picasso. A fake Picasso is a painting that the hand of Picasso never touched. It would be a forgery — an object that falsely claims to have the history of production proper to an original.

In contrast to these autographic arts, Goodman distinguishes "allographic" arts. Music, and to a lesser degree, dance and architecture, are allographic. Allographic arts involve a two step process. The first step is the conception, articulated in a notational system. The second step is the performance, based on what has been notated. This can be carried out by someone other than the conceiving artist. As Goodman says:

> When there is a theoretically decisive test for determining that an object has all the constitutive properties of the work in question without determining how or by whom the object was produced, there is no requisite history of production and hence no forgery of any given work. Such a test is provided by a suitable notational system with an articulate set of characters and of relative positions for them (Goodman 1968: 122).

A good example of the sort of notational system Goodman is talking about is found in classical music. The "articulate set of characters" would be the unambiguous set of distinct notes and the "relative positions for them" would be provided by the staff and bars. Any performance of any particular score written in this notational system can be judged to be authentic or not by testing out whether the performance complies with the particular score. Such a test presumes a suitable notational system.

The Earthscore Notational System is not as fully allographic as classical music. That is to say, because of the way Peirce's categories relate to one another, the difficulties of the

"firstness of thirdness" and the inherent ambiguities of the semiotic component, I think this notation system falls somewhere between architecture and music. While this system may not be purely allographic, I do believe the Earthscore Notational System can generalize the sort of achievements made by individual autographic modern painters into an allographic art practice. Such a practice could be carried on for generations upon generations and produce an ongoing shared perception of environmental realities that enhances our capacity for survival.

Mindful of the 1990 warning of the Worldwatch Institute that we have forty years in which to reverse the degradation of our natural environment or we will pass a threshold after which environmental restoration is simply impossible (Brown: 1990), I want to point out where I think this notational system is strong and where I think it is weak. The seriousness of the situation I am trying to address, and the scale of the project I am proposing, demands that nothing be glossed over.

Let me also say explicitly that I would also welcome critical comments from readers. A real boon to this project would be for someone who has a command of Goodman's work to play the role of the building inspector and evaluate this notational system according to the five criteria laid out in *The Languages of Art* (Goodman: 1968). Because of the technical complexity of Goodman's criteria, I have not addressed them explicitly in this writing. However, such an evaluation is certainly in order. Let me now offer some reflections on the specifics of the Earthscore Notational System. Where appropriate, I will amplify on the description of these components, which I presented earlier.

Firstness, Secondness and Thirdness

I think the value of Peirce's categories and his semiotic system is confirmed by the current burgeoning of Peirce scholarship. In September of 1989, 150 years after Peirce's birth, over 250 scholars gathered at Harvard for a seven days in-depth conference on Peirce. During that conference I showed the *Nature in*

New York City videotape. None of the twenty plus viewers objected to how I was using Peirce's categories.

One unusual feature of Peirce's categories that must be understood is how they relate to each other. Peirce explained the interrelationships between the three categories in terms of the mind's ability to prescind. Prescind comes from the Latin "prae" and "scindere", meaning literally, "before" and "to cut". Not to be confused with "precision," this word was used in medieval philosophy to describe a way of thinking "before the cut." Prescinding is the ability to pay attention in one category without severance from the other categories.

I may think about the warmth of the mug of tea on my desk without thinking about the actual mug: I prescind firstness from secondness. When I move my hand into the place where the mug actually is, I do meet with the resistance of its secondness, its actuality. That actuality includes the warmth of the tea. Secondness includes firstness. I can mindlessly knock the mug over, secondness prescinded from thirdness. I can also predict on the basis of my knowledge of the laws of physics and gravity that if I strike the mug with sufficient force at the right angle, the mug will overturn and the warm tea spill out. My prediction can preclude my spilling the warm tea. Thirdness mediates secondness and firstness (Peirce: 1931 – 1935).

As described in the essay on The Earthscore Notational System, the videotape, *Nature in New York City*, was made using Peirce's categories of firstness, secondness and thirdness. Because these categories are not disjoint or severed from each other, but rather prescinded from each other, *Nature in New York City* is not allographic. I can scan the texture of a tree's bark for firstness, frame where the tree is rooted for secondness, and take in the crown of the tree for thirdness. However, each of these three video images refers to the same distinct thing in the real world, that is to say, they are images of the same tree. That same tree is not disjunct from itself. Hence the *Nature in New York City* video, as is, fails to be fully allographic in Goodman's sense. The compliance between the notation and nature is ambiguous. This is the problem of eliciting "notes" from the perceived natural world, which I

mentioned above. A two part strategy for reducing this ambiguity is used in the Earthscore Notation.

The first part of the strategy is to deploy two teams of videographers onto the natural site. Each team would consist of three members who have established a practice of Threeing. It would be assumed that such teams could maintain a consensus of perception about what aspects of nature corresponded to firstness, secondness, and thirdness. If the consensus among the three broke down, they could resolve the disagreement by borrowing a member of the other team to act as a fourth party.

As mentioned, I have worked out a formal procedure for making consensus decisions in a triad-plus-one that does not pit two against one. To recap briefly, the procedure works this way. If the consensus among the three breaks down, for example, one member of the team, working from the position of firstness, interprets a natural phenomena as an instance of firstness which the other two see as thirdness, then the following procedure goes into effect. A predetermined fourth party from the other triad is asked to resolve the disagreement. If the fourth party agrees with the two dissenters, then the three can overide the one. If the fourth party does not agree with the dissenters, then the original decision stands. Such consensual decision making would reduce the ambiguity in compliance between covering score and the recording of natural phenomena, using the categories of firstness, secondness, and thirdness.

The second part of the strategy is to identify an articulate set of notes in nature which can be integrated into Peirce's theory of everything. For teams of videographers interpreting specific ecologies, such an articulate set of notes would correspond to what Peirce called the "firstness of thirdness." The problem of an articulate set of notes was discussed in the Earthscore Notational System essay and will be discussed below.

The Relational Circuit

The relational circuit has been carefully explicated in the essay titled 'A Sign of itself.' It is worthwhile to note here that

Peirce came closest to a triadic logic with a theorem he developed studying the work of the astronomer and topologist, Johann Listing. Peirce understood topology as pure mathematics, potentially able to provide a formal understanding of pure continua through an understanding of position and relations of inclusion. Yet the Peirce-Listing theorem, the only theorem of topology Peirce had to work with, could not establish a continuous method of reasoning. Metaphysically, it suggested an expanding universe of continua containing other continua, not unlike the relational circuit, but logically it had little power. He was unable to achieve a formal logic that utilized the continuum. My claim that the relational circuit fulfills the logic Peirce was after has yet to work its way through the community of Peirce scholars. Were Peirce scholars to fault my claim, my fall-back position is that the relational circuit is still capable of ordering the cybernetic adaptation of Peirce's system that I use in the Earthscore Notation.

Threeing

Although further experimentation would be appropriate, my experience with Threeing over the last fourteen years has convinced me that it is up to the use I am proposing. The section on Threeing (pp. 104ff.) provides instructions so that readers can experiment with Threeing on their own. These instructions, taken in and of themselves apart from the Earthscore Notation, are fully allographic.

Threeing uses the relational circuit as the core of its self-contained notational system. By following the instructions based on the unambiguous positions in the circuit, performers can neutralize the effect of choice on their relationships and transform combat, courtship, and territory instincts into an art of behavior. In Threeing, the articulate set of notes called for by Goodman corresponds to the triangle, pentagon, and circle, which unambiguously indicate the three distinct performers. By analogy, the relational circuit constitutes the musical staff and bars while the triangle, pentagon and circle are the musical notes. As an allographic art, Threeing can be taught and transferred over generations. As indicated, videographers

can further transform this art of behavior into a mosaic of shared perception using the categories of firstness, secondness, and thirdness.

For readers interested in the psychology of Threeing, I have added another appendix that discusses Threeing in relation to the idea of aura and the writings of psychoanalyst Jacques Lacan (Appendix II).

The Firstness of Thirdness

Thom's chreods have yet to prove their worth in interpreting nature's patterns. As explained above, the necessary pathways of nature modeled by his chreods are based on a set of seven fundamental mathematical figures. The combinations of these basic seven are multiple and not always readily apparent. As of this writing, Thom's claim to have developed a general theory of models has not met with universal acceptance (Ekeland: 1988). My presentation of Thom is based on an intuitive appreciation of his work that developed over twenty years of videomaking. I am an artist, not a mathematician. Most of my education in mathematics has been autodidactic. It may be that Thom's models are somehow media specific, that is, appropriate for video perception, but not as generic as Thom claims. If this is the case, then Thom's models might not work in another medium such as holography. I simply am not sure. A sustained test on a specific ecosystem would be in order.

Should Thom's models not measure up to the needs of the system I am presenting, then I would say that mathematical models for nature, of the sort Thom attempted, must be developed. What is critical for the notational system I am proposing is a coherent geometry of nature based on observables, an articulate set of notes that can codify the firstness of thirdness. Chaos theory is presently approaching a geometry of nature in a way other than Thom (Gleick: 1987). As yet, I have not been able to study it in much depth. I suspect it may be a computer-specific way of thinking. I question whether its mode of calculation can successfully model the underlying structural stability of ecosystems.

Semiotics

The use of Peirce's semiotic system brings both weakness and strength to the Earthscore Notation. On the one hand, the process of semiotic interpretation is rich with ambiguities that could reduce the value of any set of unambiguously notated articulate characters, i.e., any systemic appreciation of the firstness of thirdness. On the other hand, Peirce's semiotics is potentially inclusive of all knowledge. What this means is that any human mode of knowing, such as our legal intelligence, could be integrated into an effort to interpret the ecosystems that support our lives. While semiotics allows ambiguity into the system, it is also capable of ordering that ambiguity into a rich redundancy of understanding about our proper relationship to the natural world.

Having stated my caveats, let me end by reiterating that even though the Earthscore Notational System may not be purely allographic, I do believe it is robust enough to enable us to develop a successful operating consensus about how not to destroy the natural world on which our life depends. In poetic terms, I am saying that it is possible to shape television so that it will constantly be singing nature's score in a way that our species can enjoy for a long time to come.

Appendix II

Aura and Threeing

In his 1935 essay "The Work of Art in the Age of Mechanical Reproduction," Walter Benjamin defines aura as a "unique phenomenon of distance, however close it may be." The essentially distant object is one that is somehow unapproachable. Benjamin argues that unapproachability is what gives an image its cult value. Mass society is intent on bringing things closer, appropriating the unapproachable, demystifying the realm of the sacred images and exploiting whatever intimacy is coded there. The art image provides intimacy with Otherness and, mechanical reproduction is a technique for emancipating art from its cult context, freeing art from tradition for political use by the masses and the intelligentsia in their struggle with fascism.

By 1939, Benjamin himself had retreated from his sanguine appraisal of technique and its consequent liquidation of tradition, which he expressed in the essay on mechanical reproduction. He came to see clearly that applying advanced technology to the sphere of art does not in and of itself guarantee the emancipation of art. Moreover, the sacrifice of traditional auratic art for political purposes could undercut the potential of art to encourage human aspiration and restore a healthy reciprocity between man and nature. Writing about the correspondences of Baudelaire, Benjamin redefined the concept of aura.

> Experience of the aura...rests on the transposition of a response common to human relationships to the relationship between the inanimate or natural object and man. The person we look at, or who feels he is being looked at, looks at us in turn. To perceive the aura of an object means to invest it with the ability to look at us in return (Benjamin 1979: 188–189).

In this context he quotes Valery.

> To say, 'Here I see such and such an object' does not establish an equation between me and the object...In dreams, however, there is an equation. The things I see, see me just as much as I see them (Benjamin 1979: 189).

The psychoanalyst, Jacques Lacan, tells an interesting story about being seen by an object. As a young man, aspiring to be an intellectual and seeking experience, Lacan spent some time on a fishing boat off Brittany with an man named Petit Jean. Their catch of fish was sold to the canning industry. On one occasion, Petit Jean pointed out a small sardine can floating on the waves, glittering in the sun. Laughingly, he said to Lacan, "You see that can? Do you see it? Well it doesn't see you" (Lacan 1978: 95).

For a hard working Breton, struggling with the sea for his existence, who like many of his people would die young of tuberculosis, the remark was much more amusing than it was for Lacan. As Lacan says, what the remark indicated was that in fact, Lacan, the young intellectual, was out of place in the boat. His life was not controlled by the canning industry the way Petit John's life was. He did not really belong in the picture "seen" by the glittering can (Lacan 1978: 96).

Lacan tells this story in the context of articulating a basic split between the eye and the gaze. He quotes Jesus in the Gospel saying, "They have eyes that they might not see." "Not see what?" asks Lacan and answers that they do not see that things are looking at them. To explain "being gazed at" Lacan goes to the phenomenon of mimicry. In opposition to a traditional view of seeing mimicry in evolution as behavior directly bound up with survival, Lacan sees mimicry as a process of becoming inscribed in a picture. "To imitate is no doubt to reproduce an image. But, at bottom, it is for the subject to be inserted in a function whose exercise grasps it" (Lacan 1978: 100). Inserting oneself in a function is a matter of staining oneself for a gaze, becoming that which is given to be seen. Lacan, the young intellectual in the boat, failed to camouflage himself as a fisherman. He failed to stain himself successfully so as to fit into the picture. Mechanical reproduction can be

mere imitation without insertion into any picture. As Lacan says, without the staining of oneself to fit into a picture "seeing oneself seeing oneself" is a narcissistic avoidance of the function of the gaze. The function of the gaze is to see how someone can operate within a picture.

Lacan finds in mimicry an evolutionary analogue for painting (Lacan 1978: 101). Through his or her painting, a painter captures the gaze and eye of the viewer. Zeuxis painted grapes so realistically that the birds tried to eat them. His friend, Parrhasius, painted a veil on the wall so success-fully that Zeuxis asked him to take down the veil and show him what he had painted behind it. Such tricking of the eye that does not see dramatizes the fact that the painter invests his or her painting with aura. The aura of *tromp d'oeil* embod-ies the gaze of a painter, that is, the painter has successfully detached him or herself from the normal reciprocity of gaze between humans and, as it were, left their gaze in the painting itself. This tricks the eye of the viewer who acts as if he is not being seen and tries to insert himself as a grape eater or as a human curious about what is behind a veil into the picture, which was created by the now absent gaze of the painter. The gaze of the painter triumphs over the eye of the viewer. When the triumph is not merely a trick as in the cliches of *trompe d'oeil*, the painter in fact provides the viewer with an intimate experience of Otherness. The painter invests his gaze in the aura of the art object and invites the viewer to lay down his or her gaze, as one would lay down weapons, and feast their eyes without reproach. How many viewers, caught in the gaze of the Mona Lisa at the Louvre, have feasted their eyes until they were content?

Lacan sees the social function of this feasting of the eye as a sublimation of envy (Lacan 1978: 116). He finds the most exemplary instance of envy (*invidia*, from *videre*, to see) in Augustine. Augustine reports that his entire fate was summed up in the child seeing his younger brother enjoying a look of love while feeding at his mother's breast. The bitter sight has the effect of poison on the older brother and a desire to tear the younger brother to pieces. The breast that the older brother is separated from, which in fact he no longer needs, is

the source of a complete and closed off satisfaction for the younger brother. For the psychoanalyst Lacan, the civilizing function of painting is to tame the desperate gaze of envy.

Lacan's exposition of the relationship between the painter, his painting and the viewer owes its brilliance partly to a parallel with the psychoanalyst, the session and the patient. Both the psychoanalytic session and the painting preclude reciprocity between two parties. The painter invests the painting with an aura of its own but the gaze of the painter and the viewer never met. Similarly, the psychoanalyst and the patient do not work face to face. Reciprocity between them as gazers is precluded by the couch/chair asymmetry and various methods of intervention and directives used by the analyst. Reciprocity of gaze is considered a source of illusion for the patient. It is the gaze of the psychoanalyst that controls the relationship.

Another variation on this non-reciprocal pattern is the master/disciple relationship, common in Asia and on the increase in the West. In short, the guru is one who has been enlightened, he has eyes and sees. He is a holy man, to him there is no split between the eye and the gaze, no split between what he is and what he appears to be. This is apparent in his aura, his numinous presence, which communicates that he does see the whole picture and can see where those who approach him fit in. A potential disciple senses this and, wanting to heal the split within and find a place in the world, disarms — as it were, lays down his or her own critical ability to question the gaze — and inscribes herself or himself into the gaze of the guru. If the guru is a good teacher and the disciple follows the precepts faithfully, the disciple can heal the split within and achieve enlightenment. The guru will use knowledge to help the disciple heal and then restore the student's critical gaze to him or her, just as a good painter, after the feast of the eye, will restore the gaze of the viewer. If, however, the guru is not what he or she appears to be, but has some hidden agenda or fatal flaw, the disarmed disciple can be manipulated in horrendous ways. Some of the followers of Jim Jones paid with their lives. Insofar as it can be said that Hitler's fascism aestheticized politics, his followers

laid down their critical faculties and inserted themselves into the aesthetics of his gaze.

In the practice of Threeing, it is possible for parties to maintain a reciprocity of gaze. Three people can relate aura to aura to aura without the mediation of a painter, a guru, or video equipment. Threeing seeks to establish a reciprocal experience of aura among three people in a crisis proof form. As Benjamin says this can only be done in the realm of ritual. Ritualized, this practice would allow an ongoing fullness of relationships, aura to aura to aura. However, it must be noted that the pathology of seeing oneself seeing oneself can be extended to seeing each other seeing each other. Triadic narcissism is a possibility. In the terms offered by Lacan, such narcissism would be an avoidance of the function of the gaze, which is to insert people into some larger picture. It seems obvious to me that the larger picture is the ecological crisis our species is experiencing.

Appendix III

Videotapes, Artworks, and Texts of Paul Ryan, 1968 – 1992

Mr. Ryan is currently organizing a selection of videotapes to accompany *Video Mind, Earth Mind.* Inquire:

Electronic Arts Intermix
536 Broadway
New York, NY 10012
212-966-4605

Video Data Bank
37 South Wabash Ave.
Chicago, Il 60603
312-899-5100

* Indicates the text is included in *Video Mind, Earth Mind*

Early Video 1968 – 1971: Videotapes and Art Work

Series of b&w videotapes produced "under erasure" in 1968 and 1969, i.e., immediately erased or given to the person or persons videotaped, including, for example:
>1968a Geoff Hendricks Art Work, NYC.
>1968b Milan Knizak's Art Work, Rutgers, N.J.

1969a *The Children's Center.* Tenafly, N.J., b&w documentary 20:00 min.
1969b *Everyman's Möbius Strip.* New York City: Howard Wise Gallery, installation.
1970a *Yes and No.* Waltham, Mass.: Rose Art Museum, installation.
1969-71 Co-produced a series of black and white videotapes with Raindance Foundation, shown at the Raindance Loft and elsewhere, including:

>*Media Primer,* 30:00 min.
>*Tender is the Tape,* 30:00 min.
>*Tender is the Tape II,* 60:00 min.
>*The Rays,* 20:00 min.

> *Supermarket*
> *Alternate Media Conference at Goddard*
> *Earth Day in New York City, Uptight about Bushes*
> *Interview with Buckminster Fuller*
> *Year of the Mushroom*
> *Warren Brodey—Interviews and Verité Video of Ecological Design Commune in New Hampshire*

These and other tapes available from the Raindance Archives, 51 Fifth Avenue, NYC, 10003. Some available from Electronic Arts Intermix. (see above).

1971 *Video Wake for My Father.* B&w videotape, 12 hours. Shown privately by invitation only. Personal archive.

Early Video 1968–1974: Texts

1968a* "Videotape: Infolding Information." Published as "Videotape: Thinking about a Medium." *Media and Methods,* December.

1969a "Video and Special Education." *AV Instruction.*

1969b* "Cable Television: The Raw and the Overcooked." *Media and Methods,* October.

1970a "Three Pieces: Some Explication: 1) Ego Me Absolvo, 2) Guns, Knives or Videotape, 3) College is a High Chair." *Radical Software,* Vol. 1, # 1.

1970b* "Self-Processing." *Radical Software,* Vol. 1, # 2.

1971a* "Guerrilla Strategy and Cybernetic Theory." *Radical Software,* Vol. 1, # 3.

1971b* "Attempting a Calculus of Intention." *Radical Software,* Vol. 1, # 3.

1971c "Toward an Information Economy." *Radical Software,* Vol. 1, # 3.

Earthscore 1972–1976: Videotapes and Art Work

1972-76a *Earthscore Sketch.* 18 hours, b&w videotape, 36 continuous handheld half hours. Premiered the Kitchen Performance Space, 1976. Private archives.

1972-76b *The Triadic Tapes.* 12 hours, b&w videotape, edited from 45 hours. Premiered the Kitchen Performance Space, 1976. Private archives.

1973a *MMM, FFF, MMF, MFF.* Woodstock Video Festival, Installation.

1973b *Null and Void.* Comedy Team, b&w videotape documentation.

1974a *Color TV.* Color videotape, 5:00 min. Private archives.

1974b *Poetry Reading.* B&w video documentation, New Paltz, New York.

1974c *The Horowitz Quartet.* Four channel work with Michael Horowitz. Each b&w tape is 30 min. Premiered The Dancing Theatre, New Paltz, New York. Private archives.

1975a *Water Chreods.* 1 hour b&w video catalog of water flow patterns from 13 hours produced as a year long study of High Falls, New York. Private archives.

1975b *Tapping on Water.* With Brenda Bufalino, b&w videotape, 5:00 min. Premiered The Dancing Theatre, New Paltz, New York. Private archives.

1975c Experimental Holograms, produced regularly over the course of the year as founding member of the Pearl Street Holography Club, New York City and St. Remy, New York.

1975d *Lazer on Ice.* 5:00 min. Private archives.

1975e *Four More Years.* With TVTV, Washington, D.C. Premiere WNET.

1976a *Video Variations on Holy Week.* One Man Show, The Kitchen Performance Space.

1976b *Video Wake for My Father.* 3 hour Performance Version, Part of *Video Variations on Holy Week.* 3 hour performance videotape, distributed by Electronic Arts Intermix, 536 Broadway, NYC 10012.

1976c *Threeing.* Live Ritual, 6 hour Performance of the Relational Practice, performed as part of *Video Variations on Holy Week.*

Earthscore 1972–1976: Texts

1972 "From Crucifixion to Cybernetic Acupuncture," *Radical Software*, Vol. 1, #5.

1973 *Birth and Death and Cybernation*. New York: Gordon and Breach.

1973 *Earthscore By-Laws*. Private archives.

1974a *Cybernetics of the Sacred*. New York: Doubleday. Revised version of *Birth and Death and Cybernation*.

1974b* "Earthscore as Intentional Community" in *Cybernetics of the Sacred*. New York: Doubleday.

1975 Interview with Merrily Pascal for "Ideas," Canadian Broadcasting Corporation.

1976a* "Video As Evolutionary Tool," lecture, previously unpublished.

1976b* "Threeing," Instructions for the Relational Practice. Refined for publication in this volume.

1976c* "Earthscore as Public Work," proposal, previously unpublished.

Bioregions 1977–1980: Videotapes and Artwork

1977a "Coastal Restraints and Coastal Practices," text proposal for public works project using video along the California coastline similar to "Earthscore as Public Work." Private archives.

1977b *Bucky Fuller at Northside*. Calif., b&w video documentation, 15:00 min.

1978a *Triadic Behavior*. San Francisco: Art Event, Optic Nerve.

1978b *Dolphin Expedition*. Participant with Ant Farm, Baja California.

1978c "Manhattan Morning," text proposal for videotape. Private archives.

1978d "Video Homage to Monet," text proposal to the Museum of Modern Art for video installation. Private archives.

1979a* "Watershed Watch," Pompton, NJ, concept and text, *Talking Wood* I. No. 1.

1979b* "Watershed Watch," Paterson, NJ, concept and text, *Talking Wood* I. No. 2.

1980a* "Channel W, Your Wire to the Watershed", text proposal to local Cable Company for ecological channel.

1980b "Taping on The Great Falls," text proposal to the Great Falls Corporation for video art production with tap dancer, Brenda Bufalino. Private archives.

1980c* "Video Score for the Coast of Cape Ann," text proposal for video art production.

Earthscore Texts

1977 "Positional Intelligence/Planetary Culture." Lost text.

1977b "A Ritual of Triadic Relationships Determined by the Topology of a Non-Orientable Circuit." Private archives.

1979 – 1980a* Editorial Statements. *Talking Wood*. Selections included.

1979b "Restructuring Public Television." *Talking Wood,* Vol. I, # 3.

1980a* "Relationships." *Talking Wood,* Vol. I, # 4.

1980b* "Metalogue: Gregory Bateson, Paul Ryan." *All Area,* Vol. I, # 1.

Ecochannel 1980 – 1985: Videotapes and Art Works

1982 *A Triadic Practice*. Spring Valley, NY: Thorpe Gallery. Installation.

1983a "Monitoring the Manhattan Estuary." Text proposal for a videotape, private archives.

1983b *Where the Water Splits the Rock*. Color videotape, 5:00 min.

1984a "A Triad of Women," text proposal for a videotape, private archives.

1984b *A Ritual of Triadic Relationships*. B&w and color videotape, 30:00 min. Premiere: Primitivism Show, The Museum of Modern Art, New York.

1984c "Beethoven at the Delaware Water Gap." Text proposal for a videotape, private archives.

1985a *Coast of Cape Ann.* Color videotape, 18:00 min. Premiere: The Museum of the Moving Image, New York.

1985b *Ecochannel Design.* Color videotape, 33:00 min. Premiere: The Museum of Modern Art, New York.

Earthscore 1980–1985: Texts

1981a "Watershed Watch Manual." Text proposal to the Department of the Interior, private archives.

1981b* "From Teenage Monk to Video Bareback Rider." Willoughby Sharp Interview. *Video 81*, 2(1), 14-17.

1981c "Creating Consensus Electronically." Proposal for a computer program.

1981d* "Melusina." Proposal to the Alternate Media Center, New York University.

1982* "The Circuit." Proposal to the New York State Council on the Arts.

1982a "Sex Bias and Computer Literacy." Proposal for the Hudson School. Private archives.

1983* "Design for Ecological Consensus Along the Hudson." Proposal to the Hudson River Foundation.

1984 Review of *Steps to an Ecology of Mind* by Gregory Bateson. Private archives.

1985a "Is the Computer Revolution Real?" Unpublished talk presented at The New School for Social Research, 1985. Private archives.

1985b "The Work of Art in the Age of Electronic Circuitry." Unpublished paper. Private archives.

1984c "The Electronic Classroom." Proposal to Ramapo College. Private archives.

1985d "and...an open question...." *Continuing the Conversation,* Vol. 1, #2, p.5.

1985e* "Living Between Ice and Fire by the River that Runs Both Ways." Poem.

1985f* "Ecochannel Design." Originally presented at the Museum of Modern Art in New York City as part of a lecture demonstration. Design itself published in

1987, with theoretical appendix, as "Ecochannel Design." *IS Journal* 2 (2): 46-64. Reprinted in *Video Mind, Earth Mind* without theoretical appendix.

NEST 1986–91: Videotapes and Art Work

1986a *Tethys: TransAtlantic Voyage.* Color videotape, 70 hrs. (unedited) Video Archives, R. Schuler, Box 306, High Falls, NY, 12440.

1986b "TransAtlantic With Tethys: What the Camera Concealed." Proposal for a videotape to the New York State Council on the Arts. Private archives.

1986c* "Communications for the Riverside Park Community." Proposal for video project.

1987a *Nature Workshop.* Mohonk, New York. Video documentation and feedback.

1987b Video documentation of *Crux*, Art Work by Gary Hill. Hill archives.

1987c *Monastic Simulation.* Conceptual Art Work simulating the monastic experience for The Dalton School third grade students at The Cloisters of the Metropolitan Museum of Art.

1987d* "Video Rangers." Proposal for video project.

1987e "Three of You." Proposal for a triadic game. Private archives.

1988a *ICM Method.* Color videotape documentation, 8:00 min. The Dalton School, New York City.

1988a* "Symphony for the Jersey Shore." Proposal for a videotape to the Dodge Foundation.

1988b *From Site to Sound.* Collaborative radio series, WBAI, Paul Gorman et al.

1988c *Human Nature Dance Company.* Unedited documentation and feedback. Petrolia, California. Human Nature archives.

1988d *Black Rock Rangers.* Color videotape 6:00 min. Documentation of Black Rock Ranger project at The Dalton School. The Dalton School Archives.

1989a *Nature in New York City.* Color videotape, 27:00 min. EAI, 536 Broadway, NYC, 10012.

1989b *Is This Your Park?* Color videotape, 3:00 min. with Urban Conservation Corps members, UCC archives, The Parks Council, 457 Madison Avenue, NYC, NY 10022.

1989c* "NEST." Proposal for a municipal television channel in NYC

1989d* "The Tricultural Tournament." Proposal to the Rockefeller Foundation for intercultural television event. Private archives.

1989e "A Trilateral Liturgy." Proposal to the Cathedral of St. John the Divine for a Liturgical Event before Desert Storm War. Private archives.

1989e "A Triadic Narrative." Proposal for a videotape. Private archives.

1989f "Earthscore." Proposal of Global Television Network for the Third Millennium to *Leonardo*. Private archives.

1990a *Threeing: Rug Design* with Michael Kalil, work in progress, V'soske, New York.

1990b *Crossing Brooklyn Ferry*. Color videotape 17:25 min. Poem of Walt Whitman produced with Allen Ginsberg, Charles Potter, and the Sundown Poem workshop. Staten Island Community Television, Staten Island, NY, 10303.

1990c *Water Web*. Color videotape 16:00 min. with Judy Goldhaft. Planet Drum, Box 31251, S.F., Ca. 94131

1990d* *Mountain Waters*. Color videotape of Shawangunk Mountain water ecologies. Work in progress.

1990e* "Video Meditation on the Arthur Kill and The Kill Van Kull." Proposal for a videotape. Private archives.

1991h "NYC Ecology." Proposal for TV series. Private archives.

1991i "Earthscore Workshop." Proposal for teaching the Earthscore Method. Private archives.

1991j* "Forests Forever: The New York City Cycle." Proposal for a videotape. Private archives.

1991k *Young Eyes: Green Parks*. Color videotape, 30:00 min. With Urban Conservation Corps teenagers at Staten

Island Community Television, UCC archives, The Parks Council, 457 Madison Ave, NYC, NY 10022.

1991l *Exploring Black Rock Forest.* Color videotape, 14:00 min. Documentary for the New Laboratory for Teaching and Learning at The Dalton School. The Dalton School Archives.

NEST 1986–1991: Texts

1986a "Acid Rain." Sermon. Cathedral of St. John the Divine. Cathedral archives.

1986b* *Water Wisdom.* Cathedral of St. John the Divine. Report in Cathedral archives.

1986d "Triadics and Trance." Milton Erickson Society, NYC. Audio recording of presentation with Betty Kronsky and performers from The Renegade Theatre. Private archives.

1986e "Charles in the Box." Article about Charles Olson and Expert Computer Systems. *Poetry Project Newsletter*, Jan. p 7.

1986f Reply to Reader's Response about Charles Olson. *Poetry Project Newsletter*, Feb.

1986g "Computers In Turkey." *Cumhuriyet*, (Turkish Daily, date unspecified).

1988a* "A Genealogy of Video." *Leonardo*, Vol. 21, No. 1, pp. 39–44.

1988* "Jesus Crucified, The Living Earth and Television." A Gaia Green Paper written for The Gaia Institute, Cathedral of St. John the Divine, New York. Previously unpublished.

1988 "Bateson, Peirce and Heidegger." *Continuing the Conversation*, Spring, No. 12, pp. 14–15.

1988–89a "The Ecology Movement Becomes a Learning Alliance." *Raise the Stakes,* Winter/Spring No. 14.

1989b "Al Robbins Was A Warrior Artist." *Millennium,* Winter/Spring 1989–90 No. 22.

1989c "Forging Feedback for the Smiths." *Continuing the Conversation*, Spring No. 16.

1989d Proposal for Reforming Peer Review Panels, submitted to NYSCA. Private archives.

1989e* "The Earthscore Curriculum." Proposal developed at the New Lab for Teaching and Learning at The Dalton School. Private archives.

1989f Book Review of *Coming to Our Senses* by Morris Berman. *Continuing the Conversation*, Summer No. 17.

1989g* "Video, Computers and Memory." *Ways of Knowing. The Reality Club #3*, Ed. John Brockman, New York: Prentice Hall.

1989h* "American Video Art and the Future of European Television." Paper presented at a symposium on The Politics, Sociology and Aesthetics of Audio Visual Media, chaired by Dr. Rolf Kloepfer at the XXI Romanistentag, in Aachen, Germany, 1989. Publication in German forthcoming.

1990a "Greening of Television." *Newsday* , Nov 8, 1990.

1990b "Environmental Consensus." Proposal to NYNEX. Private archives.

1991a "New York City Needs an Environmental Television Channel." *Raise the Stakes*, #17: Winter.

1991b* "'A Sign of itself.'" *On Semiotic Modeling*. Edited by Myrdene Anderson, Floyd Merrill, Mouton de Gruyter, New York: 509–524.

1991c* "The Earthscore Notational System for Orchestrating Perceptual Consensus about the Natural World." *Leonardo* Vol. 24. No. 4.: 457–465.

1991d "The Mission to Planet Earth, The Earthscore Notational System, and Television." *Earth Observations and Global Change Decision Making*, (NASA Conference). Vol. II, 1990: 319–324. Edited by I. Ginsberg and J. Angelo, Malabar, Florida: Krieger Publishing.

Reference List

Apel, Karl—Otto
1981 *Charles S. Peirce, from Pragmatism to Pragmaticism.*
 Amherst: University of Massachusetts Press.

Arendt, Hannah
1978 *Willing.* New York: Harcourt, Brace Jovanovich.

Bateson, Gregory
1958 *Naven.* Stanford, Calif.: Stanford University Press.
1974 "Observations of a certacean community" in
 McIntyre, Joan. *Mind in the Waters.* New York:
 Scribner.
1972 *Steps to an Ecology of Mind.* New York: Ballentine.
1979 *Mind and Nature.* New York: Dutton.

Benjamin, Walter
1979 *Illuminations.* New York: Schocken.

Bennett, D.W.
1987 *New Jersey Coastwalks.* Sandy Hook Highlands, New
 Jersey: American Littoral Society.

Berg, Peter (ed.)
1978 *Reinhabiting a Separate Country.* San Francisco, Calif.:
 Planet Drum.

Berry, Thomas
1970 Private Conversation. Riverdale Center for Religious
 Research, Riverdale, NY.
1988 *The Dream of the Earth.* San Francisco, Calif.: Sierra
 Club Press.

Bickerton, Derek
1990 *Language and Species.* Chicago: University of Chicago Press.

Birdwhistell, Ray
1970 *Kinesics and Context.* Philadelphia: University of Pennsylvania Press.

Boff, Leonardo
1988 *Trinity and Society.* Maryknoll, New York: Orbis.

Brown, G. Spencer
1972 *Laws of Form.* New York: Julian Press.

Brown, Lester
1990 *State of the World.* New York: W.W. Norton.

Casti, J. L.
1988 *Alternate Realities.* New York: Wiley.

Cavell, Stanley
1982 "The Fact of Television," *Daedalus* III, #4, Fall, pp. 75–96.

Dinnerstein, Dorothy
1976 *The Mermaid and the Minotaur.* New York: Harper Colophon.

Eco, Umberto
1979 *The Role of the Reader.* Bloomington: Indiana University Press.

Ekeland, Ivar
1988 *Mathematics and the Unexpected.* Chicago: Chicago University Press.

Foucault, Michel
1979 *Discipline and Punish.* New York: Vintage.

1980 *Power/Knowledge.* Colin, Gordon, ed. New York:
 Pantheon.

Fuller, Peter
1981 "The Crisis of Professionalism." *Art International* 6, No.
 2, 31 July.

Gans, Eric
1985 *The End of Culture.* Berkeley: University of California
 Press.

Gerbner, George
1976 "Living with Television: The Violence Profile."
 Journal of Communications 26, No. 2, Spring, pp. 173–
 200.
1982 "Life According to TV by Harry Waters." *Newsweek*
 100, No. 23, 136, 6 December.

Gigliotti, Davidson
1983 "Video Art of the Sixties" in *Abstract Painting: 1960–
 69,* exh. cat. P. S. 1, (Project Studies One), The
 Institute for Art and Urban Resources, Inc., Brooklyn,
 New York (January 16 – March 13), unpaginated.

Gillette, Frank
1978 "Aransas: Axis of Observation." *All Area* 1:1.

Gleick, James
1987 *Chaos.* New York: Penguin.

Gödel, Kurt
1962 *On Formally Undecidable Propositions of Principia Mathe-
 matica and Related Systems.* New York: Basic Books.

Goodman, Nelson
1968 *Languages of Art.* New York: Bobs – Merrill Co, Inc.

Heidegger, Martin
1968 *What Is Called Thinking?* New York: Harper & Row.

Hopkins, Gerard Manley
1953 *Gerard Manley Hopkins.* Gardner, W. H., ed. New York: Penguin.

Judson, William D.
1988 *American Landscape Video.* Pittsburgh, Pa.: The Carnegie Museum of Art.

Kevelson, Roberta
1990 *Peirce, Paradox, Praxis, The Image, The Conflict, and The Law.* New York: Mouton de Gruyter.

Korot, B. and Schneider, I. eds.,
1972 *Radical Software* 2, No. 1, September.

Kuhns, Thomas
1962 *The Structure of Scientific Revolutions.* Chicago: University of Chicago Press.

Lacan, Jacques
1978 *The Four Fundamental Concepts of Psycho-Analysis.* New York: W. W. Norton.

Levy, Steven
1984 *Hackers.* New York: Doubleday.

Lieb, Irwin
1977 "Appendix B." *Semiotic and Significs (The Correspondence between Charles S. Peirce and Victoria Lady Welby)* Harwick, C., ed. Bloomington, Indiana University Press.

Lilly, John,
1970 *Programming and Metaprogramming in the Human Bio-computer — Theory and Experiments.* Menlo Park, Calif.: Whole Earth Catalog.

McCulloch, Warren
1965 *Embodiments of Mind.* Cambridge, Ma: M.I.T. Press.
1967 *International Symposium on Communication Theory and Research.* First Symposium, Kansas City, Mo.: 1965; *Communication Theory and Research.* Springfield. Ill: Thomas, Charles C., pub.

McLuhan, Marshall
1962 *Gutenberg Galaxy.* Toronto: University of Toronto Press.
1964 *Understanding Media.* New York: McGraw Hill, p. 21.
1966 "Address at Vision 65." *The American Scholar* 35, #2, Spring, pp. 196–205.
1967–68 Lectures at Fordham University, unpublished.
1968 *War and Peace in the Global Village.* New York: Bantam.

Meyrowitz, Joshua
1985 *No Sense of Place.* New York: Oxford University Press.

Murphey, Murray
1961 *The Development of Peirce's Philosophy.* Cambridge, Ma.: Harvard University Press.

Peirce, Charles S.
1931-35 *Collected Papers.* Harthshorne C. and Weiss P., eds. Cambridge, Ma.: Harvard University Press.
1982 "Harvard Lecture I," *Writings of Charles S. Peirce, a Chronological Edition*, Vol. I. Bloomington, Indiana: Indiana University Press.

Raindance Classics.
1969–71 B&w videotapes, Electronic Arts Intermix, 536 Broadway, NYC, NY, 10012.

Rappaport, Roy
1971 "The Sacred in Human Evolution." *Annual Review of Ecology and Systematics* 2, pp. 23–44.

1975 "Ritual as Communication and as a State." *CoEvolution Quarterly*, Summer.
1979 *Ecology, Meaning and Religion.* Berkeley, Calif.: North Atlantic Books.

Ringel, G.
1974 *Map Color Theorem.* New York: Springer Verlag.

Ryan, Paul
1968–1991 For all chronological entries please see Appendix III.

Scarry, Elaine
1985 *The Body in Pain.* New York: Oxford University Press.

Scheflen, Albert
1974 *How Behavior Means.* New York: Doubleday.

Shamberg, Michael
1971 *Guerrilla Television.* New York: Holt.

Talbot, Allan
1983 *Settling Things.* Washington D.C.: The Conservation Foundation.

Thom, Rene
1975 *Structural Stability and Morphogenesis.* Reading, Mass.: W. A. Benjamin, Inc.

Urban Conservation Corps
1989 *Is This Your Park?* Color videotape, 3 min., Archives, The Parks Council, 457 Madison Avenue, New York, NY 10022.
1991 *Young Eyes, Green Parks*, Color videotape, 30 min., Archives, The Parks Council, 457 Madison Avenue, New York, NY 10022.

Waddington, C. H. ed.
1968 *Toward a Theoretical Biology.* Chicago: Adline Publishing Co.
1970 *Behind Appearances.* Cambridge, Ma.: MIT Press.

Weschler, Lawrence
1982 *Seeing Is Forgetting The Name Of The Thing One Sees.* Berkeley: University of California Press.

Wittgenstein, Ludwig,
1975 *Wittgenstein's Lectures on the Foundations of Mathematics Cambridge 1939*, Diamond, Cora, ed. Chicago: The University of Chicago Press.

Index